Norman Rockwell

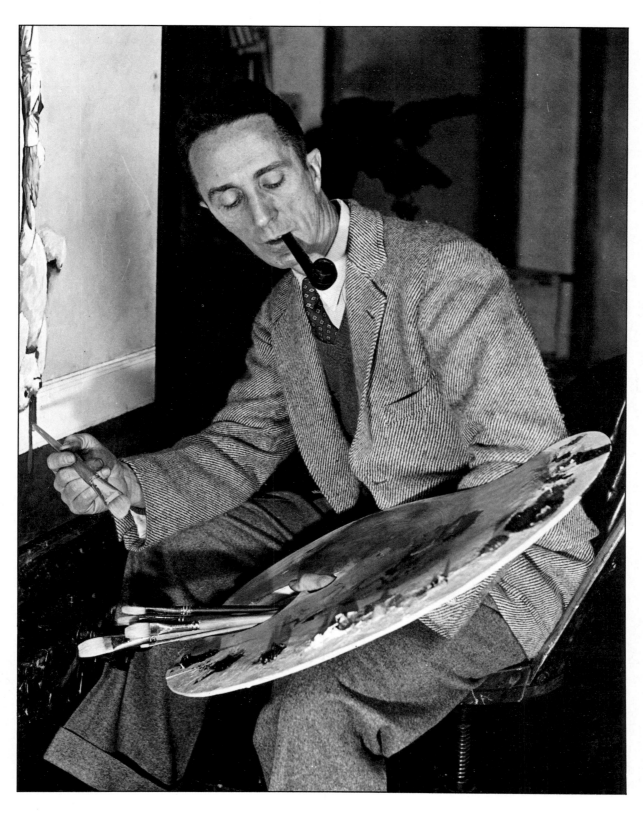

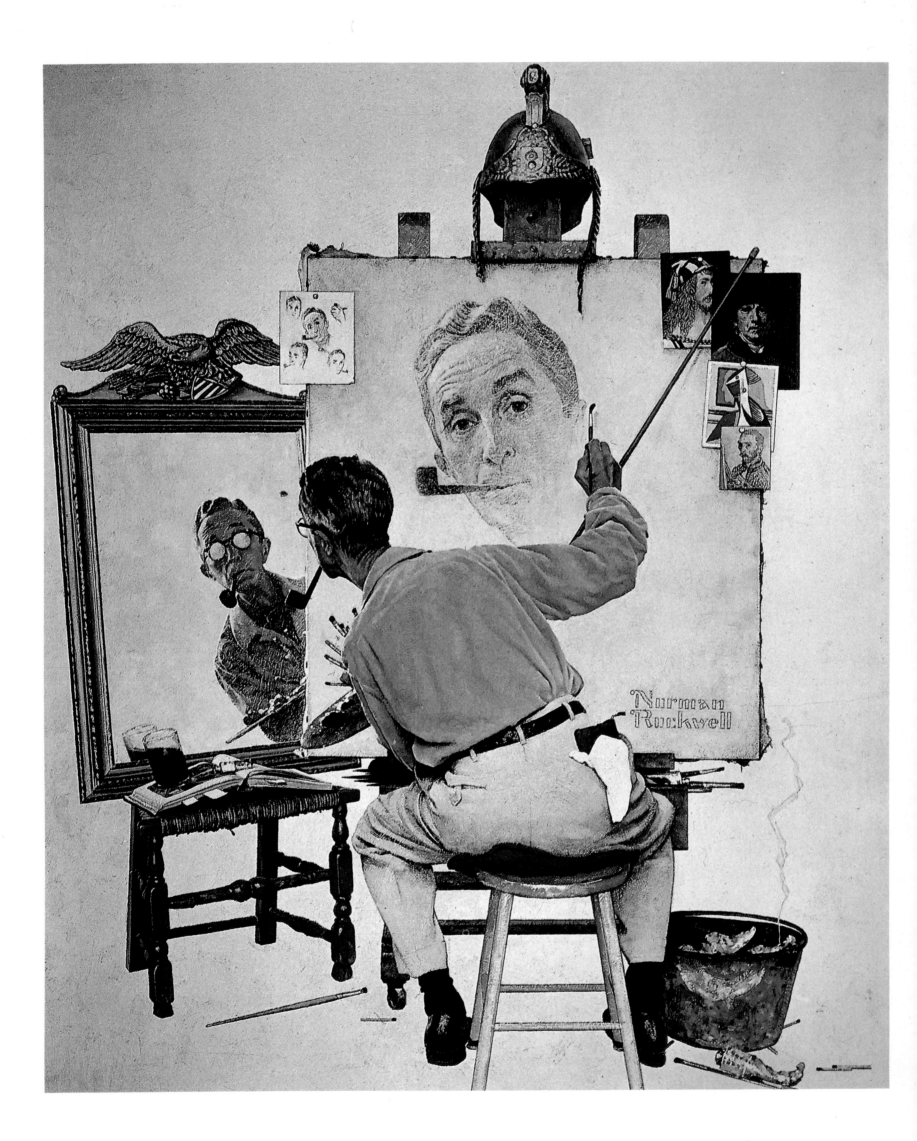

Norman Rockwell

Elizabeth Miles Montgomery

Brompton

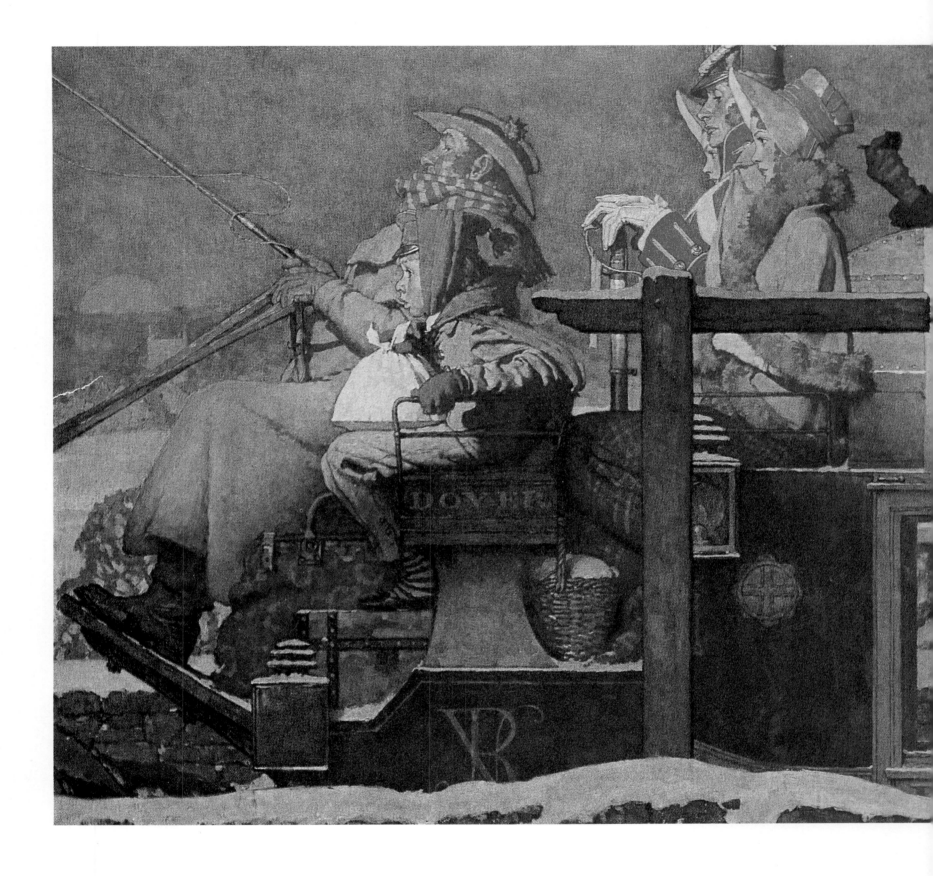

Published by
Brompton Books Corp.
15 Sherwood Place
Greenwich, CT 06830

Copyright © 1989 Brompton Books Corp.

ISBN 0-86124-459-1

Printed in Spain

Reprinted 1998

ACKNOWLEDGMENTS

The author and publisher would like to thank the following people
who helped in the preparation of this book: Donna Cornell Muntz,
who did the picture research; Mike Rose, who designed it; John
Kirk, who edited it; and Thomas M SerVaas, who photographed
the plates. Special thanks are due Thomas Rockwell, Estate of
Norman Rockwell, and Steven C Pettinga, *Saturday Evening
Post*, for their invaluable assistance and advice.

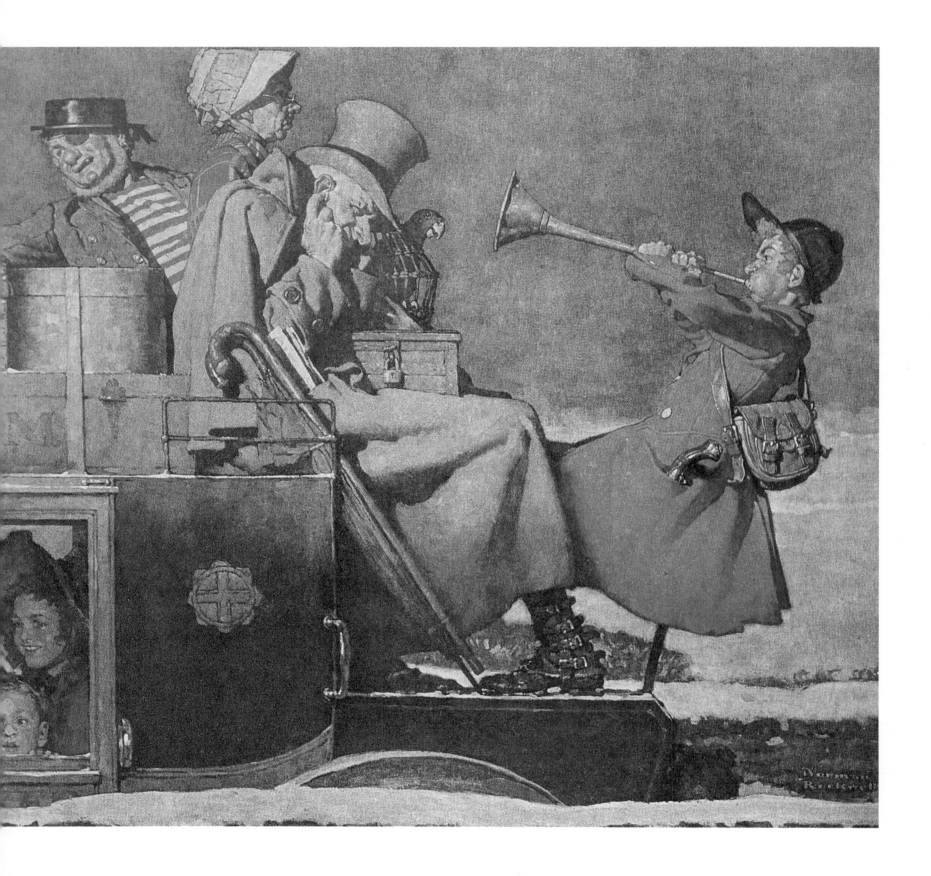

Page 1: *Norman Rockwell.*

Page 2: Triple Self-Portrait,
oil painting for Post *cover,*
13 February 1960.

Pages 4-5: Dover Coach,
Post *illustration for "From*
the Posthumous Papers of
the Pickwick Club," 28
December 1935.

Page 7: *An unpublished*
Rockwell portrait of the
author's father, W S Miles.

For Daddy

N O R M A N R O C K W E L L

NORMAN ROCKWELL

Norman Rockwell may now be the most popular painter in the history of the United States, for he has managed to please a larger audience for a longer time than any other artist. Certainly his technical accomplishments – his uncanny skill at portraying character and mood, his draughtsmanship, his composition, his lighting – were formidable. But his real popularity derives from the sense of familiarity, the instant recognition, his work provides to virtually every American. His critics have said that he chose to depict only the good side of the American experience. This is not altogether accurate, but in any case, it is beside the point. The real question is, how true were the things he *did* choose to paint? Millions of Americans have decided that they were very true indeed.

Obviously Rockwell won his vast audience of admirers because of the inherent appeal of his work, but the fact that he was given access to such an

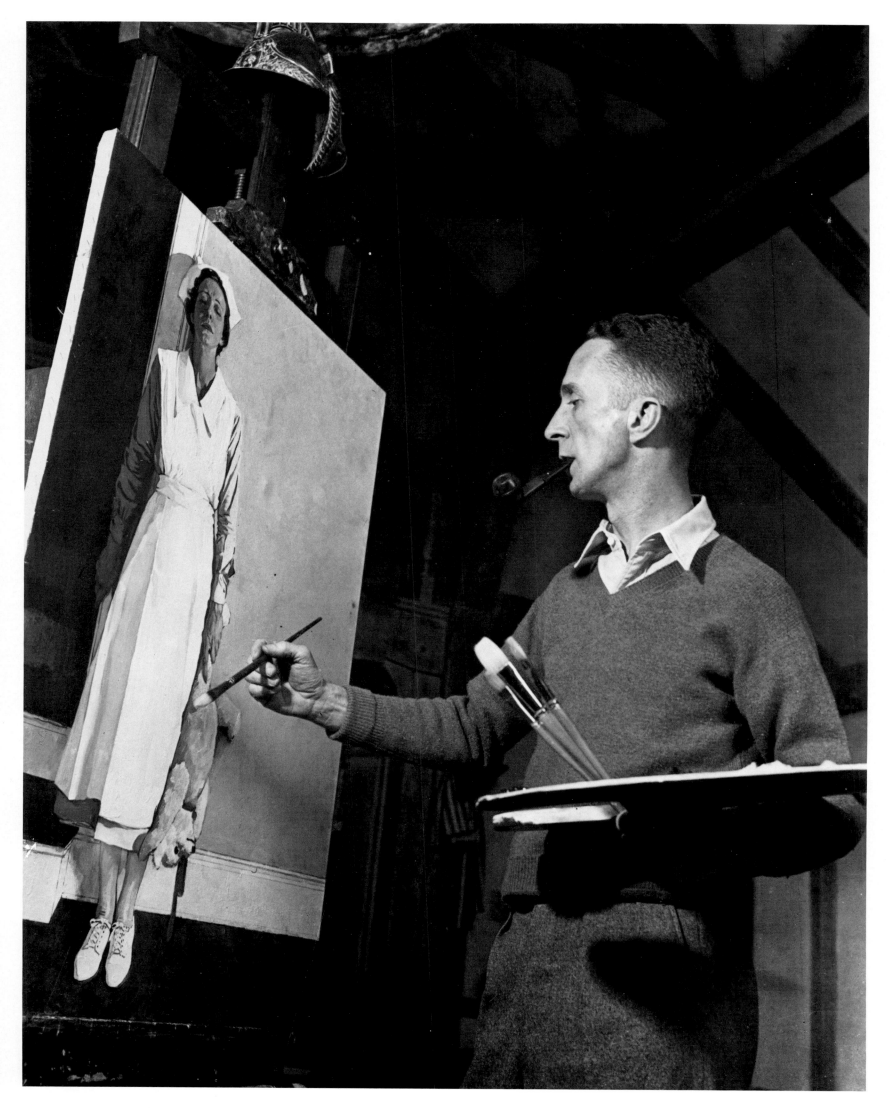

Rockwell in 1939, posing beside an interior illustration for the Saturday Evening Post. *Note the unpigmented brushes.*

audience in the first place was more fortuitous, the result of a particular set of external circumstances that existed at just the time when he was at the height of his artistic powers. The first of these had to do with the pre-eminence of newspapers and magazines as vehicles of mass communication in the roughly 50-year period between the turn of the twentieth century and the coming of television. The second concerned the special cultural role that had been bequeathed to twentieth-century illustrators by their nineteenth-century forebears. And the third related to the advent of certain new technologies – notably the technique of photoengraving and its derivatives: the use of the halftone screen and the development of four-color process printing. In combination these circumstances produced what may well have been illustration's Golden Age, an historically unrepeatable moment when the talents of illustrators such as Rockwell could be displayed more advantageously, and to a larger and more receptive audience, than ever before or since.

Two examples of Charles Dana Gibson's immortal 'Gibson Girl,' one of the early twentieth century's most famous icons.

Howard Pyle (left) almost certainly influenced the course of illustration in this century more than any other man. Winslow Homer (right), one of the most noted illustrators of the preceding generation, had given up illustration in 1876 in favor of full-time easel painting, at which he succeeded brilliantly in the media both of oil and, more especially, of watercolor.

It is easy to forget in our own era of instant electronic communication the extraordinary influence wielded by newspapers and magazines in the nineteenth and early twentieth centuries. Not only were they the sole media for the broad dissemination of news and information, for most people they were also the primary source of new images. In the nineteenth century these images were conveyed almost entirely through the medium of the hand-made engraving – usually woodcut. Although as the century wore on photographs were increasingly used as the basis for these engravings, the overwhelming majority continued to be made from artists' renderings. Thus it was artists' visions of reality, rather than the objective but impersonal imagery of the camera lens, that people were most accustomed to seeing, and in many cases preferred to see. The way most readers of *Harper's Weekly* in the 1860s visualized the Civil War, for example, had little or nothing to do with photographs and much to do with battle sketches by such artists as Winslow Homer. Similarly, once readers had seen Howard Pyle's engravings, most neither could nor wanted to imagine that pirates ever looked any other way. Writing in 1892 of Frederic Remington's illustrations, critic William Coffin noted: 'It is a fact that admits of no question that Eastern people have formed their conception of what Far-Western life is like more from what they have seen in Mr Remington's pictures than from any other source. . . .' By the early 1900s Charles Dana Gibson had virtually defined for the country the ideal of aristocratic feminine beauty in his 'Gibson Girl' (modeled on his wife, Irene).

The great nineteenth-century illustrators achieved their eminence as national image-makers despite the severe restrictions placed on them by the contemporary state of printing technology. On ordinary hand-engraved woodcuts or lithographs representations of gradations in tone from black to white (halftones) were subject to the same limitations as in a pen-and-ink sketch: That is, they could only be implied by laborious hatching or stippling. As for color printing, though it was technically possible, it was too expensive and time-consuming for newspapers or magazines to employ, and in any case, the finished results tended to be of indifferent quality.

*For a time Howard Chandler Christy's 'Christy Girl' almost rivaled the 'Gibson Girl' in popularity, but whereas Gibson specialized in pen-and-ink, Christy was the more proficient painter. Perhaps Christy's most famous work, **The Signing of the Constitution**, hangs in the Capitol rotunda in Washington, DC. It is said that Christy researched the details used in the painting for over three years.*

A breakthrough came in the 1880s, when the halftone screen – a wholly mechanical photoengraving technique that made it possible to produce printing surfaces capable of rendering halftones on fields of nearly invisible, various-sized dots of ink – began to come into use. Although the first such screen halftones were black and white, the application of color process printing to the technique followed quickly, and the first successful color halftone was printed in 1892.

Since halftone printing made it possible for the first time to reproduce photographs accurately, there were many dire predictions at the century's end that now that the day of the photograph had dawned, the age of the illustrator was over. Nothing could have been farther from the truth, for the new printing techniques presented illustrators with opportunities to dazzle their audiences as never before. They could now dispense with the sometimes distorting, often deadening and always limiting intermediacy of the engraver and display their work in something very close to its original form. All the manifold qualities of media – the airiness of pencil, the boldness of charcoal, the brilliance of pastel, the subtlety of watercolor, the authority of oil – were now at the illustrator's disposal, and most important, so was color.

The first two decades of the twentieth century witnessed a kind of revolution in illustration. In America the direction that this revolution took owed much to the influence of the masterly Howard Pyle, who set for his colleagues brilliant and imaginative examples of how they might exploit their new-found freedom of expression and who personally trained (without fee) some of the best of the new breed of illustrators – the great N C Wyeth, for example, Frank Schoonover and Harvey Dunn, himself destined to become a famous teacher. Rockwell, though he properly belonged to the succeeding generation of illustrators, never hesitated to cite Pyle's work as one of his earliest and most important influences.

The public greeted the new kind of illustration enthusiastically, and by the 1920s a number of American illustrators had achieved a remarkable degree of personal recognition. There were, for example, Maxfield Parrish, with his luminous, dreamy recreations of Golden Ages that could never have existed, and James Montgomery Flagg, whose 'Uncle Sam Wants You!' recruitment poster remains one of World War I's most memorable icons. Howard Chandler Christy's provocative Christy Girl and Coles Phillip's stylish 'fadeaway' girls rivaled the Gibson Girl in popularity. And if not everyone knew the names of Joseph and Frank Leyendecker, virtually everyone recognized and admired the distinctive, glossy, neo-Art Deco style they imparted to their *Saturday Evening Post* covers and to their hugely successful Arrow Shirt advertisements.

The old distinction between illustration and fine art was also beginning to blur. The best illustrators yielded to none in matters of technical proficiency or inventiveness. (Though to be sure, both popular taste and the demands of their editor and corporate art director clients limited most illustrators' choice of subject matter and obliged them to hew fairly closely to realistic representation.) By the same token, a growing number of 'pure' artists such as William Glackens, George Grosz, E L Blumenschein, W Herbert Dunton and others were beginning to experiment with illustration – as would Dali, Dufy and even Picasso later on.

Into this rich artistic ferment came Norman Rockwell. Born in New York on 3 February 1894, he was the younger son of Jarvis Waring Rockwell, the New York agent of a Philadephia textile firm, and his wife, Nancy. Nancy's father, William Hill, was an English painter who specialized in finely detailed

genre paintings, as well as portraits and paintings of animals, and it may be that Norman was inspired by his example. In any case, Norman began to draw as a child. Mr Rockwell enjoyed reading aloud, and Norman sketched scenes from Dickens while his father read.

When, in 1903, the family moved to Mamaroneck, New York, at that time almost rural, Rockwell felt truly at home. Like many other families at the turn of the century, the Rockwells had frequently spent summers as boarders on farms in New Jersey or upstate New York. Farm life had changed little from early nineteenth century, and Rockwell developed a taste for rural life, memories of which would become the source of many of his early works.

In 1907 he began to study art at the Chase School of Fine and Applied Art in New York, at the age of fourteen having fixed on a career in art. He earned some of the tuition for his classes by teaching sketching to actress Ethel Barrymore and a friend. His first true art commission was to design four Christmas cards for Mrs Arnold Constable.

At fifteen, he left high school to become a full-time art student at the National Academy School in New York, sketching plaster casts and live models, learning anatomy and painting still lifes. Several months later he transferred to the Art Students League, at that time the most liberal art school in the country. Among Rockwell's instructors at the ASL were George

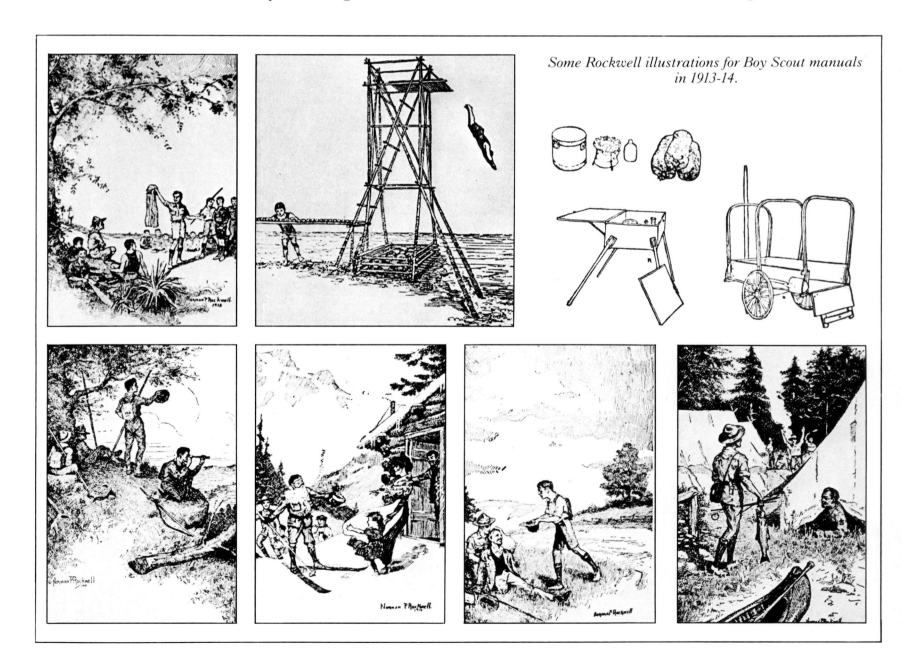

Some Rockwell illustrations for Boy Scout manuals in 1913-14.

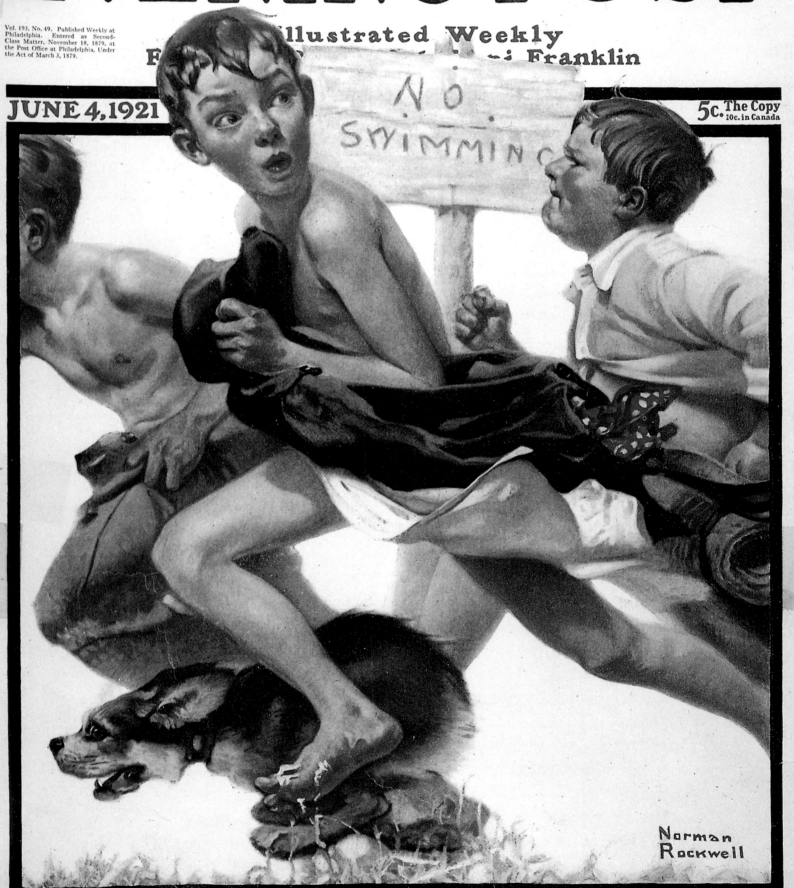

No Swimming, one of Rockwell's best-liked early Post *covers.*

Bridgman and Thomas Fogarty. Bridgman taught draughtsmanship and anatomy, occasionally sketching the muscles and bones on live models for emphasis. Fogarty taught illustration, with special stress on accuracy in portraying setting and fidelity to the intentions of the author. Fogarty also pushed his students to take real assignments, so as to gain the experience they would need if they were to succeed in the field of illustration.

Rockwell's first commission was to execute a dozen illustrations for a children's book, *Tell Me Why Stories*, a series of explanations of natural phenomena. This was followed by assignments from publishers of other children's books and magazines, and in 1912 he was hired to illustrate one of the Boy Scout handbooks. The following year he became the art director of *Boys' Life*, the official magazine of the Boy Scouts of America. The position involved a monthly cover painting and some of the interior illustration, as well as production details and the assignment of projects to other artists. For this he was paid $50 a month and was allowed to take on freelance work in his spare time.

The Rockwell family moved to New Rochelle in 1914. At that time the New York suburb claimed many of the great illustrators as residents, including Charles Dana Gibson, Howard Chandler Christy, James Montgomery Flagg and the Leyendecker brothers.

Rockwell continued to work for *Boys' Life*, while providing illustrations for such well-known juvenile magazines as *St Nicholas, Youth's Companion, Harper's Young People* and *Everyland*, but he wanted to move into the field of adult illustration. Eventually he overcame his natural shyness and prepared three works for submission to the *Saturday Evening Post*, the most widely-read magazine of the time. Two were finished oils, one of a boy pushing a baby carriage and being teased by his baseball-playing friends, and the other of a children's backyard circus. The third, of an elderly man playing baseball with children, was a mere sketch. All three were seen by Walter Dower, then the art editor of the *Post*, and accepted. The first appeared on the cover on 20 May 1916, the second on 3 June 1916 and the third, which Rockwell had to re-do five times to please George Lorimer, the demanding editor of the *Post*, appeared on 5 August 1916. Before the year was out, Rockwell had sold three more cover illustrations.

Acceptance by the *Post* meant acceptance by other magazines as well, and Rockwell received commissions from *Life, Leslie's* and *Judge*. Recalling this time in his life Rockwell would report, 'You offered your stuff to the *Saturday Evening Post* first, then to the old *Life, Leslie's* and the others in regular order. If we couldn't sell a drawing anywhere else we shipped it out to Des Moines to the *People's Popular Monthly*. They bought everything and paid fifty dollars for each drawing, good or bad.'

These successes gave Rockwell confidence that he would succeed in his profession, and on the strength of that confidence he married his first wife, in 1916. The new Mrs Rockwell had been Irene O'Connor, a schoolteacher from Potsdam, New York.

Marriage and career were both interrupted by the declaration of war in April 1917, and in 1918 the chronically underweight Rockwell stuffed himself

Rockwell in his studio.

Portrait of Mary Barstow Rockwell.

with bananas and doughnuts long enough to pass a Navy physical. Rockwell never saw active service, but worked on the newspaper *Ashore and Afloat* while stationed in Charleston, South Carolina. He also continued to produce covers for the *Post* and to work for several other magazines, as well as painting portraits of the officers at Charleston. Thus the war had little affect on his career, and after his return to New Rochelle, Rockwell continued to paint *Post* covers, as well as do advertisements. Perhaps the only noticeable change in his style was a certain increase in his use of patriotic themes and images.

His income by this time was already substantial, and the Rockwells rapidly became part of the New Rochelle social scene, joining the golf club and patronizing the best bootlegger. By 1923 Rockwell could also afford to take himself to Europe for the first time, and while in Paris he attended classes at Calorossi's art school, where Joseph Leyendecker had been a student. This trip opened Rockwell's eyes to the changes that had swept through art in the previous decades. But a brief attempt at introducing abstraction into his work was immediately rejected by Lorimer, who knew that Rockwell's greatest talent

lay not in his ability to experiment but in his almost uncanny mastery of the common touch.

After that Rockwell continued to paint in the old way throughout the 1920s, creating *Post* covers celebrating Victorian Christmases, or portraying historical vignettes and, always, children. He and his wife underwent a trial separation, but patched up their marriage and moved to a new house in New Rochelle, to which Rockwell added a studio. It was described by *Good Housekeeping* as 'A House with Real Charm'. His growing importance to the *Post* and the *Post* readers was evident when he became the subject of one of their articles in 1926.

Another proof of Rockwell's popularity was his commission to paint the first *Post* cover in full color. Entitled *The Old Sign Painter*, it was an historical subject, showing the making of a tavern sign in the eighteenth century. The model for the painter was one of Rockwell's favorites, James K Van Brunt, who had become instantly recognizable by his immense mustache. For this cover Rockwell persuaded Van Brunt to shave off the mustache, which revealed an even more impressive protruding lower lip.

In 1929, after 13 years of marriage, Irene Rockwell at last asked for and obtained a divorce. Rockwell moved back to New York, to the Hotel des Artistes. Subsequently, to escape a persistent art director from *Good Housekeeping*, who wanted the artist to illustrate the life of Christ, Rockwell

Sketches of Paris made during the 1932 European trip.

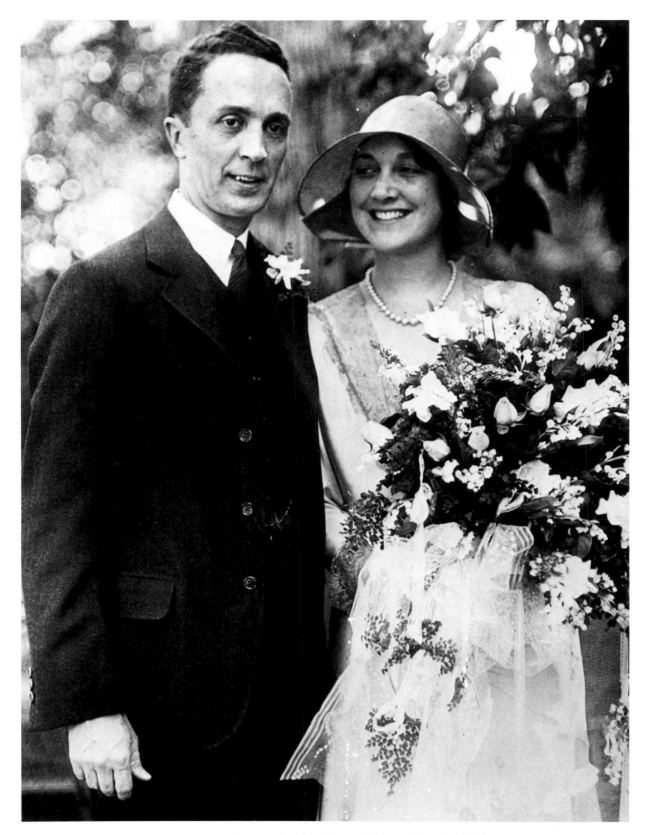

Norman and Mary Rockwell at their wedding in 1930.

took an extended trip to California. He painted one *Post* cover there, of Gary Cooper being made-up, which appeared on the 24 May 1930 issue. But even before the publication date Rockwell had met and married a young California schoolteacher, Mary Barstow. The couple moved back to New Rochelle.

Ever concerned about improving the quality of his work, Rockwell now began to experiment with a movement called dynamic symmetry, which involved the artist's use of mathematical formulae to establish proportion and balance. The *Post* published one cover painted according to this theory, but Rockwell was never happy with the result.

In 1932 the entire family, which by then included his eldest son, Jarvis, took an extended trip to Europe. After several months in Paris, which included

The original painting for this illustration (see pages 4-5) was hung over the clubhouse bar of the Society of Illustrators in New York.

study at several well-known art schools, Rockwell realized that his attempts to master the fashionable approaches of modern art were unsuccessful and unsatisfying. He was at last reconciled to the fact that his strength lay in painting what he knew best in his own clearly defined style.

Although Rockwell had long since demonstrated his ability to convert other people's ideas into powerful images, he had had relatively little experience in the somewhat more complex business of illustrating literary texts. He therefore turned more and more to internal illustration for the magazines, and was delighted when he was commissioned by Heritage Press to create a new series of illustrations for *The Adventures of Tom Sawyer* and *Huckleberry Finn*.

The escapades of two boys in an historical rural setting was a perfect Rockwell assignment, and some people think the results were as good as anything he ever did. He began by reading the books again, over and over, making small sketches of incidents that might define the characters and catch the essential spirit of the story. After studying and being dissatisfied with the works of previous Twain illustrators, he decided to go to Hannibal, Missouri, and see for himself the places Twain had written about. In the mid-1930s Hannibal had not been taken over by tourism, and Rockwell found the little river town much as it had been in Twain's time. He even bought clothing from Hannibal's citizens that he thought might suit his characters. Such devotion to detail was always a hallmark of Rockwell's work. For many years he collected authentic properties and antique costumes to clothe his models accurately.

The illustrations for *Tom Sawyer* and *Huckleberry Finn* were a triumph, and soon after, when he was commissioned to illustrate a series of articles about Louisa May Alcott in *Women's Home Companion*, he went to Concord, Massachusetts, to gather the same wealth of detail of place that he had in Hannibal.

This was followed by a mural at the Nassau Tavern in Princeton, New Jersey. Rockwell chose Yankee Doodle as his subject and portrayed a young bumpkin, with a feather in his hat, riding nonchalantly (and somewhat gracelessly) past a company of British soldiers at ease. The fee for this job was

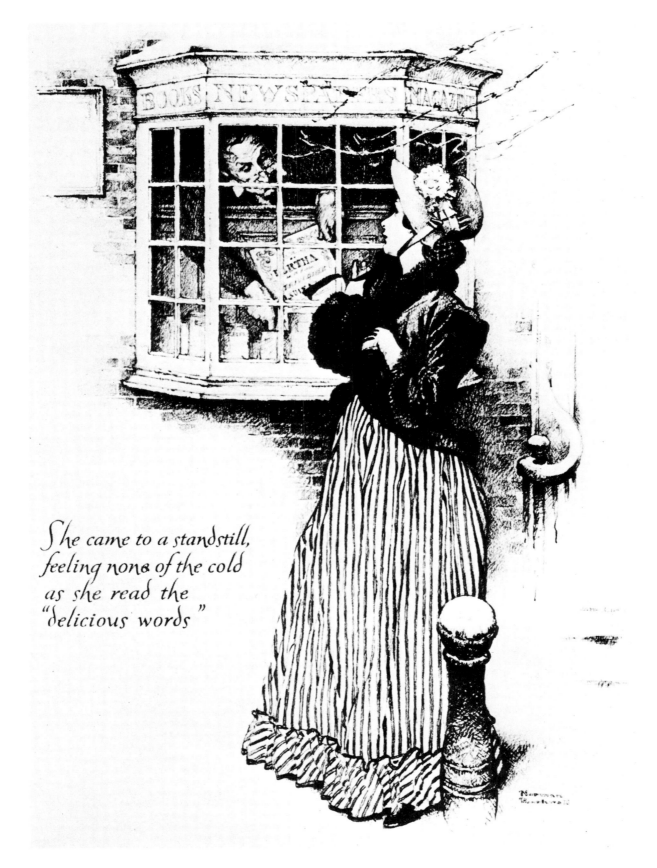

She came to a standstill, feeling none of the cold as she read the "delicious words"

An illustration for a series on Louisa May Alcott that appeared in The Woman's Home Companion *in 1937-8.*

almost entirely swallowed up by the uniforms Rockwell had made for his troops, accurate to the last button and knot of ribbon. Though the portraits seem to be gentle caricatures, each face, when studied, is that of a real person.

Following the retirement of long-time *Post* editor George Lorimer in 1936, Rockwell entered a period of self-doubt. Lorimer's successor, Wesley Stout, was critical of Rockwell's work, and frequently requested time-consuming changes. Once again Rockwell felt an urge to move out of his normal pattern of life. A trip to Europe in 1938 with all three children (two more sons had joined the family – Tommy, born in 1933, and Peter, born in

1936) proved expensive and, thanks to the darkening political situation, more disquieting than refreshing.

On the advice of one of his models, Fred Hildebrand, Rockwell and his wife began to search for a house in the country, finally buying property in the small Vermont town of Arlington, north of Bennington. The move to Arlington, in 1939, opened a new field for Rockwell, for the local citizens were precisely the sort of people whom Rockwell felt most comfortable portraying. Soon after the Rockwells moved to Arlington they were joined by several other artists, including Mead Schaeffer, Jack Atherton and George Hughes, all of whom also worked for the *Post*, and a small artist's colony sprang up.

The years in Arlington were some of the most fruitful for Norman Rockwell. The Vermont hills and the independent, isolated villages and farms inspired him to paint differently. There was less caricature in his work and more tranquillity, subtlety and genuine warmth. In some ways the coming of World War II only served to deepen this tendency.

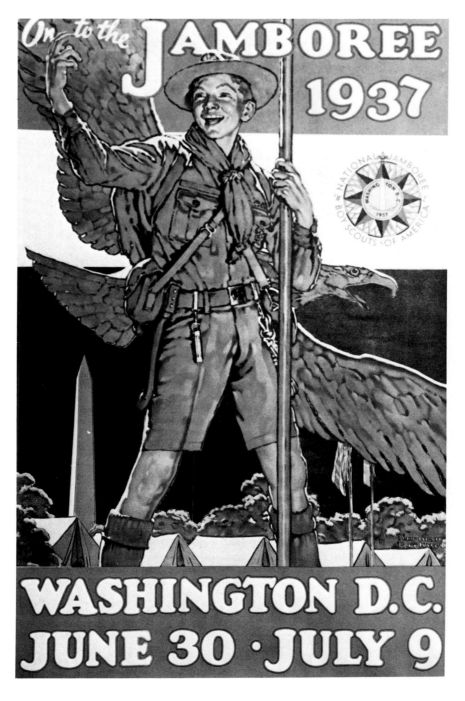

Throughout his life Rockwell continued to paint posters and calendars for the Boy Scouts of America.

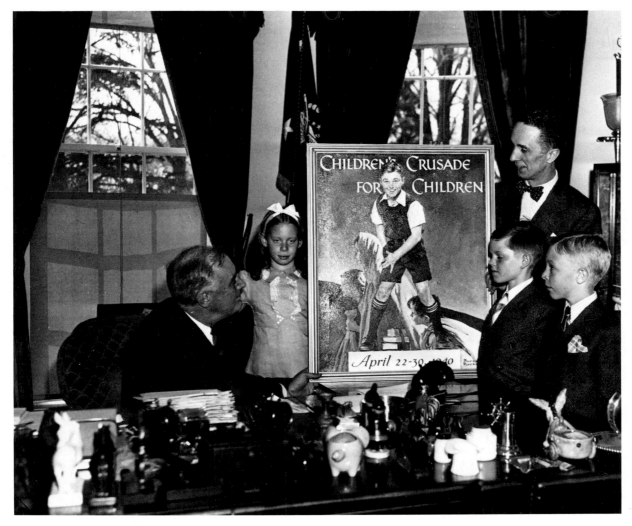

*1940: President Roosevelt receives a Rockwell
poster for a children's war relief drive. The boy on
the right is Jarvis Rockwell.*

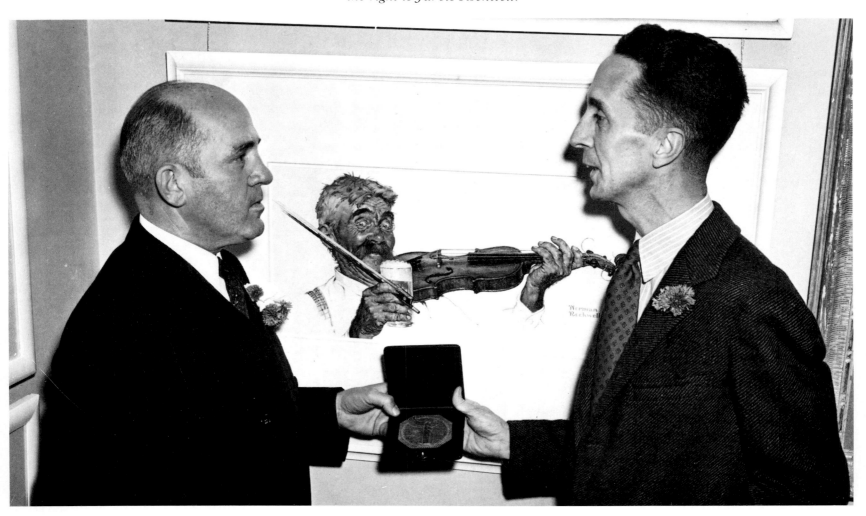

*Rockwell accepts an award from the Art Directors
Club for the best advertising poster of 1940.*

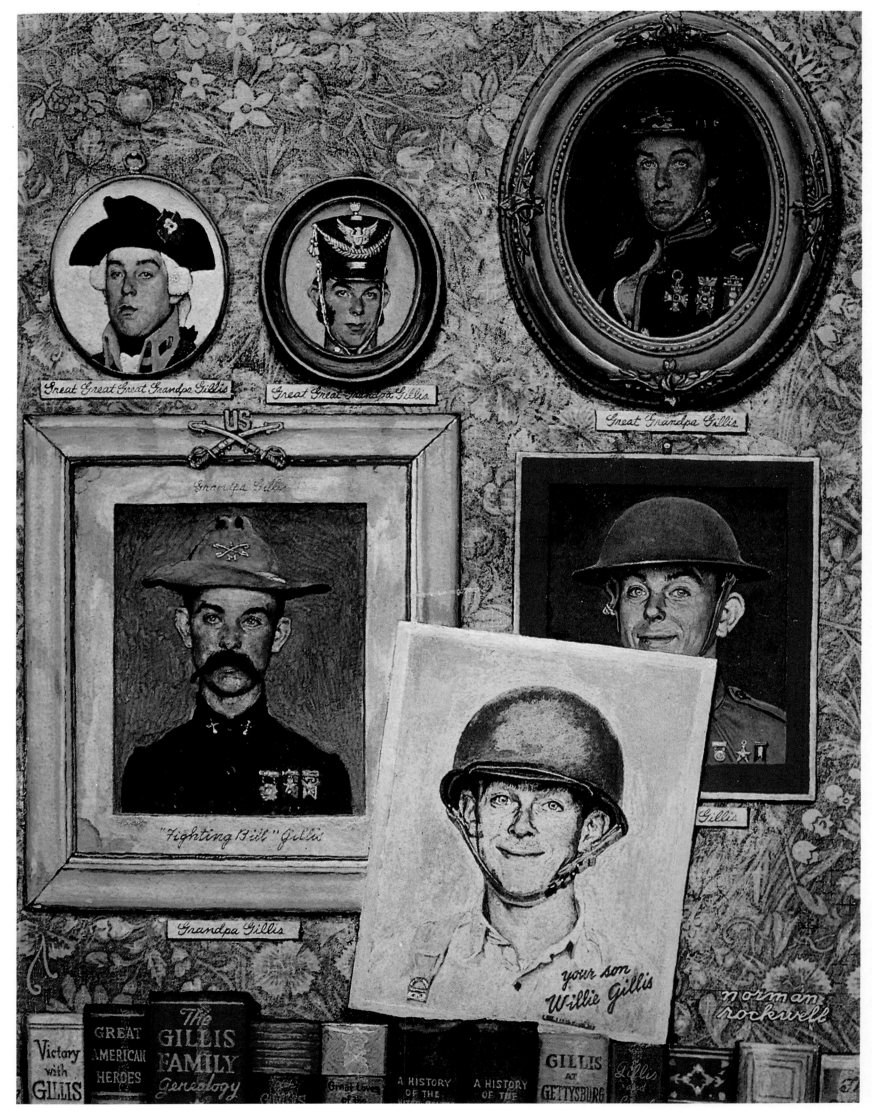

The Fighting Gillises, *a painting for the* Post *cover of 16 September 1944.*

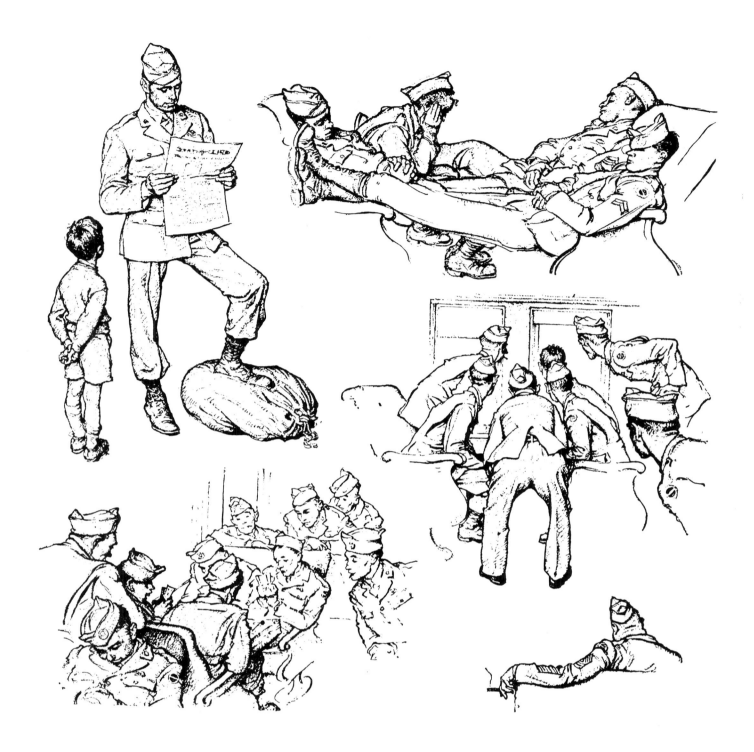

A Night on a Troop Train*. This is a part of a spread appearing in the 8 May 1943 issue of the*
Post. *Army censors permitted Rockwell to make these candid sketches of young paratroopers*
starting on the last lap of their journey before shipping overseas.

No one was better than Norman Rockwell at showing the war on the
home-front. Besides the covers, the *Post* ran several series of pen and ink
sketches by Rockwell describing a visit to a draft board, a ration board and even
a visit to the President of the United States. Rockwell also created a fictitious
soldier named Willie Gillis, whose progress he traced from basic training
through the war to college on the G I Bill. The model for Gillis was an
Arlington neighbor, Robert Buck, and when Buck enlisted in 1943 Rockwell
continued the series by painting photographs of Willie Gillis in his home-front
compositions. One of them showed portraits of six generations of Gillises in
uniforms dating back to the American Revolution, framed and hung over a
shelf of books describing the place of the Gillis family in American history. For
years after the cover was published in 1944 people wrote Rockwell to ask where
they could find these imaginary works, which featured titles like *With Gillis at*
Valley Forge, Gillis and Lincoln and *The Gillis Legacy.*

In 1942 Rockwell began a sequence of paintings known as the *Four Freedoms*. These were conceived not as *Post* covers but as original works, Rockwell's attempts to depict the values for which the United States had gone to war. He offered the paintings to the various government agencies, but none seemed able to grasp the significance of Rockwell's contribution. The four paintings depicting *Freedom of Speech, Freedom from Fear, Freedom of Worship* and *Freedom from Want*, as portrayed by ordinary Americans, were eventually published inside the *Post* in 1943. The public response was overwhelming. The immense canvases, which were 44 inches by 48 inches, were then exhibited as part of a war bond drive in 16 cities, where they were seen by over a million people who bought more than $130 million-worth of bonds. Reprints wound up on the walls of many of the same government agencies that had been too slow to accept Rockwell's offer.

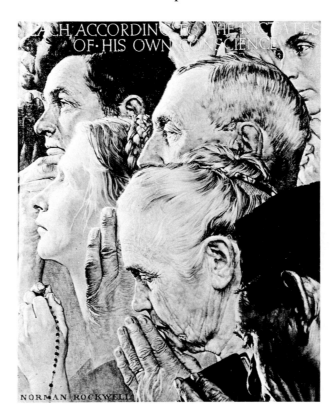

Freedom of Worship, *one of the famous* **Four Freedoms** *series.*

Shortly after the last of the *Four Freedoms* was delivered to the *Post* office in Philadelphia, Rockwell's studio in Arlington burned to the ground. In the fire were lost countless sketches and a score or so of original finished paintings. Also lost were the vast collection of costumes and props, his files, his print library, his correspondence and even his brushes. Rockwell was heard to say at the time of the fire, 'There goes my life's work.'

After the fire Rockwell resettled in nearby West Arlington. Understanding the gravity of a loss that could destroy so much of a man's work, his Vermont neighbors pitched in, in a fashion Rockwell would later celebrate in his work. They helped him build a new studio, and they donated heirloom clothing to replace the collection he had lost. He was deeply moved by this experience, and it helped to further the tendencies already apparent in his work. Increasingly he was turning away from nostalgic retrospection and was focusing on the contemporary life he found about him.

It was about this time that he began to use photographs of his models in composing his canvases. This cut down on the necessary posing time and allowed Rockwell to include more people in his pictures. Critics would later imply that this use of photography somehow diminished the integrity of his work, but such objections are captious. Rockwell was not the only artist to use photographs, nor did he always use them. They simply acted as reminders, giving the artist just the angle of a position or the stretch of a muscle. In some pictures the artist would use a number of photographs, extracting the information they held, but never simply copying what had been filmed.

The end of World War II inspired Rockwell to paint the returning military troops and inspired some of his most popular covers. One of these, painted for Thanksgiving 1945, showed a G I released from KP happily peeling potatoes with his mother; another, a returned sailor asleep in a hammock that swings over fresh spring grass rather than the deck of his ship; and a third, the *Homecoming G I,* shows the G I still baffled by the idea of being home, while his family races down to meet him, his mother with her arms thrown wide in greeting. It is not set in the usual rural village, but in a backstreet tenement of a New England mill town. Yet the sense of community is strong, and Rockwell has included details like the flags with stars (indicating a son in the service) in

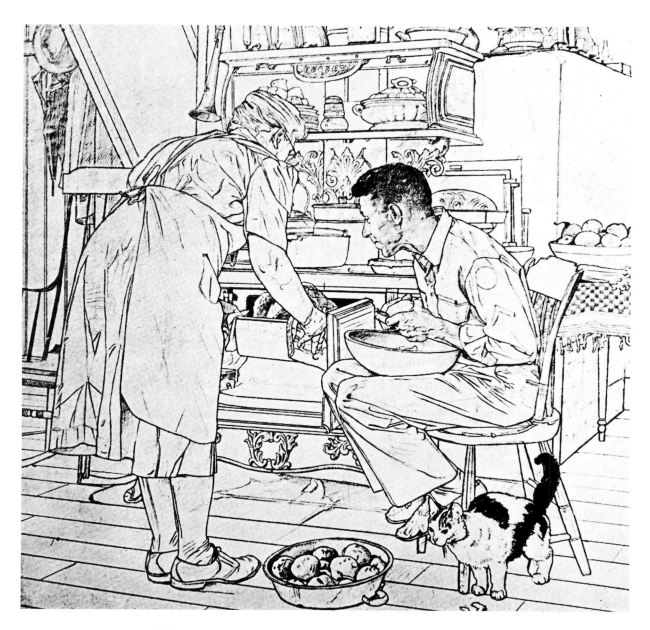

This elaborate preliminary sketch for a Post *cover did not satisfy Rockwell. For the final version see page 158.*

the windows, letting the observer perhaps think for a minute how different a homecoming each soldier might have had. Rockwell's ability to catch such emotion without turning to bathos is undeniable.

After the war, Rockwell began the series of calendars depicting the four seasons for Brown and Bigelow. Many of the designs for these harked back to the work he had done in the 1920s. He also drew his first Christmas cards for Hallmark at this time. His reputation was growing in other ways. *The New Yorker* featured him in a Profile in 1945, and a one-man show at the Milwaukee Art Institute proved the continuing interest in the artist, while his work was also featured in a number of the artists' trade magazines.

Many of his post-war paintings, including some of the most popular, are not as idyllic as his earlier work. A hint of pathos has crept in, and in most cases it makes the paintings stronger. Many paintings of this period are also mood pieces rather than narratives. The most famous of these is probably *Shuffleton's Barber Shop*, painted in 1950, a view through the window of a country barber shop that has closed for the day. The main focal point is a group of amateur musicians gathered in a well-lit back room. The light from that room spills through the door into the darkened shop, where the barber's tools and chair are highlighted. Also in the picture are a cast-iron stove, with the red-hot coals visible through the grate, and a rack of magazines for prospective customers. It is an homage to a time when people were able to create their own amusements and were not dependent on outside stimulation.

After the war Rockwell also joined the faculty of the newly-established Famous Artists School in Westport, Connecticut, a correspondence school for young artists and illustrators, and as the most famous of the contributing instructors, Rockwell was featured in the advertising campaign. But the position was no sinecure. Rockwell contributed to the lessons and advised students on many matters, especially the difficult subject of composition. The school flourished at first, but with the decline of the great illustrated magazines and the consequent loss of market for illustration the school fell on hard times and eventually closed down in the 1970s.

In 1951 Rockwell painted a cover that *Post* readers would later vote their all-time favorite. *Saying Grace* is, in fact, the quintessential Rockwell work, a simple, rather sentimental theme dazzlingly executed. The scene is the interior of a grimy railroad coffee shop. Seated at one end of a cluttered table are a small, grandmotherly lady and a little boy, their heads bowed in prayer as they say grace before beginning their meal. From the other end of the table two young workingmen watch them intently, as do a couple of other shabbily dressed restaurant patrons. The picture is composed in such a way as to produce the equivalent of what in film would be an action-reaction sequence. Via linear and lighting cues, as well as by the strong golden mean positioning of the focal point, our eyes are at first inexorably drawn to the bowed heads of the old lady and the little boy. Only after we have grasped what they are doing, and in what kind of a setting, do our eyes move away from the focal point to the other diners. Obviously they are interested in what is going on, but what do they make of it? That Rockwell gives no explicit answer constitutes the true power of this painting. The onlookers are virtually expressionless. All we can

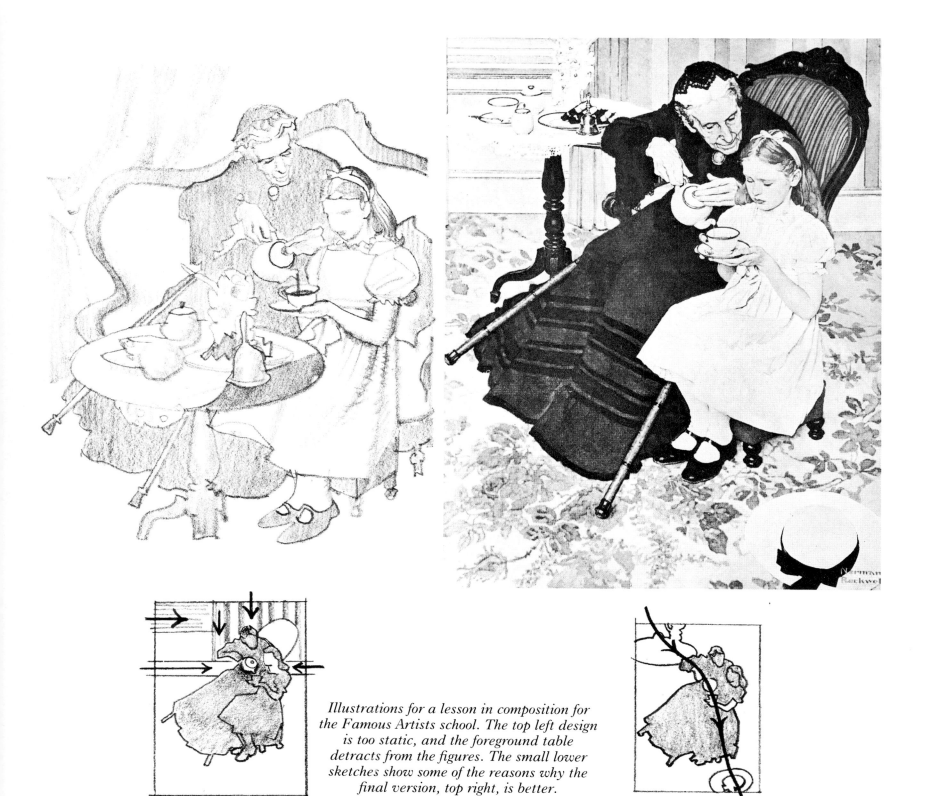

Illustrations for a lesson in composition for the Famous Artists school. The top left design is too static, and the foreground table detracts from the figures. The small lower sketches show some of the reasons why the final version, top right, is better.

say for sure is that each is interested and that each is wrapped in his own thoughts. We may surmise that they are moved and a little abashed, but we cannot be certain. And then we realize that this ambiguity is the central point, for in the end, the real question is less how *they* feel about the scene than how *we* feel about it.

Despite his successes, Rockwell was again beginning to feel discouraged about his work. He also had to face a personal problem, for his wife had developed a severe mental depression. She found help at the Austin-Riggs Center in Stockbridge, Massachusetts, a town that was situated about half-way between rural Arlington and urban New York. After spending a winter there, the Rockwells moved to Stockbridge permanently in 1953, exchanging the isolated mountains of Vermont for the pleasant valley in the Berkshires that was the home of such cultural attractions as Tanglewood and the Berkshire Playhouse.

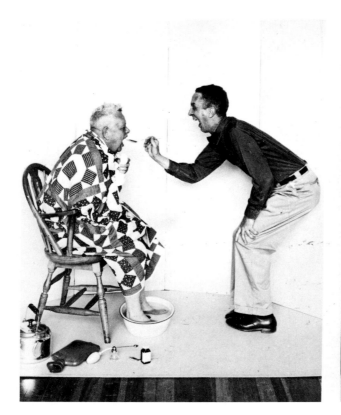

Rockwell paid great attention to the selection and posing of his models, often demonstrating the poses himself.

Rockwell's work and his attitude to it improved greatly after he moved into his studio over a row of shops on Main Street. This position allowed him to observe passers-by and occasionally to select models from the Stockbridge residents. In 1957 he moved the studio into a converted carriage house behind his newly-purchased square Federal house. This would be his last move and his last studio.

The *Post* covers that Rockwell painted in the early years of the fifties include some of his best known, *Breaking Home Ties, The Marriage License* (painted in the old Town Hall in Stockbridge), *After the Prom* and *The Runaway*. It was also in the 1950s that Rockwell began to paint portraits of the Republican and Democratic presidential candidates, as well as numerous other celebrities.

Mary Rockwell died suddenly of a heart attack in 1959, and the loss of his wife may have helped to induce the new wave of despondency that overwhelmed the artist. There were other reasons as well. Changes in public taste and the declining circulation of the many magazines to which Rockwell contributed were preying on his fragile self-confidence. On one hand, his work was celebrated when the *Post* published his autobiography, *My Life as an Illustrator*, in 1960, which later also appeared in hard-cover. But an earlier article in the *Atlantic Monthly* by Wright Morris had criticized Rockwell for 'destroying the taste of the American people' by not taking into account such new art movements as Abstract Expressionism. The social and political attitudes of the era had changed, and some readers seemed to find less relevance in Rockwell's work. Many of the magazines, including the *Post*, which he had served so faithfully, were scrambling to adjust their editorial formulae to the new sensibilities and were less inclined to give him new commissions.

Rockwell remarried in 1961. His new wife, Molly Punderson, was a retired teacher from Milton Academy, who had grown up in Stockbridge. Her

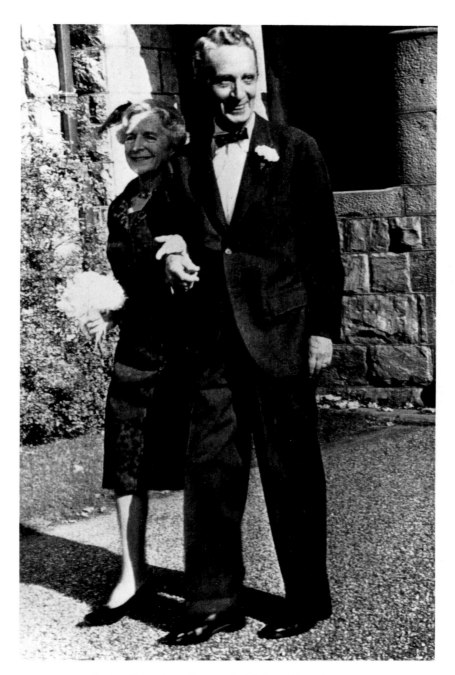

In 1961 Rockwell married Mary Punderson,
a former teacher at Milton Academy Girls School.

connections to the town anchored Rockwell to the place, and he continued to celebrate the virtues he found in small towns. The continuity he found at Stockbridge was a bolster against another major blow. After 47 years, the *Saturday Evening Post* decided they no longer wanted Norman Rockwell as a cover artist. They felt he embodied an attitude and a time the magazine no longer represented. His last *Post* cover, appearing on the issue published on 14 December, 1963 was a portrait of recently-assassinated President John F Kennedy. It was his 420th *Post* cover. The *Post's* attempt to change its format was, however, unsuccessful. The magazine went under, and after a four-year hiatus a new management revived it as a publication devoted to nostalgia, with cover art as close to Rockwell's as they could find. The new publishers still held the rights to many of Rockwell's paintings, and they were used liberally inside the magazine, but Rockwell never painted another cover for them. The ironies of all this need no emphasis. During the 1950s a Rockwell cover on the *Post* would have increased the magazine's newsstand sales by 200,000 copies.

The loss of the *Post* meant that he was now free to accept commissions from other magazines. *Look* even wanted him to paint important news events.

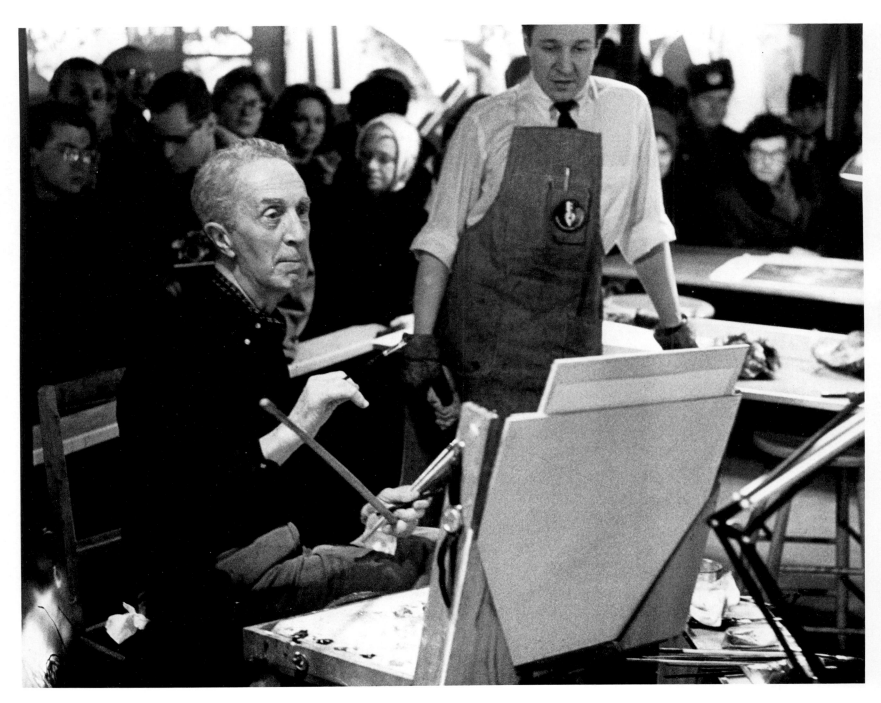

*Rockwell, in the USSR in 1964 for the American Graphic Arts
Exhibit, gave painting demonstrations to Soviet audiences.*

The best-known painting from this period is *The Problem We All Live With,* the moving scene of a small black girl, dressed in immaculate white, being escorted to school past a wall spattered with tomatoes and racist graffiti by four U S Marshals. Rockwell arranged the composition so that the child is the only figure that is seen completely. The contrast of the child's white dress and the filthy wall is memorable and affecting.

Other magazines besides *Look* were quick to take advantage of Rockwell's availability. *McCall's* commissioned him to paint several large landscapes, one of the Main Street of Stockbridge at Christmastime and another of the Town Hall and Congregational Church in spring. For *Ramparts* he painted portraits of such major figures as Bertrand Russell. Rockwell was also one of the artists chosen by NASA to record the great achievements of the conquest of space. As such, Rockwell was given clearance to wander about the highly restricted areas at Cape Canaveral and the Space Center at Houston. Rockwell's sketches and those of the other artists included in the program were published in a book called *Eyewitness to Space.* Subsequently, he also painted

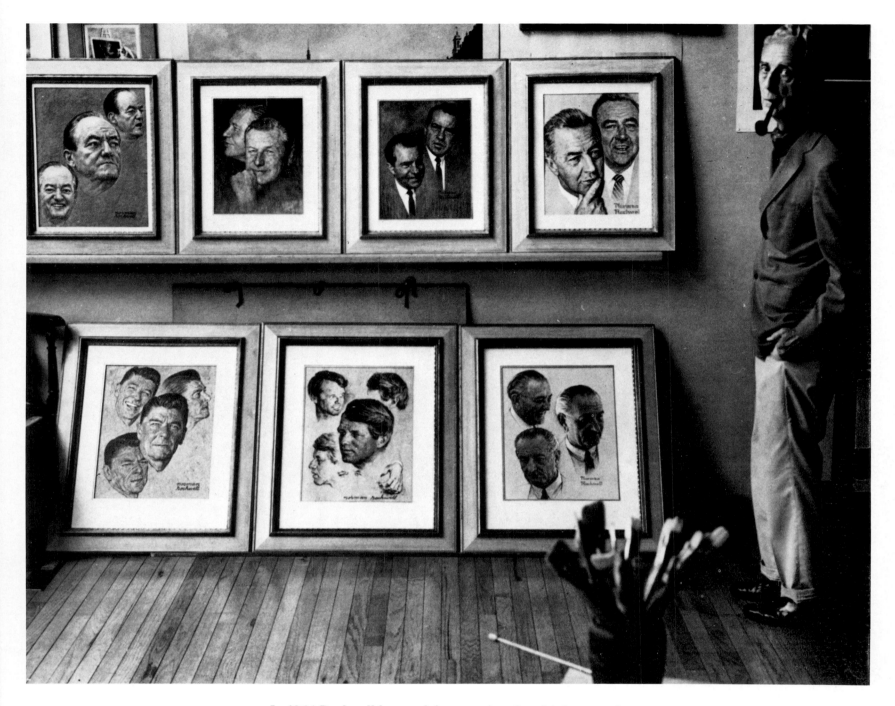

*In 1964 Rockwell began doing a series of multiple portraits
of famous American political leaders for* Look *magazine.*

a series of illustrations for *Look* on various aspects of the exploration of space, including *Man's First Step on the Moon. Look* also commissioned several paintings on the Peace Corps, for which the Rockwells toured Ethiopia, and later they went to Russia to paint other illustrations for the magazine.

Rockwell continued to execute works for advertisements, including a series of pen and ink sketches for the Massachusetts Mutual Life Insurance Company showing average people living average lives. He also did catalog covers for Top Value Stamps and several record jackets. And he continued to illustrate calendars for the Boy Scouts of America, as he had since 1924.

In 1968 Rockwell was honored by a retrospective exhibition at the Dannenberg Gallery in New York. The exhibit, which consisted mainly of the final canvases for magazine covers, attracted many people who were surprised by the quality of Rockwell's work when seen first hand. For most of his career his work had been seen in reproduction, and indeed had been created for that, but the astonishing technique revealed in the originals demonstrated to all how fully he had mastered his trade. And though most critics remained aloof, public

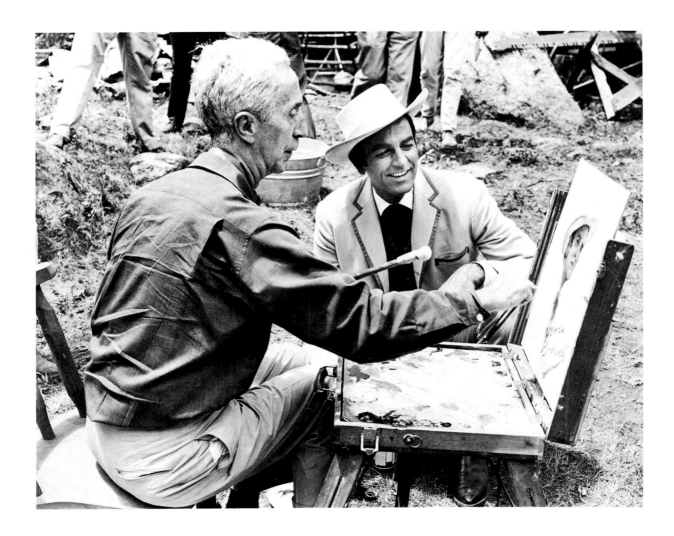

*In 1966 Martin Racklin, producer of the 20th Century-Fox release **Stagecoach**, commissioned Rockwell to make paintings of the film. Here, a portrait of actor Mike Connors.*

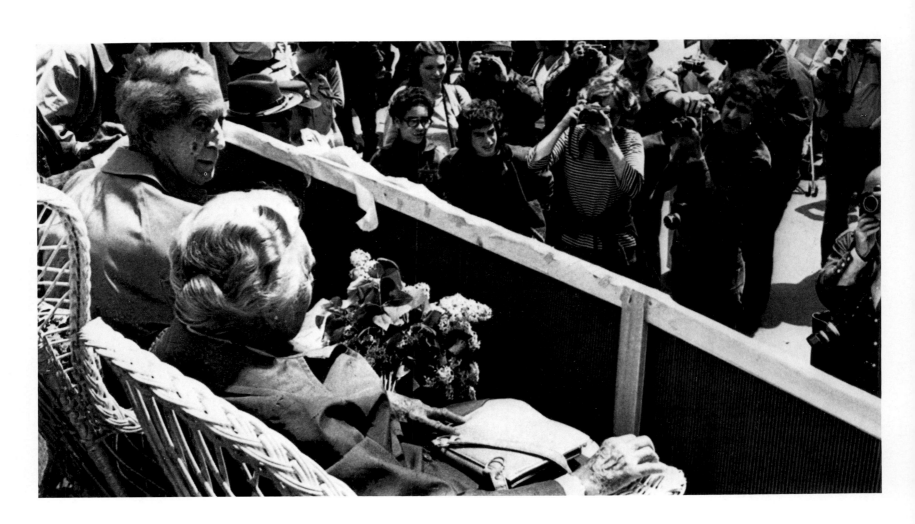

Norman and Mary Rockwell in a reviewing stand before the start of the 1976 'Norman Rockwell Parade' in Stockbridge, Mass. It was the longest parade in the town's history.

interest in Rockwell's work as art continued to grow. In 1972 and 1975, major exhibitions of his paintings were presented in exhibition centers in nine cities across the United States, including the Brooklyn Museum and the Corcoran Gallery of Art in Washington, D C.

Further public interest in Rockwell seemed evident in the successful sale of ornaments and plates bearing his designs, some of them adaptations of his best-known work. These were manufactured at a time when life in America was undergoing the strains of the Civil Rights movement, the Vietnam War and other upheavals of the 1960s. It may well be that their popularity owed as much to nostalgia for less troubled times as to aesthetic judgement, but at least they helped to keep Rockwell's name in the public consciousness.

Rockwell's longevity as a *Post* cover artist contributed both to the rise and fall of his popularity. Success at an early age meant that he was still working at a time when most of his fellow *Post* cover artists were either dead or retired. By the 1960s he knew as well as anyone that times had changed, that television had taken the place of the great magazines, revealing everything to the viewer, where the magazines could only suggest with one or two images. It was easy for a new generation to forget the power of illustration in the face of such largesse. It was easy, too, for a new generation to turn its back on the vanished world that Rockwell's work was supposed to epitomize, though in fact this did not take into account how the artist's work had evolved. Many of those who derided his images did not bother actually to look at them. They remembered the jolly skating grandfathers rather than, say, the young Marine relating the horror that was behind the capture of a Japanese battle flag. Because he was still alive and still working, they forgot the length of his career and that he had changed with the times – not in style, but in the life he portrayed. They preferred to imagine that he represented the world their parents clung to, the world they wished to change.

Rockwell's work was, to be sure, criticized on more specific grounds. During the 1960s artist Peter Hurd's commissioned portrait of President Lyndon Johnson was turned down by the sitter, who had envisaged a work more in the Rockwell style. Hurd sniffed that Rockwell might be a good commercial artist but that he, Hurd, had never learned to copy photographs. The story was used as proof of Rockwell's lack of talent by people who had no understanding of how he used photographs or the painstaking manner in which he worked, preparing sketch after sketch and canvas after canvas until he felt the composition was right.

For the cover of *American Artist* in 1976, Rockwell painted himself placing a banner reading 'Happy Birthday' on the Liberty Bell. It was to be his last cover. A series of slight bicycle accidents had weakened him, although he continued to travel. He was honored by the President's Medal of Freedom in 1977, one of the many awards he gathered in the last years of his life. On 8 November, 1978 he died at his home in Stockbridge at the age of 84.

By the time of his death the upheavals of the 1960s and 1970s were settling down, the rebellious generation had grown up, the mood of the country was turning more conservative and Rockwell's work seemed ripe for revival. What it received was not so much popular revival as critical reappraisal. For the

first time, critics seemed to look directly at Rockwell's work as art, rather than illustration. For example, in the appreciation that accompanied *The New York Times* obituary of the artist, critic John Russell suggested that 'Norman Rockwell was lucky enough to live at a time when the demand for what he could do had no limits. . . .(that) he happened to be around when the cover of *The Saturday Evening Post* was an infallible index to popular feeling.' Because of that and his excellent training, Russell said, he managed to portray his own era with affection and accuracy. For many years he was criticized precisely because he was so good at what he did and because he declined to adapt to the changing styles of art that developed during the twentieth century.

Rockwell, himself, never put forward any large claims for his work. He considered himself simply to be an illustrator, and was proud of it. He freely admitted the disadvantages that illustrators faced: 'We paint for money, against deadlines, our subject matter often prescribed by an editor or an author.' Obviously fully 'creative' painters were not bound by such restrictions. What Rockwell was too diffident to say was that the fact that illustrators had to submit to disciplines did not necessarily guarantee the inferiority of their work.

One of the principal criticisms leveled at him was that he showed an ideal life rather than reality, a world untroubled by controversy. If this was so, the artist agreed. 'I unconsciously decided that if it wasn't an ideal world, it should be, and so painted only the ideal aspects of it, pictures in which there were no drunken fathers or self-centered mothers.' Yet if Rockwell's world were really so unreal it would hardly strike the chords it does. Rockwell never pretended that he painted every situation, from every point of view. He simply painted what he knew, which was small town and rural America at a time when the greater part of the population lived in small towns or had first hand memories of them. And the incontrovertible fact is that millions of Americans recognized what he painted and responded to it.

Also criticized for his lack of subtlety, Rockwell's reply was brief. 'You have to be obvious. You've got to please both the art editor and the public. This makes it tough on the illustrator as compared with the fine artist, who can paint an object any way he happens to interpret it.' To make sure that the public was pleased Rockwell would frequently ask the opinion of any person who happened to be passing by when a work was in progress. He was convinced that

'Norman Rockwell from the Cradle to the Grave.'

if his public didn't understand it, he wasn't doing his job.

Indeed, so great was Rockwell's modesty about his work that he never valued his paintings after they had served the purpose for which he had painted them. When he was asked in the early 1940s to donate a picture to a local auction, he did so reluctantly, telling his assistant to put a price of $500 on it. The assistant priced it at $1000, and the picture (one of Rockwell's April Fools *Post* covers) was instantly snapped up. When Rockwell offered to buy it back the new owner would not sell. Rockwell was incredulous.

Rockwell's popularity with one part of the population was in direct contrast to his dismissal by another. To some, confronted by the day-glo colors and controlled cartoons of such artists as Peter Max and R Crumb, Rockwell was all that was sane and correct, and the social values he seemed to represent were precisely those they were prepared to fight for. Others denounced him for the same reasons. In the process, the true merit of his work was generally ignored.

Only with the end of the rebellion of the 1960s and 1970s has it again become possible to view his work as existing outside of some imagined political context. Today we can recommence to look at his work and try to appreciate it for what it is and for what it was when it was painted. In order to do this we need not get involved in such sterile debates about aesthetics as establishing the relative position of Realism in the hierarchy of artistic schools: Rockwell was of course a superb realist painter, and we can leave it at that. Perhaps more valid is to ask how valuable was his legacy as an ethnographer. And here the answer is clear. His ability to see and paint the details has made him an enormously important guide to life in early and middle twentieth-century America.

Simple details of clothing of an earlier era may be understood, for example, from such small things as the elastic cord that anchors the hat worn by the disgruntled child in the first *Post* cover. Rockwell's early covers bring us a world where the Civil War veterans were still an active part of every Decoration Day ceremony, where little boys might still wear long curls in the manner of Little Lord Fauntleroy, where the ouija board was an evening pastime.

But the easy world of America in the 1910s and 1920s changed, and Rockwell changed with it. The later illustrations show a wider world, one of early airplane travel, the great days of passenger trains and the gradual

urbanization of America. The Rockwell paintings of World War II strike the same chord as Frank Capra's film *It's a Wonderful Life*. It may not have been everyone's view of the war, but it was close enough, and it was in any case the way many people wished to remember, and have remembered, the time.

Rockwell returned to the same subjects several times during his career, and the changes in the paintings reveal changes in daily life. In 1953, for example, he painted a family walking to church. In a similar cover painted six years later the father no longer accompanies the group. There were no doubt irate letters, but Rockwell knew that there had been a decline in church going, and his work reflected it. As time passes and the last years of Rockwell's life recede, similar changes may reveal themselves in paintings executed in the decades of the 1960s and 1970s.

Similarly, much of his narrative work included history paintings, especially those depicting the colonial era in America. These paintings have a double worth as visions of times past, not just because they are accurate, but because they also show the early twentieth-century idea of the eighteenth century. Rockwell, it was said, stood 'head and shoulders above almost all others in depicting scenes from his country's colonial days.' One of the reasons for this was his consuming interest in everyday details of the period. He knew, for example, because he had seen and handled them, that some colonial shoes were soled with wooden pegs, just as he understood how certain details of eighteenth century clothing construction changed the way the clothes draped and moved when worn. Yet for all his authenticity in particulars, his approach to his colonial subject matter seldom lost its twentieth-century sensibility. Thus he functioned both as a super-faithful recorder and as an interpreter – as indeed he did in all his paintings.

The ability to see and portray the small details of life in such a way as to make them important is an unusual one. Rockwell himself understood that that was where his talents lay. 'My worst enemy is the world-shaking idea, stretching my neck like a swan and forgetting that I am a duck.' In fact many of his pictures referred to large ideas, but they succeed precisely because Rockwell had a genius for relating them to an ordinary context. The *Freedom of Speech* canvas depicts a New England town meeting, one of the most democratic forms of government in existence, and one of the most intimate. *The Problem We All Live With* reduces the issues of Civil Rights to one small child wanting an education. *The Right to Know* and *The Golden Rule* similarly portray concepts through individuals. Thus Rockwell could be both duck and swan.

Rockwell saw the poetry and beauty in everyday life and made others see it too. He also saw the humor and the sadness, and passed those emotions on. It is all too easy to discredit a popular figure of the past for being a man of his time. It is less easy to value him for the same reason. Rockwell's ability to catch emotion was an old-fashioned one, and it has been an asset to artists for centuries. It is hardly a reproach to Rockwell that there will always be people who do not like to be reminded that their emotions are not much changed from those of their ancestors or that a painting does not lose its claim to greatness because it can move its viewers to tears or laughter.

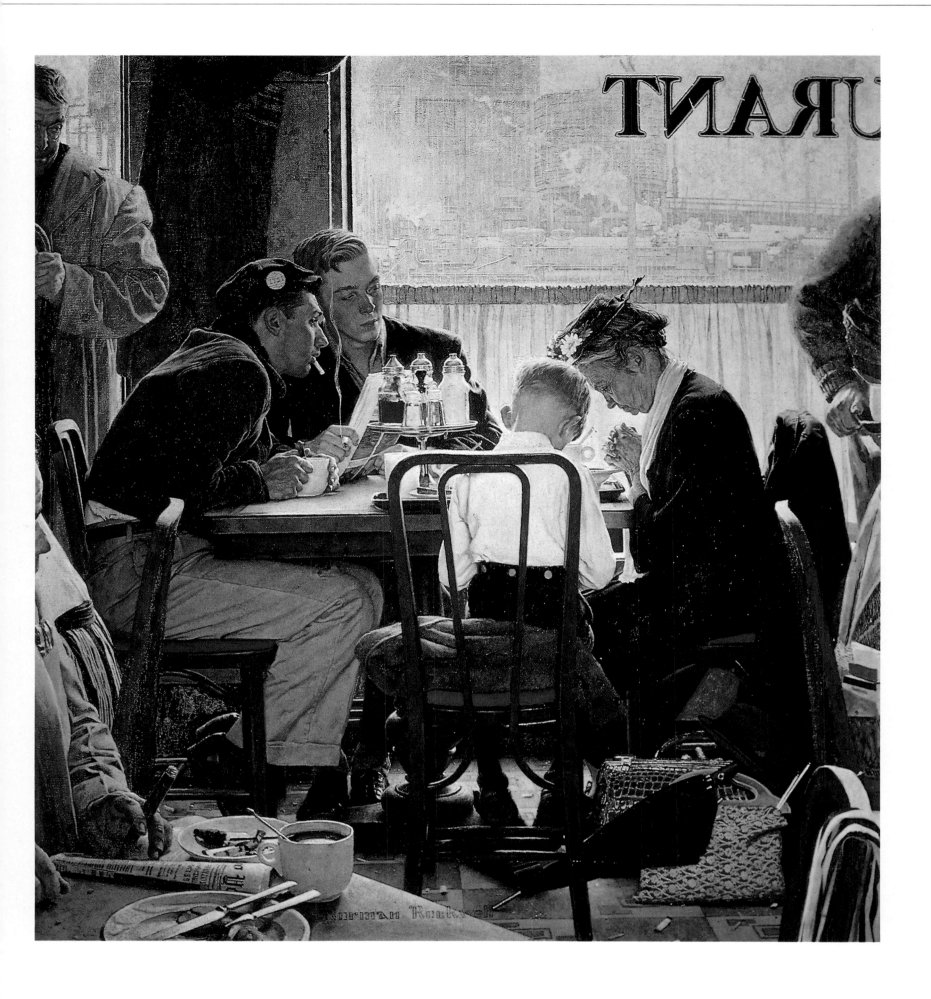

Readers voted **Saying Grace**, *Rockwell's* Post *cover for 24 November 1951, their all-time favorite.*

THE PLATES

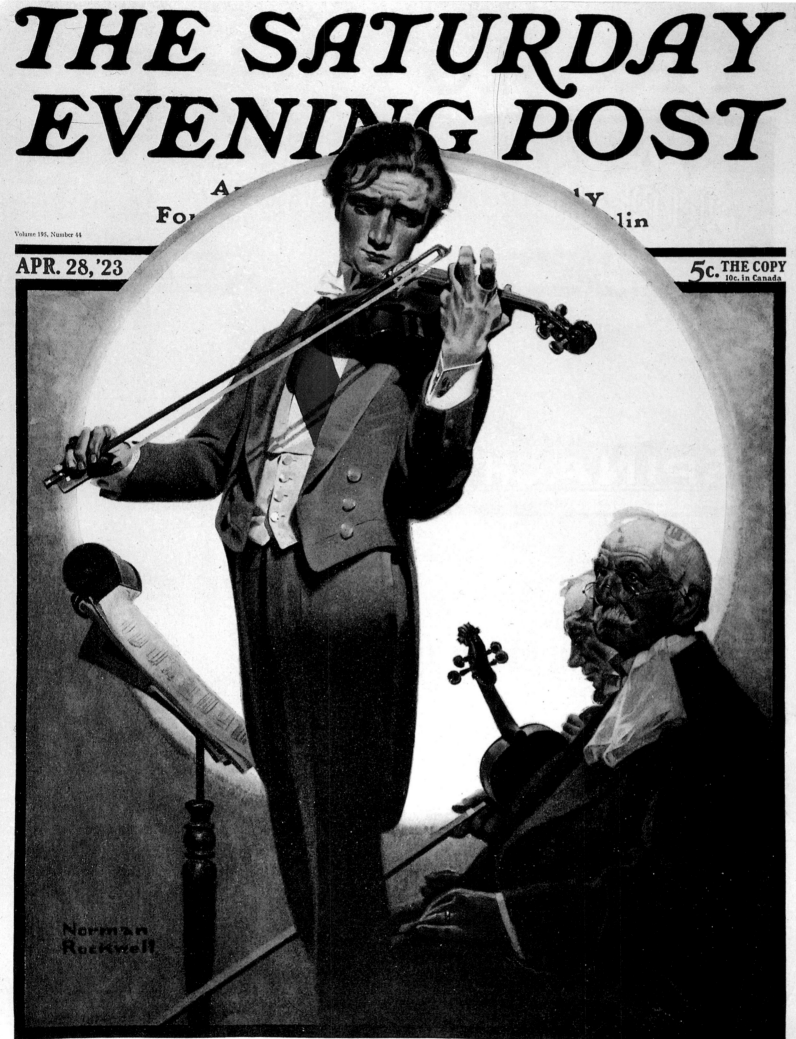

The Violinist. Post *cover, 1923.*

Shall We Dance? Post *cover, 1917.*

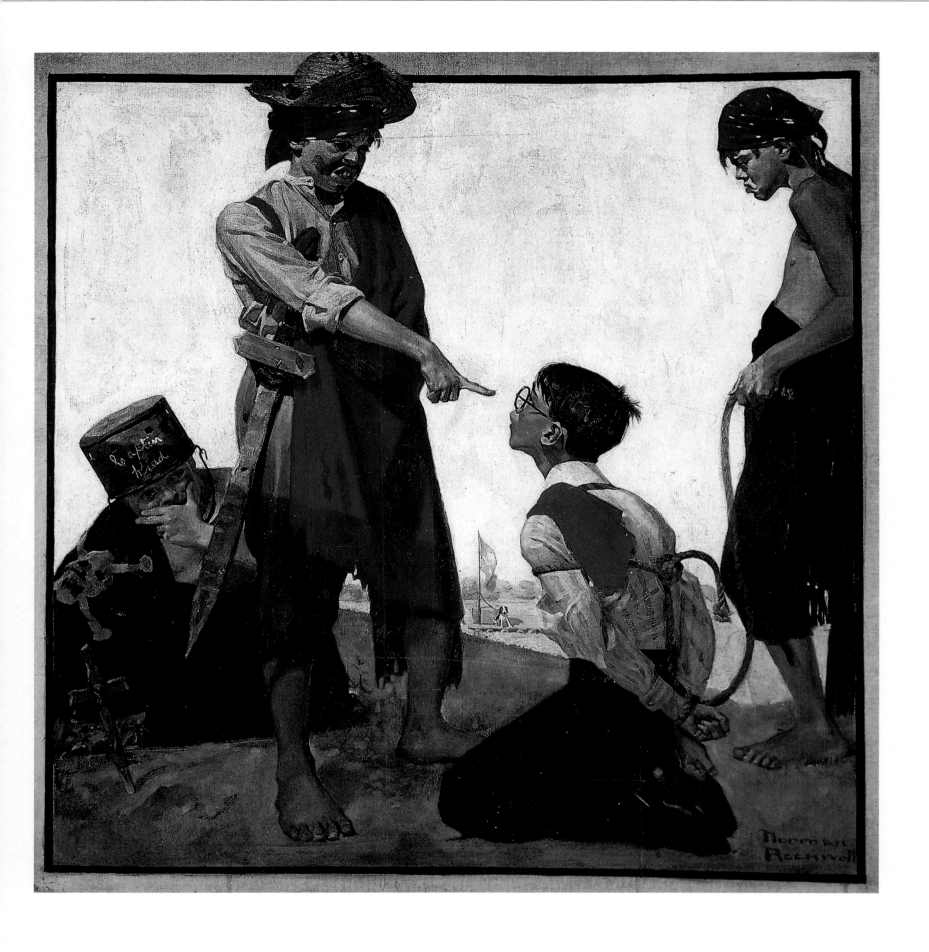

Cousin Reginald Plays Pirate. Country Gentleman *cover, 1917.*

THE SATURDAY EVENING POST

An Illustrated Weekly
Founded A°. D°. 1728 by B. Franklin

MAY 20, 1922

5c. THE COPY
10c. in Canada

RADIO PHONE

RADIO PROGRAM OPERA

Vol. 194, No. 47. Published weekly at Philadelphia. Entered as second-class matter November 18, 1879, at the Post Office at Philadelphia, under the Act of March 3, 1879.

John Taintor Foote—Josephine Daskam Bacon—George Kibbe Turner
C. E. Scoggins—Perceval Gibbon—George Pattullo—Chester S. Lord

The Wonders of Radio. Post *cover, 1922.*

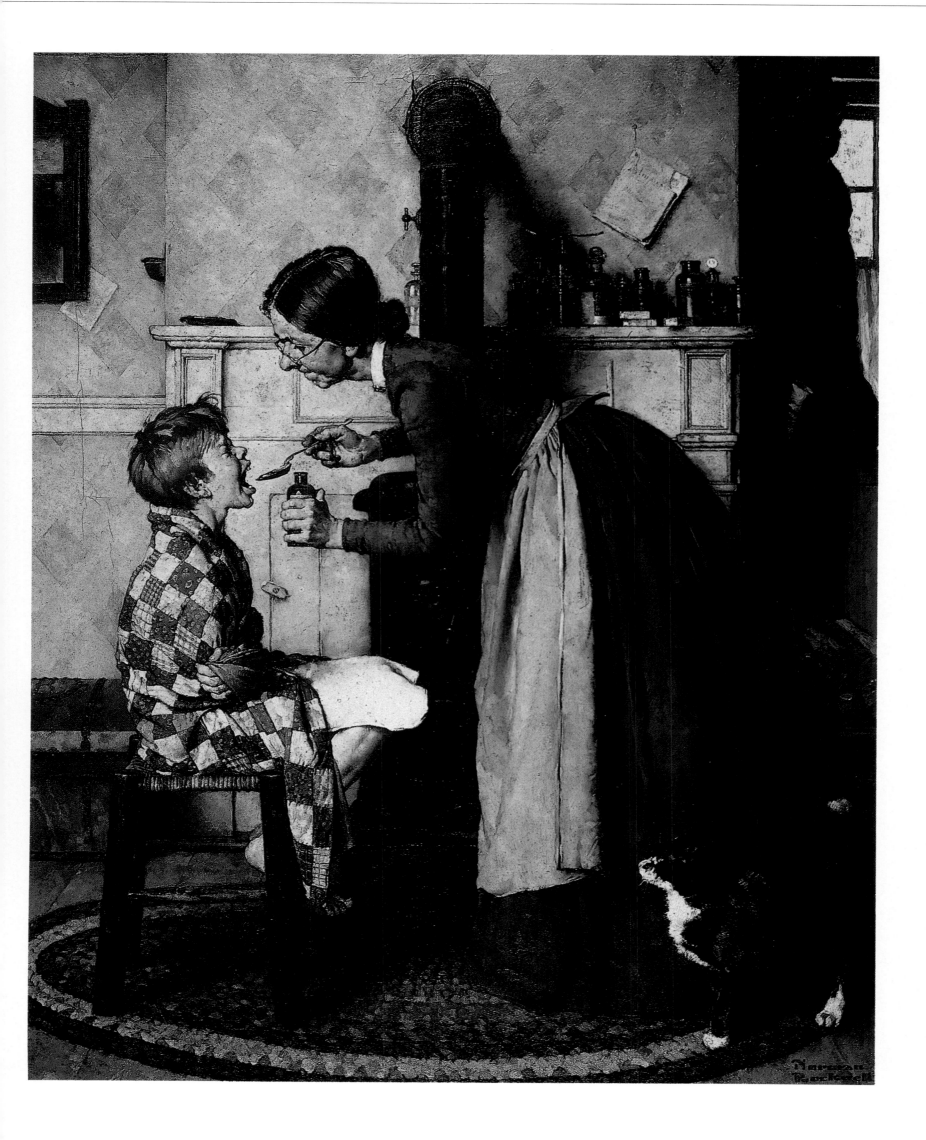

The Spring Tonic. *Original oil painting for a* Post *cover, 1936.*

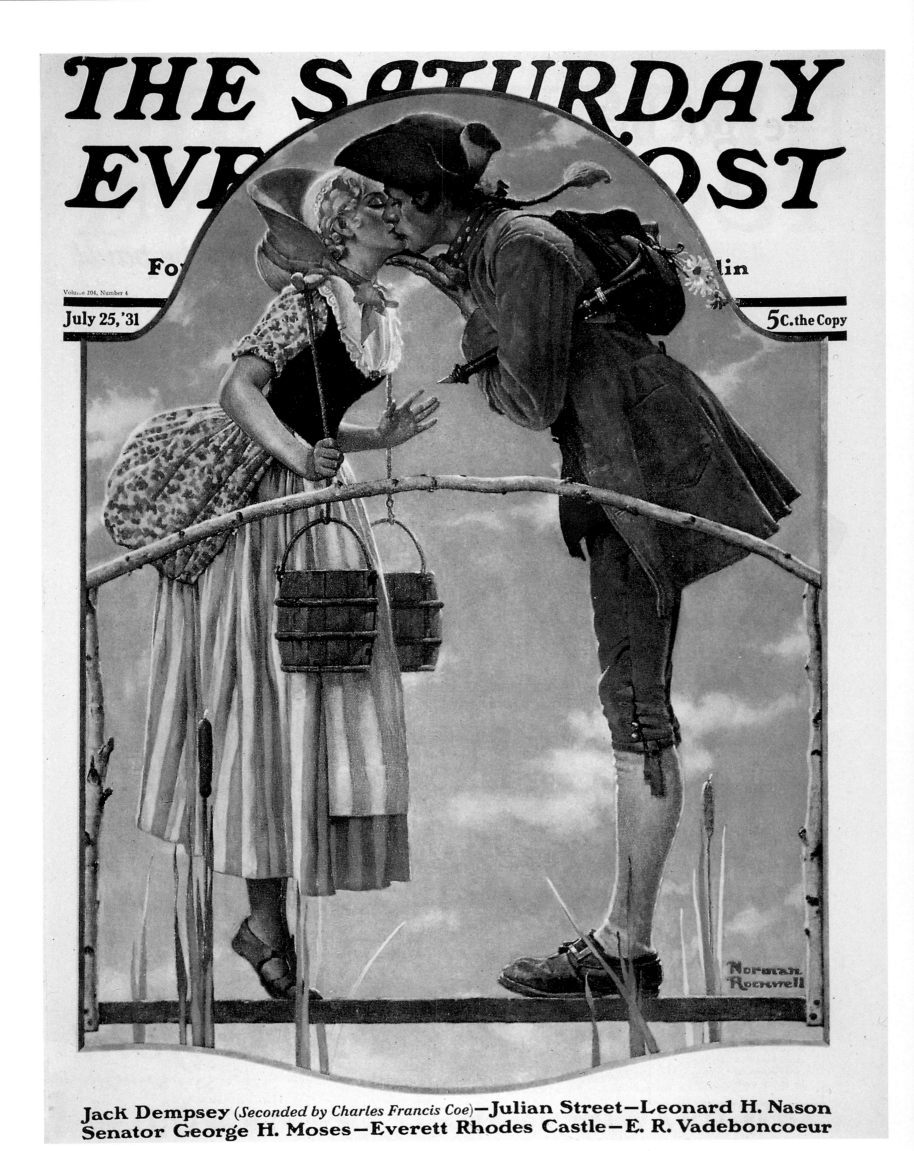

The Milkmaid. Post *cover, 1931.*

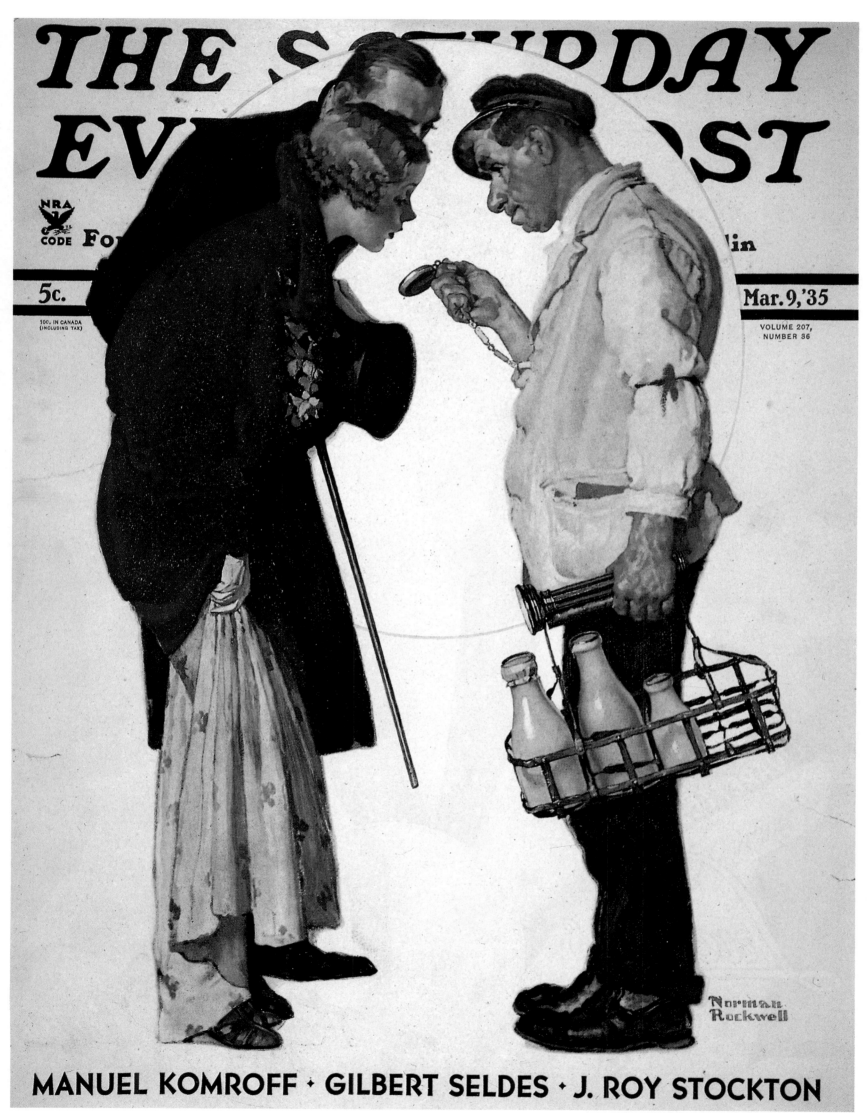

The Partygoers. Post *cover, 1935.*

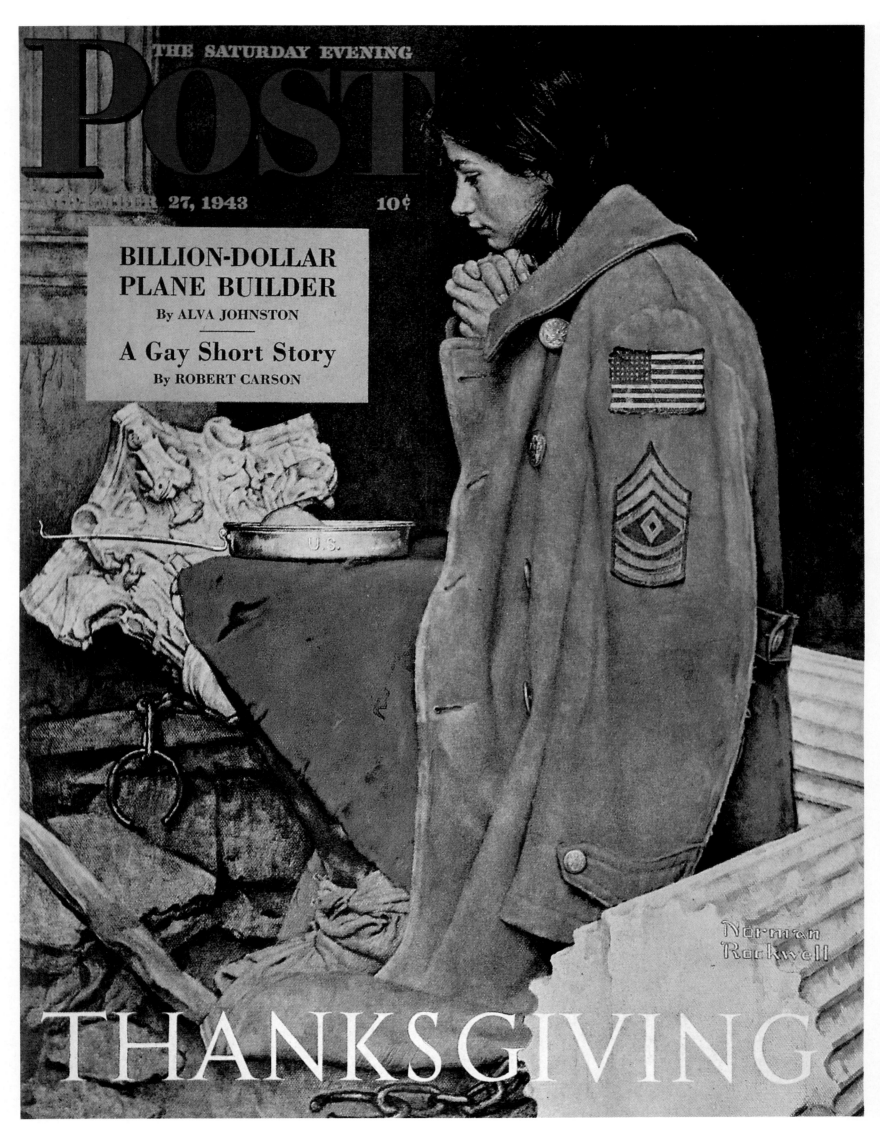

THE SATURDAY EVENING

POST

27, 1943 10¢

BILLION-DOLLAR PLANE BUILDER
By ALVA JOHNSTON

A Gay Short Story
By ROBERT CARSON

U.S.

Norman Rockwell

THANKSGIVING

Thanksgiving. Post *cover, 1943.*

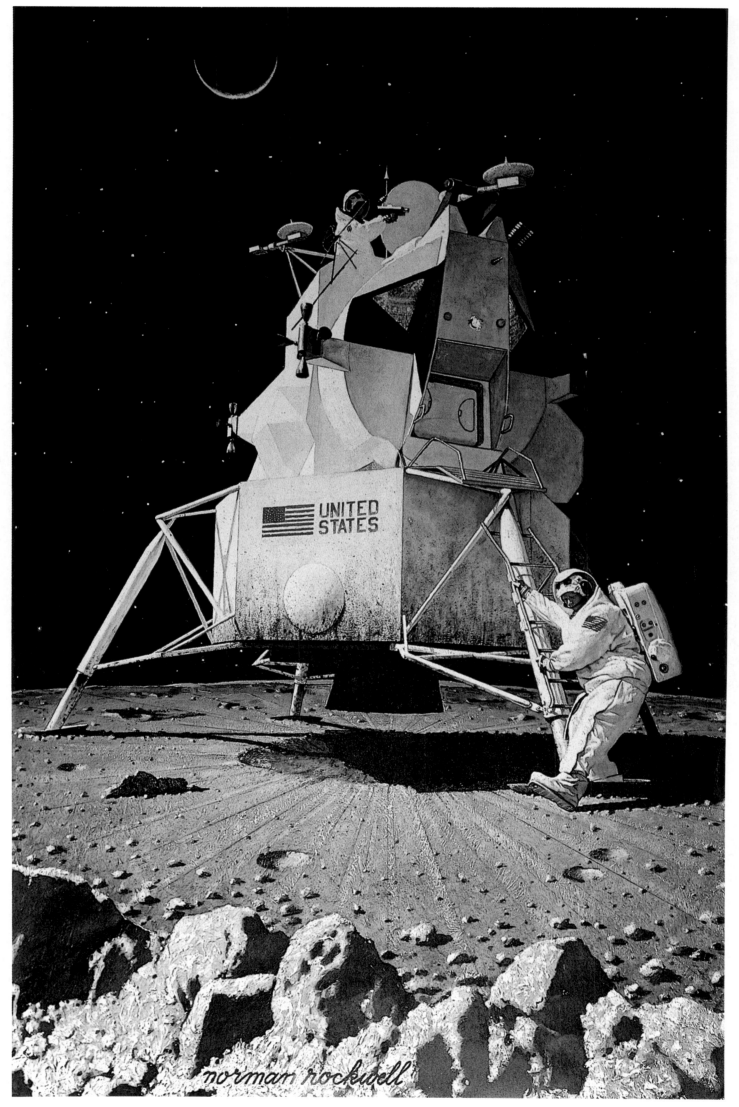

Astronauts on the Moon. *Original oil painting for a* Look *illustration, 1967.*

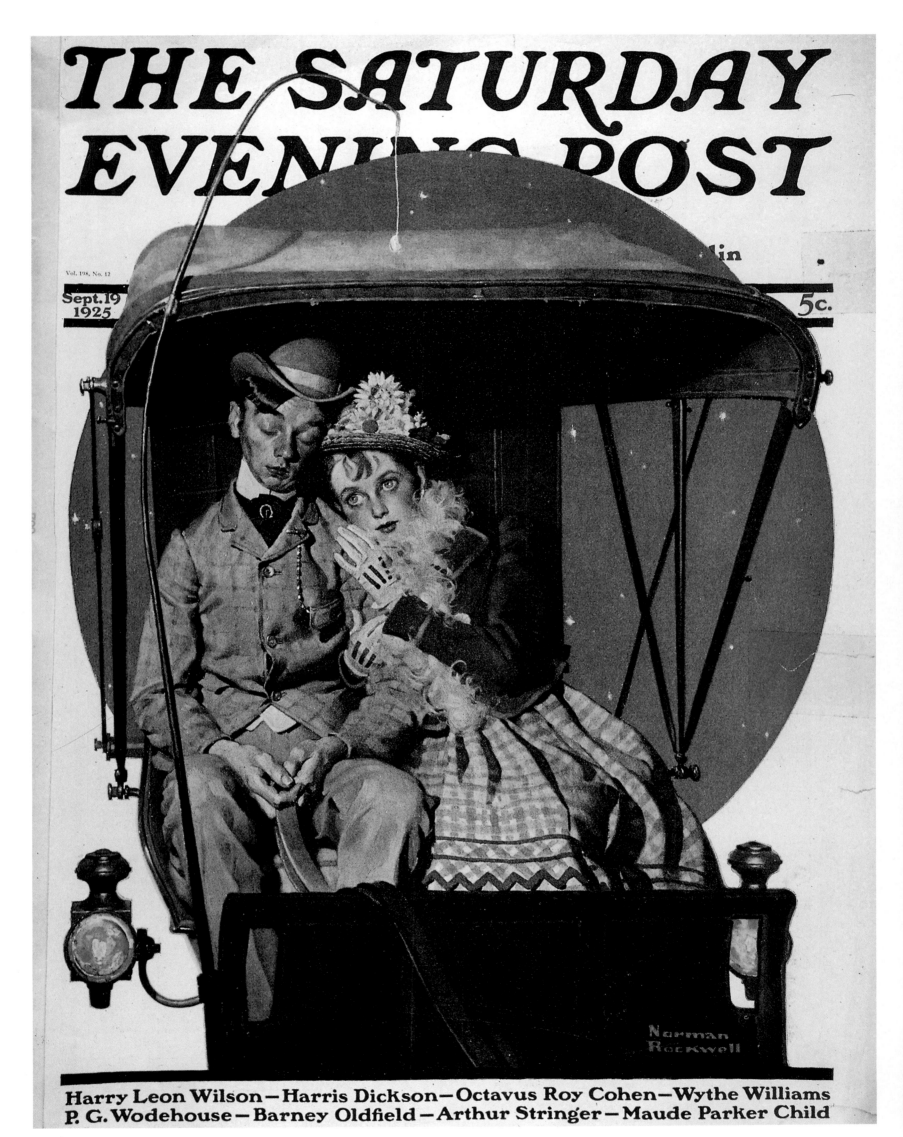

The Buggy Ride. Post *cover, 1925.*

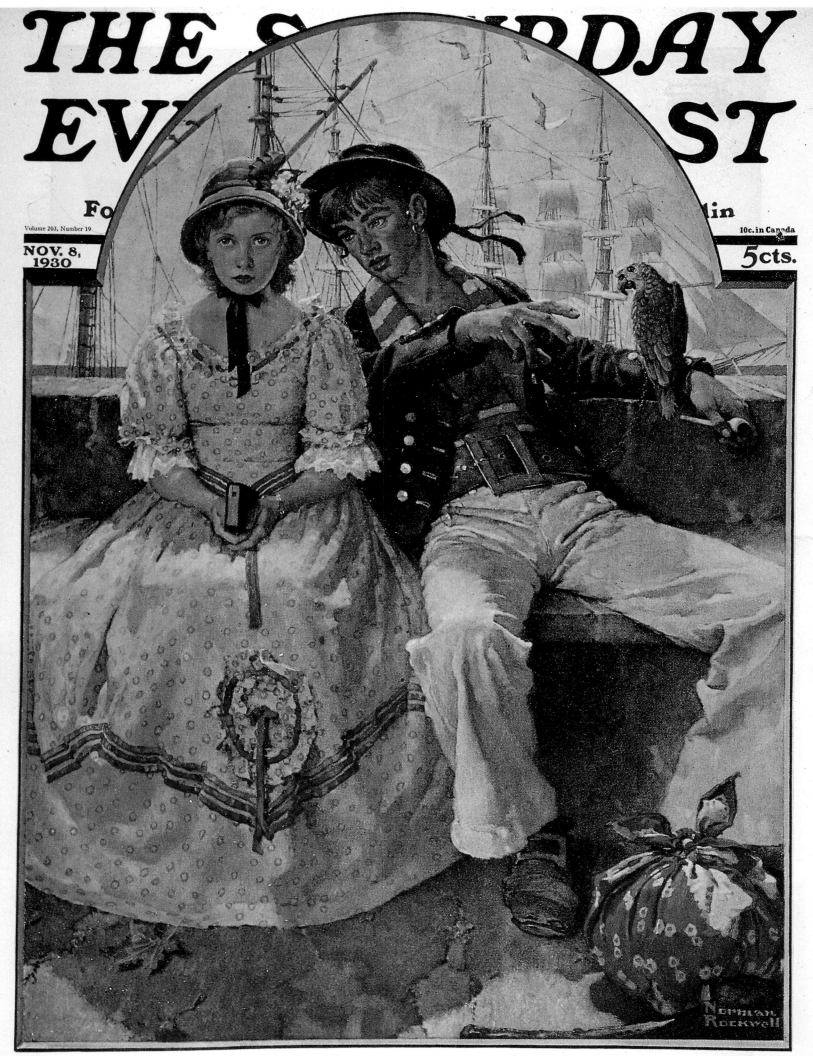

The Yarn Spinner. Post *cover, 1930.*

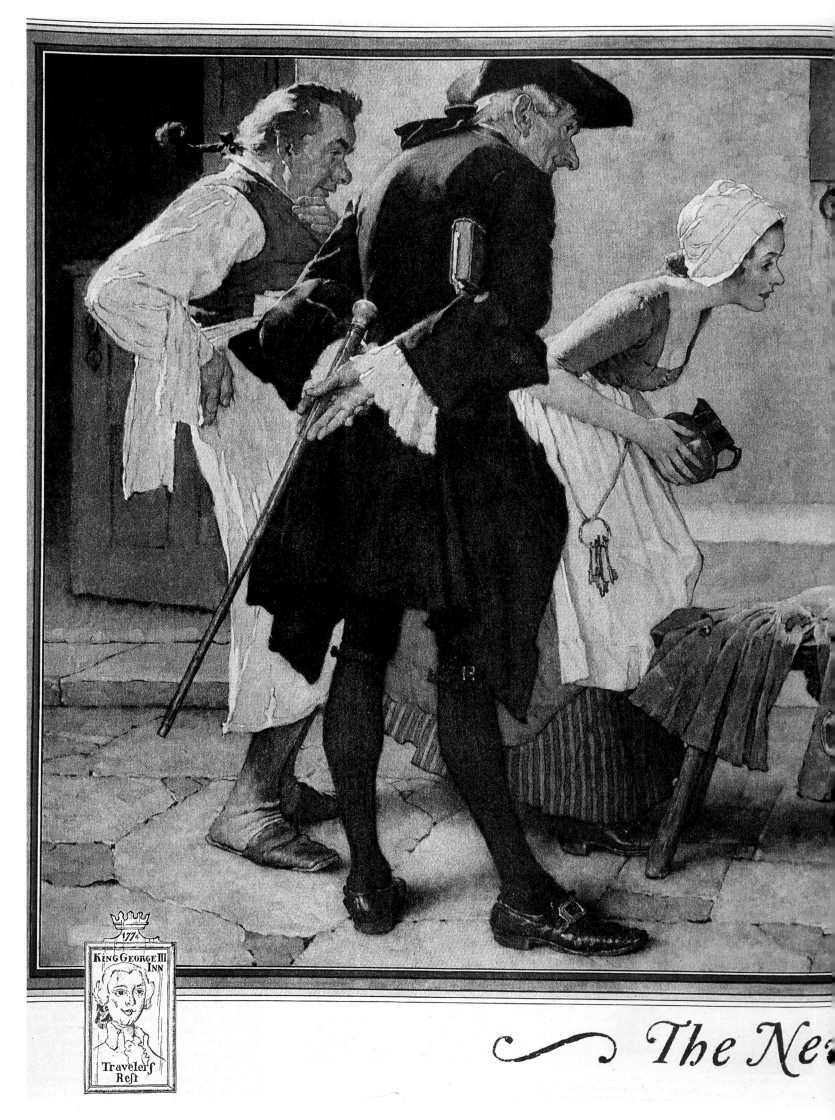

The New Tavern Sign. Post *illustration, 1936.*

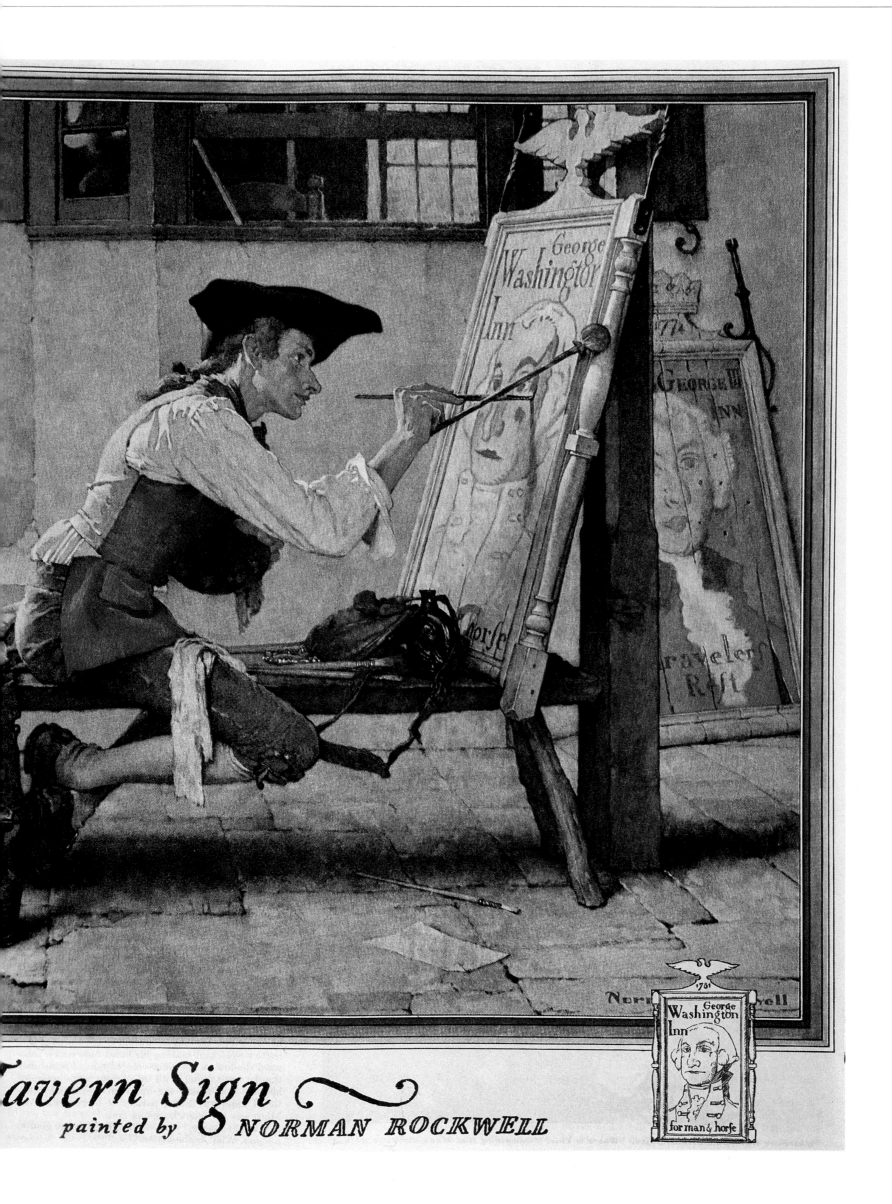

Tavern Sign
painted by NORMAN ROCKWELL

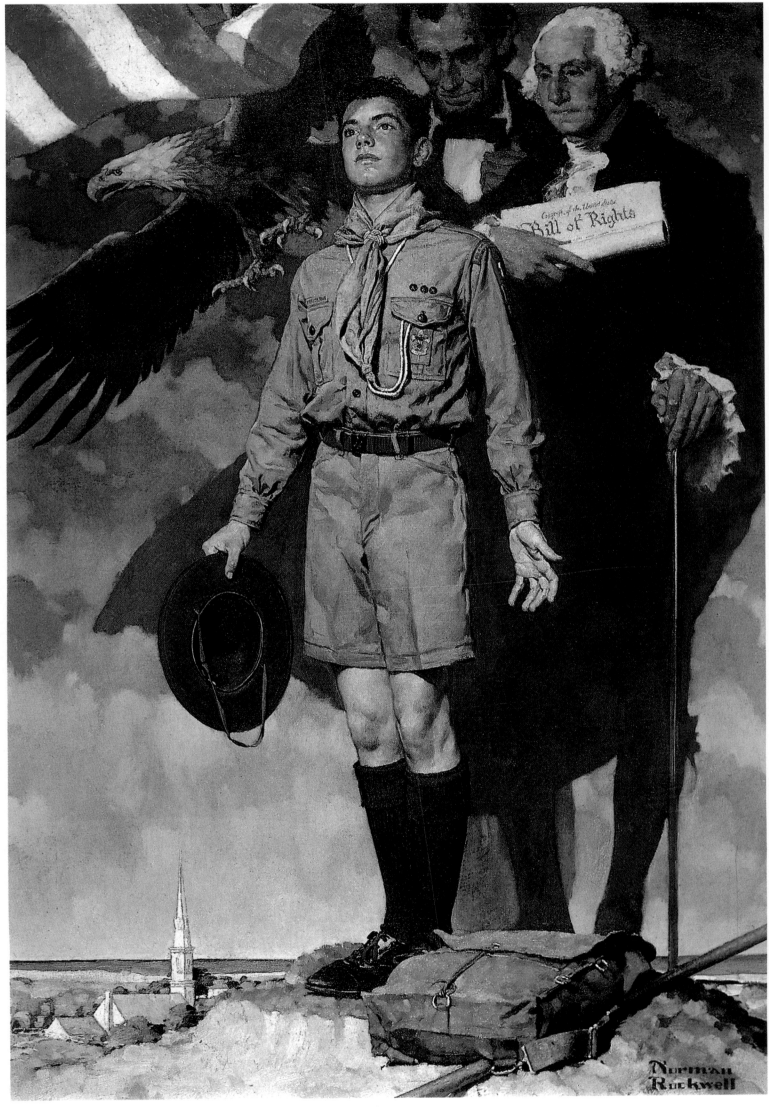

Boy Scout Calendar, 1942.

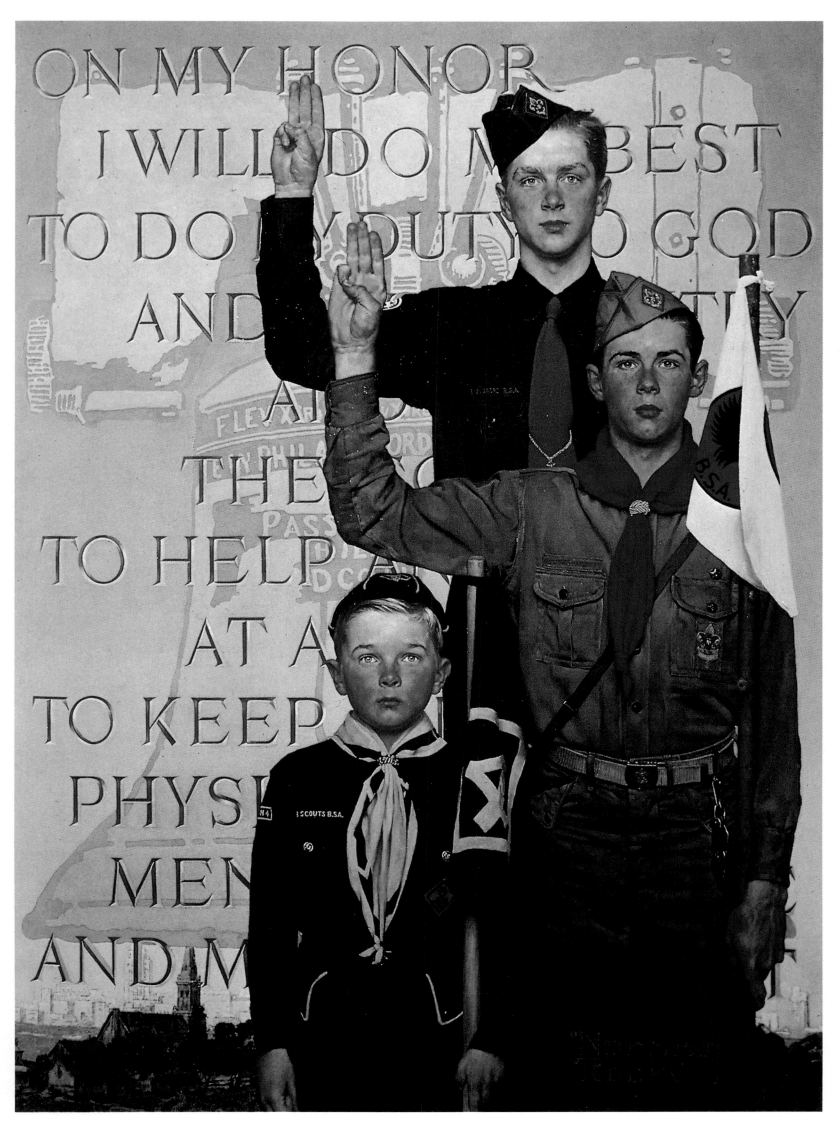

Boy Scout Calendar, 1953.

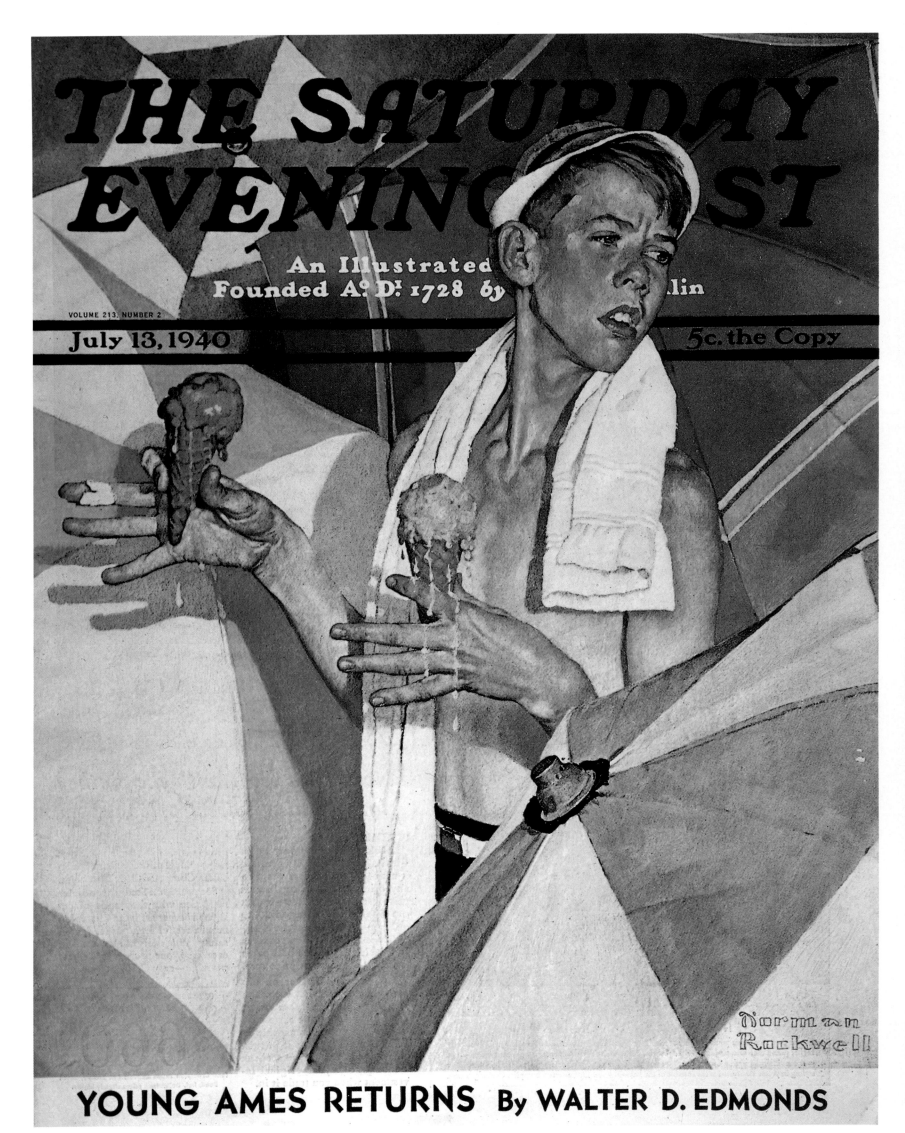

Ice Cream Carrier. Post *cover, 1940.*

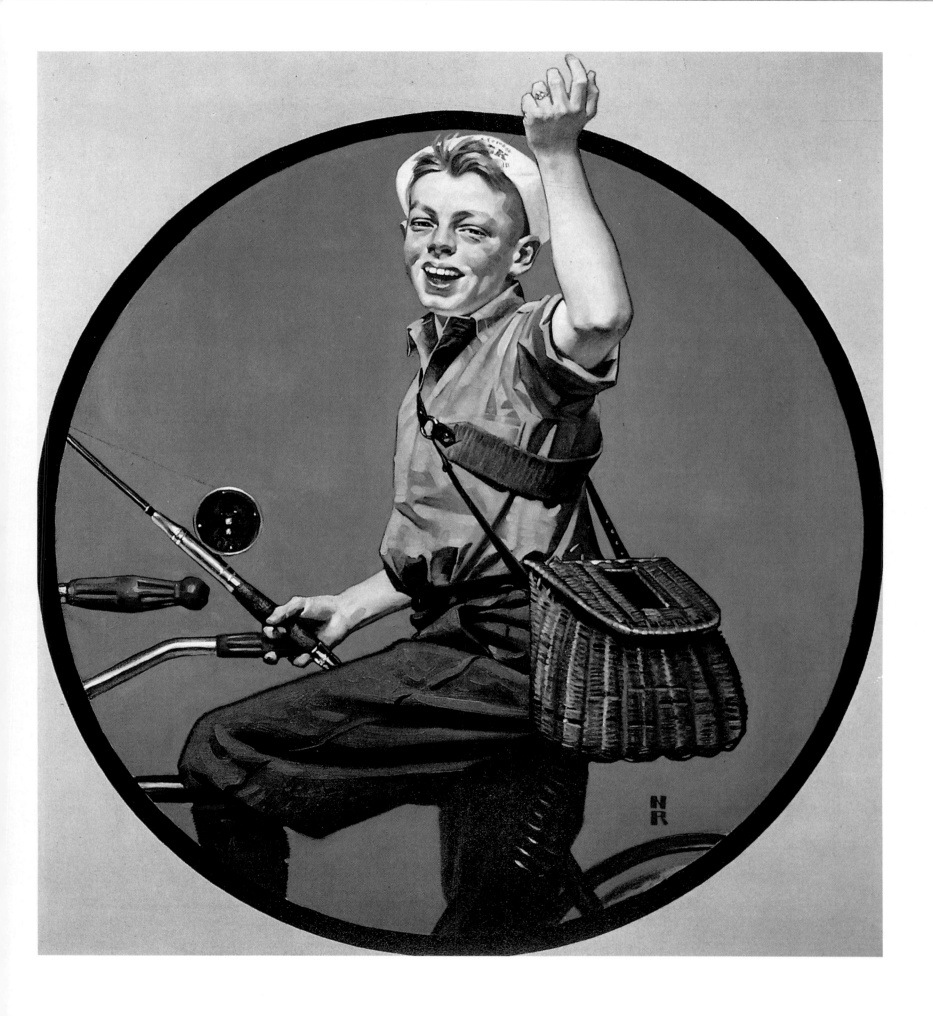

Advertisement for Fisk bicycle tires, Boys' Life, *1919.*

THE LAND OF

Parent of golden dreams, Romance!
Auspicious queen of childish joys,

Painted by NORMAN ROCKWELL

Land of Enchantment. Post *illustration, 1934.*

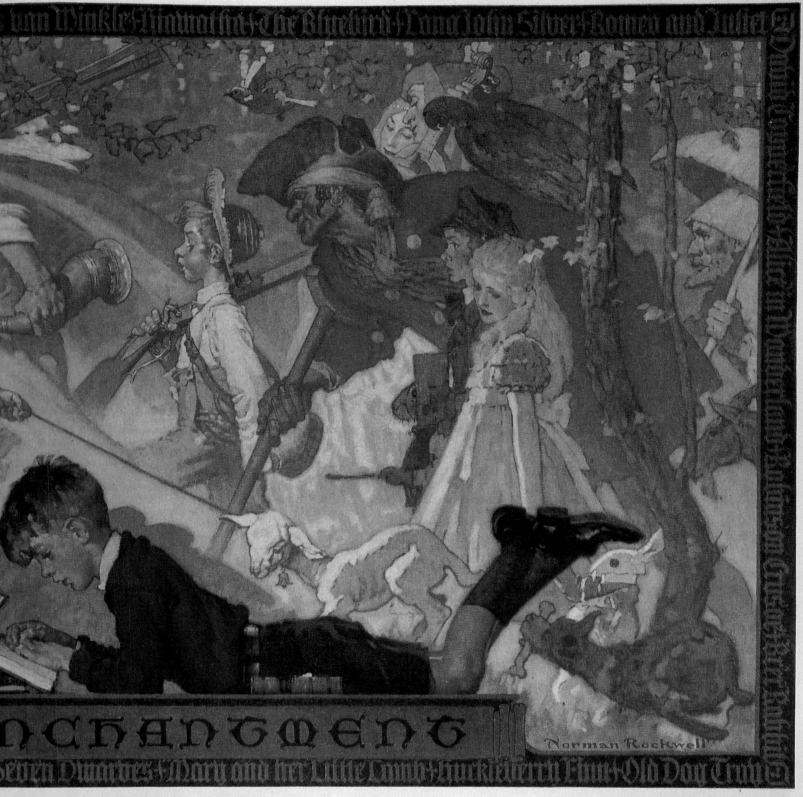

Who lead'st along, in airy dance,
Thy votive train of girls and boys.
 —*Byron.*

for The Saturday Evening Post

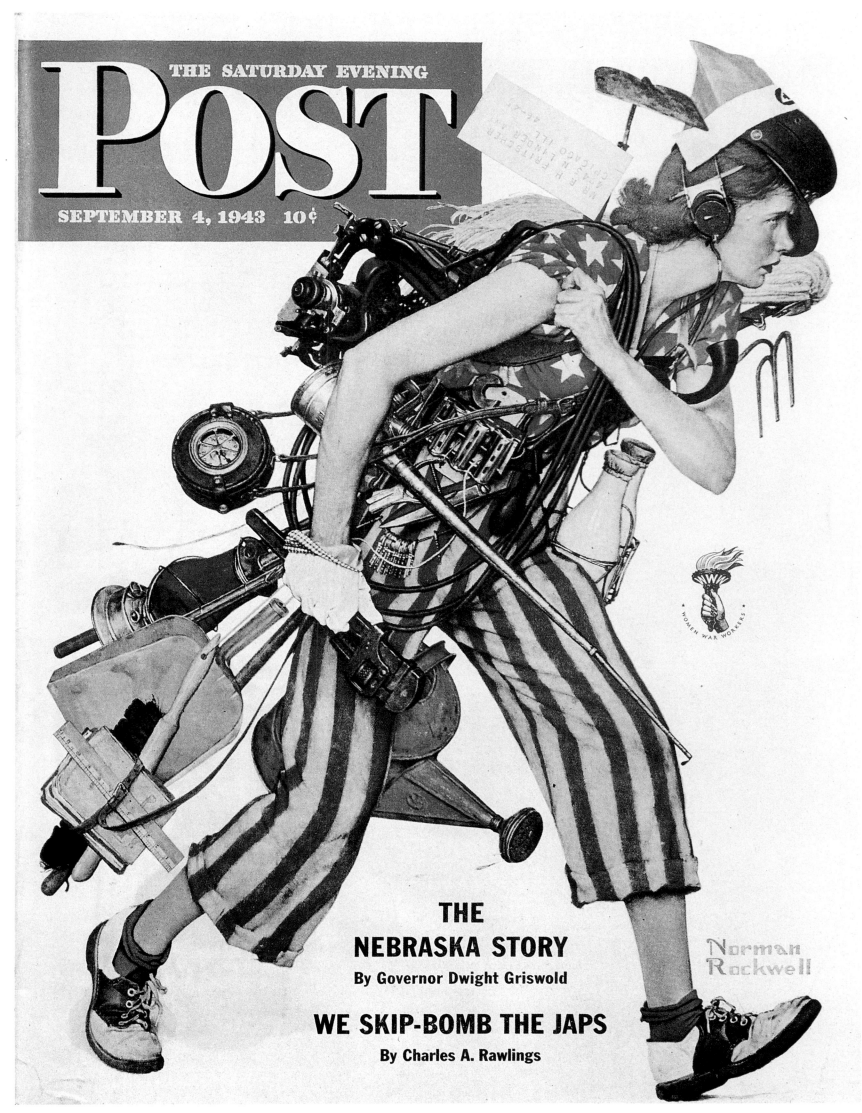

Liberty Girl. Post *cover, 4 September 1943.*

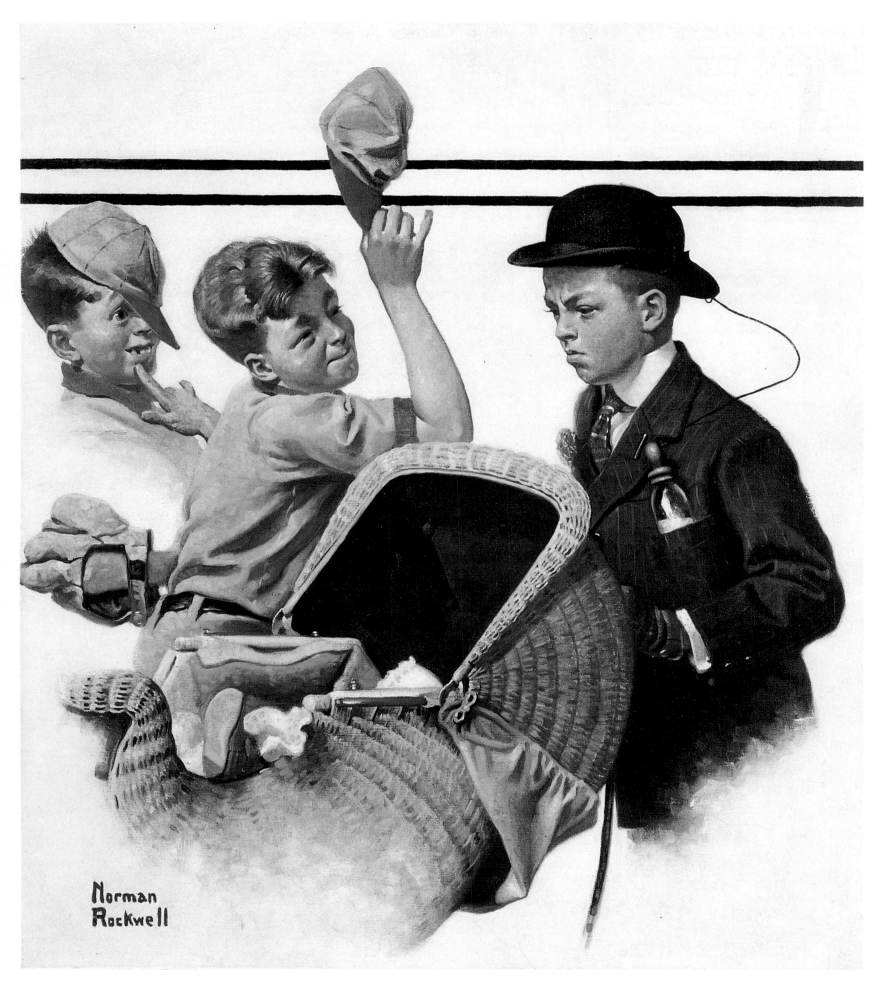

Boy with Carriage. Post *cover, 20 May 1916.*

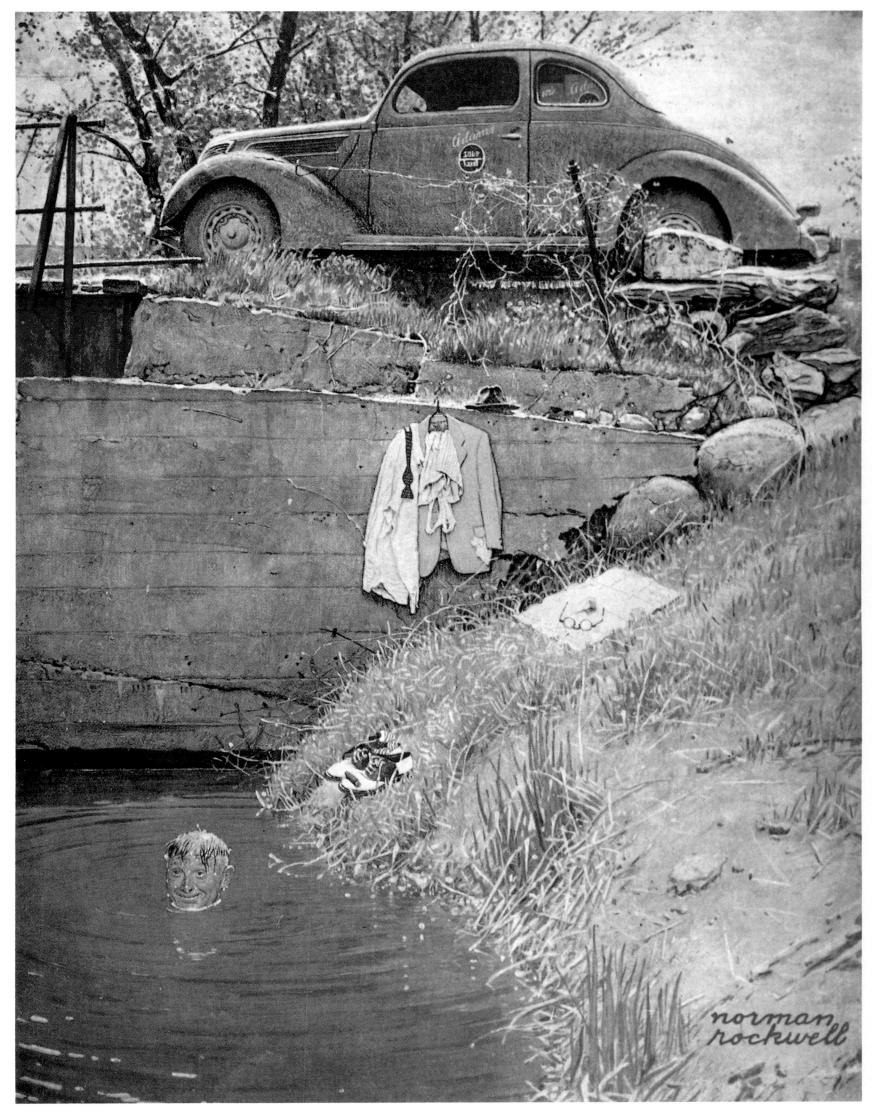

The Swimming Hole. *Original oil painting for a* Post *cover, 1945.*

Traffic Conditions. Post *cover, 1949.*

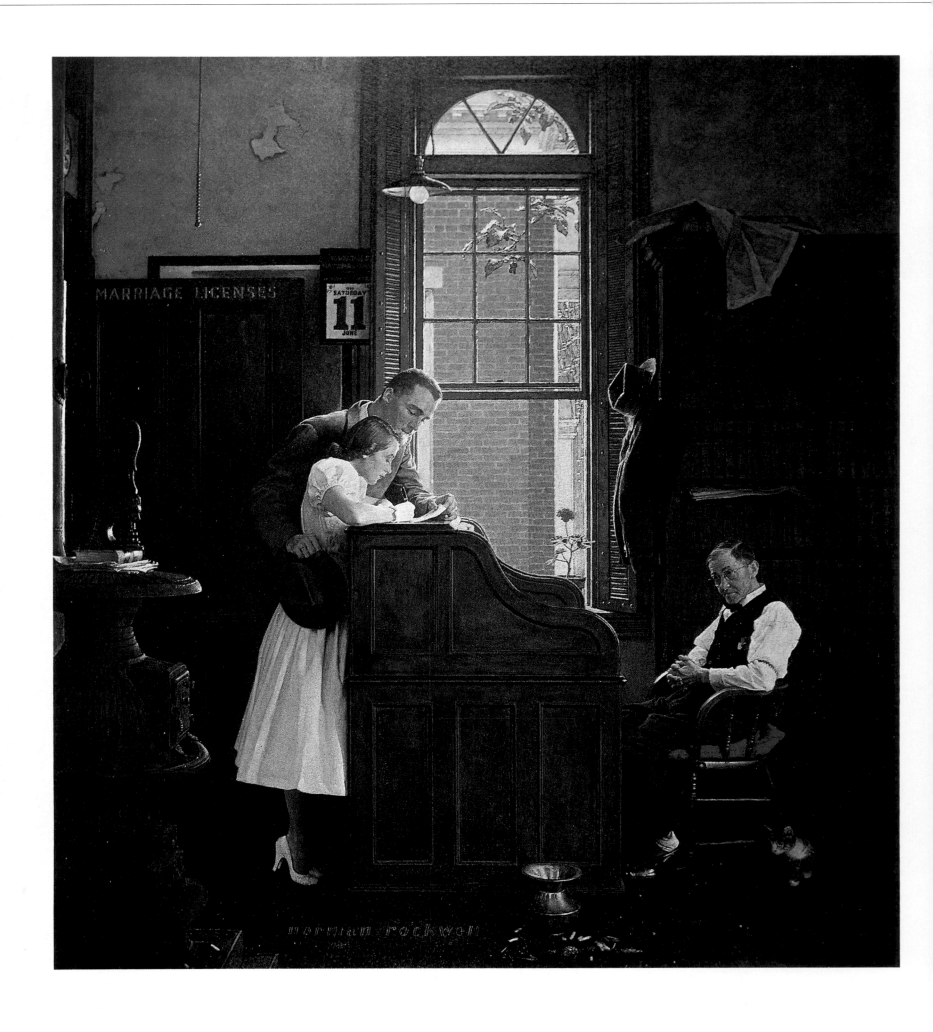

The Marriage License. *Original oil painting for a* Post *cover, 1955.*

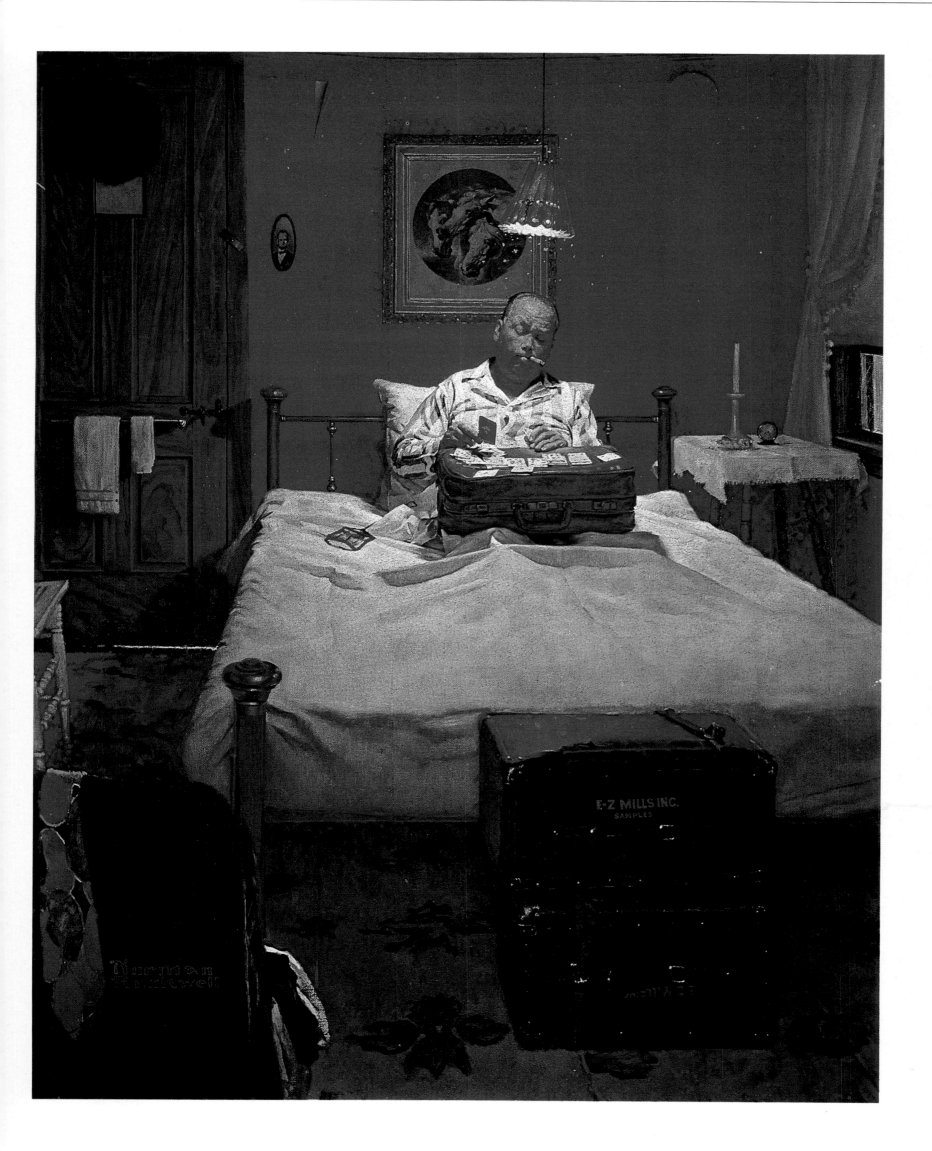

Solitaire. Post *cover, 1950.*

Checkers. *Original oil painting, undated.*

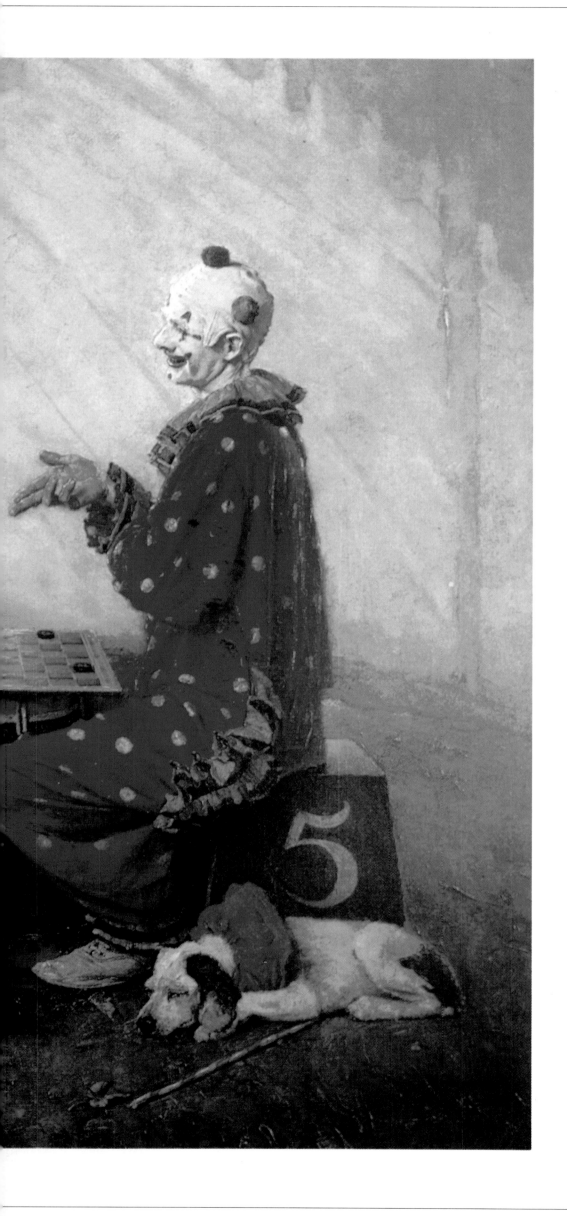

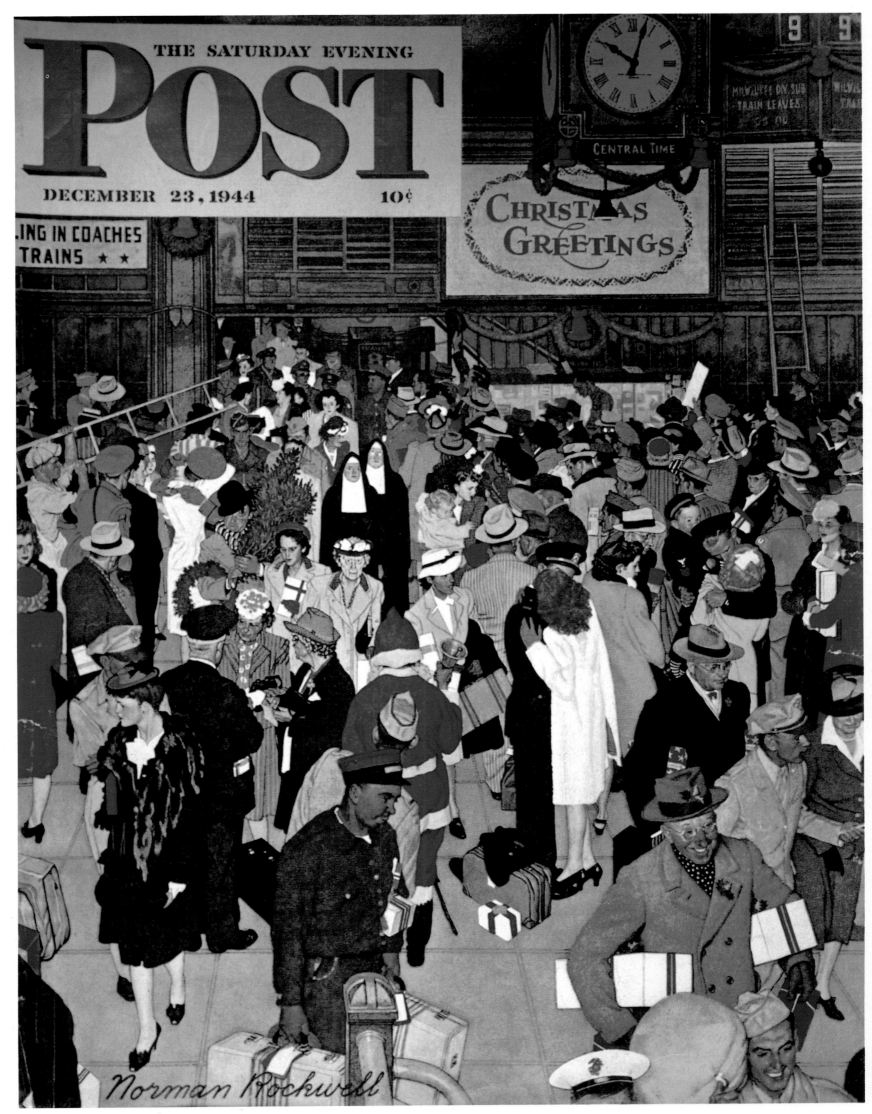

North Western Station, Chicago. Post *cover, 1944.*

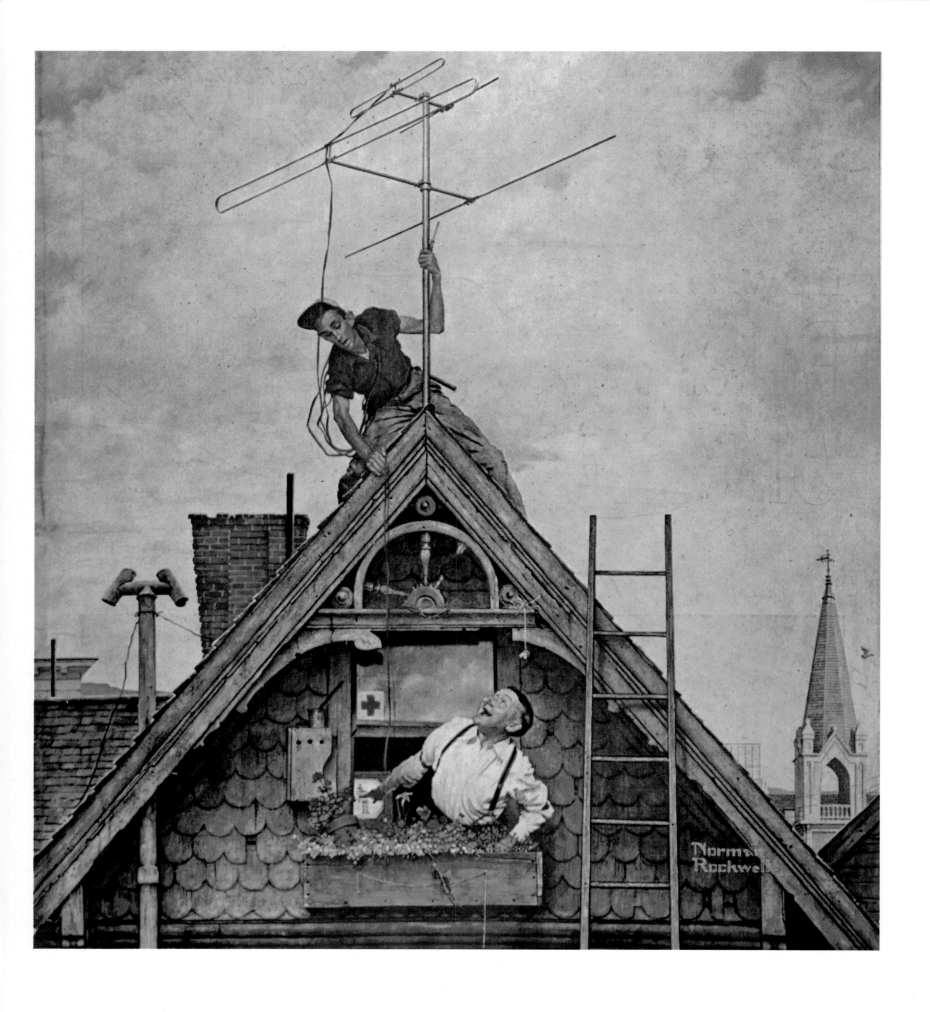

The New Television Set. Post *cover, 1949.*

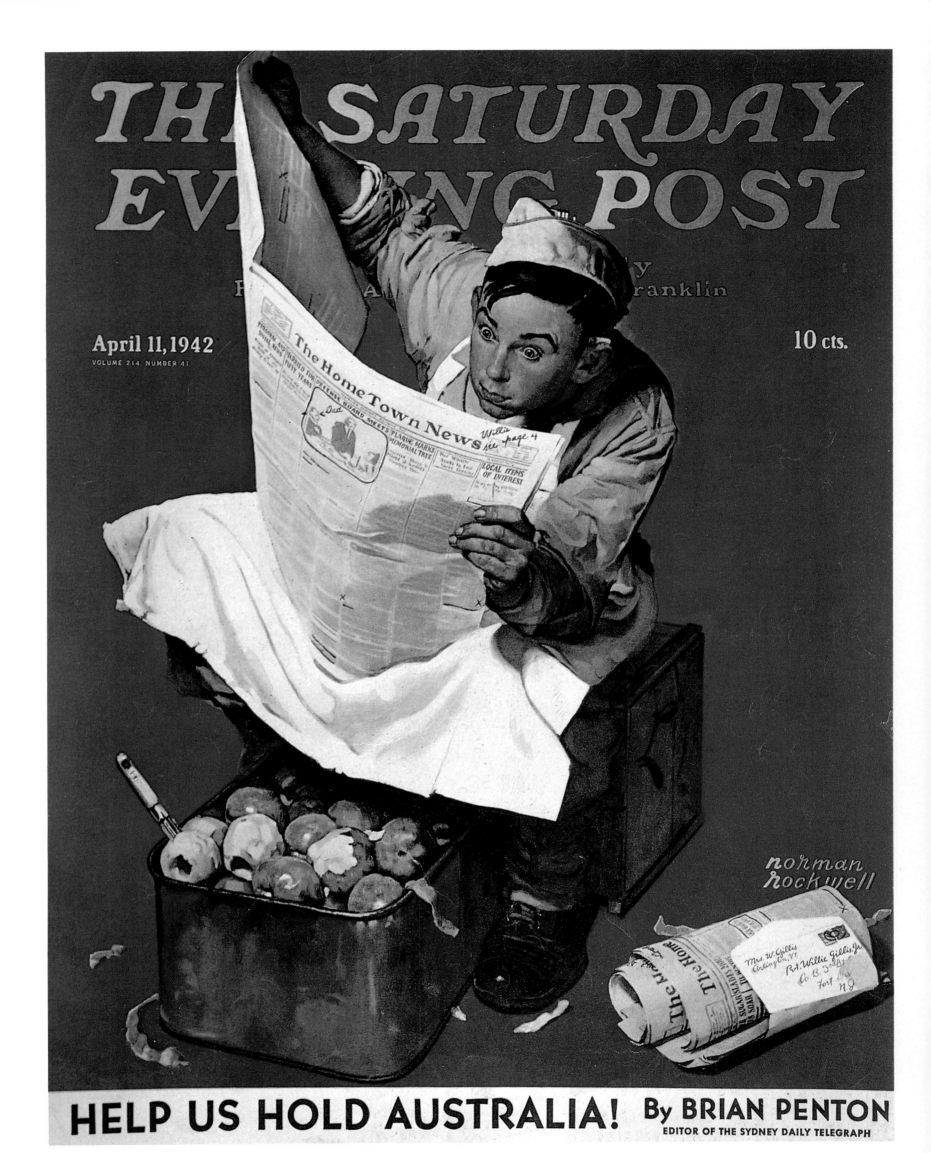

The Home Town News. Post *cover, 1942.*

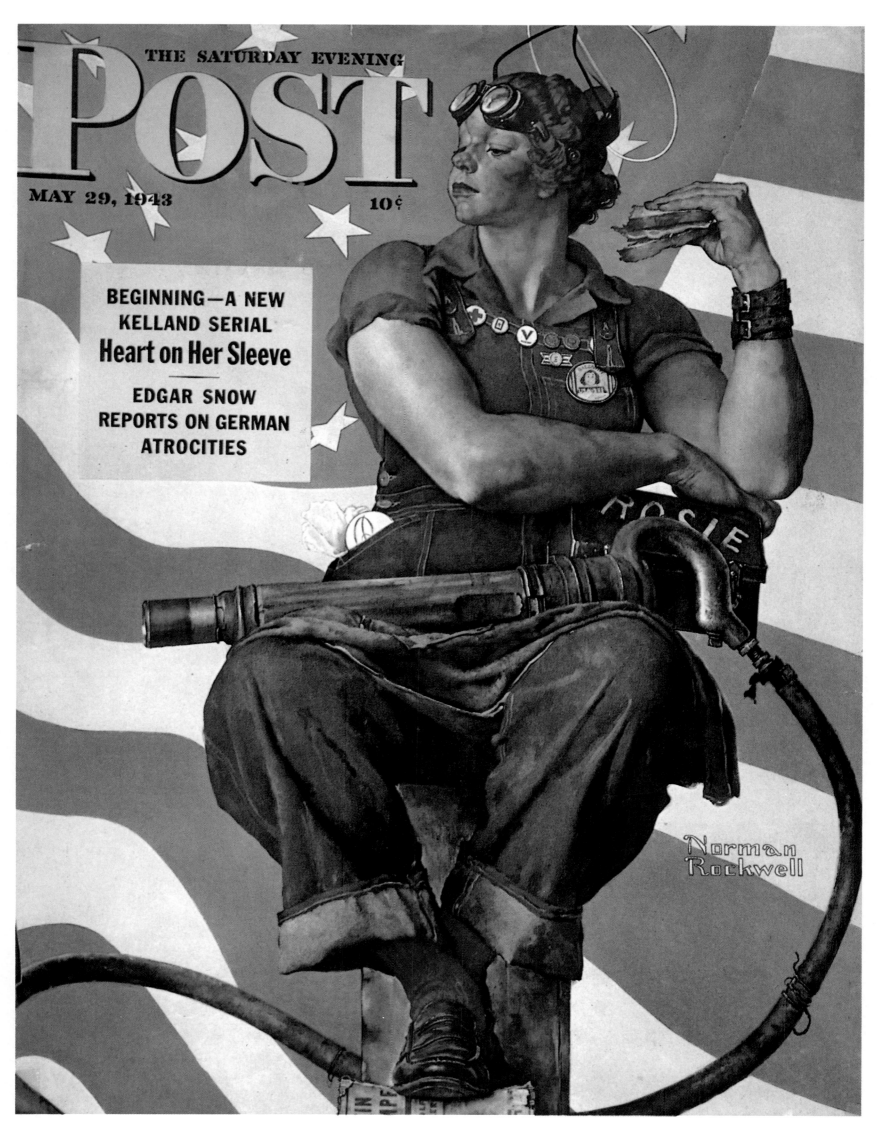

Rosie the Riveter. Post *cover, 1943.*

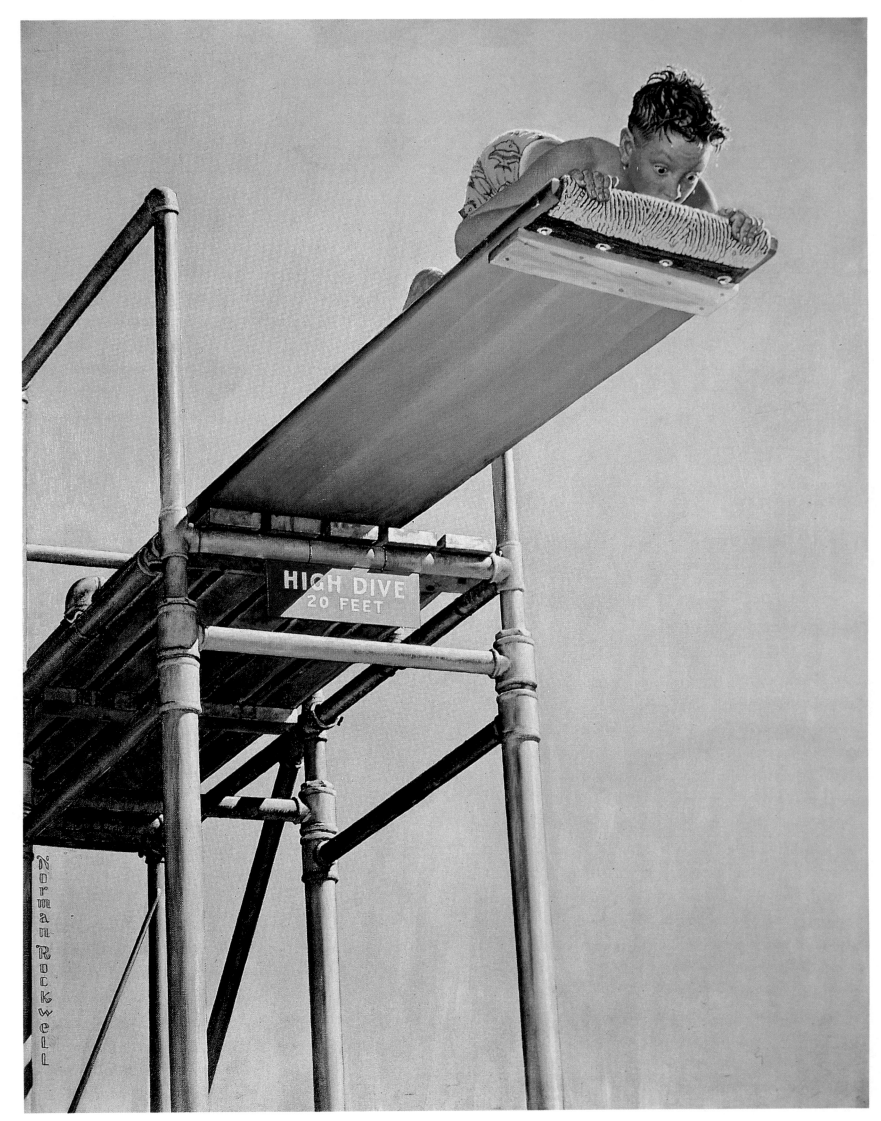

The Diving Board. *Original oil painting for a Post cover, 1947.*

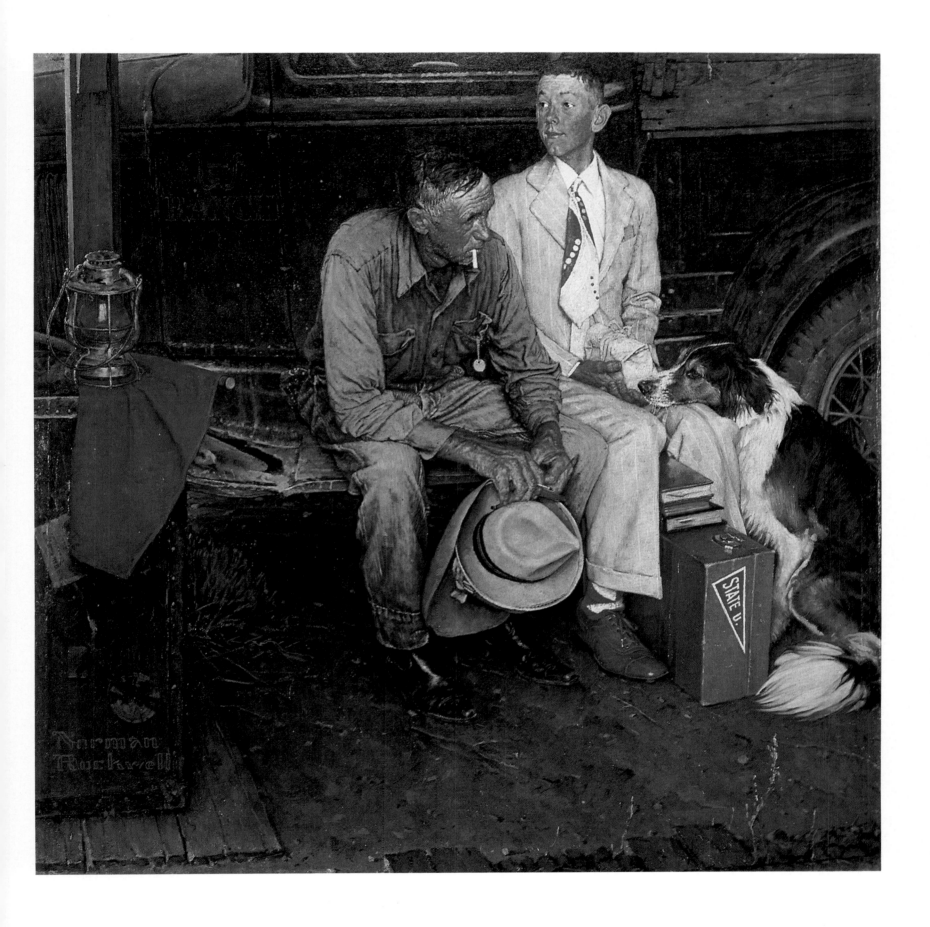

Breaking Home Ties. *Original oil painting for a* Post *cover, 1954.*

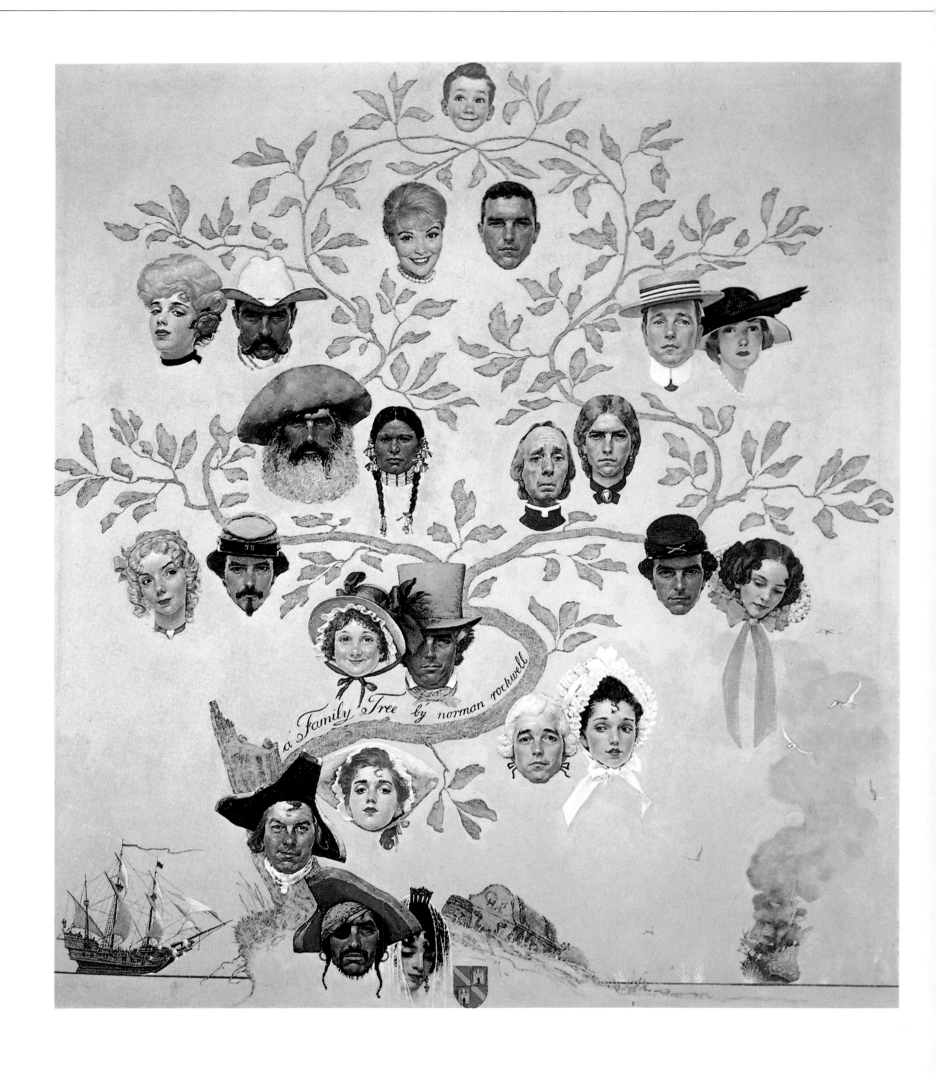

A Family Tree. *Original oil painting for a* Post *cover, 1959.*

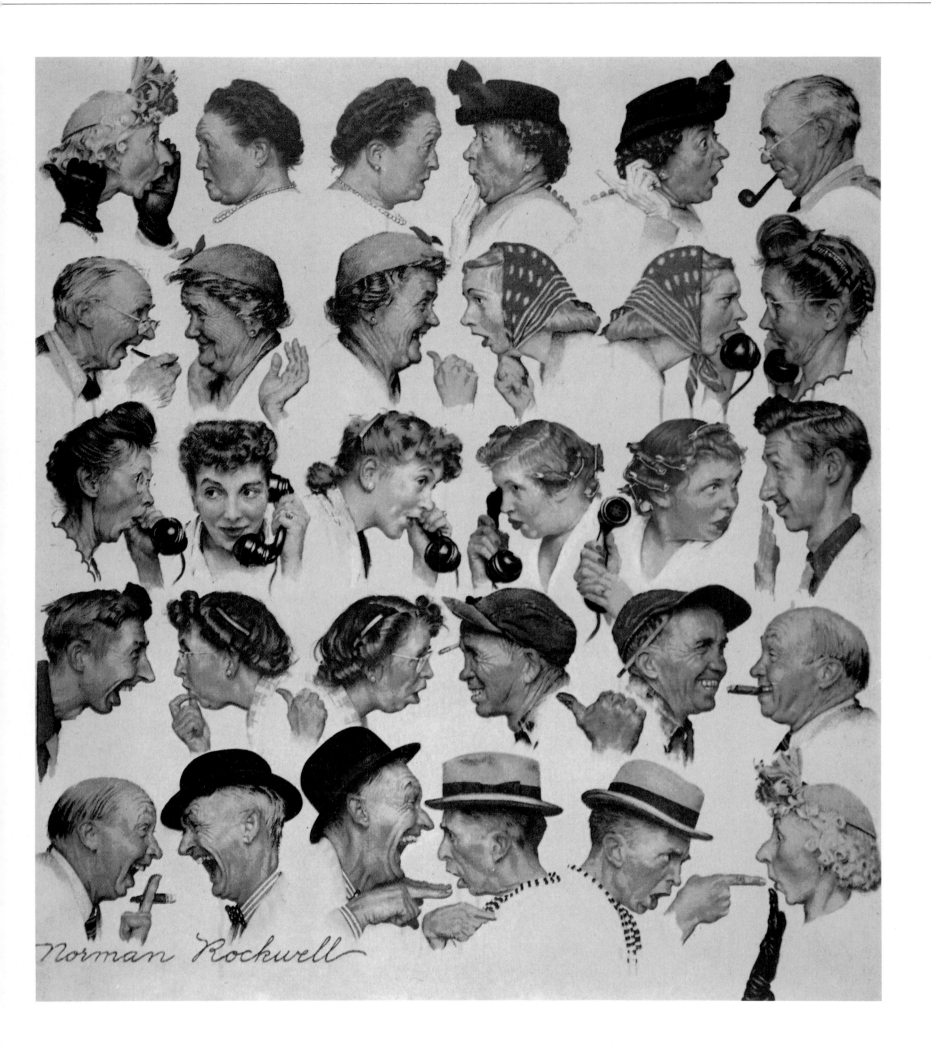

The Gossips. Post *cover, 1948.*

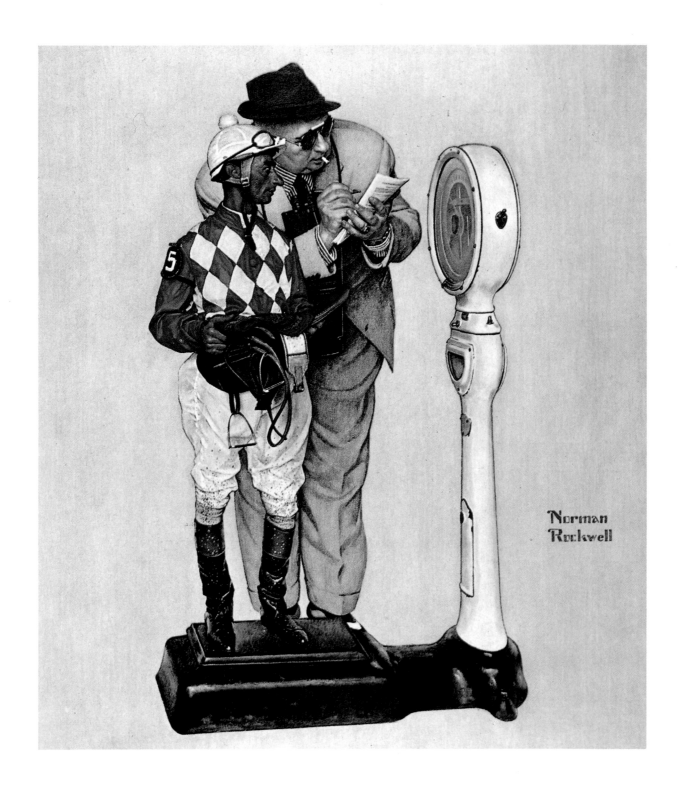

Weighing In. Post *cover, 1958.*

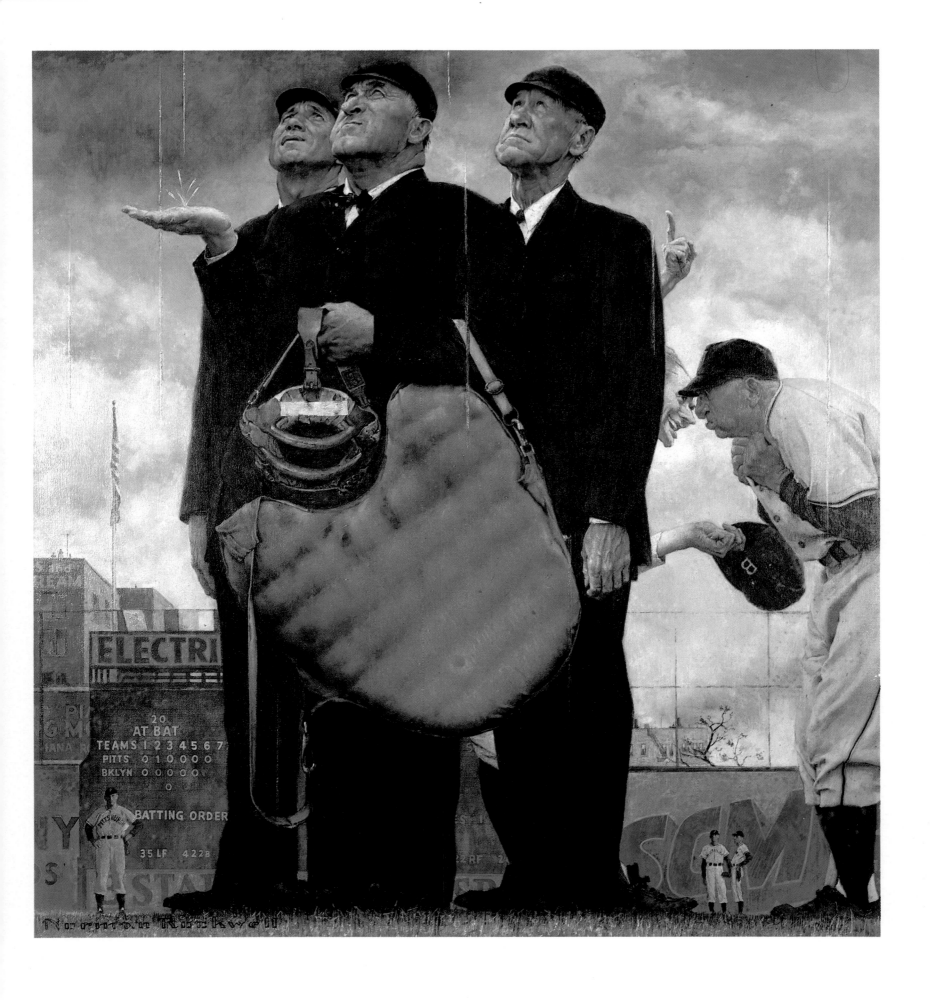

Game Called Because of Rain. *Original oil painting for a* Post *cover, 1949.*

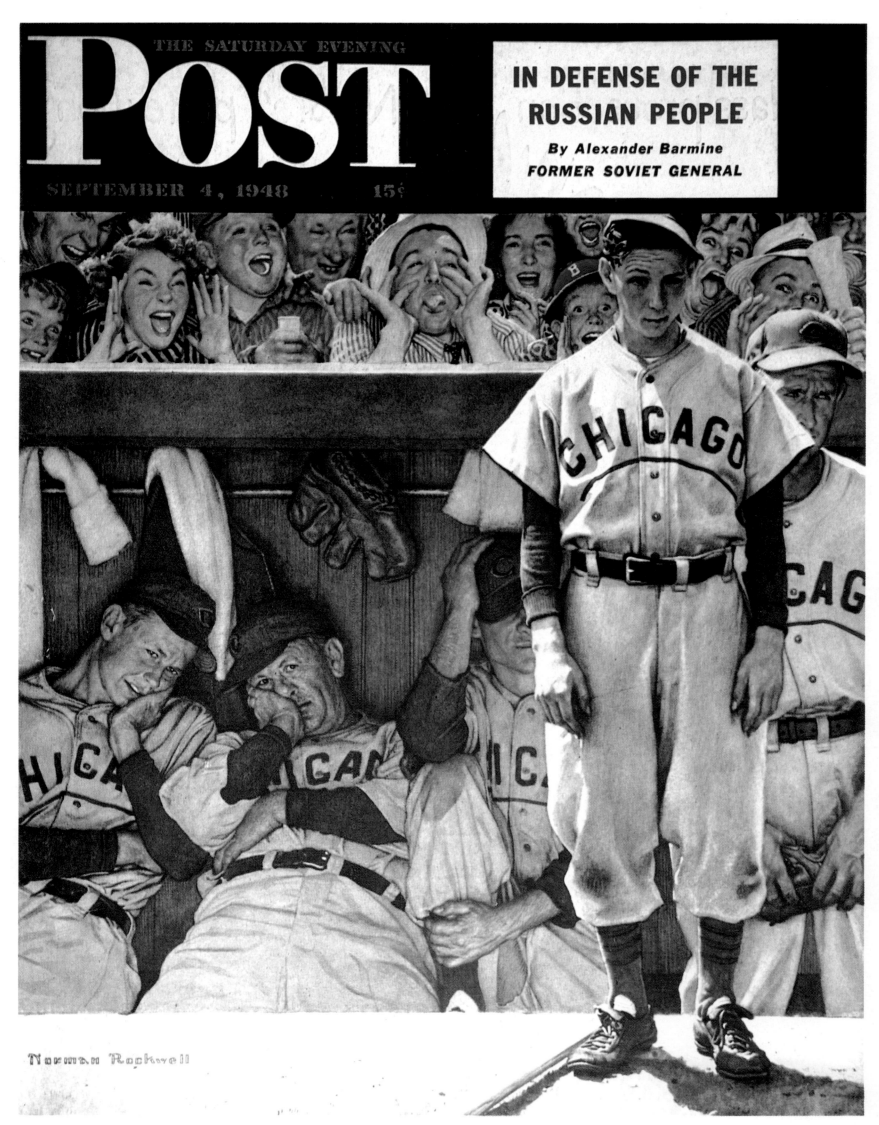

The Dugout. Post *cover, 1948.*

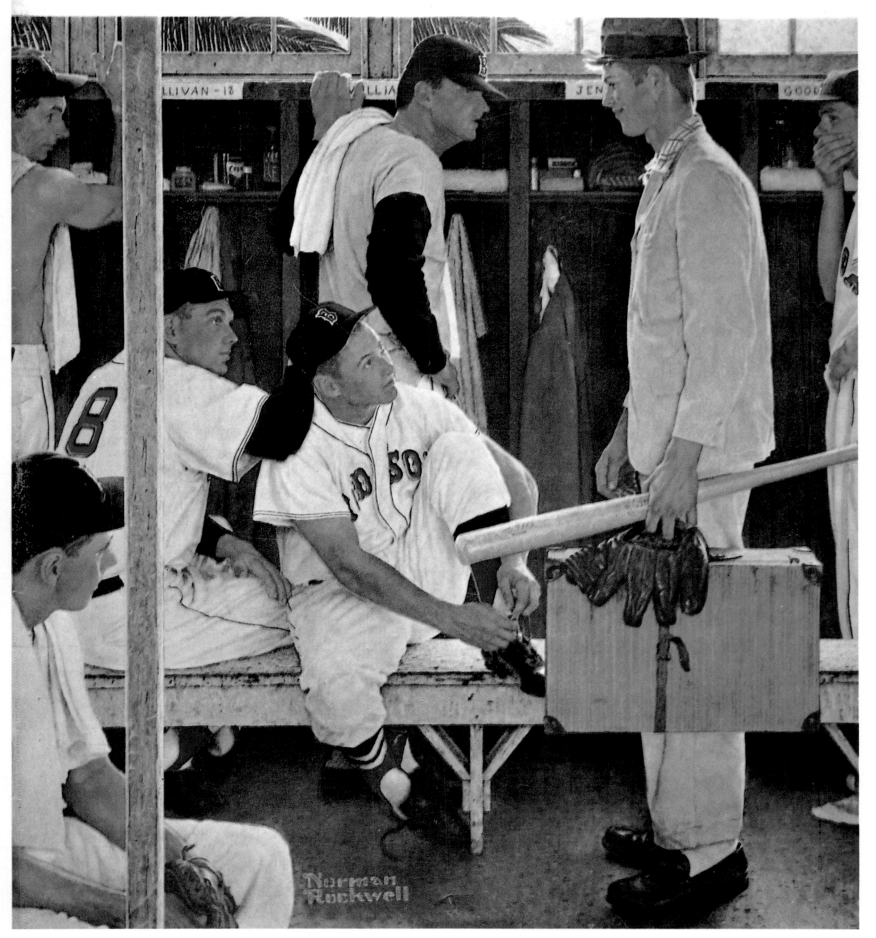

The Saturday Evening

POST

March 2, 1957 – *15¢*

THE SIXTH FLEET
Watchdog of the World's Most Troubled Area

The Locker Room. Post *cover, 1957.*

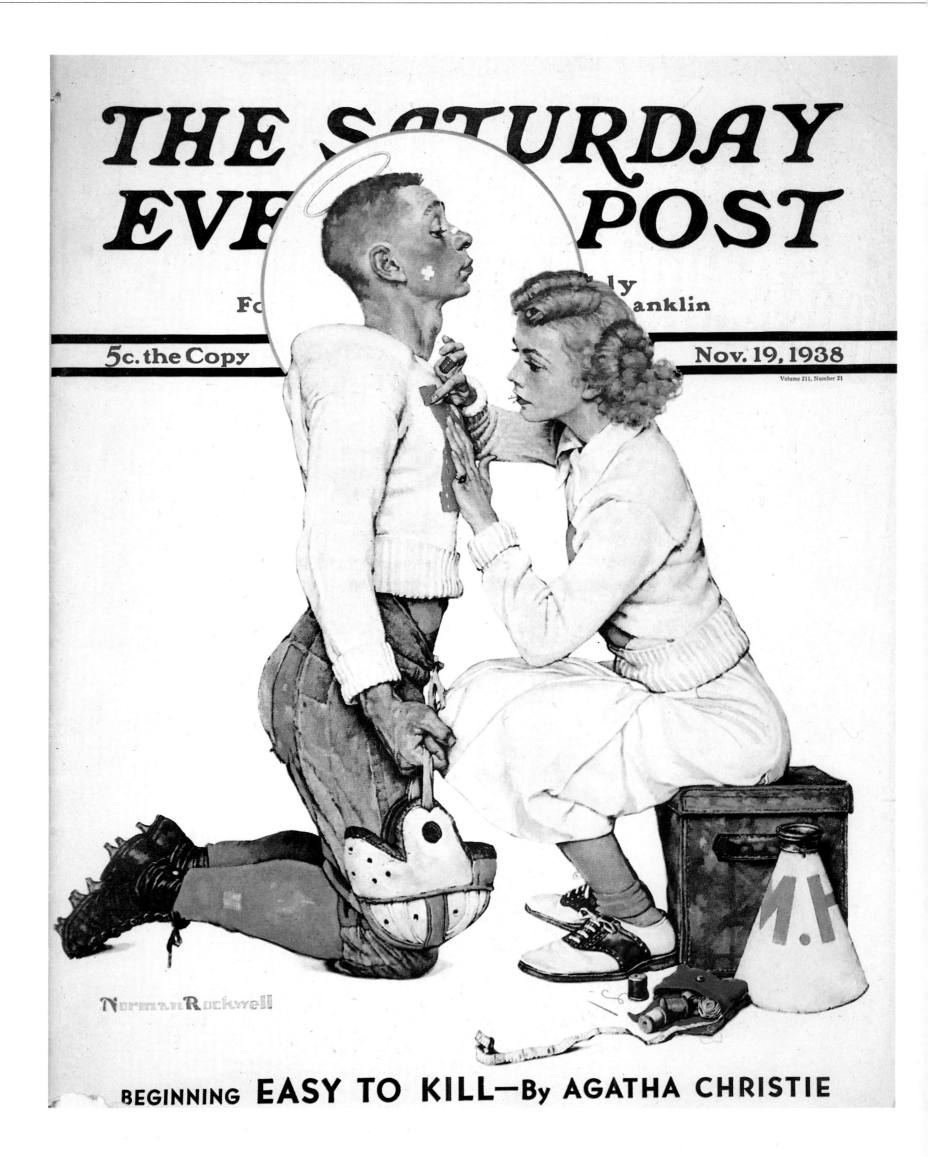

The Letterman. Post *cover, 1938.*

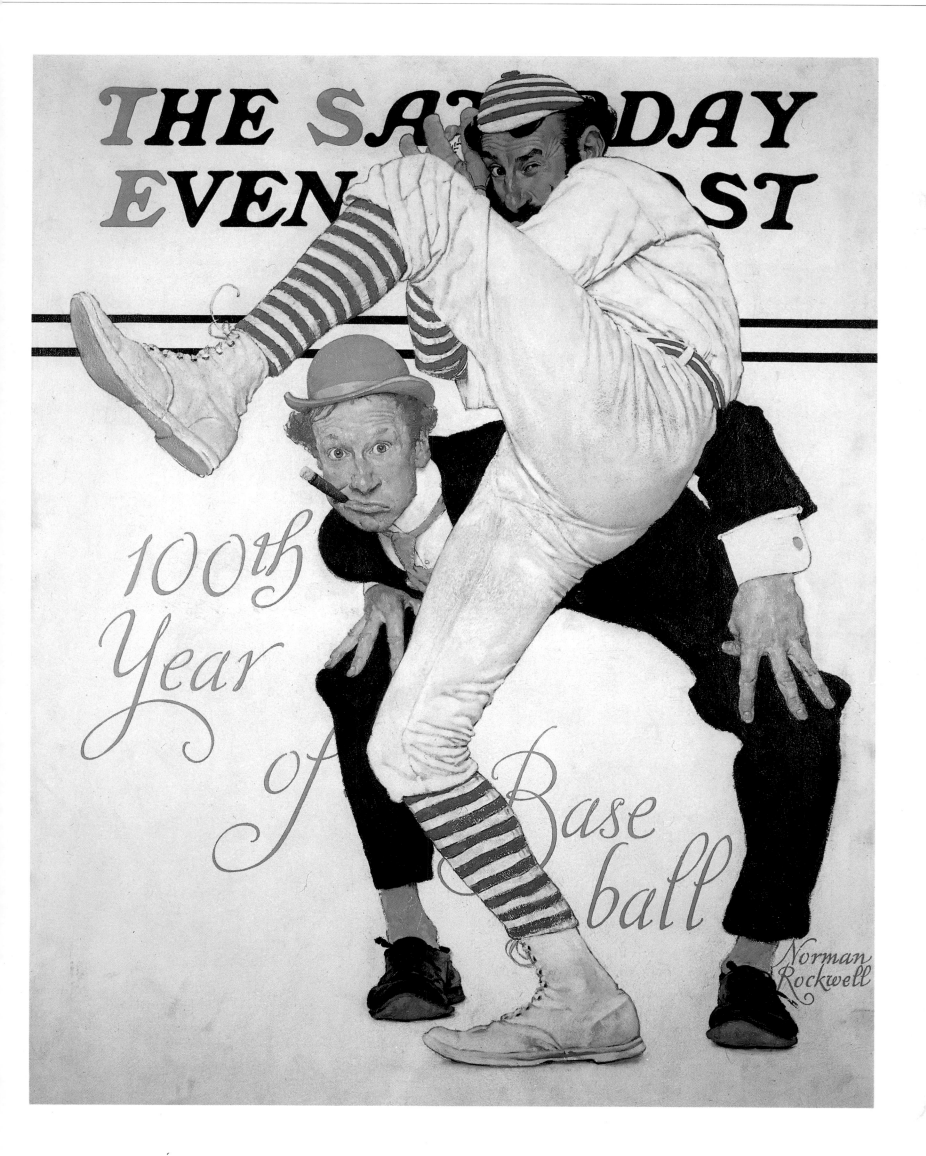

100th Year of Baseball. *Original oil painting for a* Post *cover, 1939.*

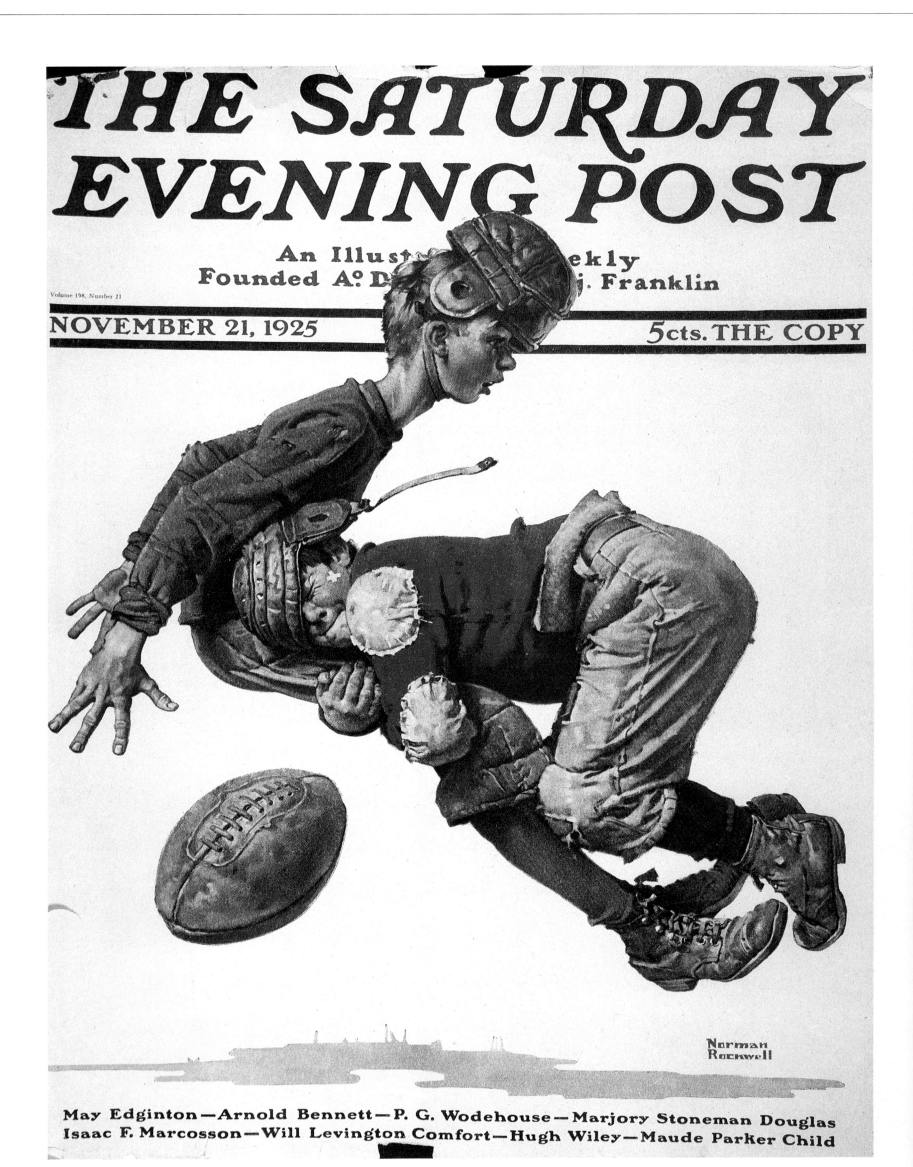

Tackled. Post *cover, 1925.*

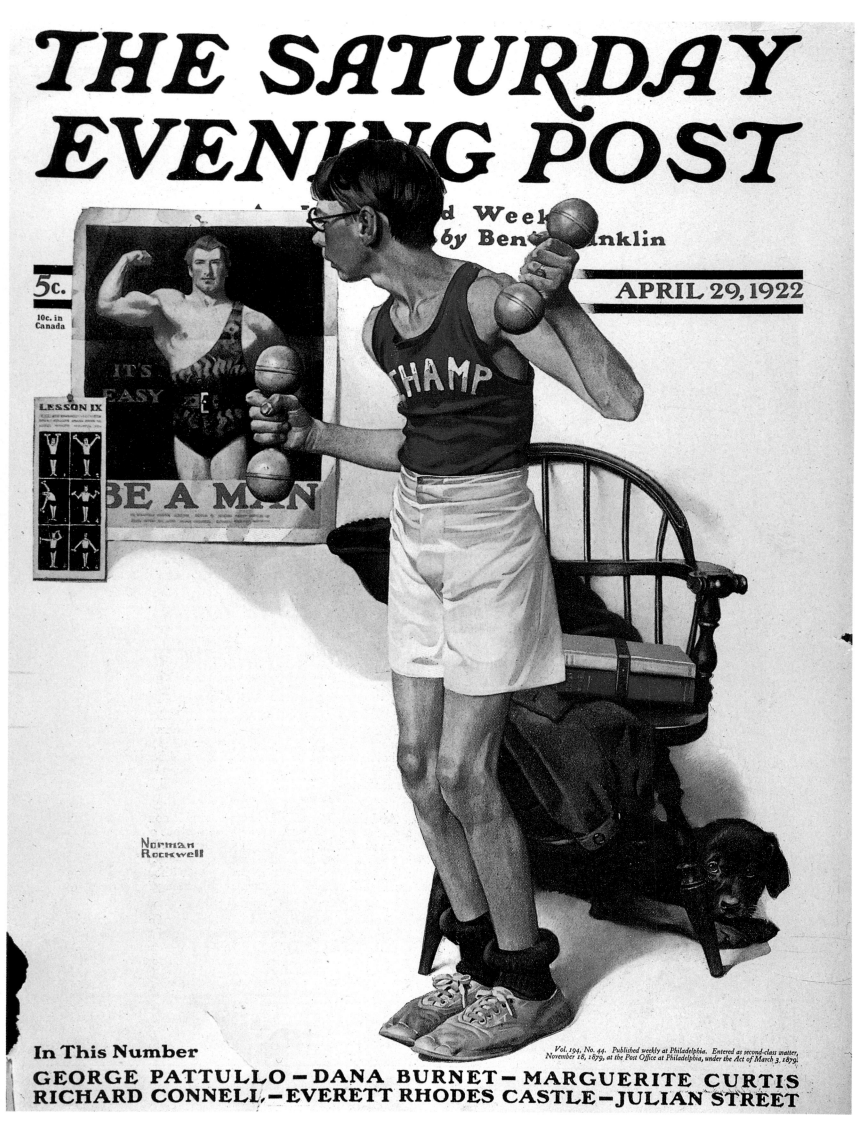

The Bodybuilder. Post *cover, 1922.*

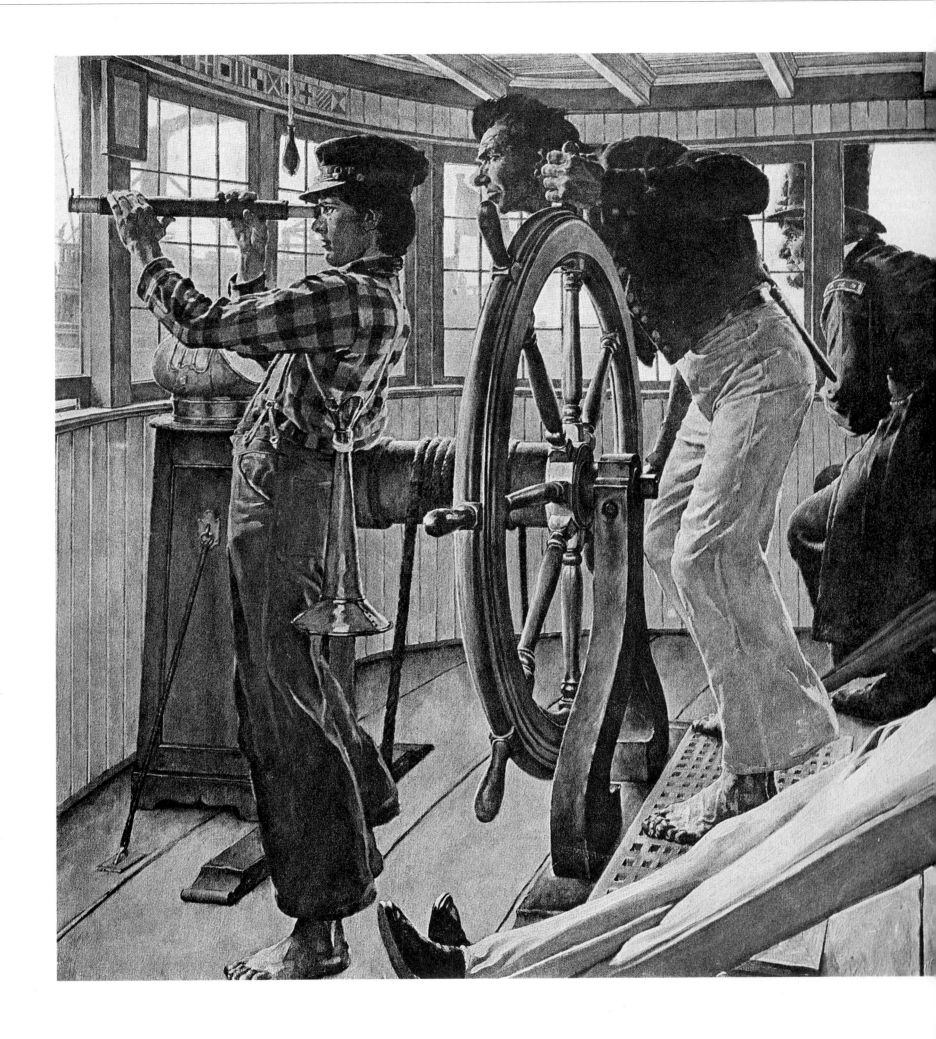

River Pilot. Post *illustration, 1940.*

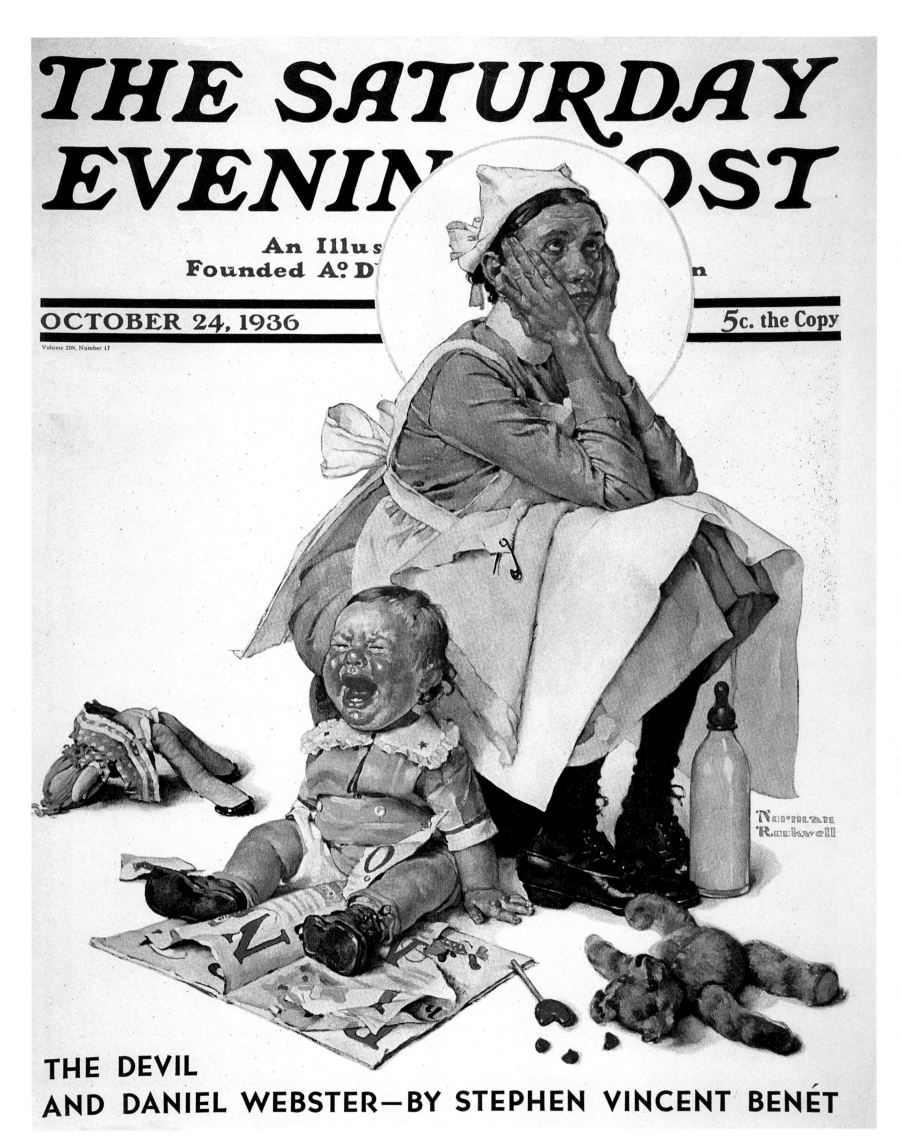

The Tantrum. Post *cover, 1936.*

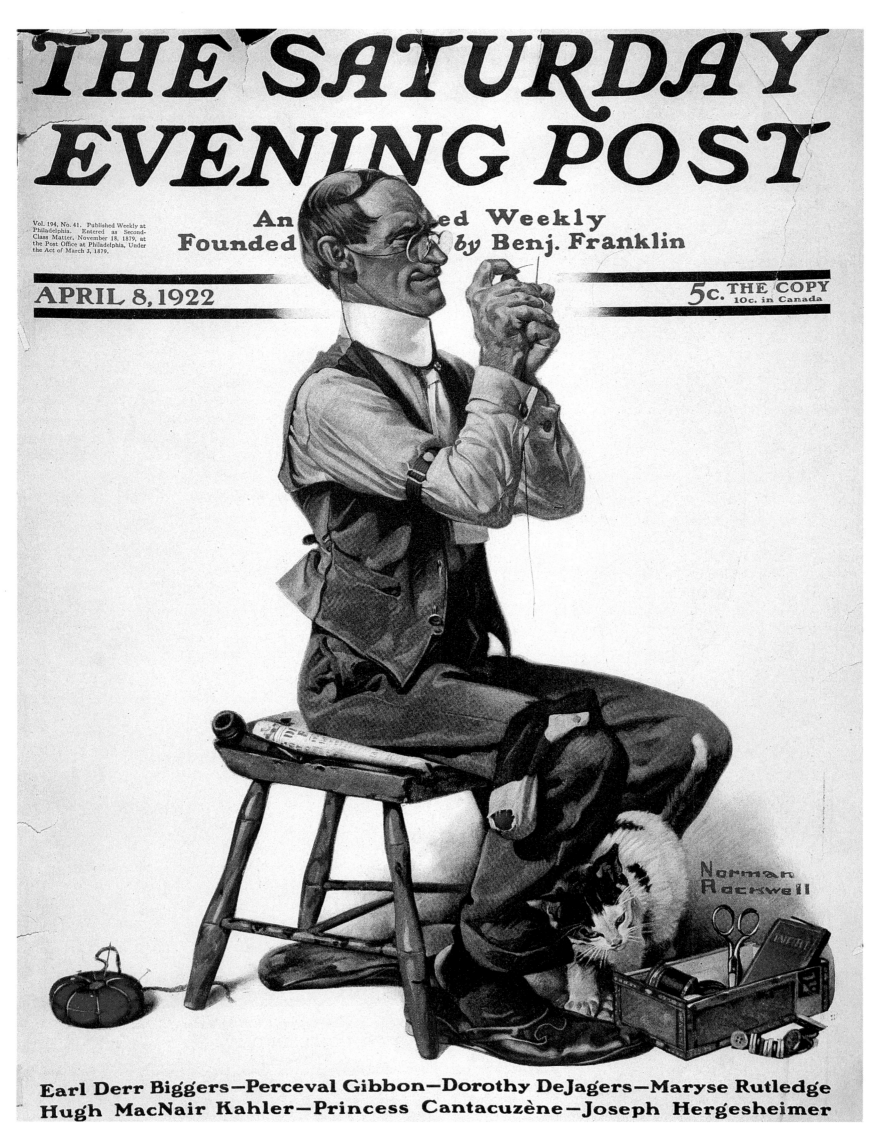

Man Threading Needle. Post *cover, 1922.*

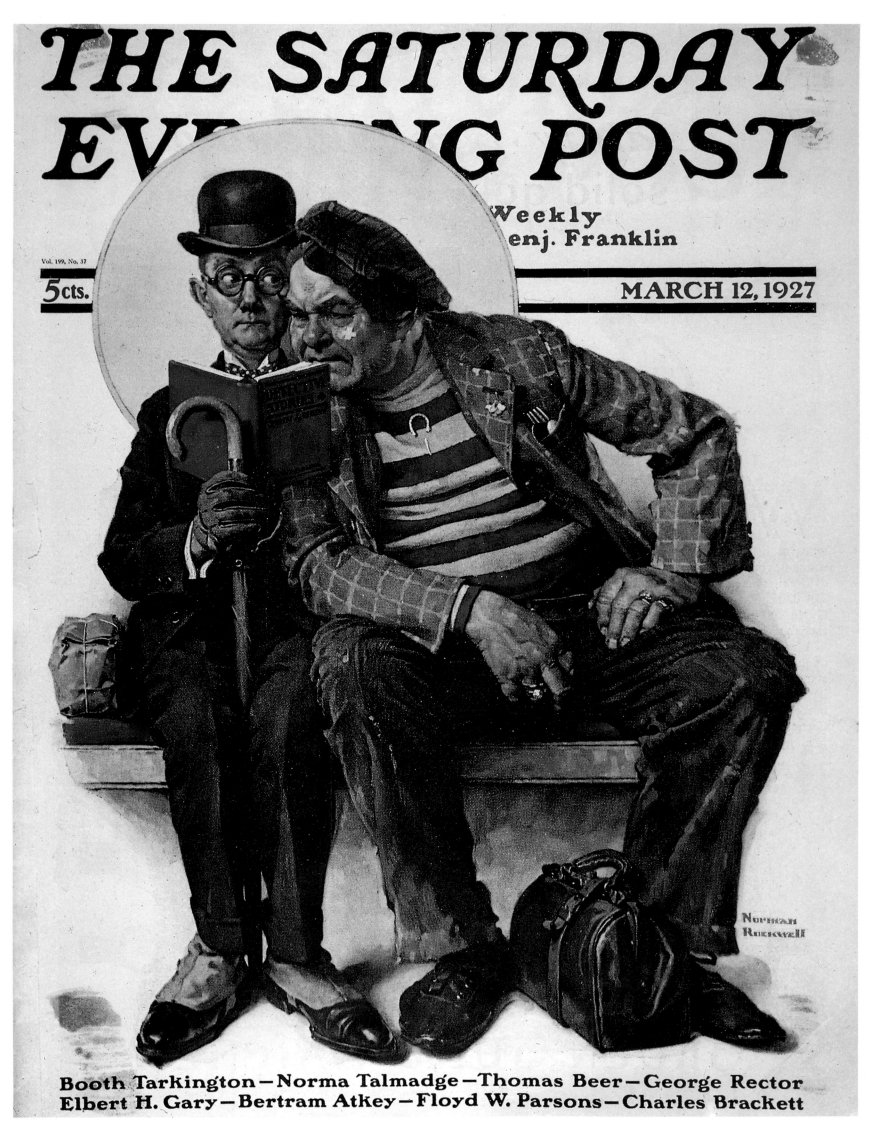

Second Reader. Post *cover, 1927.*

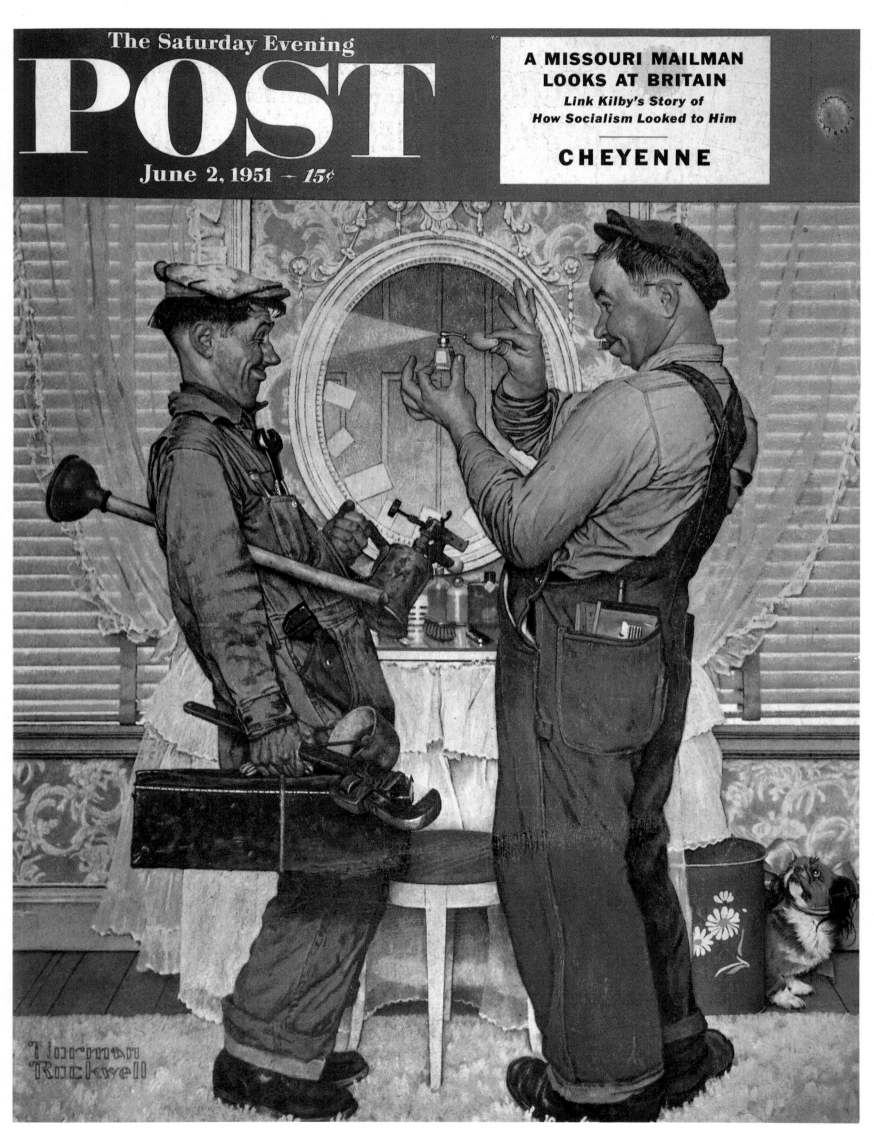

The Plumbers. Post *cover, 1951.*

The Decorator. Post *cover, 1940.*

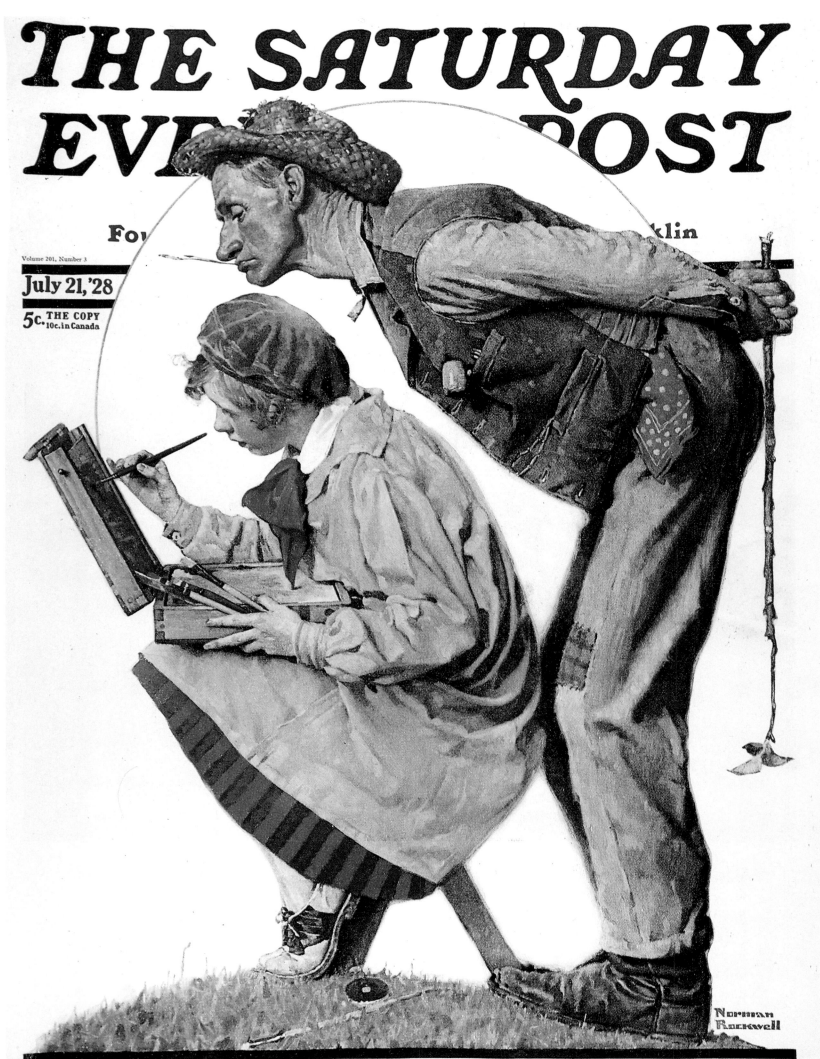

The following text appears within the magazine cover illustration:

THE SATURDAY
EVE **POST**

Fo klin

Volume 201, Number 3

July 21, '28

5c. THE COPY
10c. in Canada

Norman Rockwell

Benito Mussolini–Rob Wagner–George Allan England–James Warner Bellah
Charles Francis Coe–F. Scott Fitzgerald–Maximilian Foster–Donald E. Keyhoe

Artist and Critic. Post *cover, 1928.*

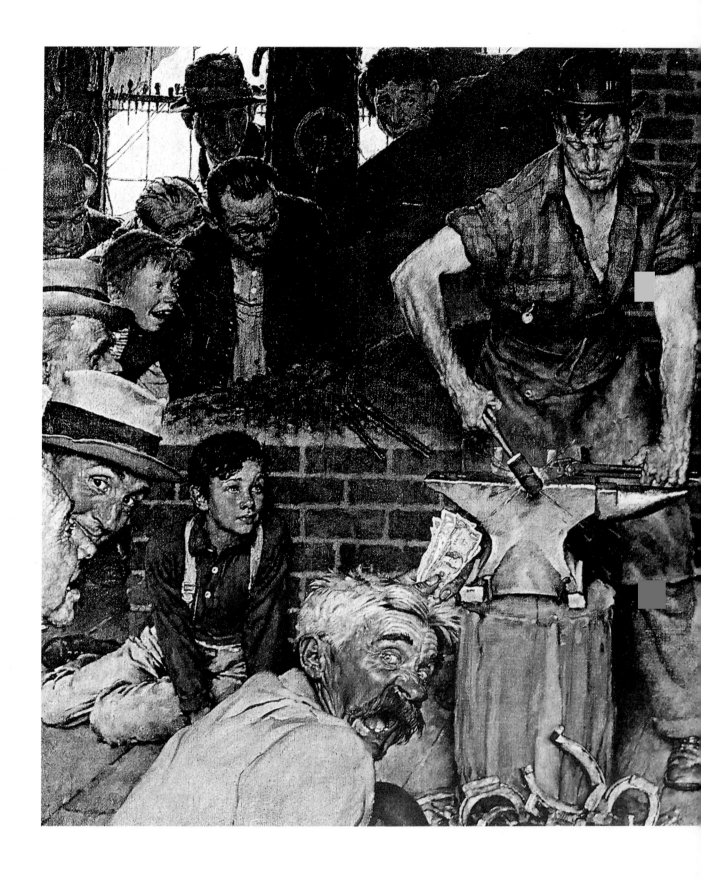

The Horseshoe Forging Contest. Post *illustration, 1940.*

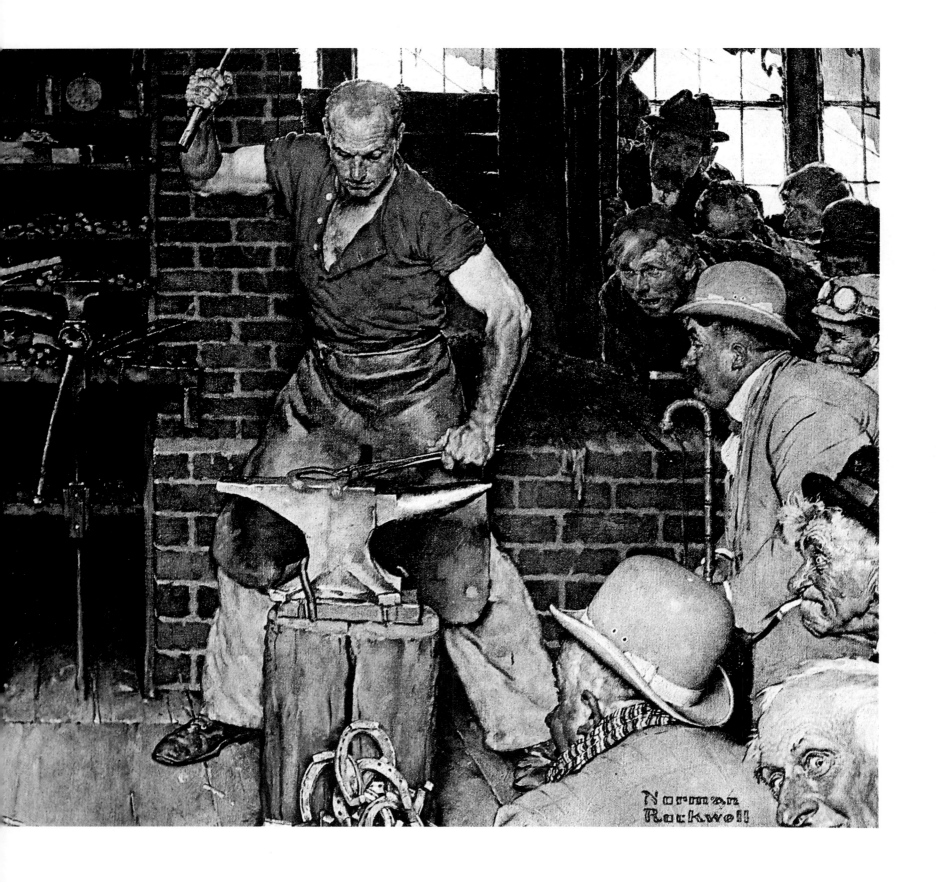

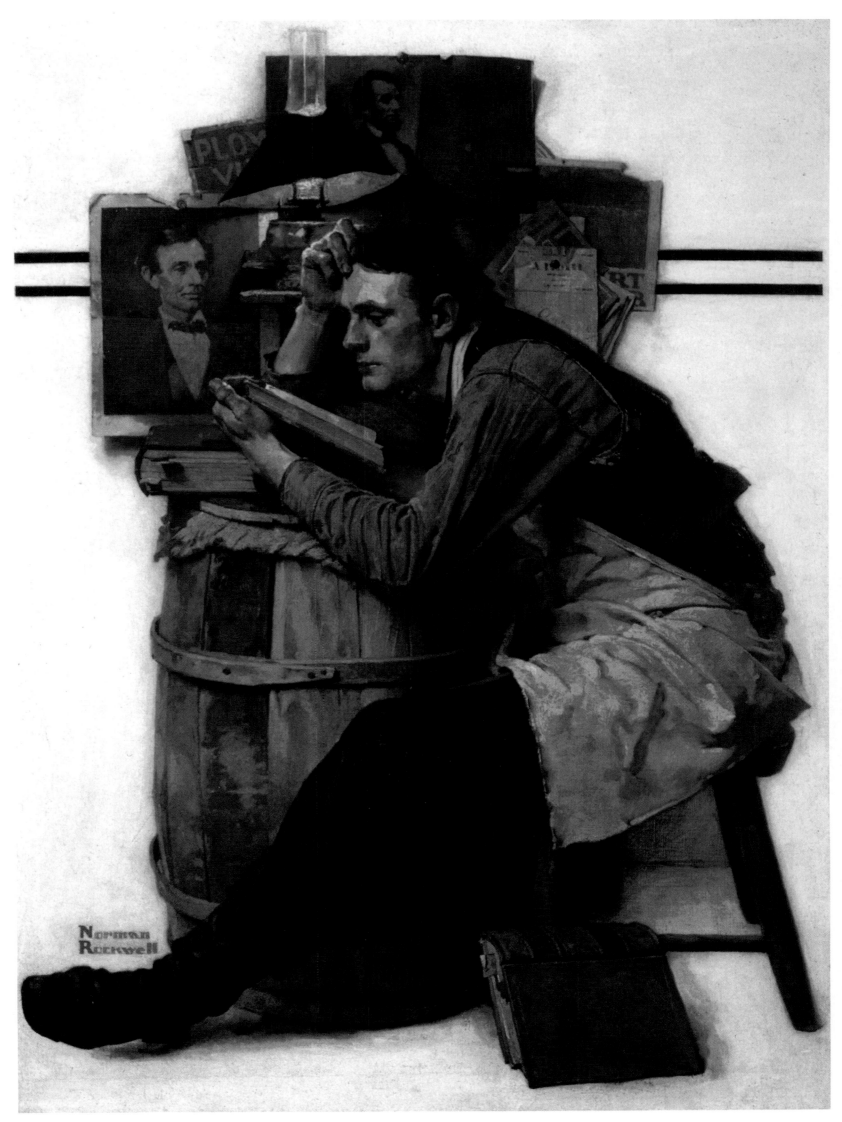

The Law Student. *Original oil painting for a* Post *cover, 1927.*

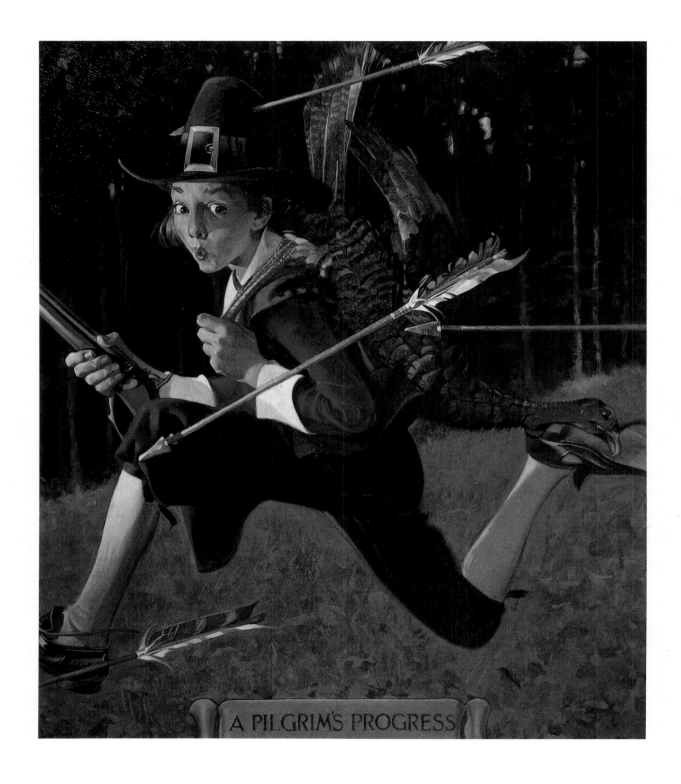

A Pilgrim's Progress. Life *cover, 1921.*

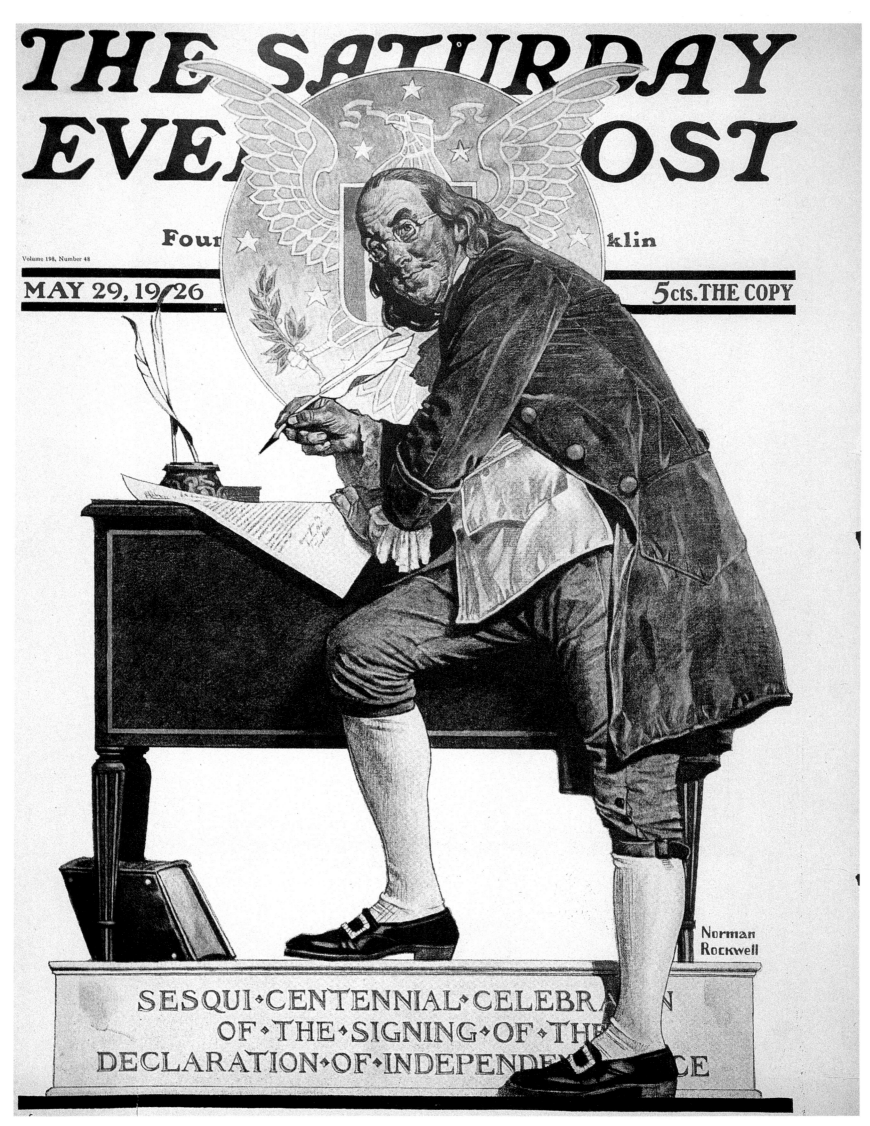

Ben Franklin Signing the Declaration of Independence. Post *cover, 1926.*

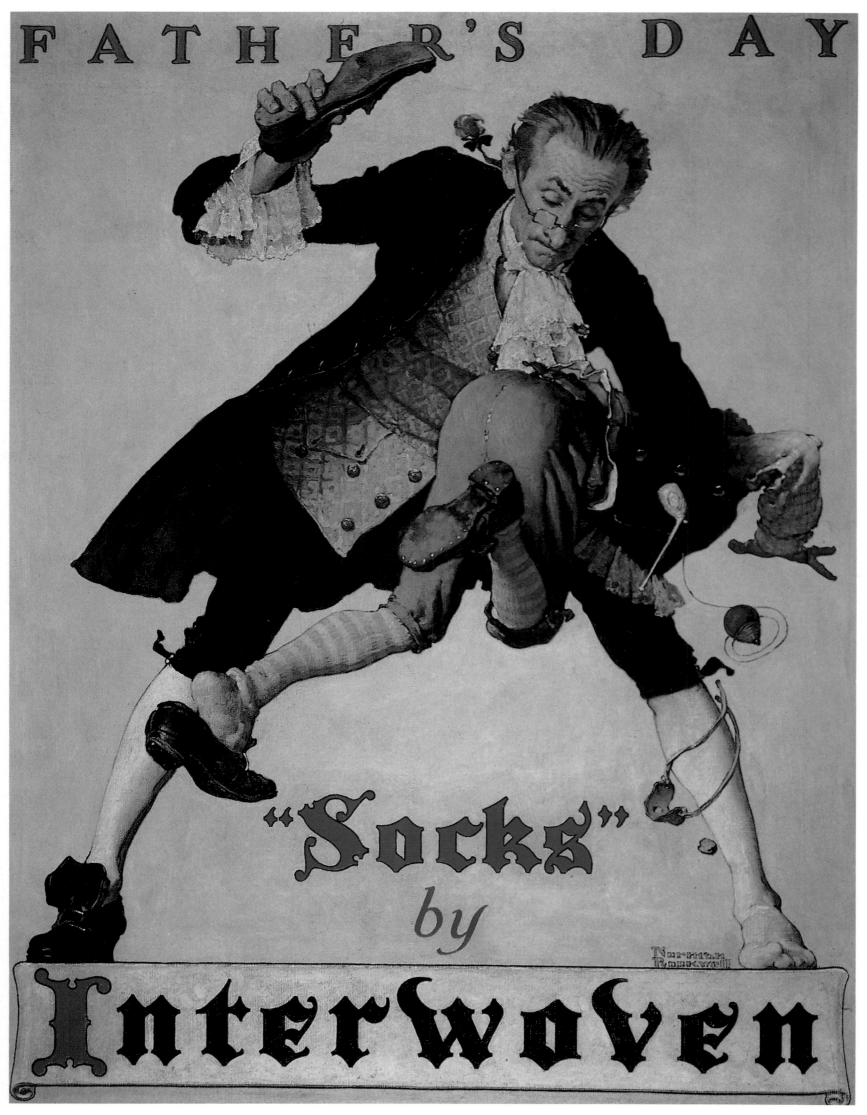

Father's Day. *Advertisement for Interwoven Socks, undated.*

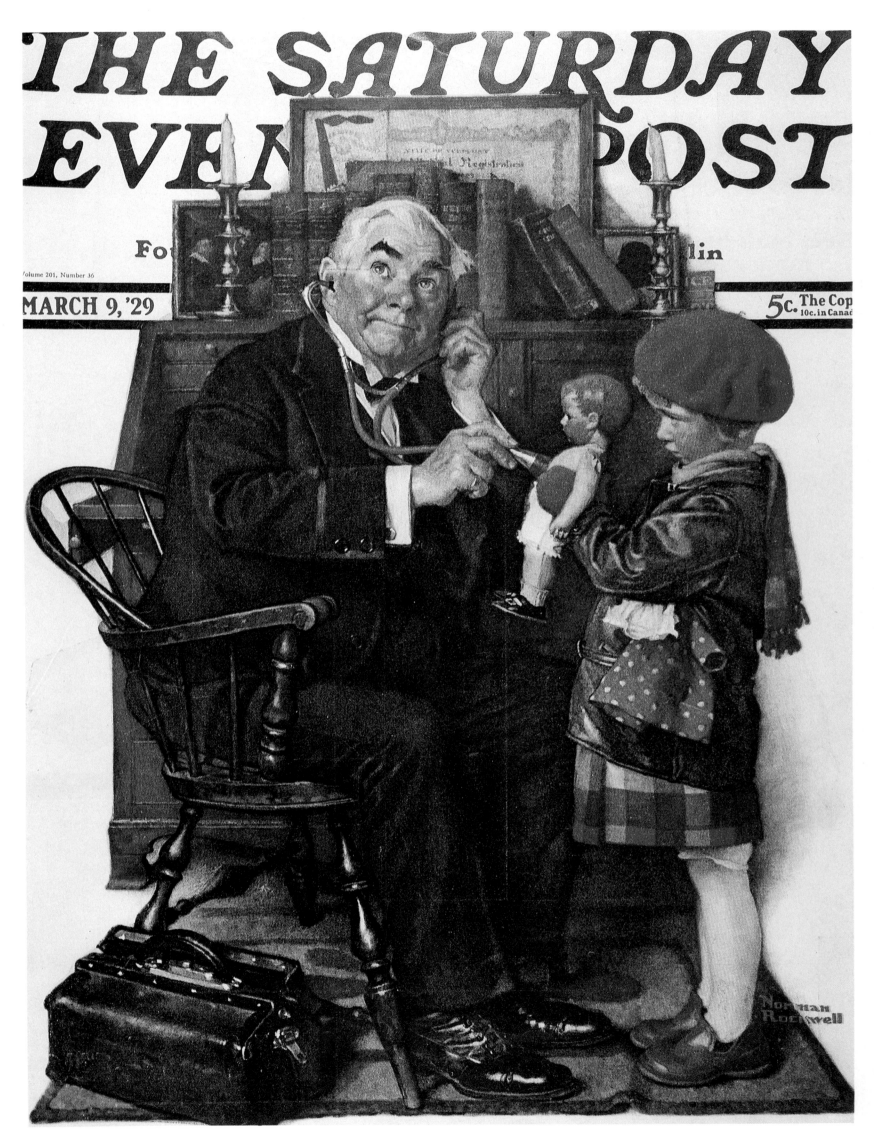

Doctor and Doll. Post *cover, 1929.*

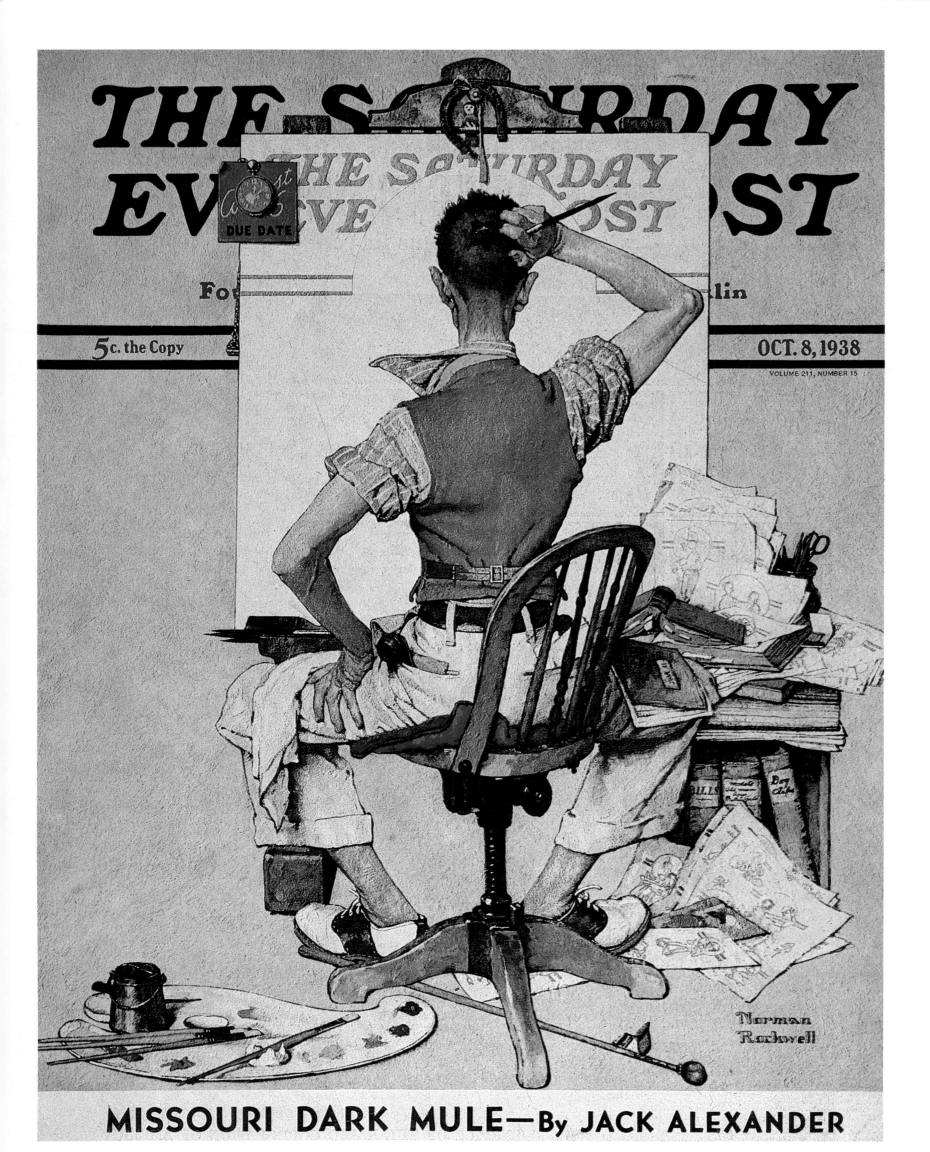

Artist Faced with Blank Canvas. Post *cover, 1938.*

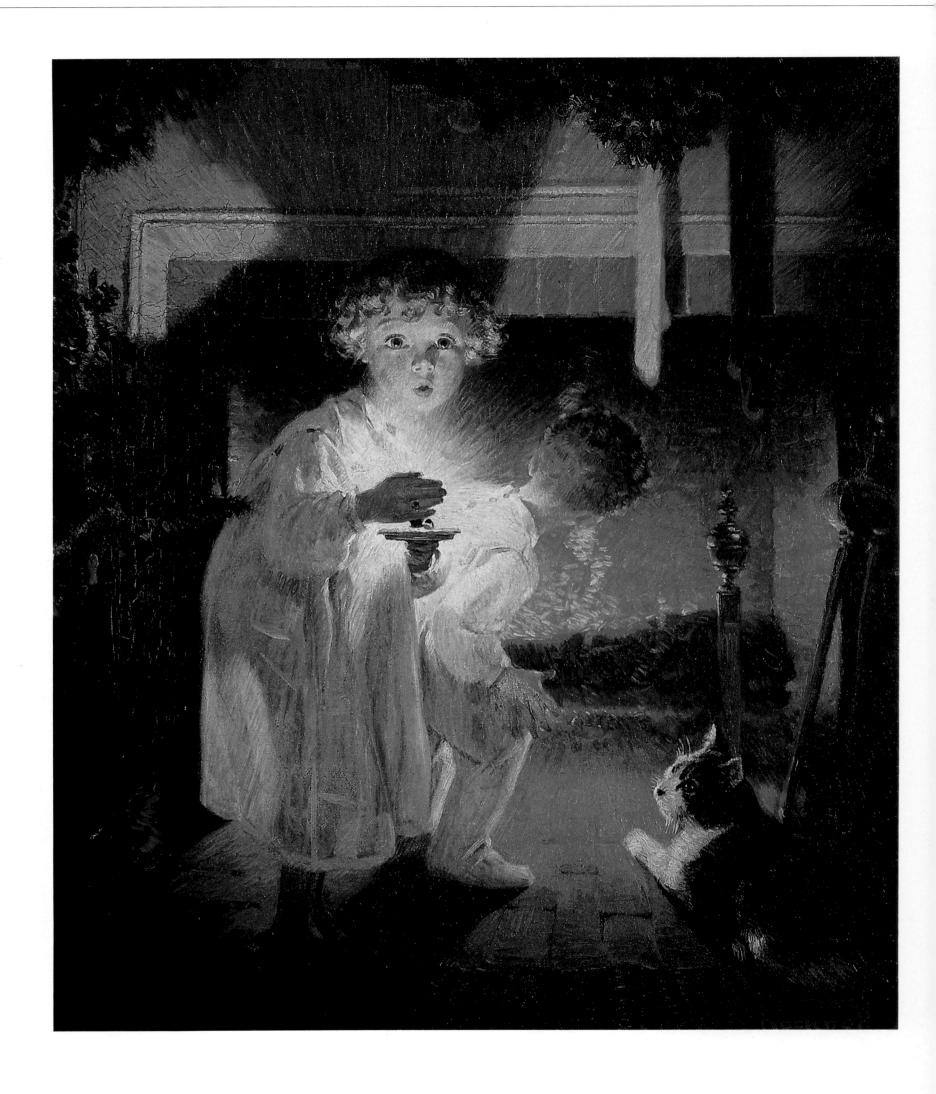

Is He Coming? Life *cover, 1920.*

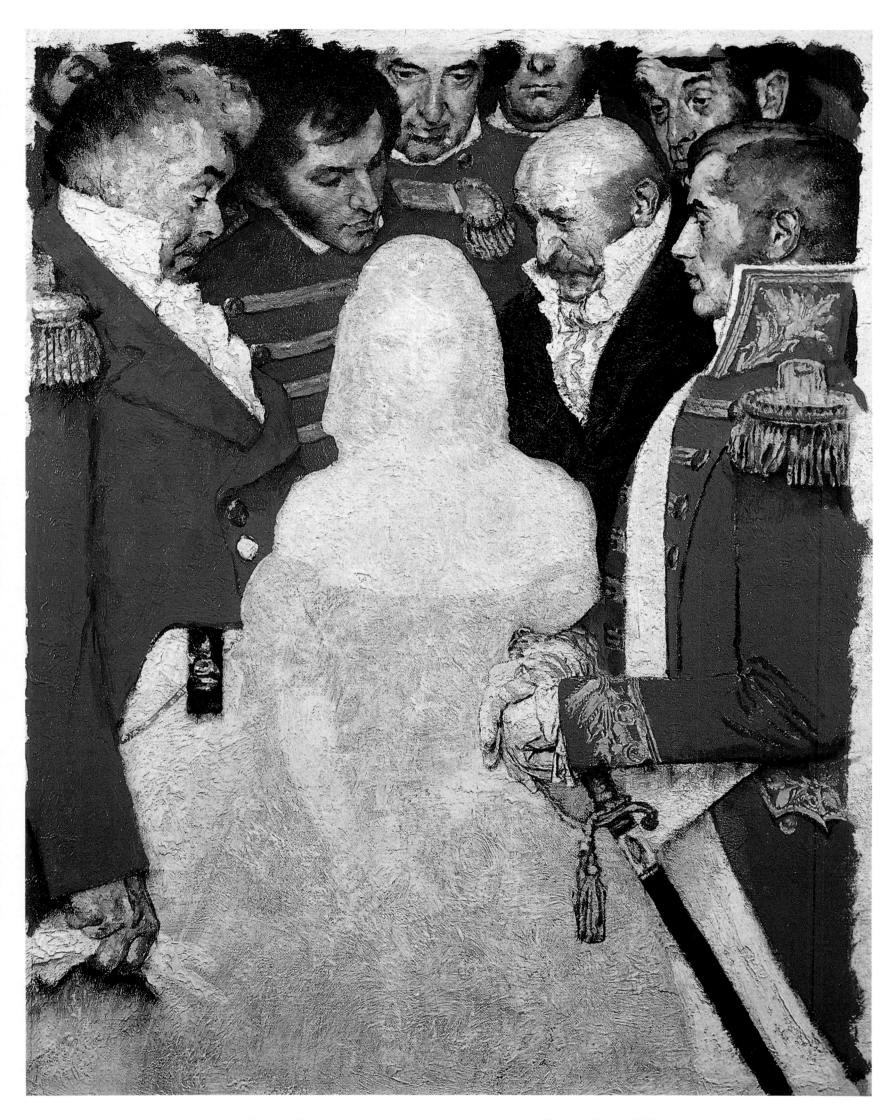

Becky Sharp. *Original oil painting (unused as illustration), 1965.*
(White overpainting by the artist.)

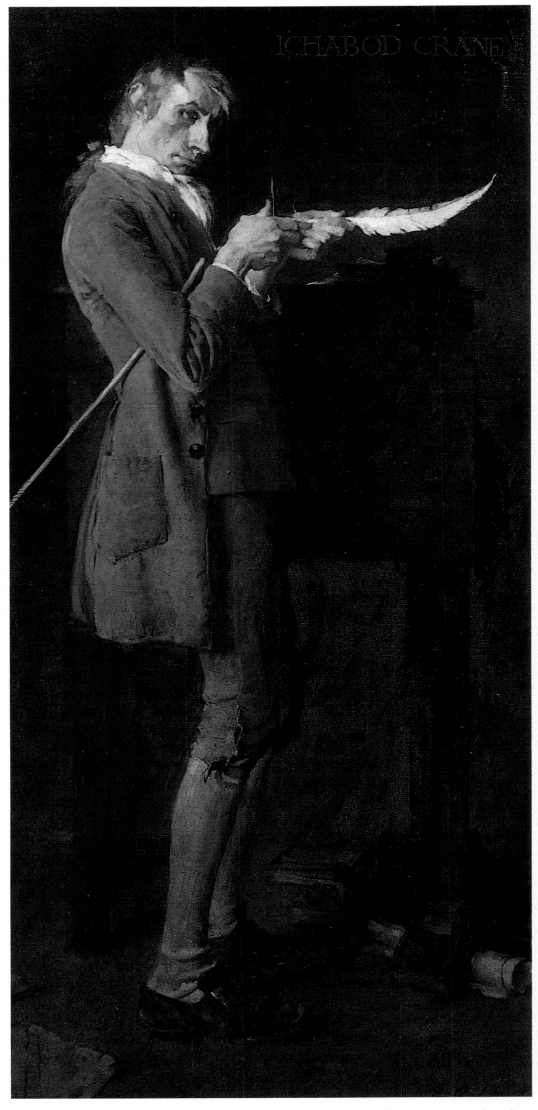

Ichabod Crane. *Original oil painting (unused as illustration), undated.*

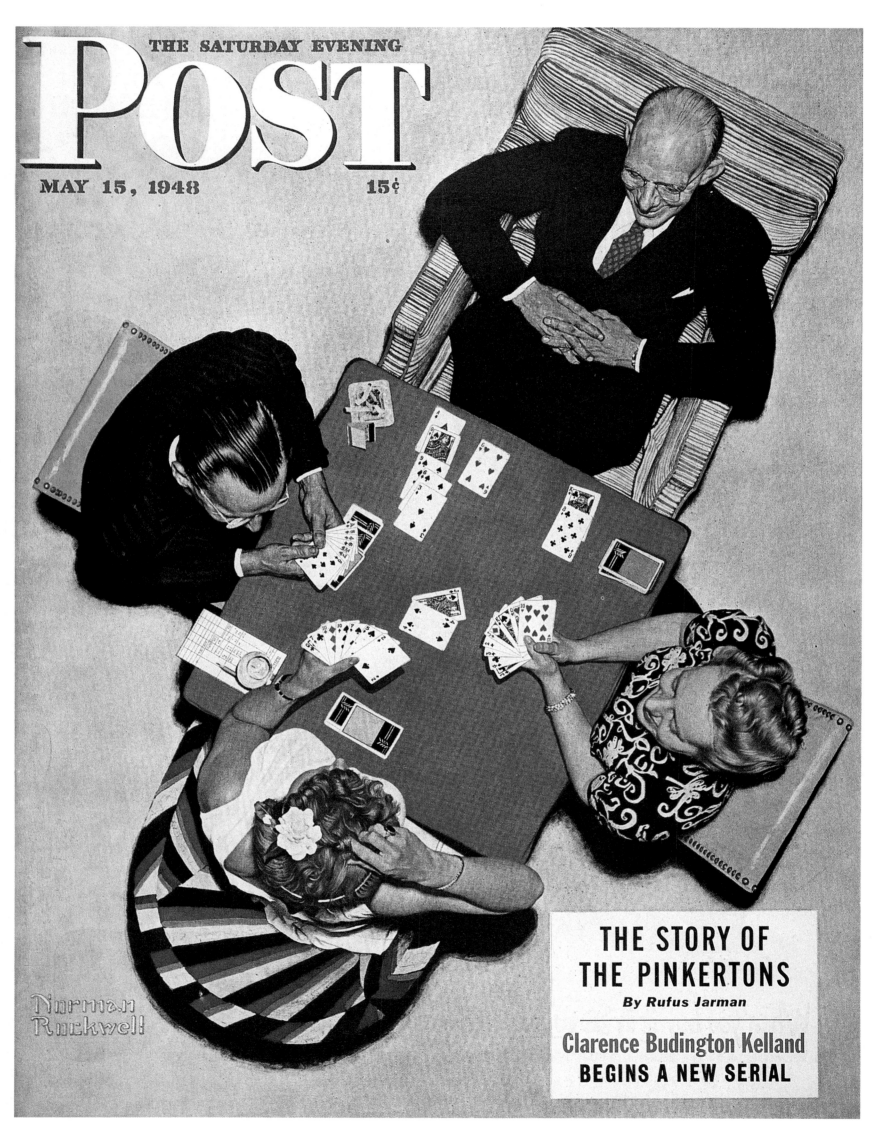

Bridge Game. Post *cover, 15 May 1948.*

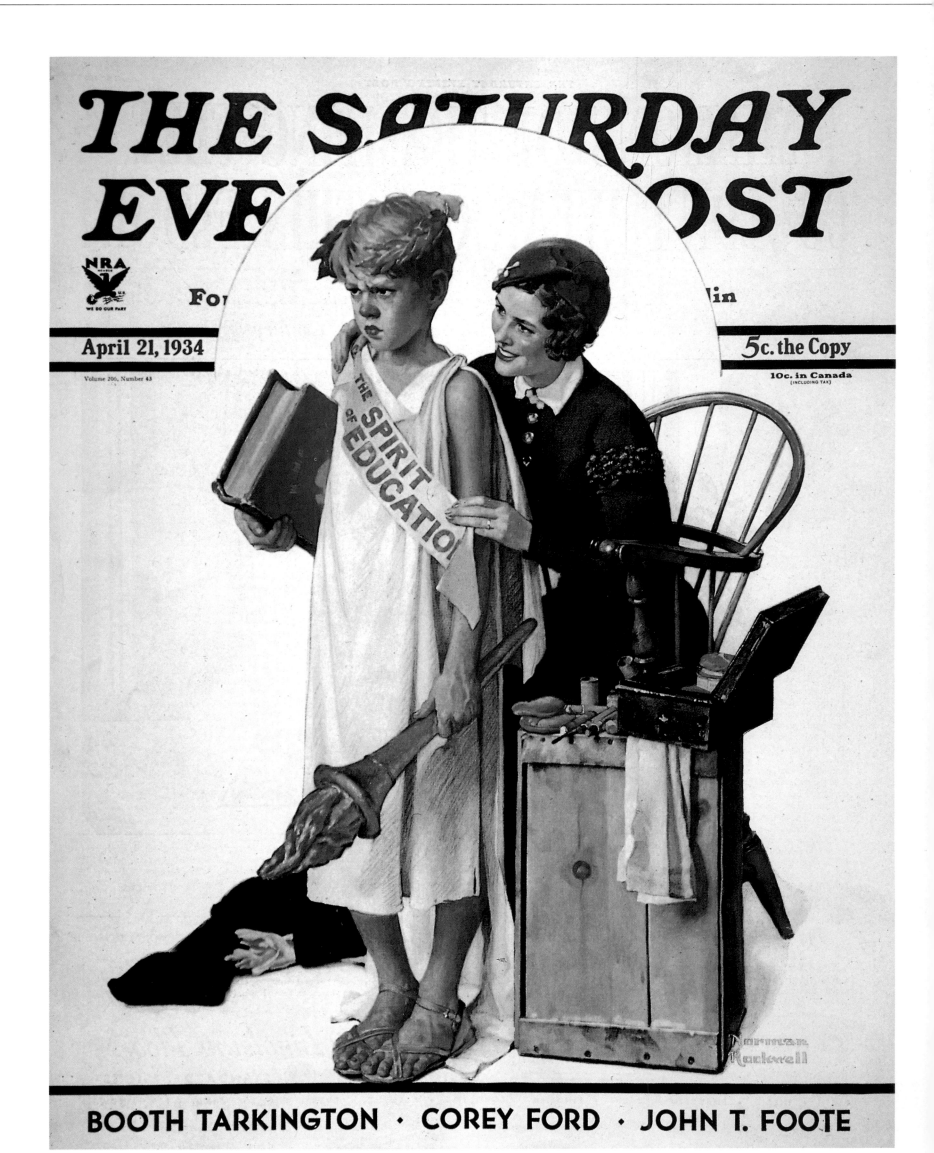

The Spirit of Education. Post *cover, 1934.*

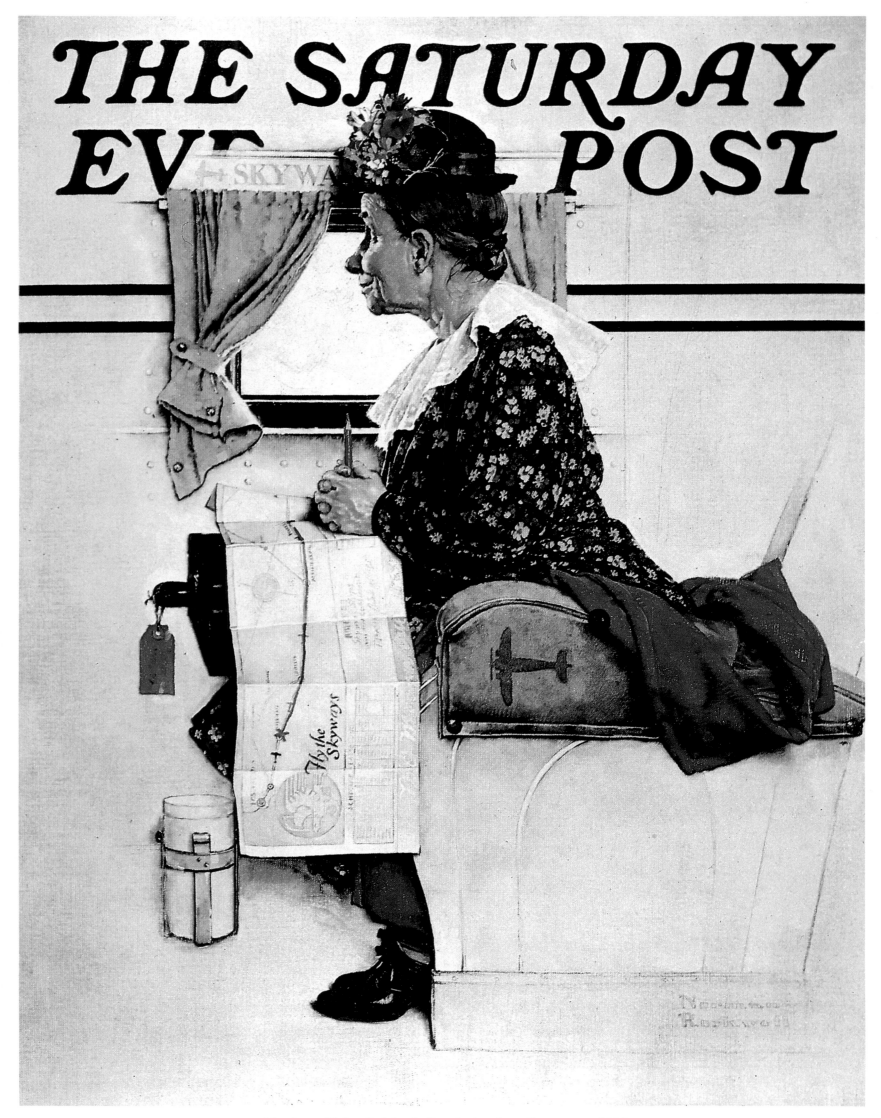

Airplane Trip. *Original oil painting for a* Post *cover, 1938.*

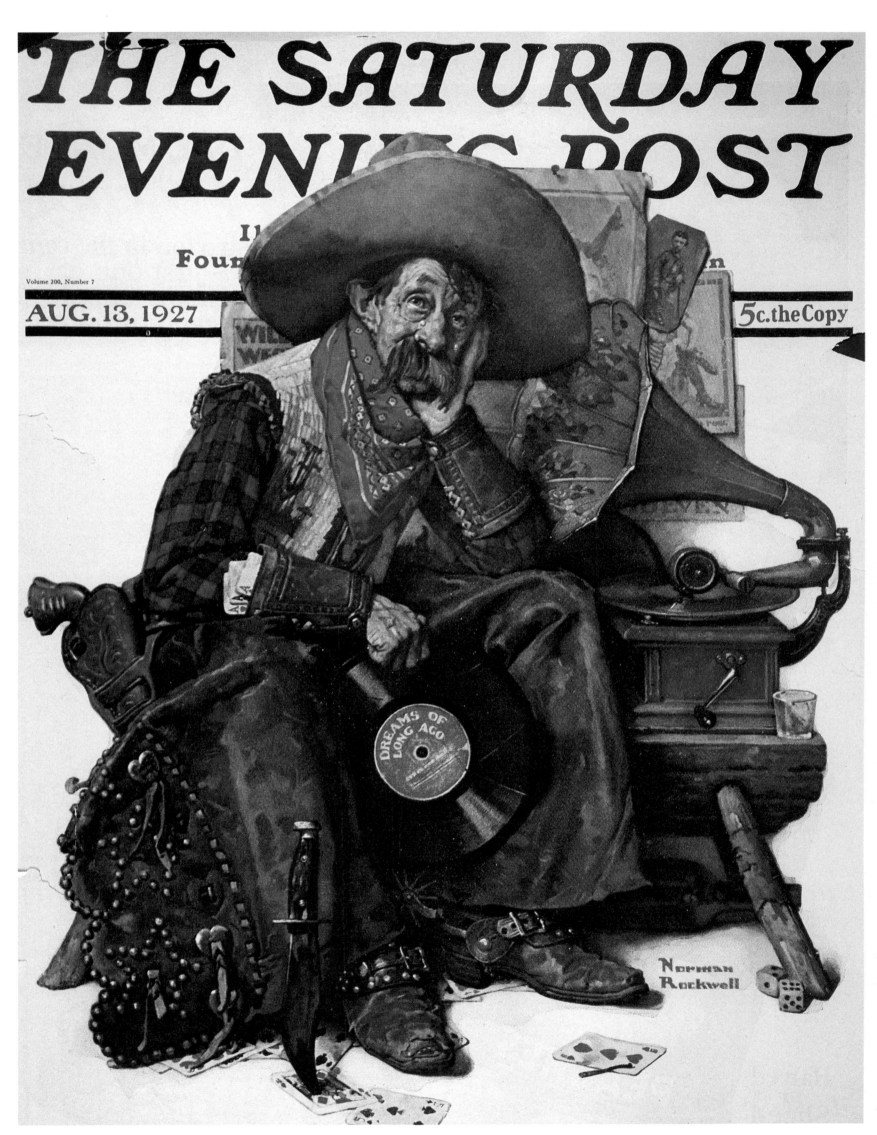

Dreams of Long Ago. Post *cover, 1927.*

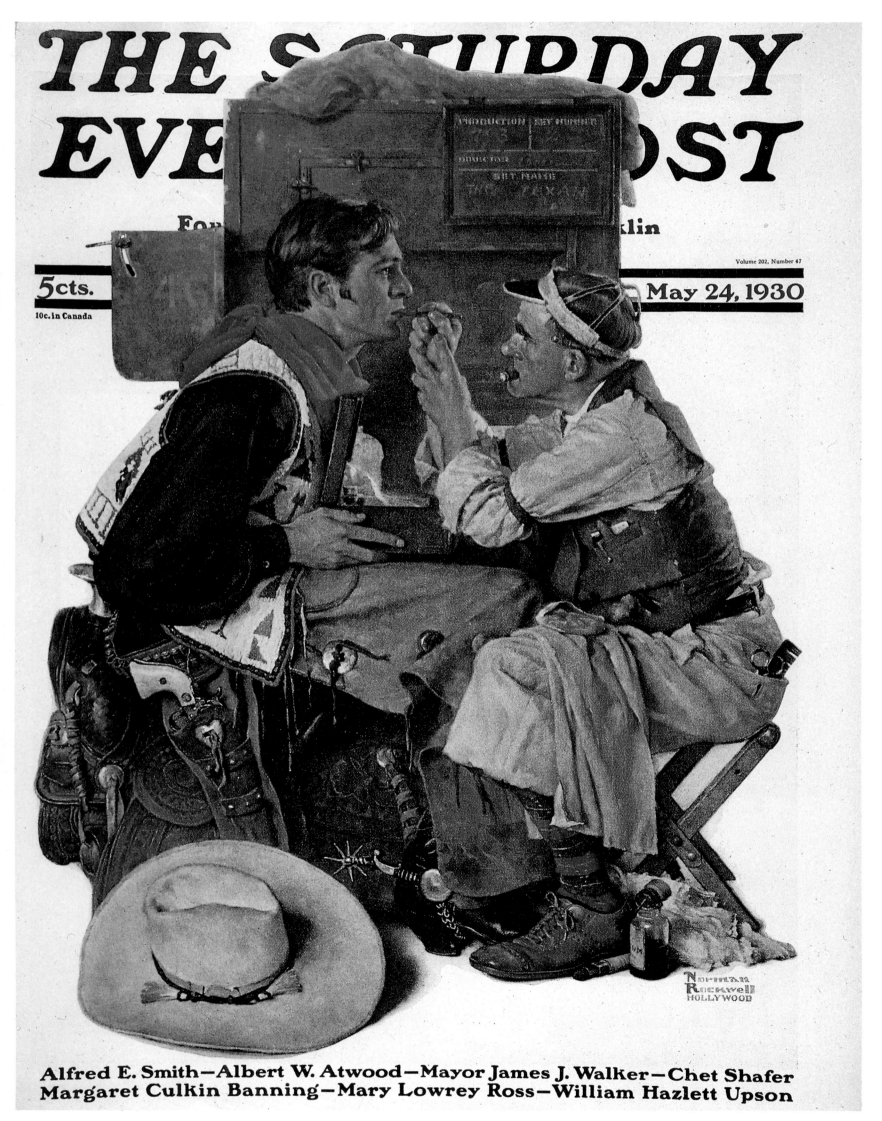

Gary Cooper. Post *cover, 1930.*

He Tipped her Head. American Magazine *illustration, 1945.*

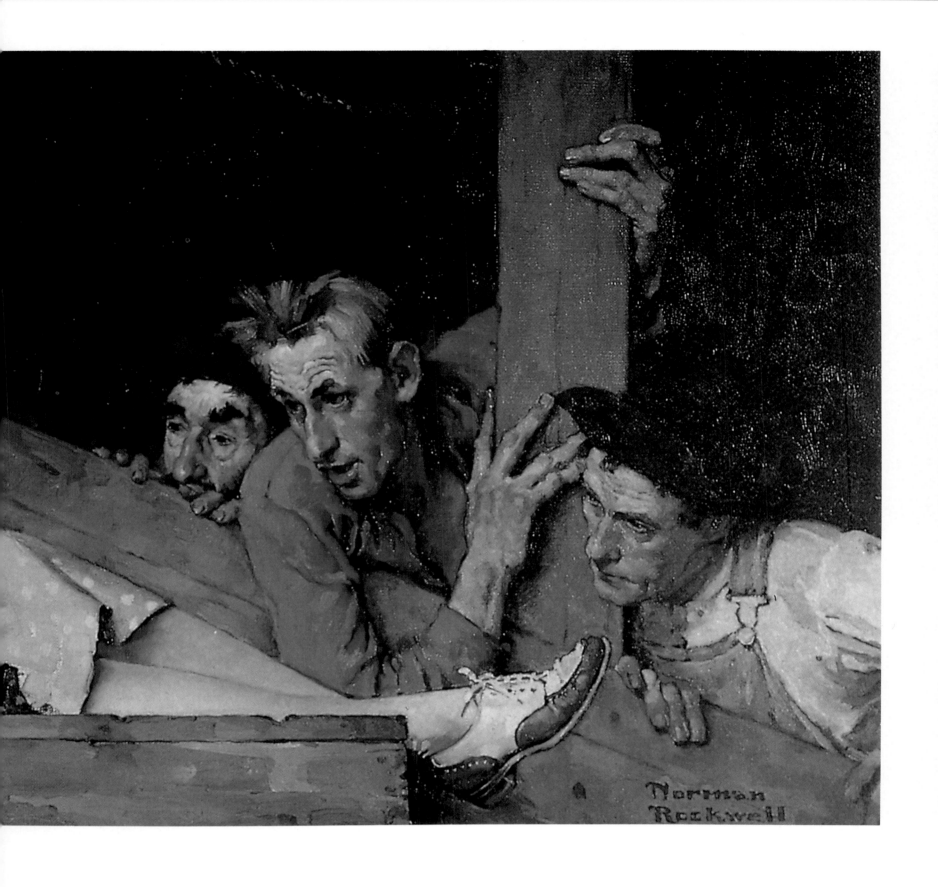

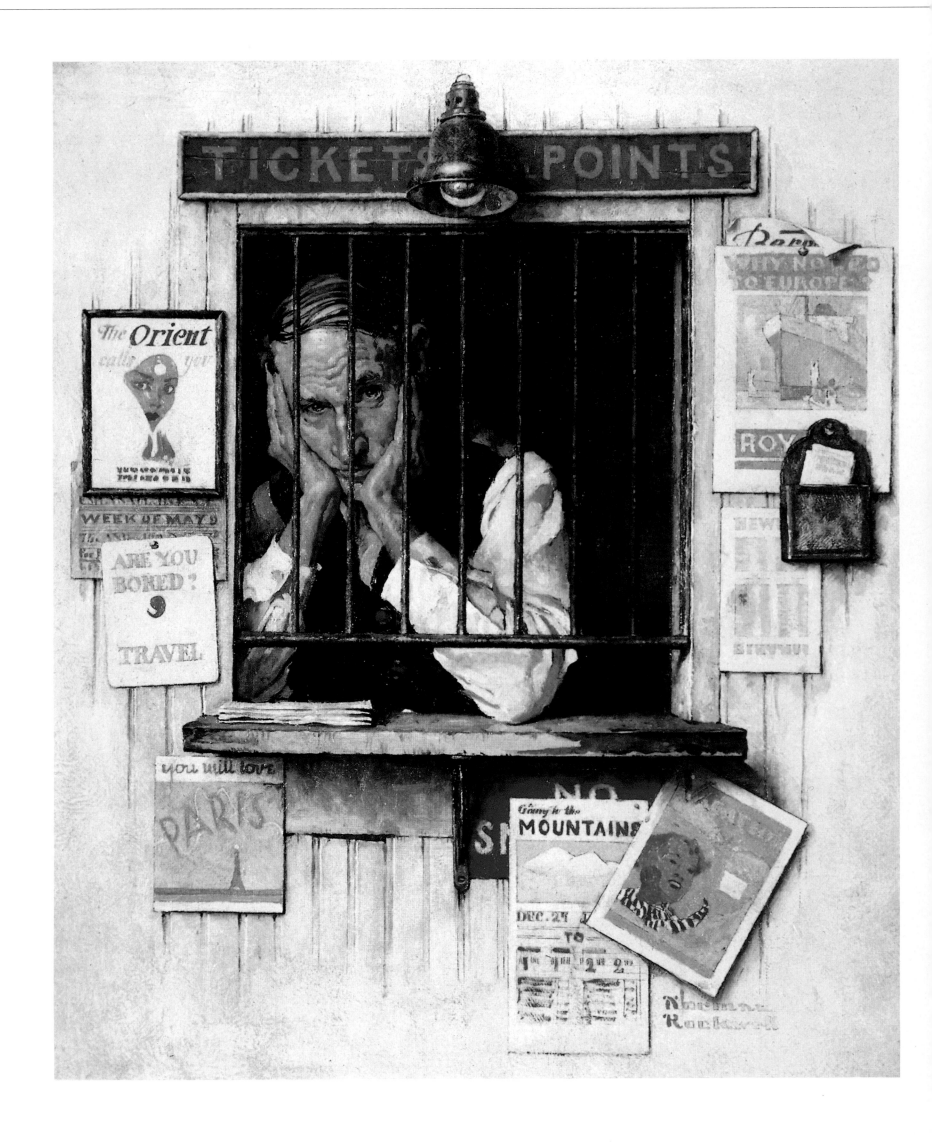

The Ticket Agent. Post *cover, 1937.*

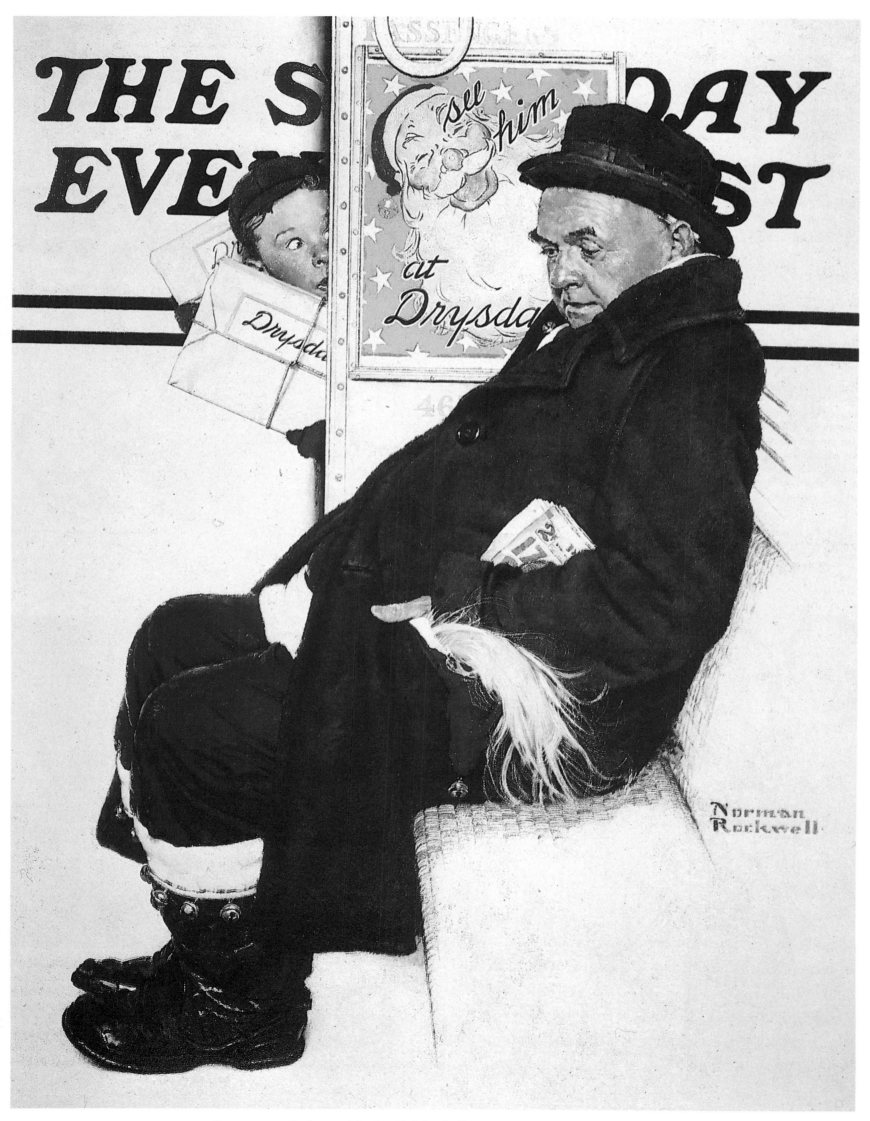

Santa on a Subway Train. *Original oil painting for a* Post *cover, 1940.*

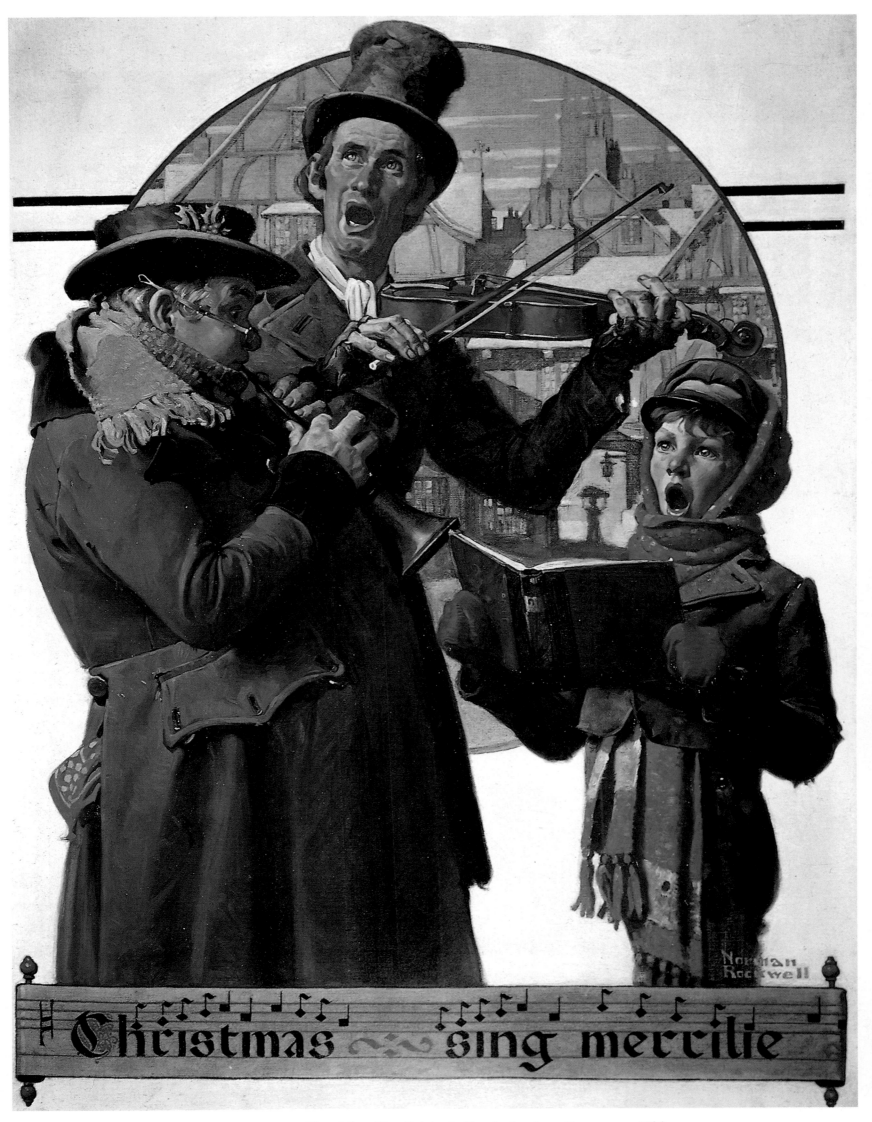

Christmas . . . Sing Merrilie. *Original oil painting for a* Post *cover, 1923.*

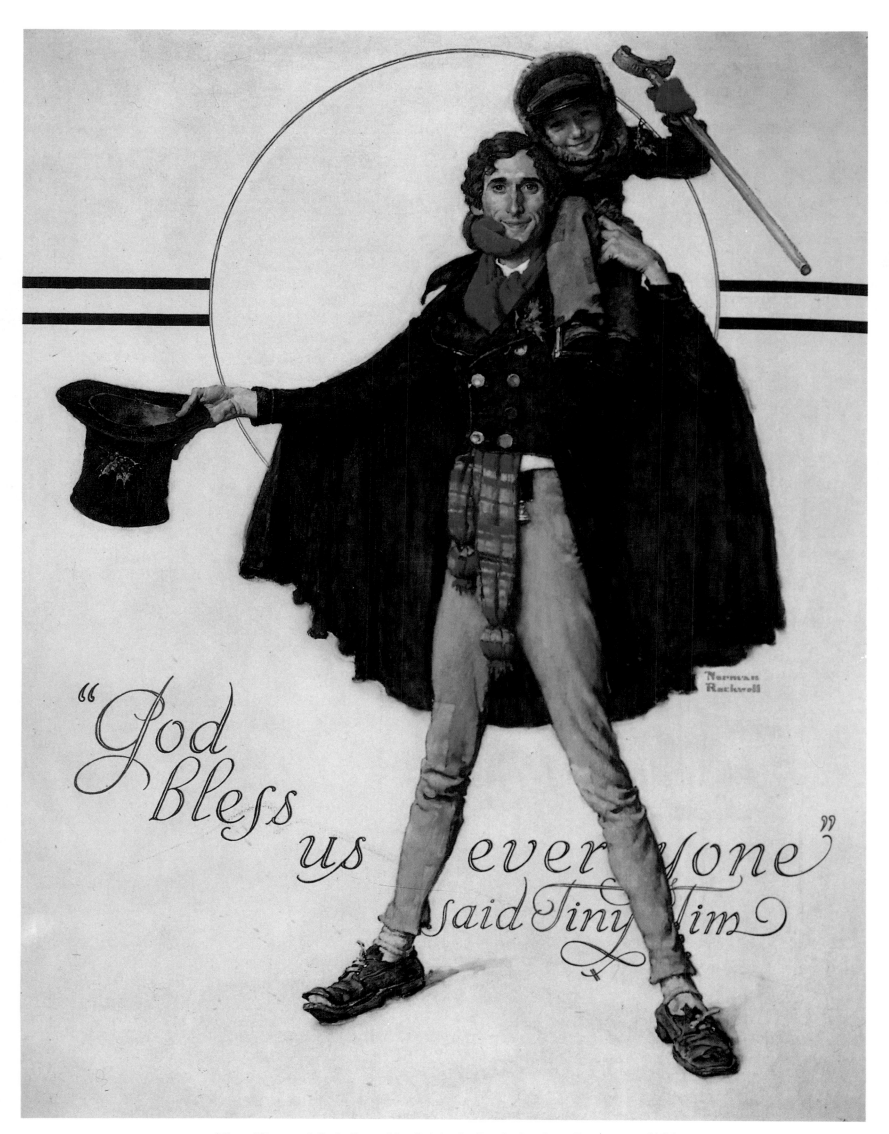

Tiny Tim and Bob Cratchit. *Original oil painting for a* Post *cover, 1934.*

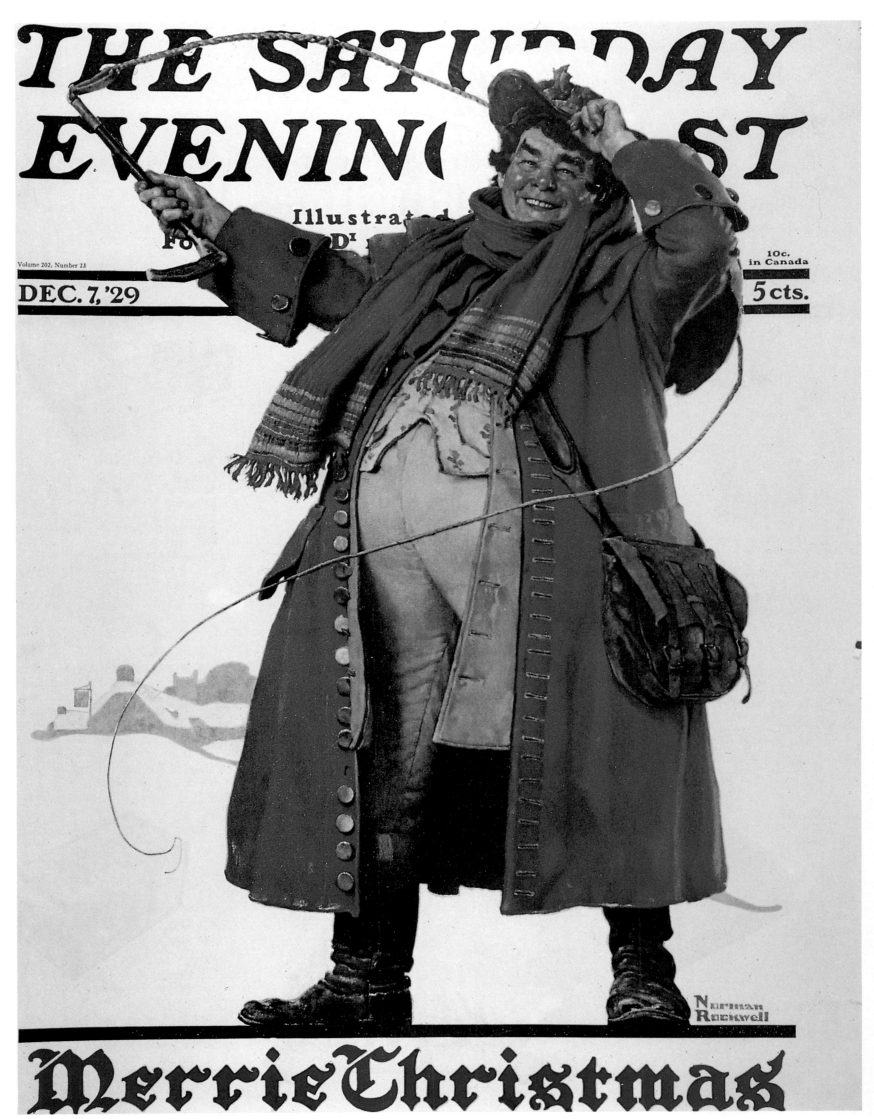

Merrie Christmas. Post *cover, 1929.*

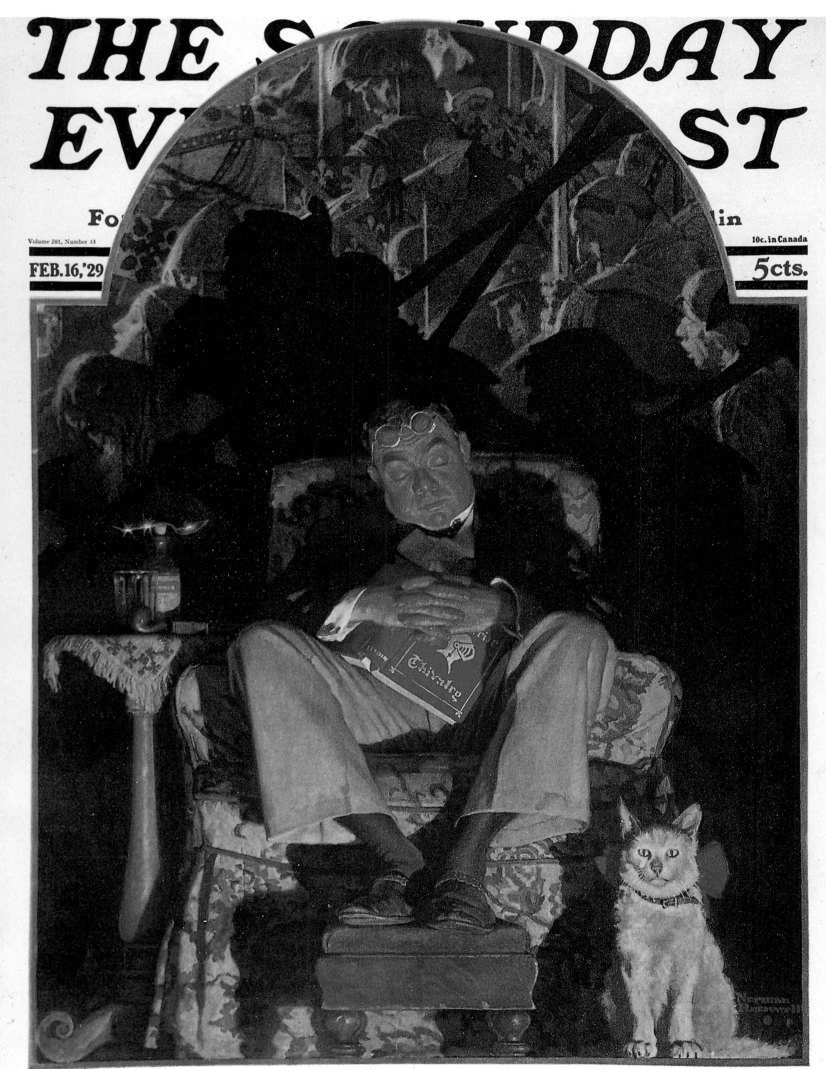

Dreams of Chivalry. Post *cover, 1929.*

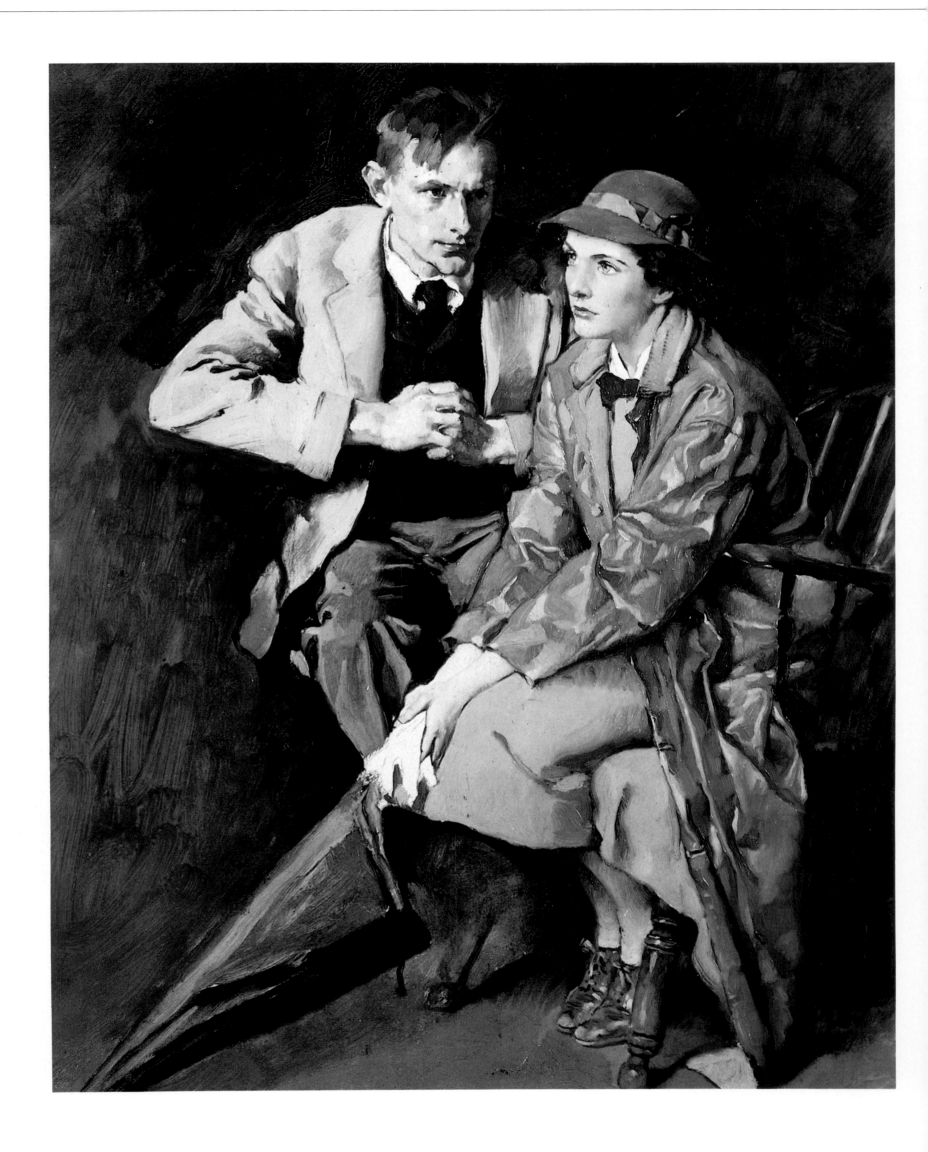

Seated Couple. American Magazine *illustration, undated.*

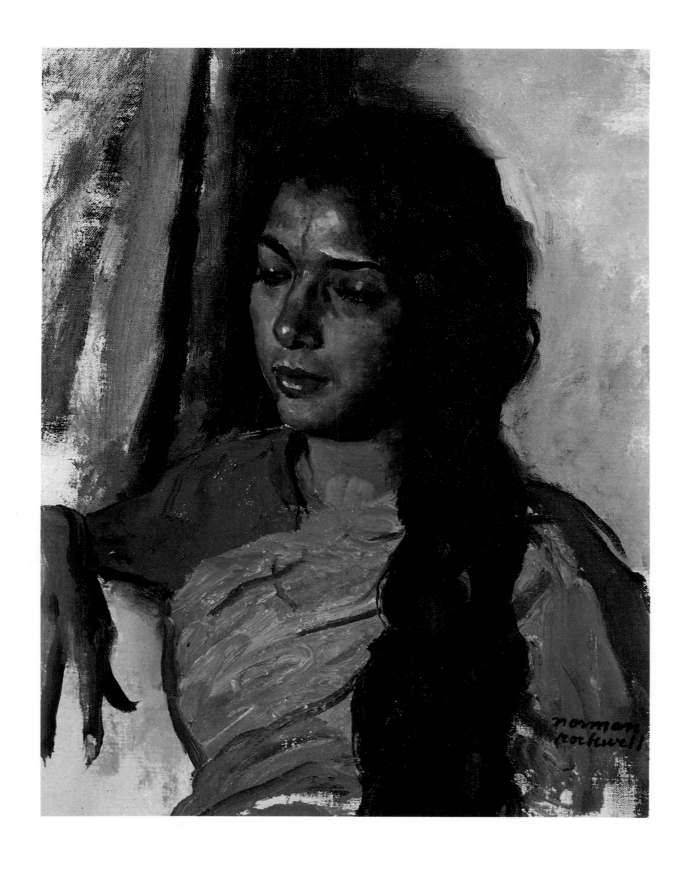

An Indian Art Student. American Artist *illustration, 1964.*
(Original portrait painted 1962.)

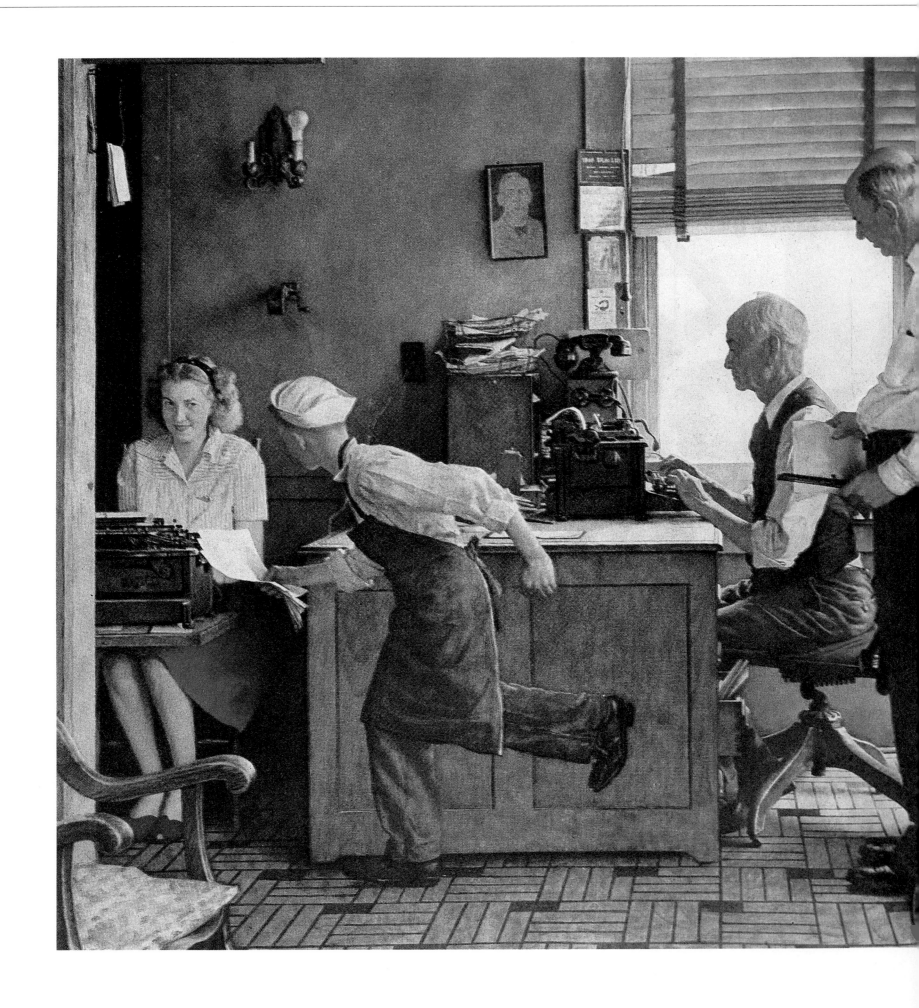

Norman Rockwell Visits a Country Editor. Post *illustration, 1946.*

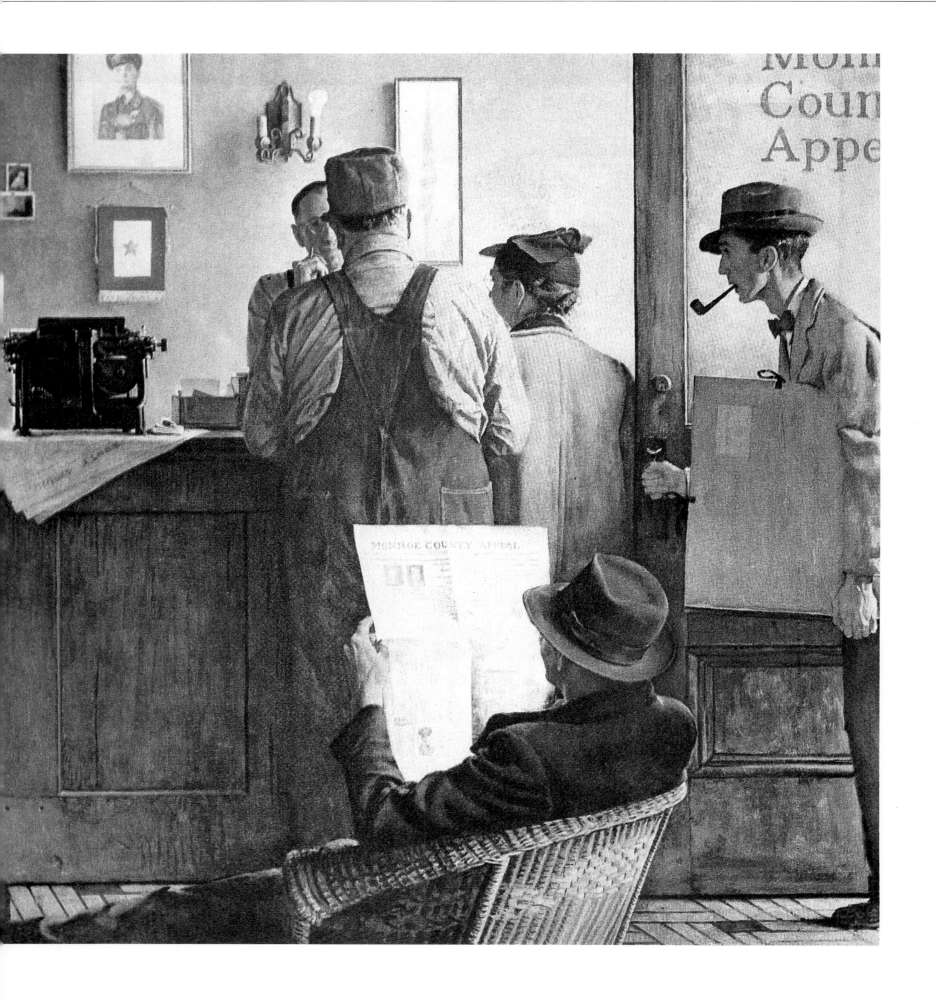

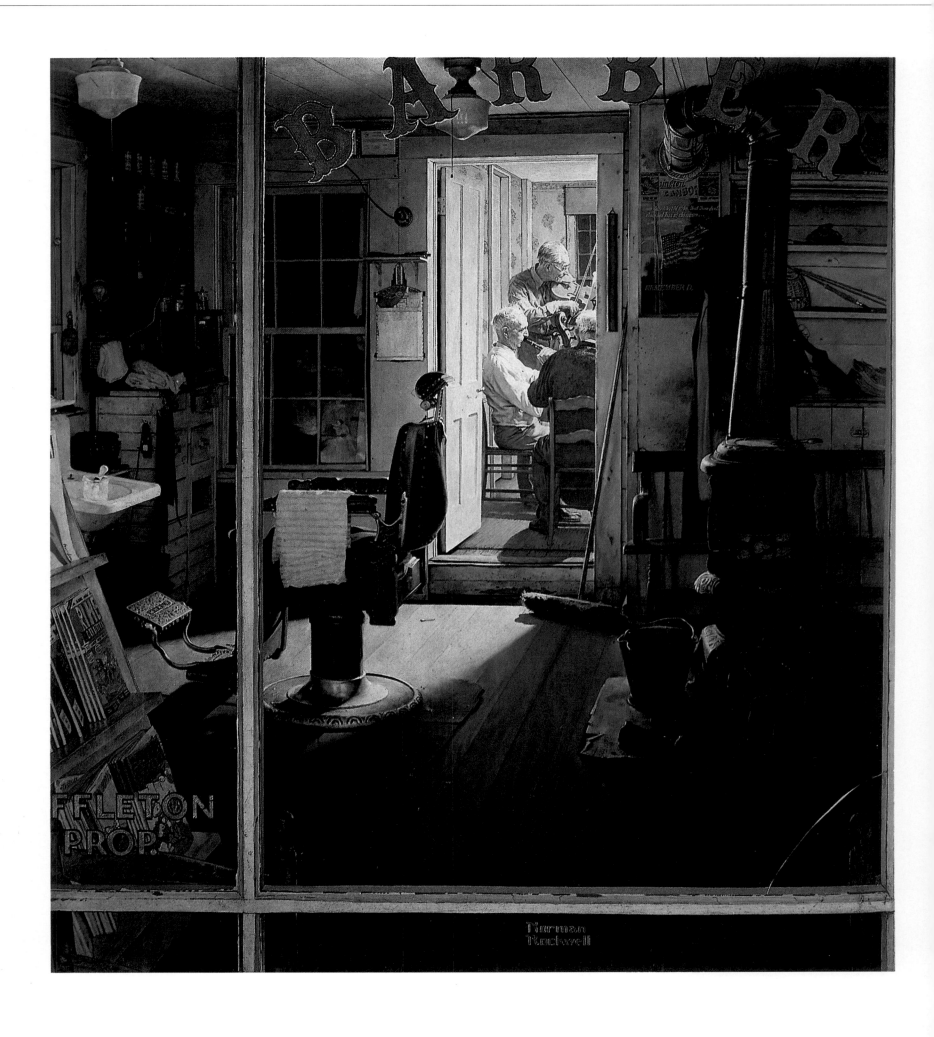

Shuffleton's Barber Shop. *Original oil painting for a* Post *cover, 1950.*

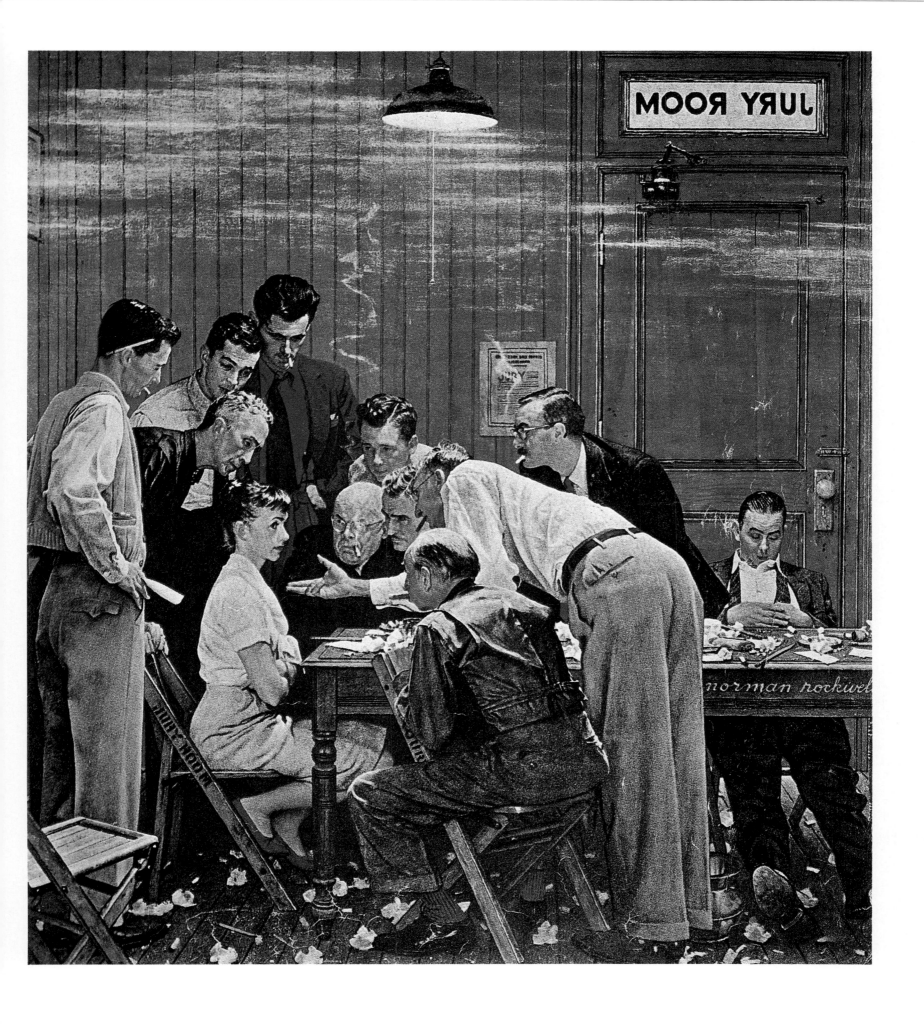

The Jury. Post *cover, 1959.*

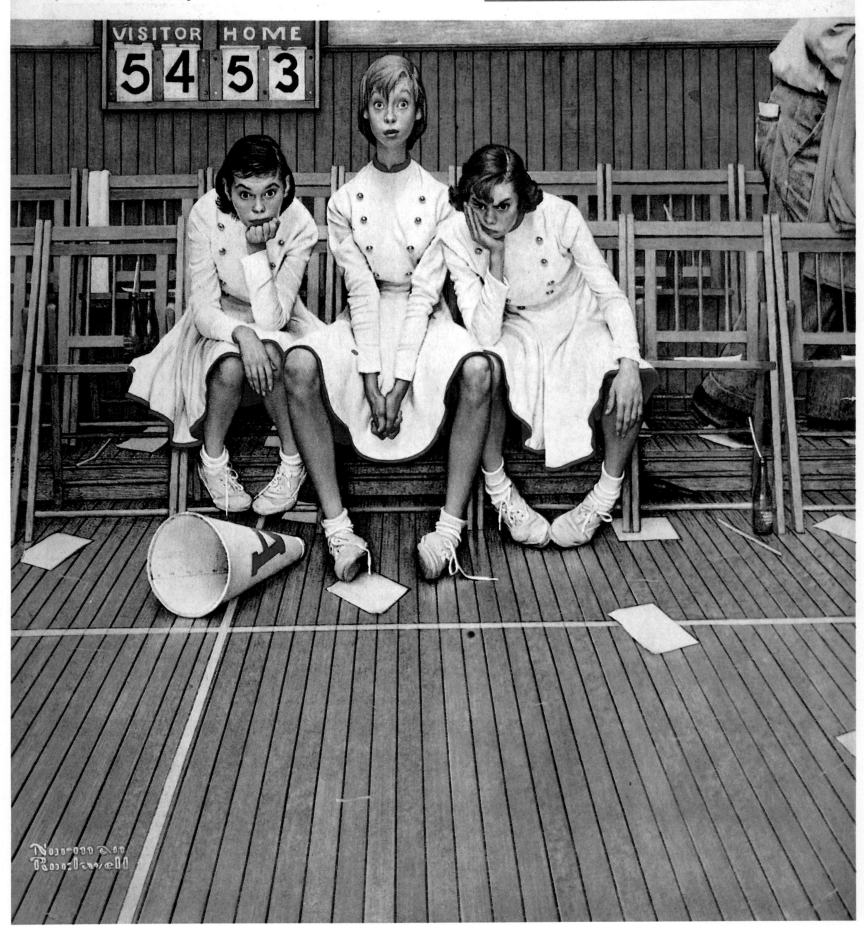

Losing the Game. Post *cover, 1952.*

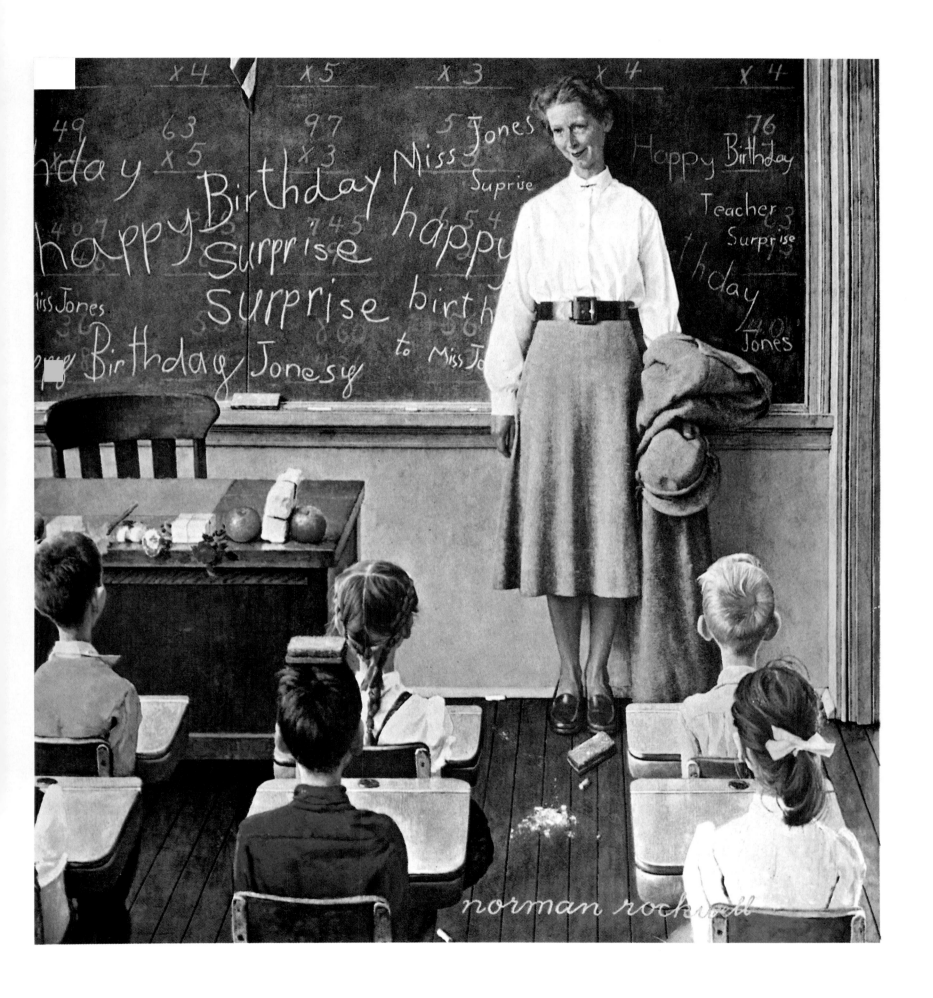

Teacher's Birthday. Post *cover, 1956.*

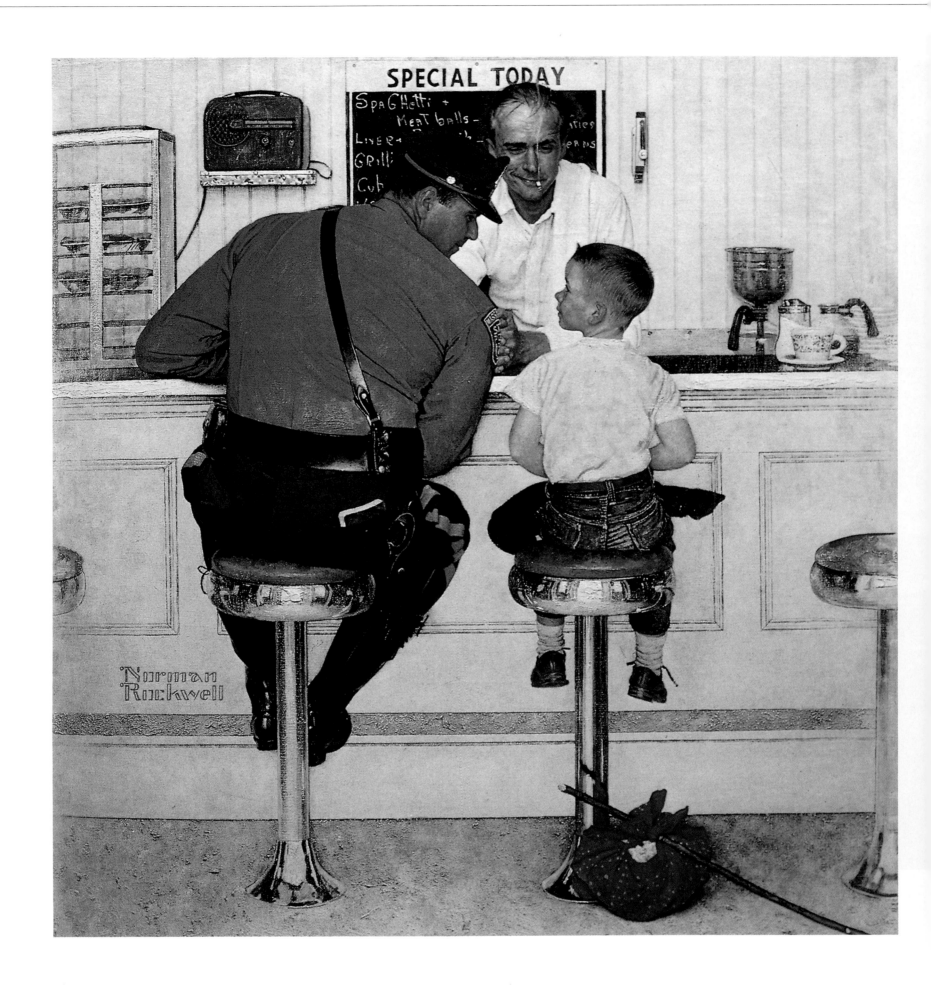

The Runaway. *Original oil painting for a* Post *cover, 1958.*

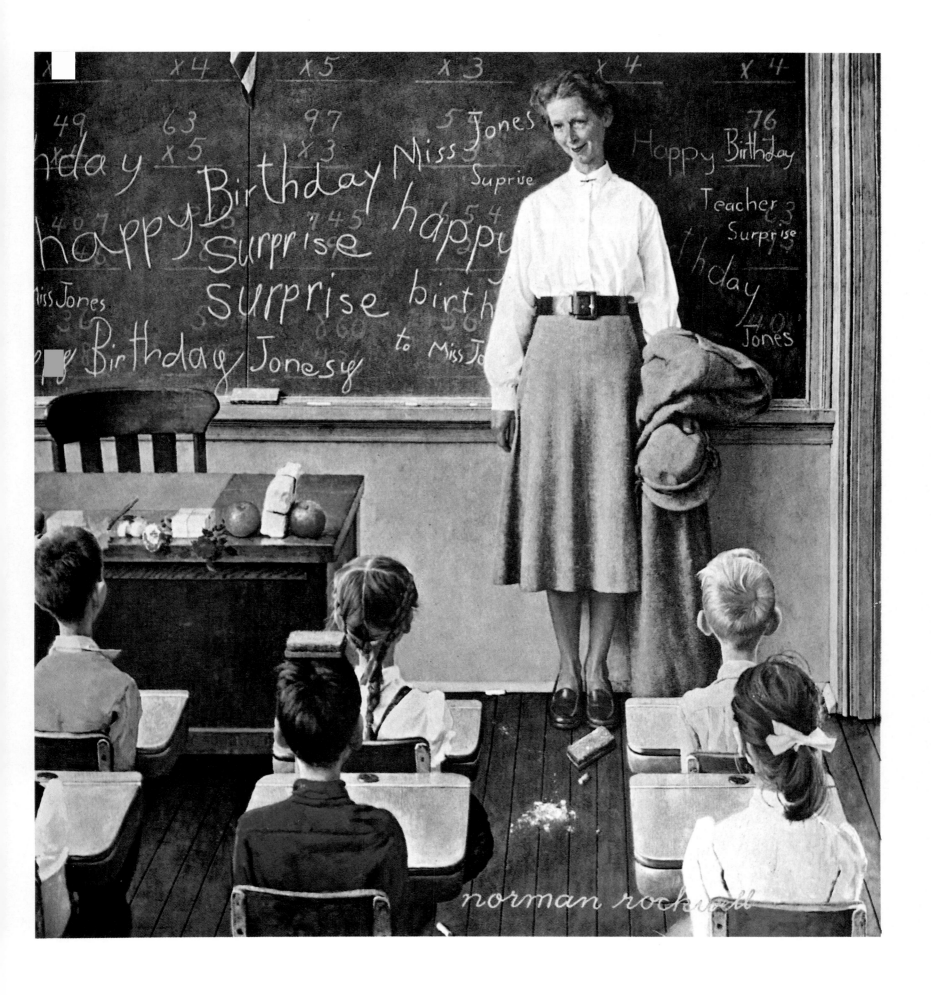

Teacher's Birthday. Post *cover, 1956.*

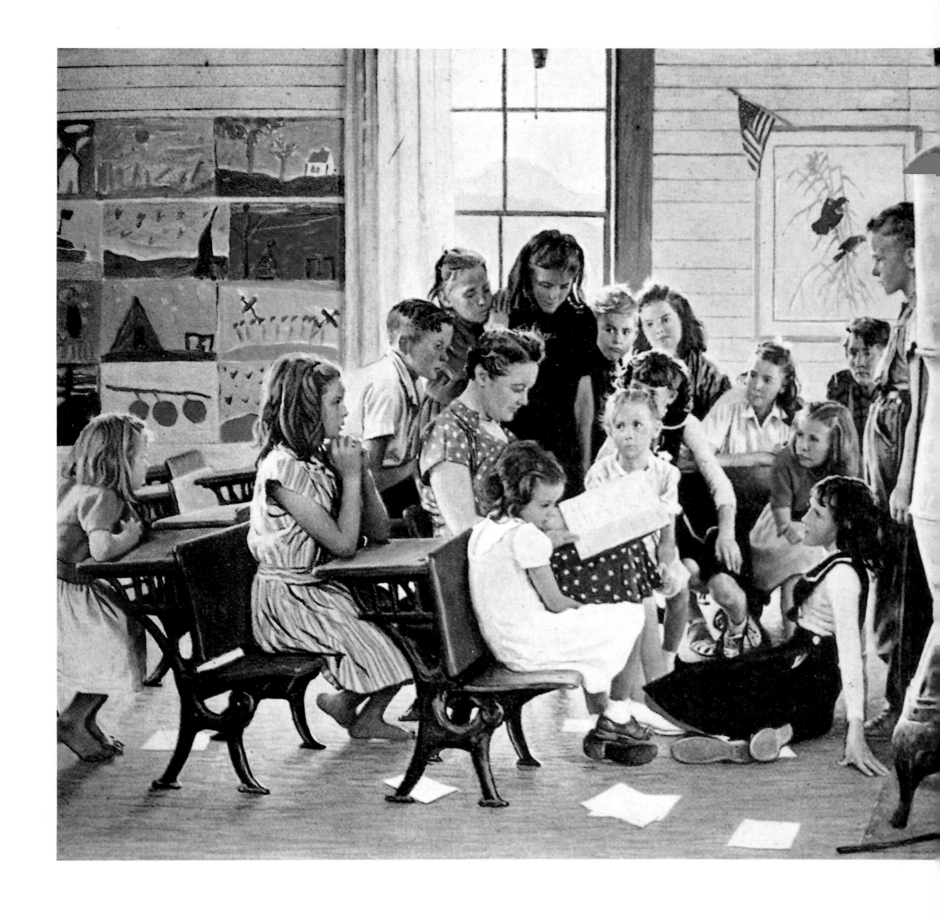

Norman Rockwell Visits a Country School. Post *illustration, 1946.*

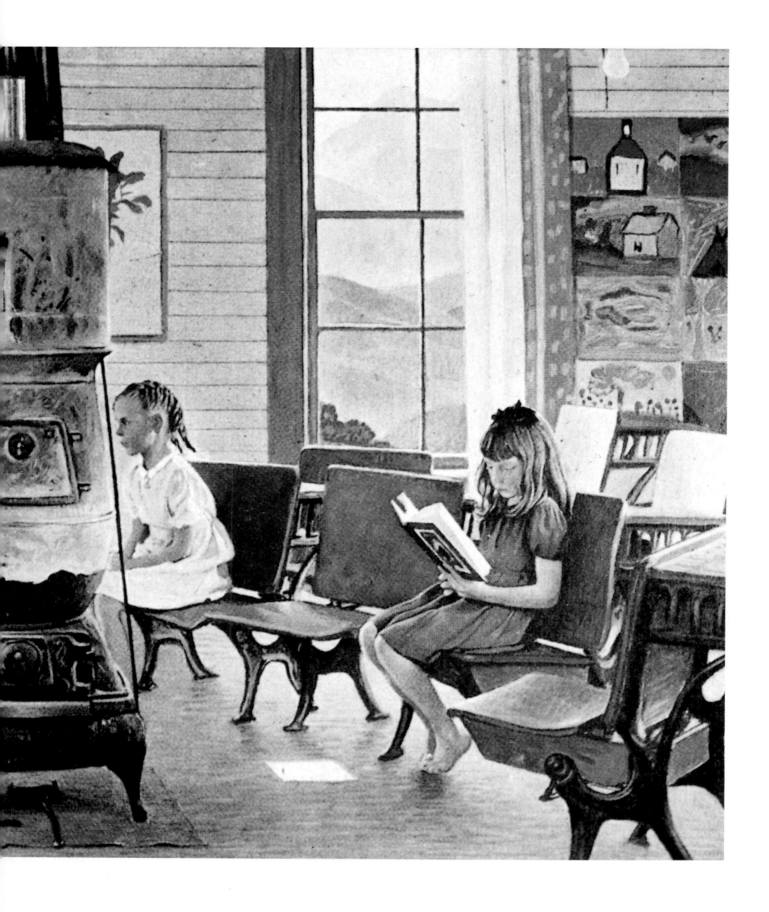

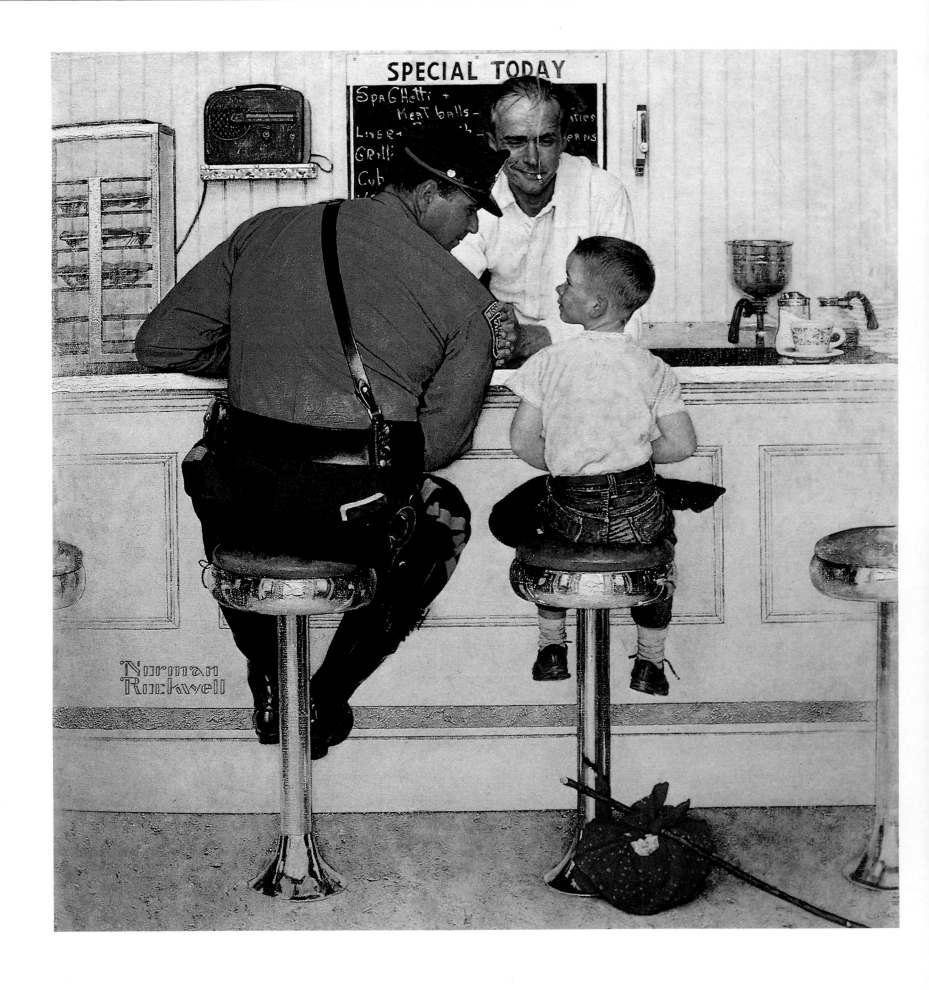

The Runaway. *Original oil painting for a* Post *cover, 1958.*

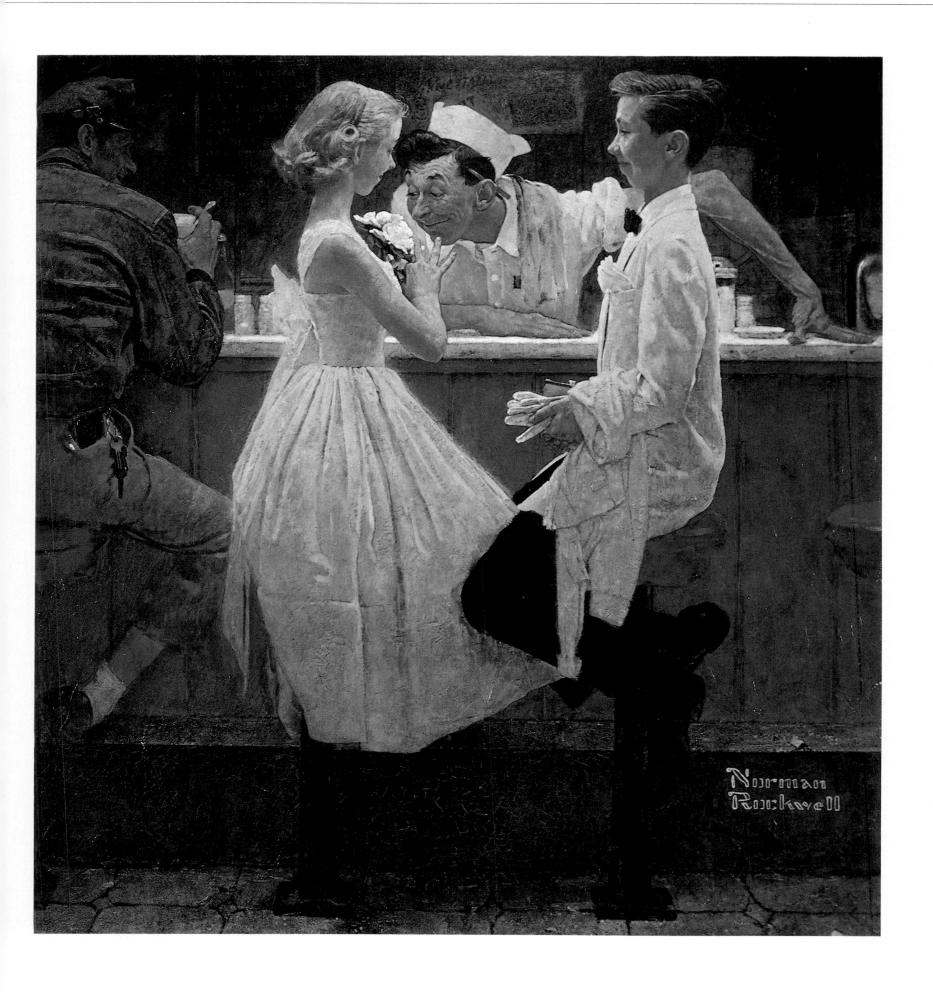

After the Prom. *Original oil painting for a* Post *cover, 1957.*

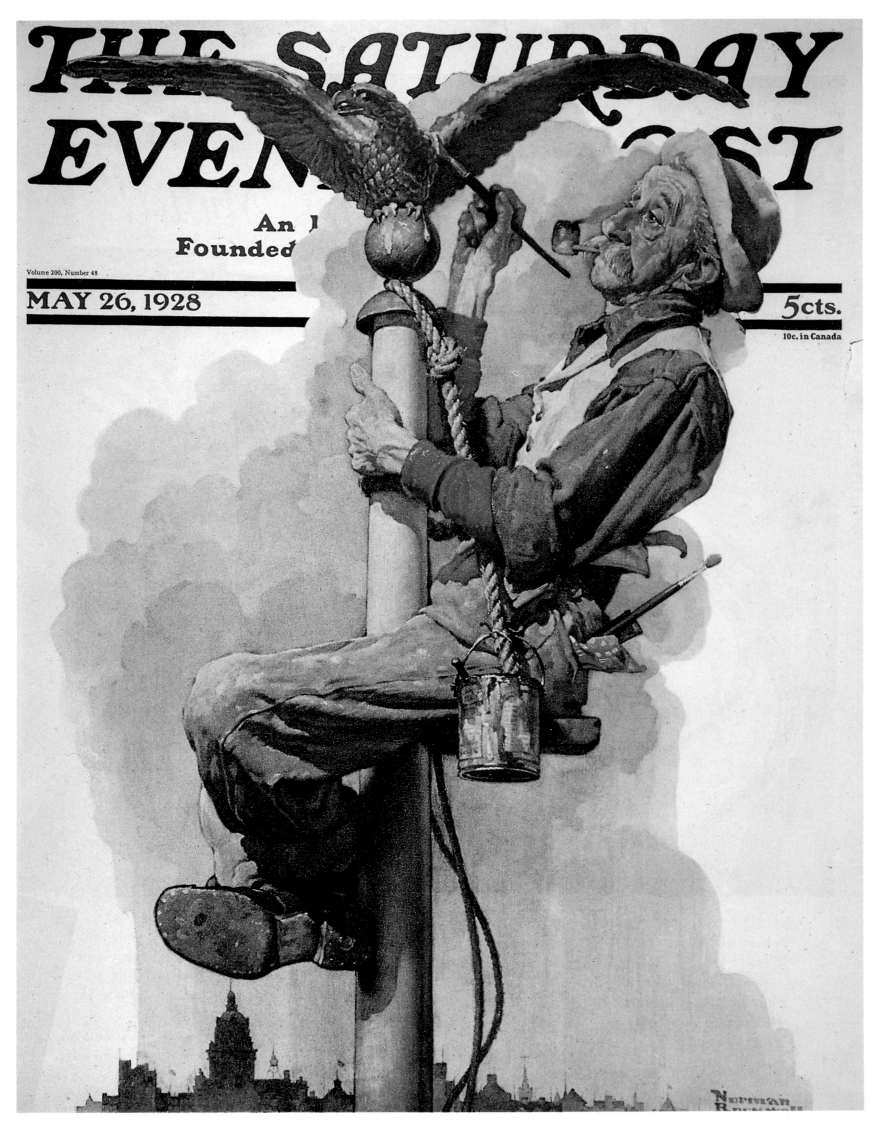

Man Painting Flagpole. Post *cover, 1928.*

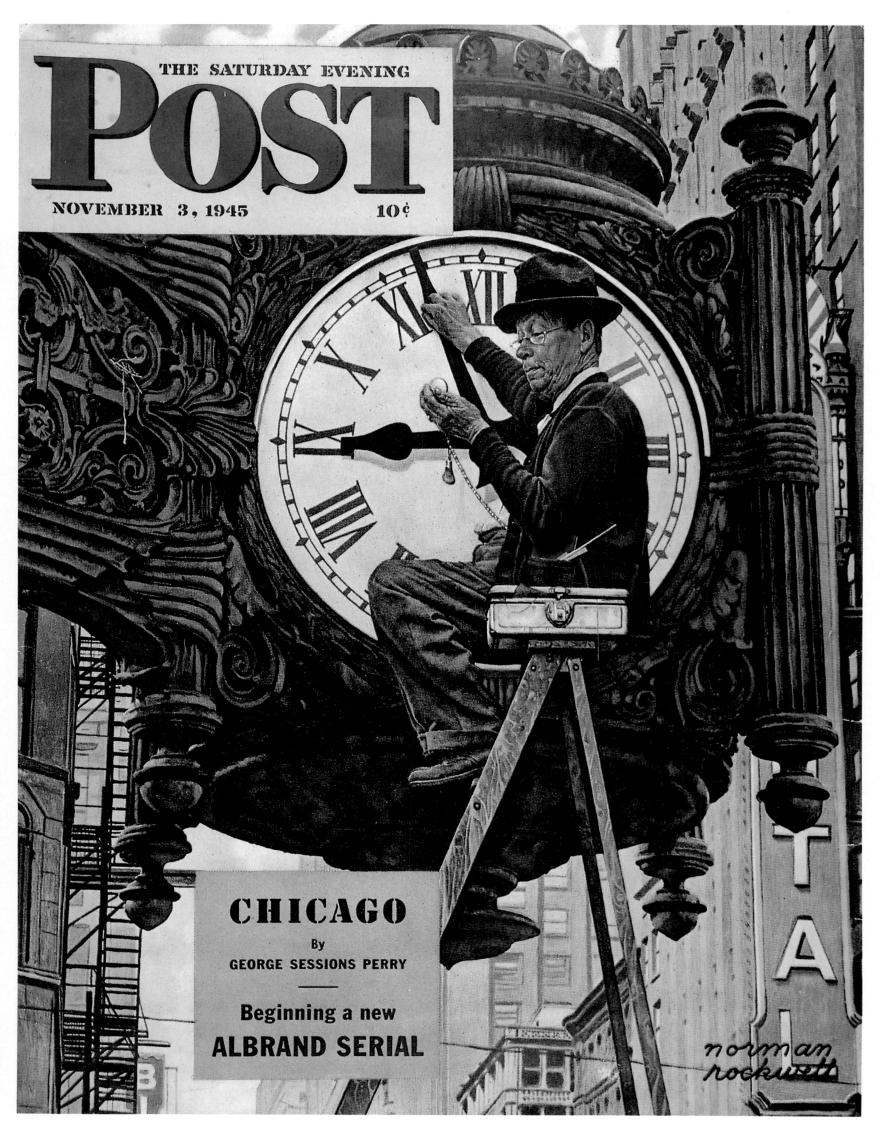

Clock Repairman. Post *cover, 1945.*

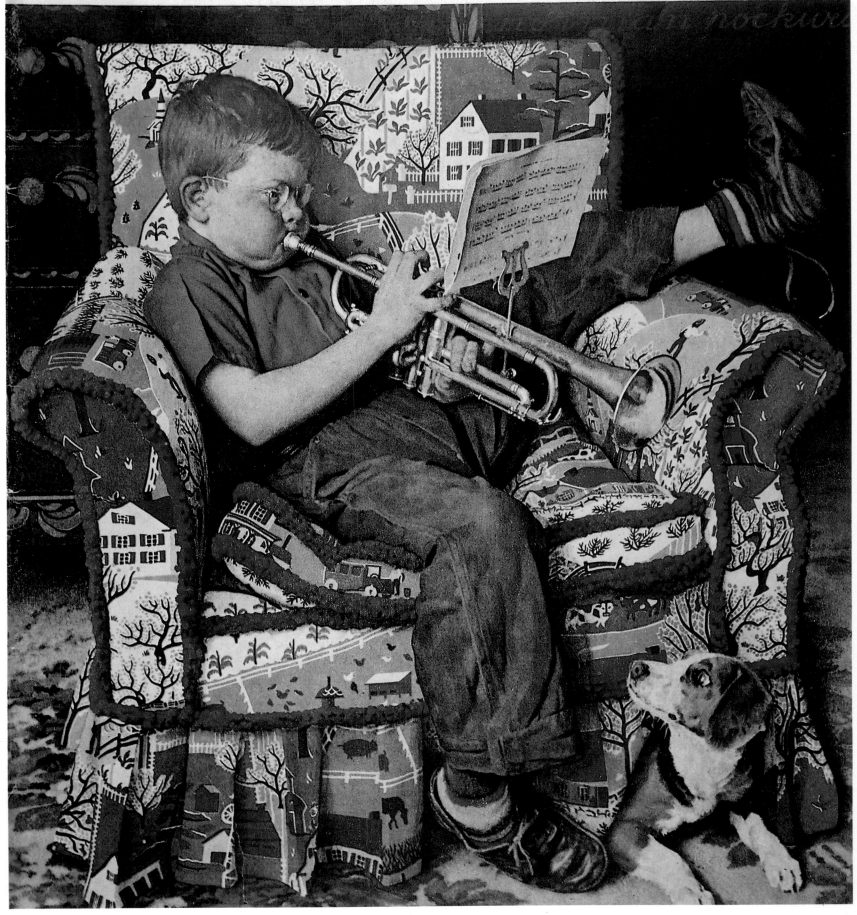

Trumpeter. Post *cover, 1950.*

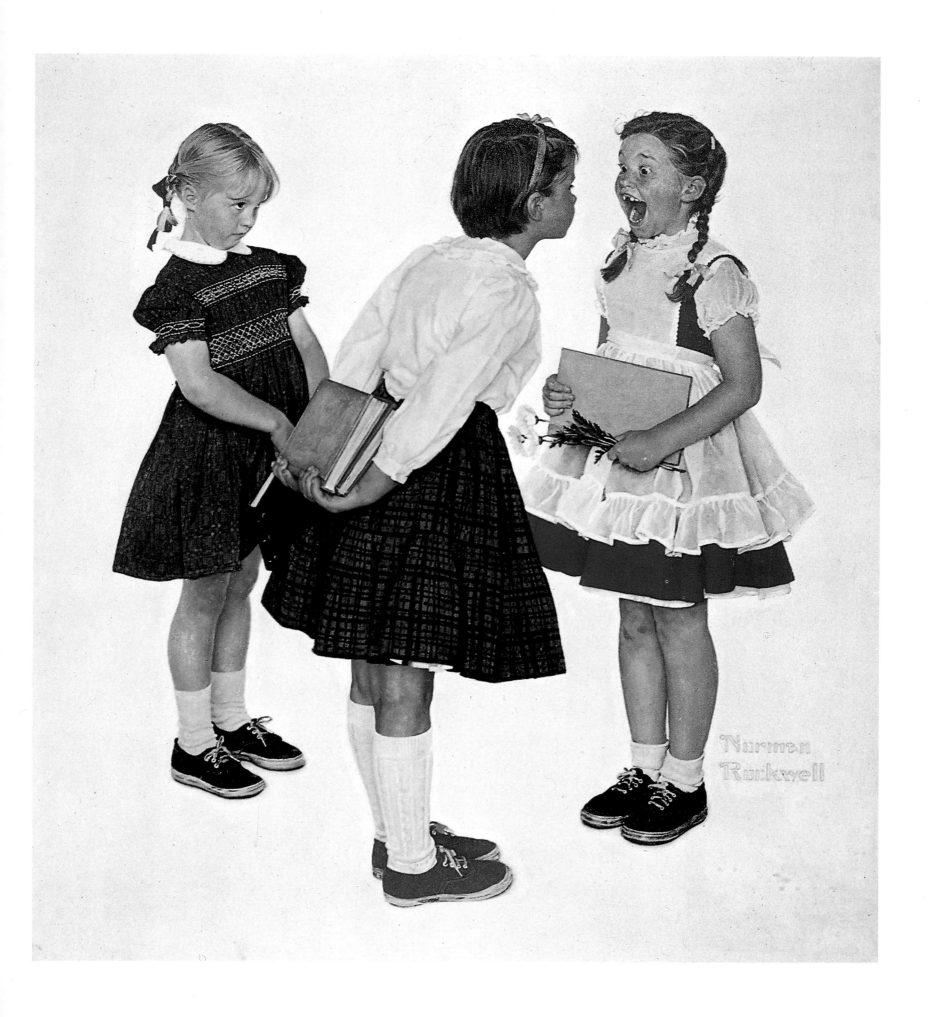

Checkup. Post *cover, 1957.*

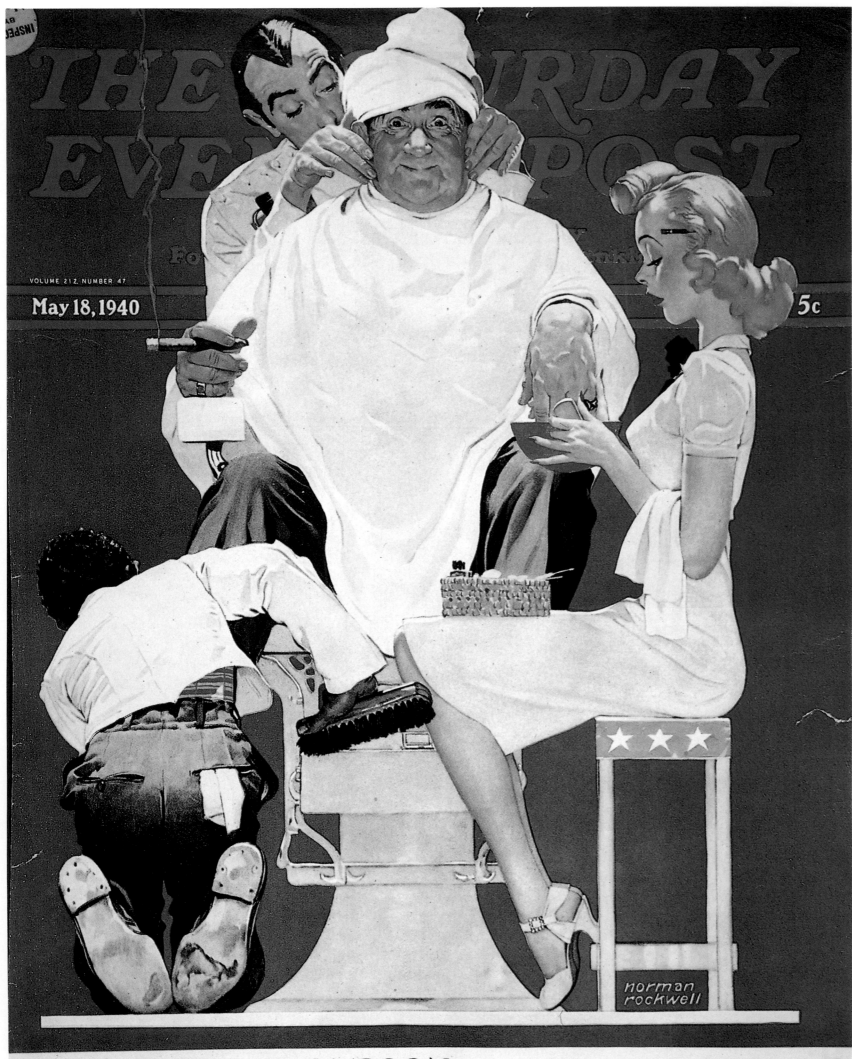

The Full Treatment. Post *cover, 1940.*

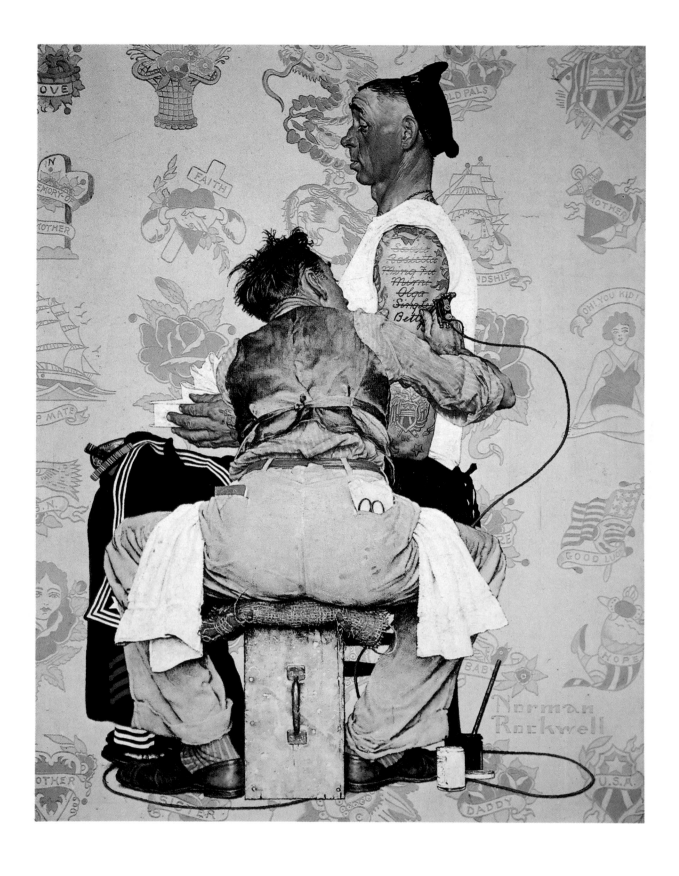

The Tattooist. *Original oil painting for a* Post *cover, 1944.*

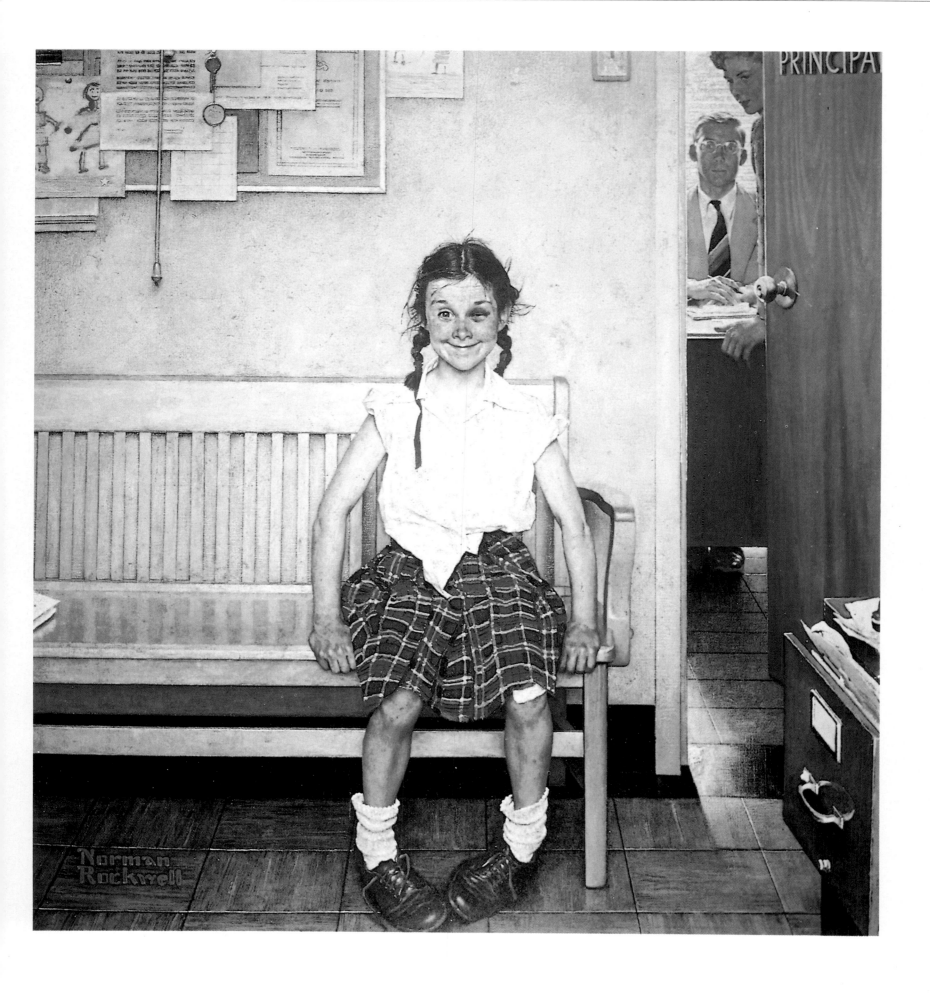

Outside the Principal's Office. *Original oil painting for a* Post *cover, 1953.*

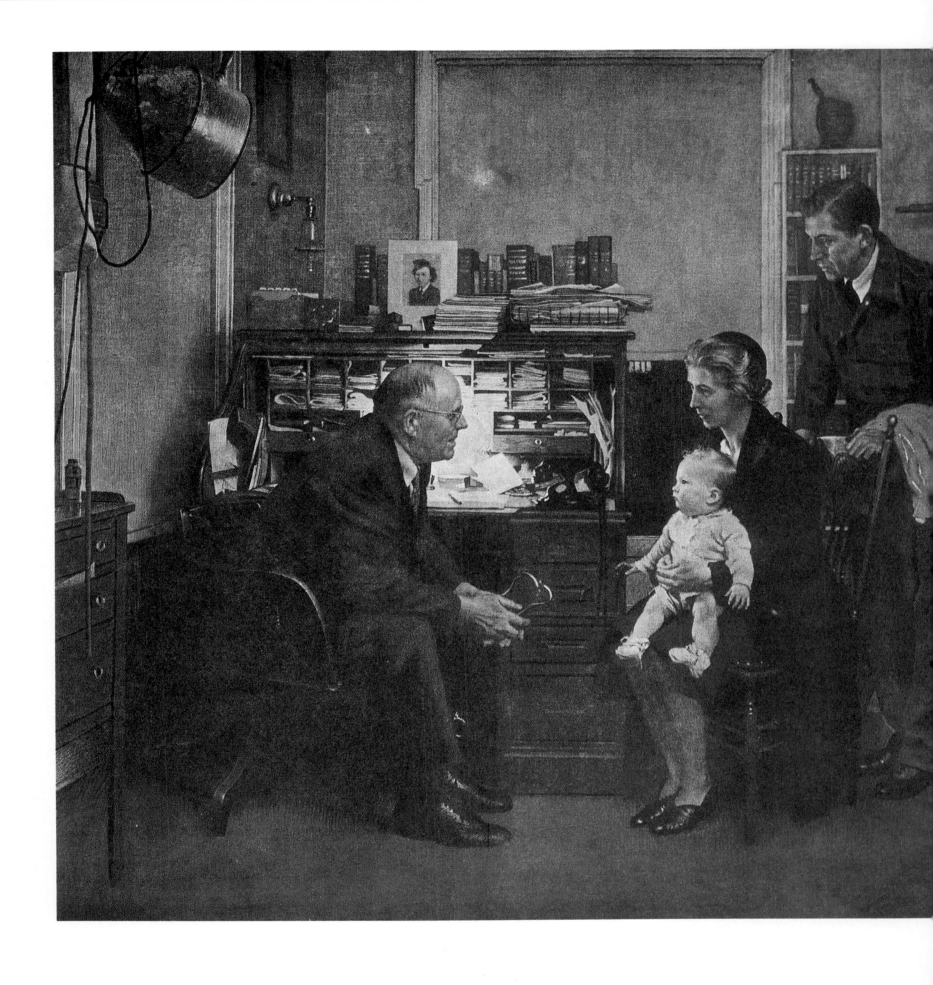

Norman Rockwell Visits his Country Doctor. Post *illustration, 1947.*

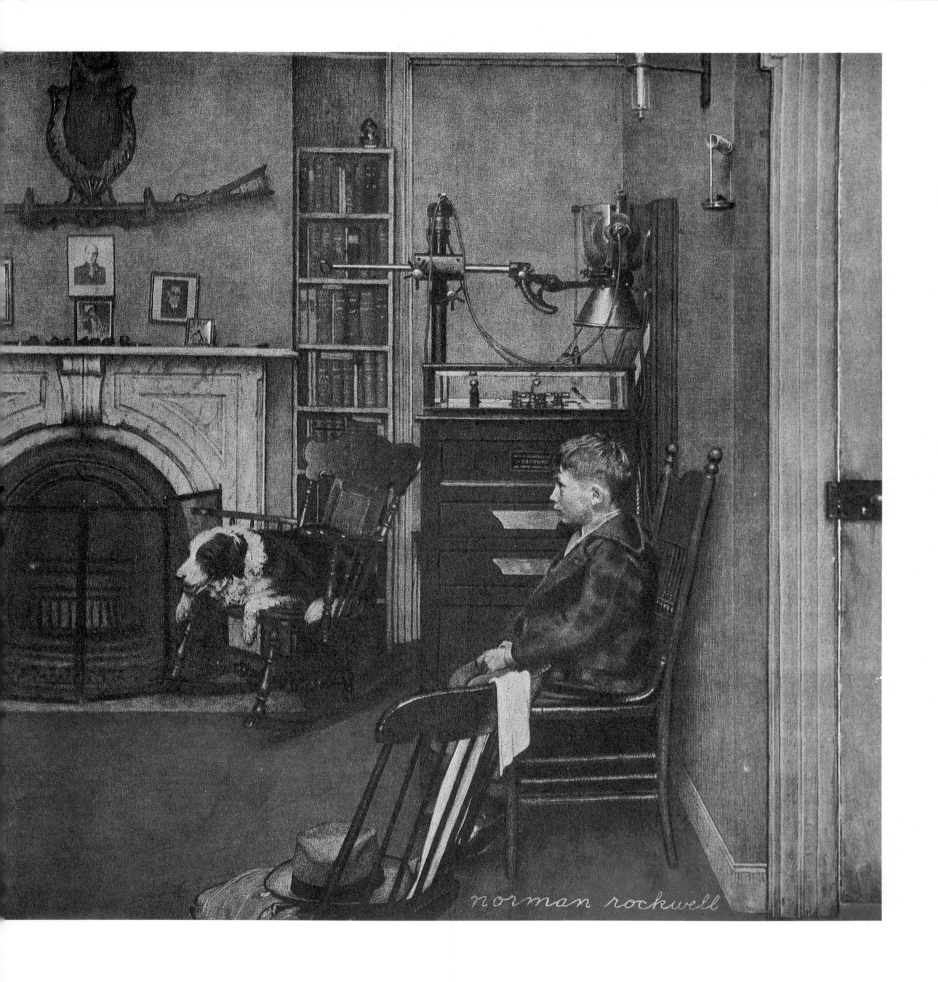

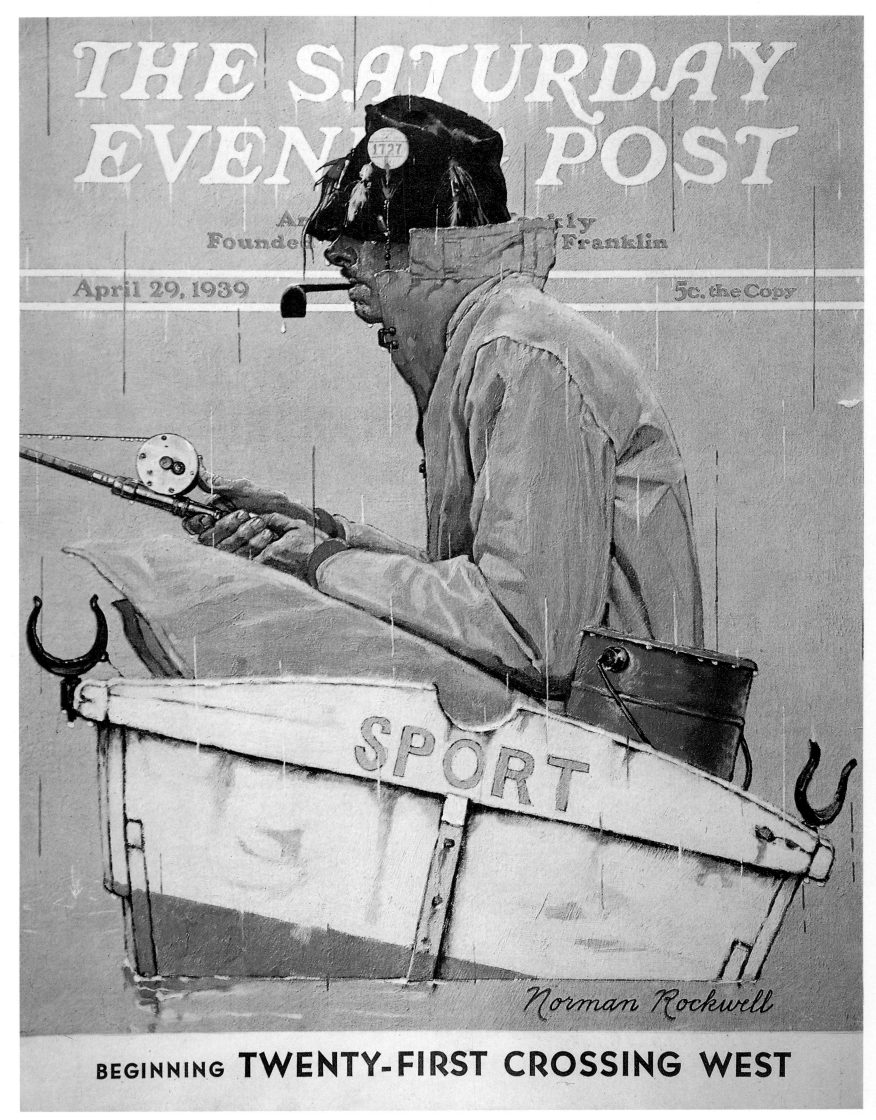

Sport. Post cover, 1939.

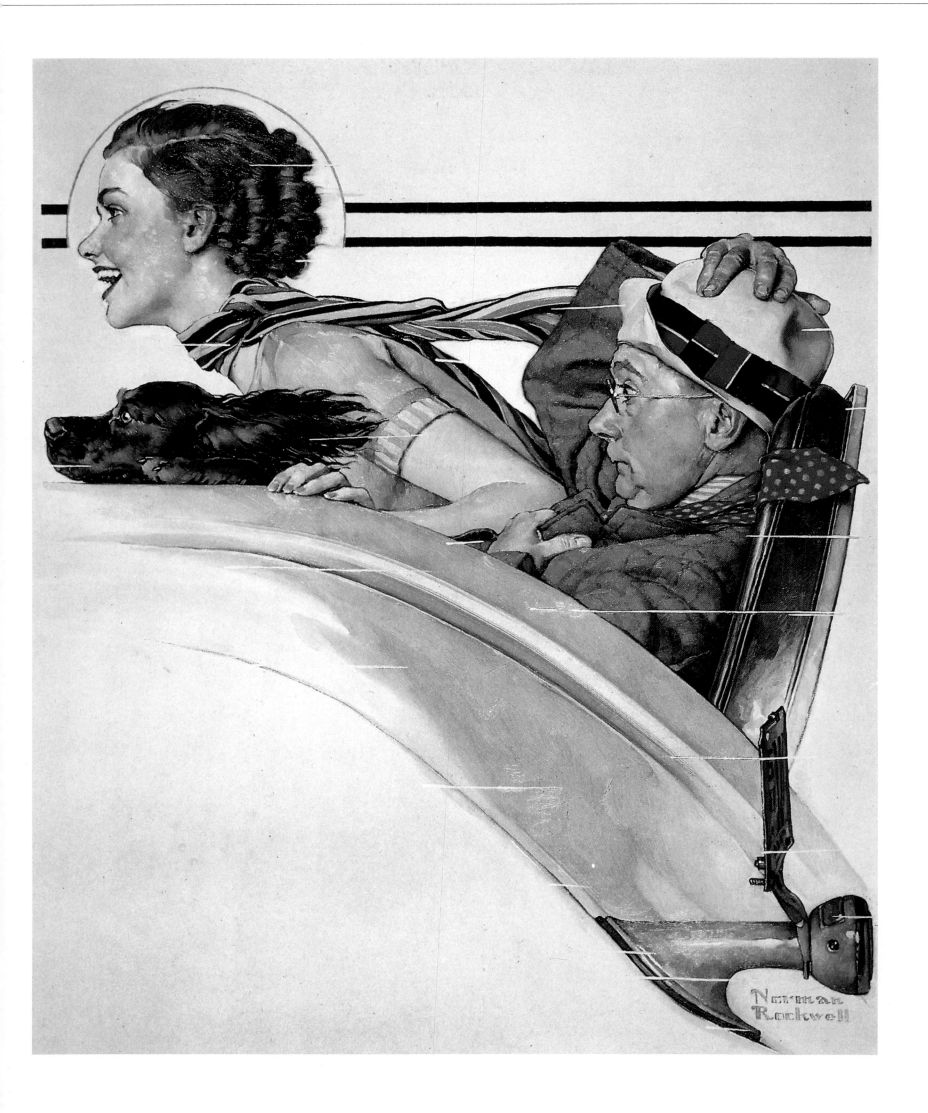

Couple in Rumbleseat. *Original oil painting for a* Post *cover, 1935.*

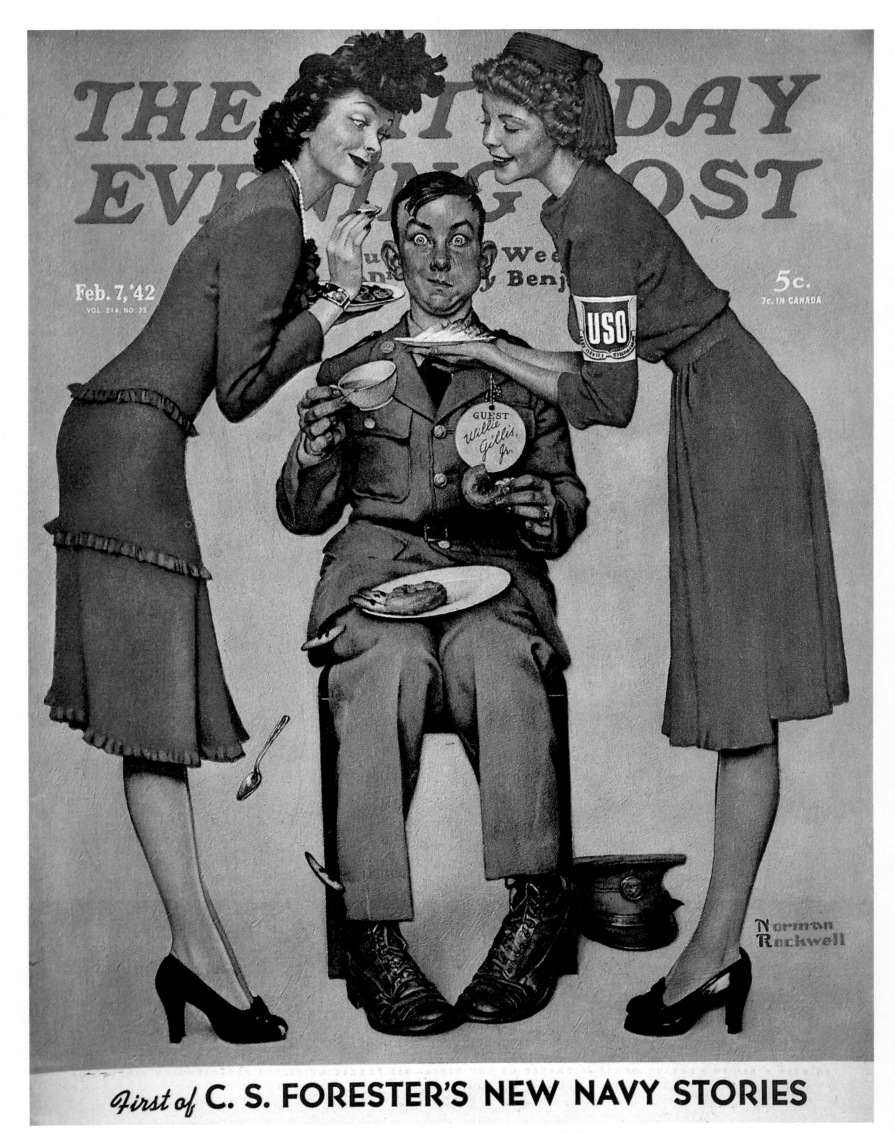

Willie Gillis at the USO. Post *cover, 1942.*

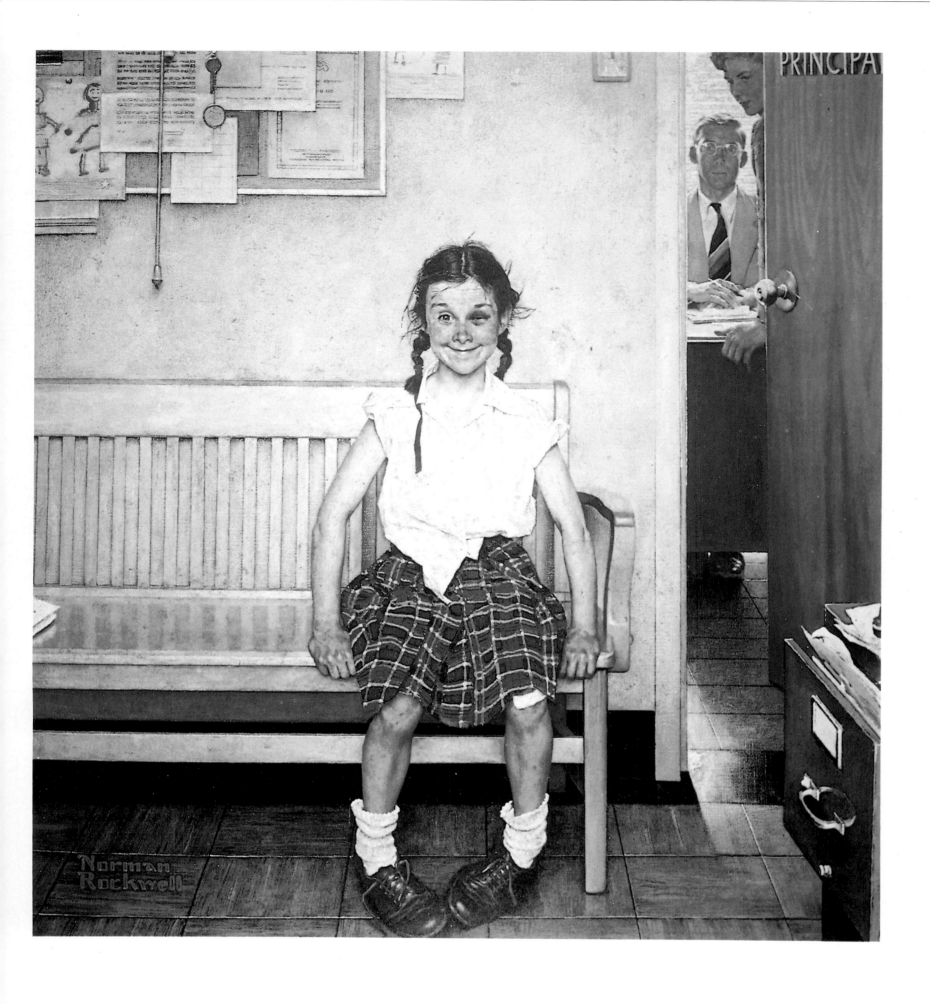

Outside the Principal's Office. *Original oil painting for a* Post *cover, 1953.*

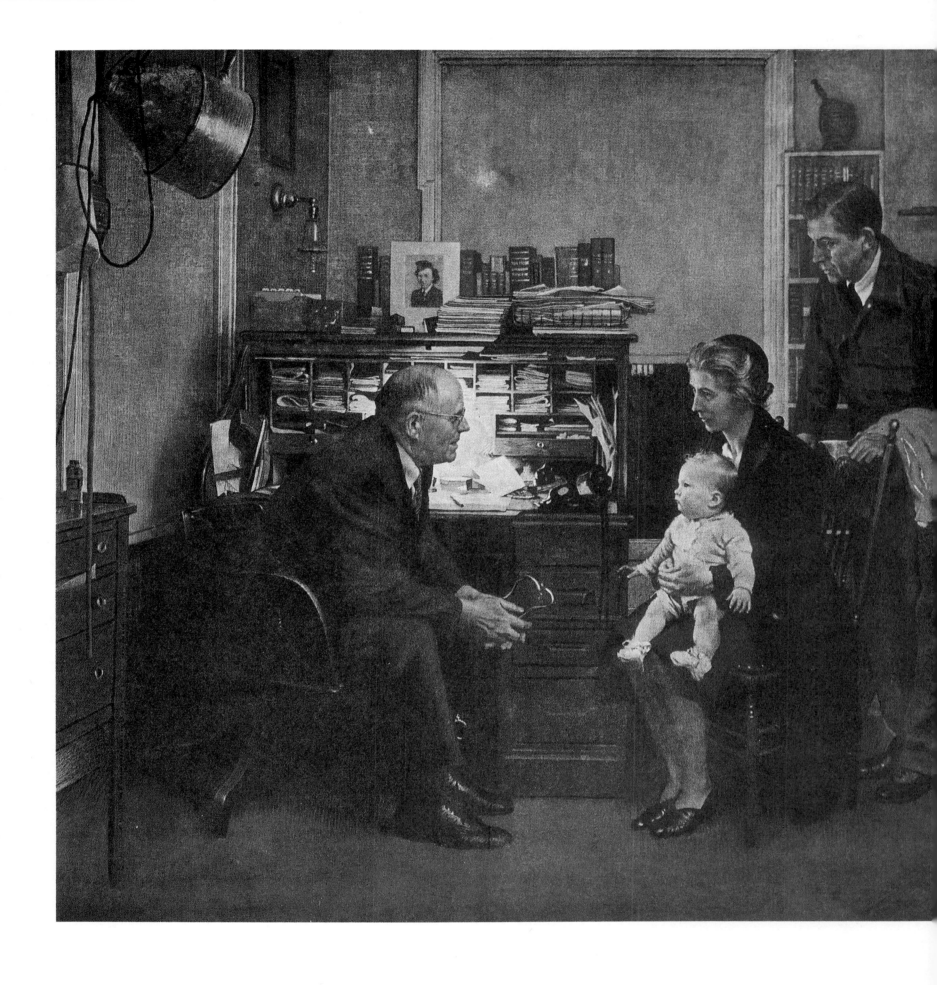

Norman Rockwell Visits his Country Doctor. Post *illustration, 1947.*

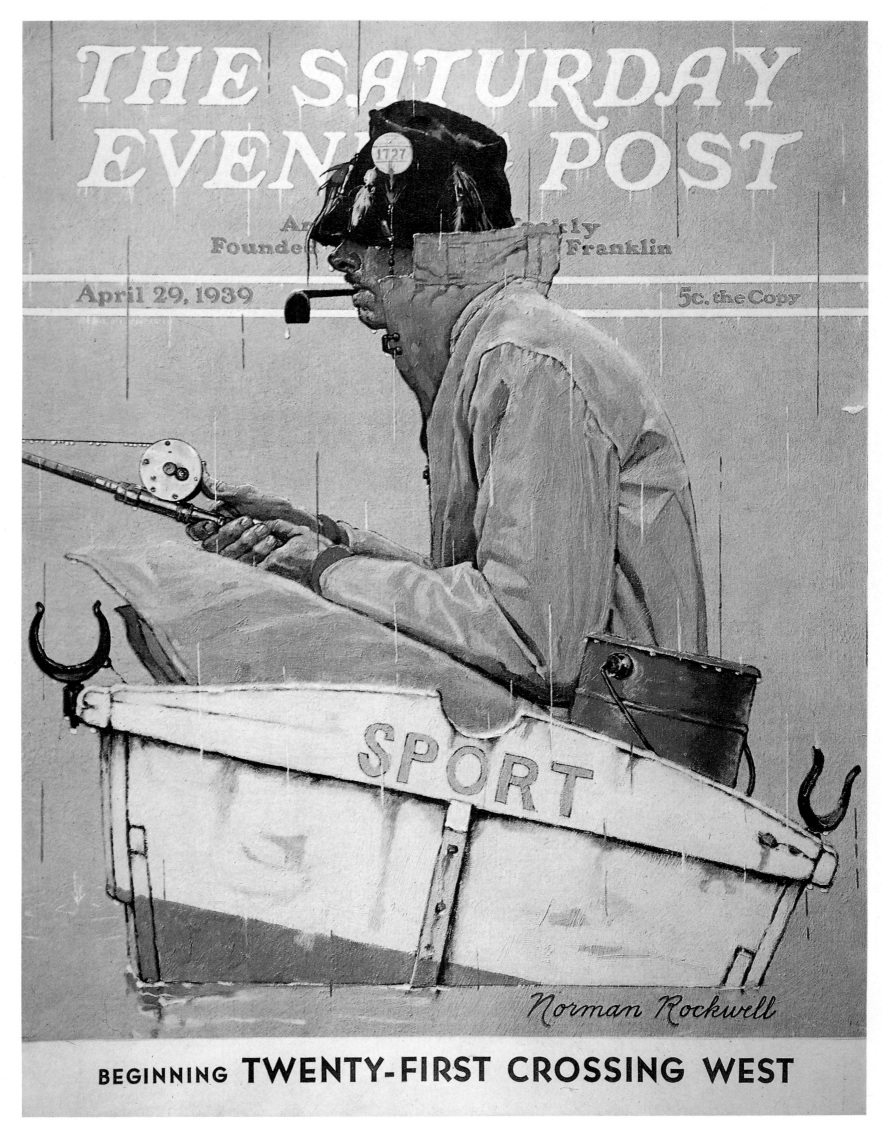

Sport. Post *cover, 1939.*

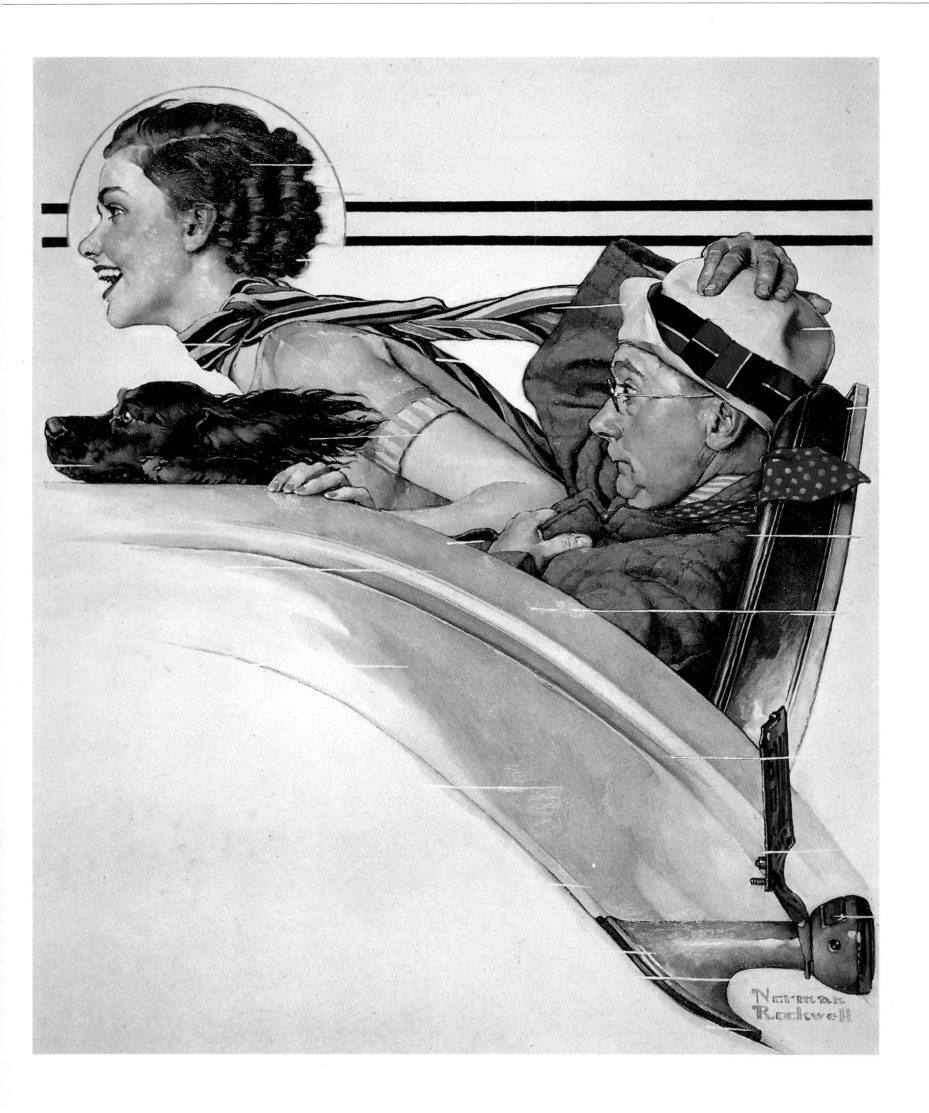

Couple in Rumbleseat. *Original oil painting for a* Post *cover, 1935.*

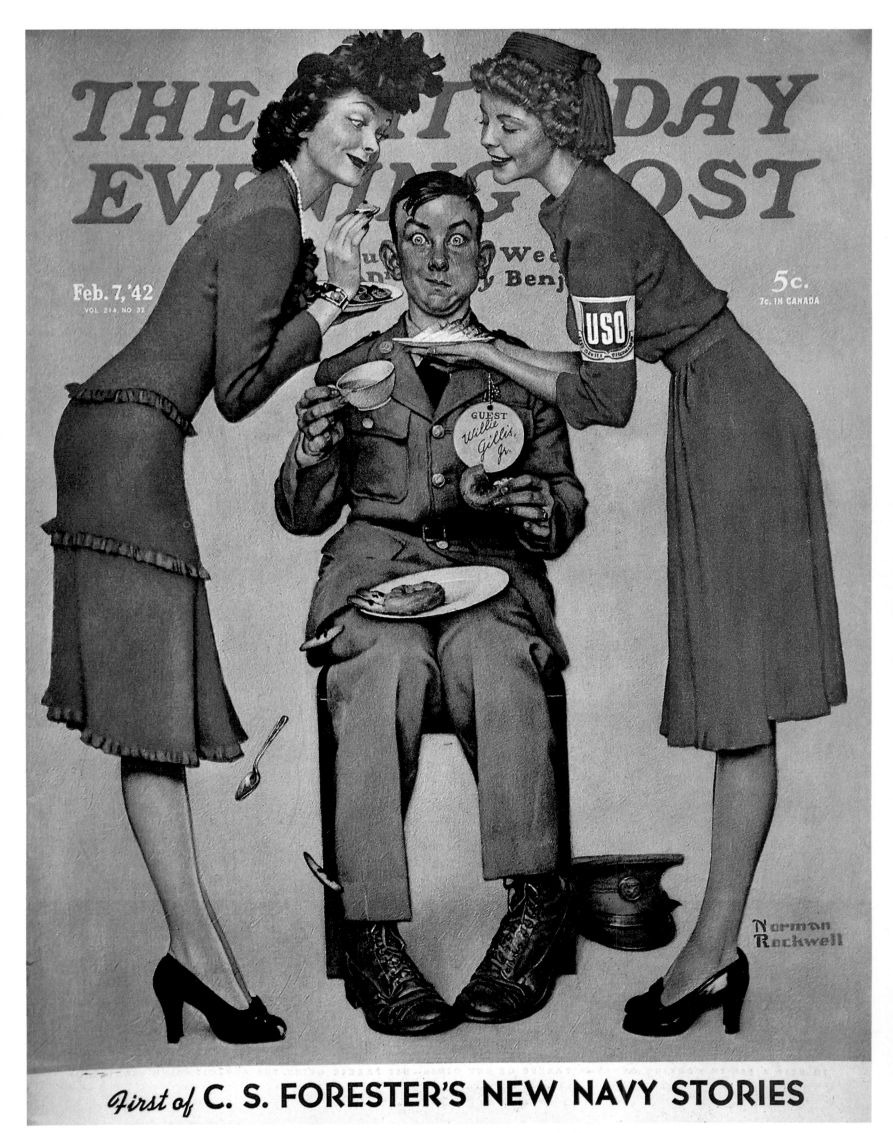

Willie Gillis at the USO. Post *cover, 1942.*

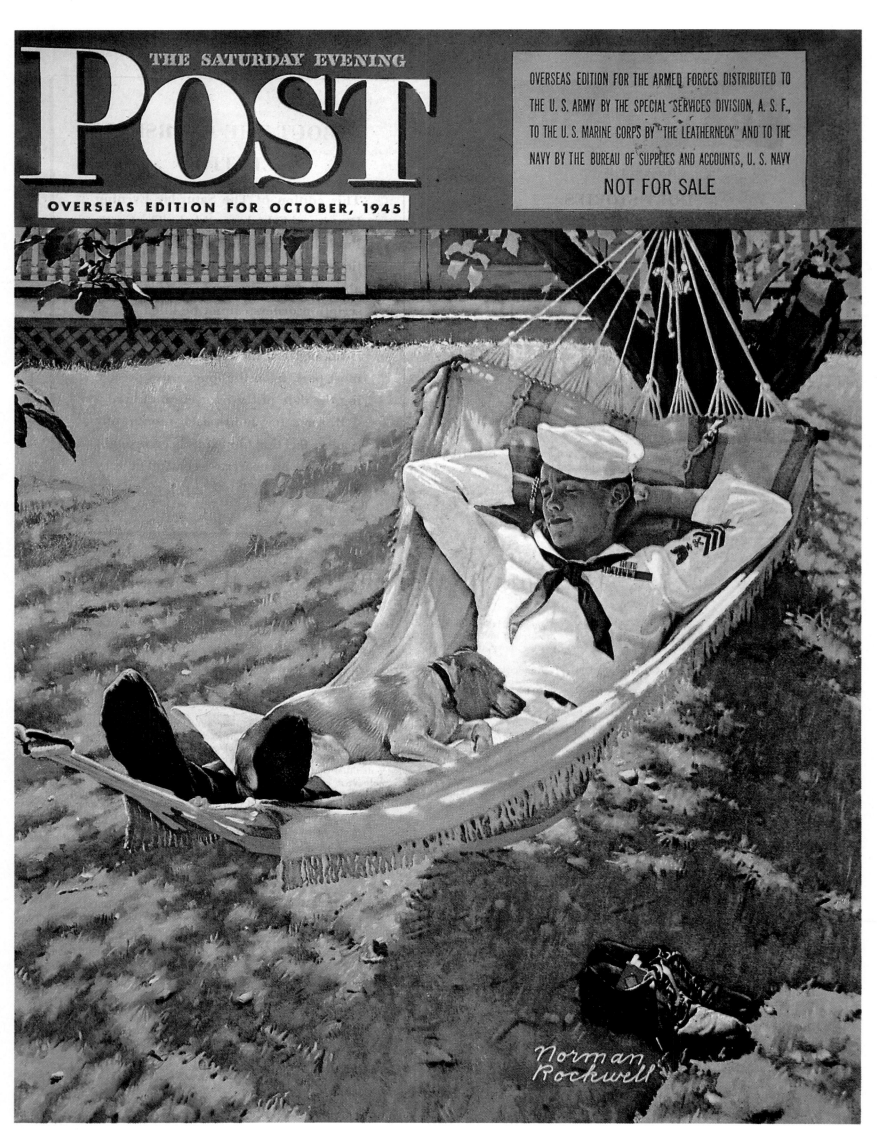

On Leave. Post *cover, 1945.*

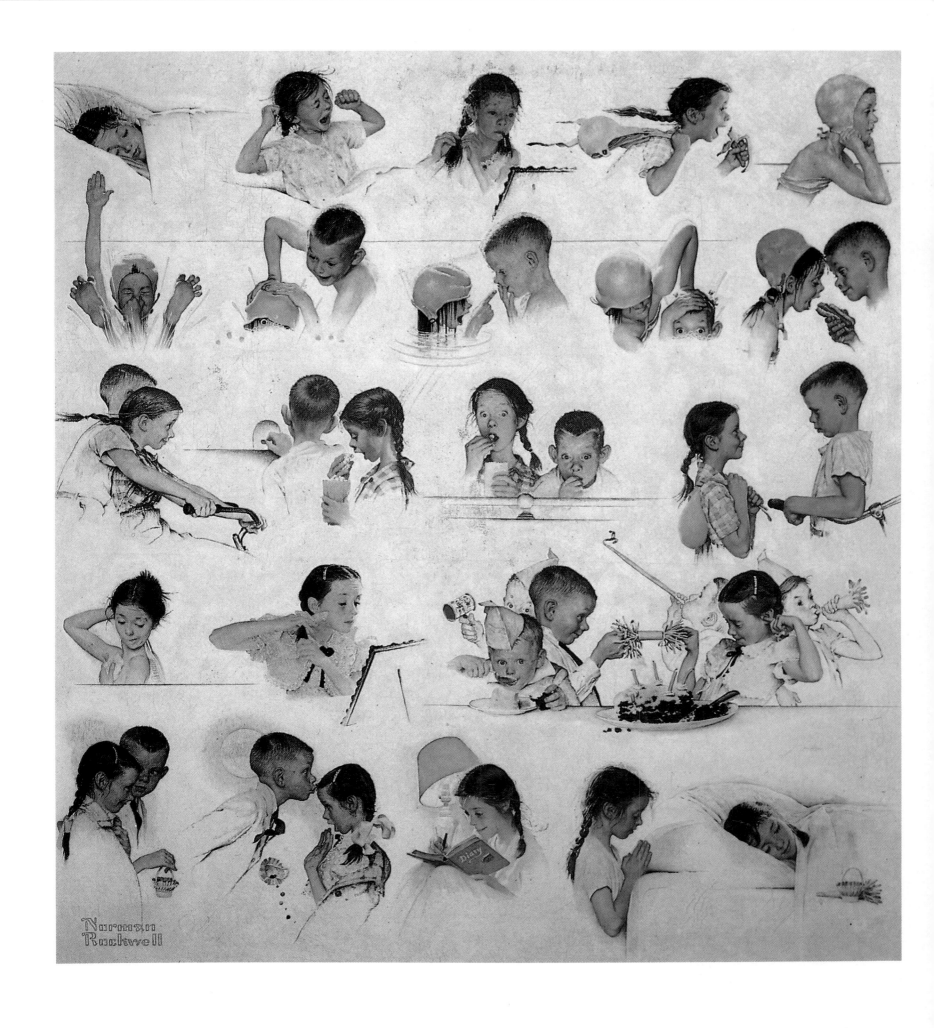

A Day in the Life of a Girl. Post *cover, 1952.*

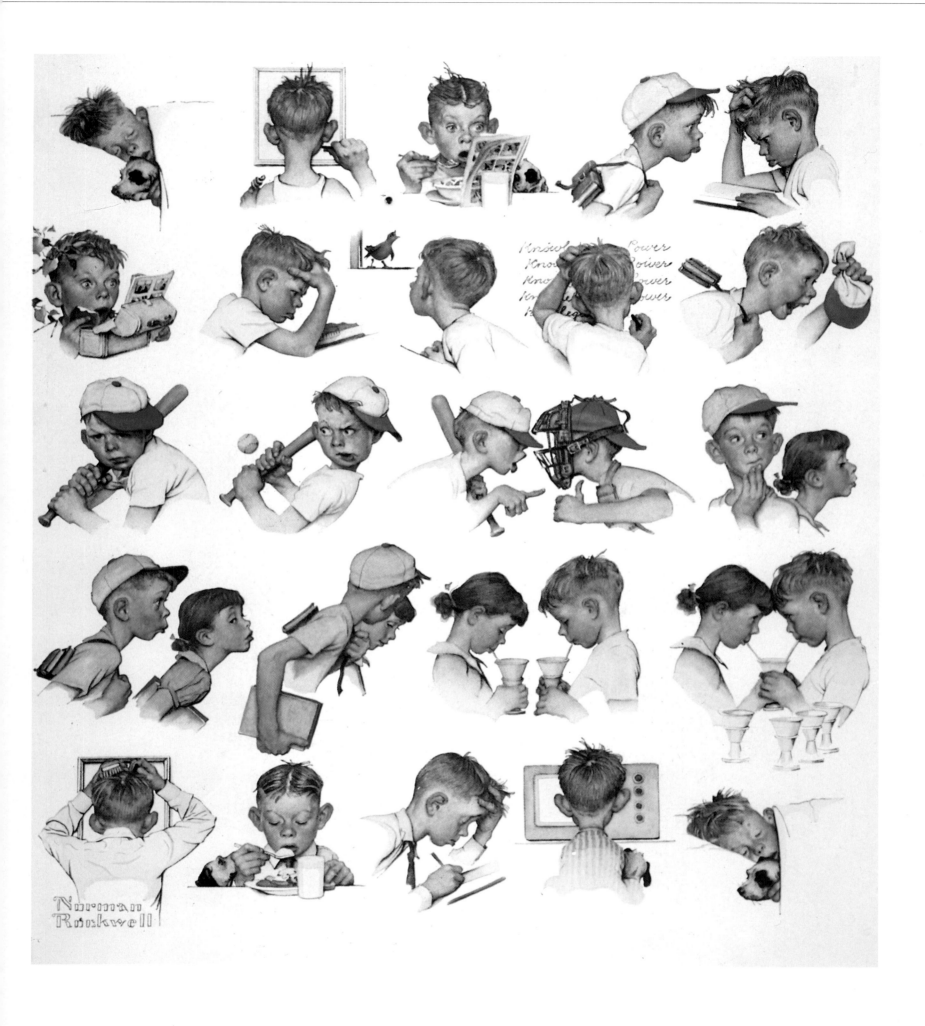

A Day in the Life of a Boy. Post *cover, 1952.*

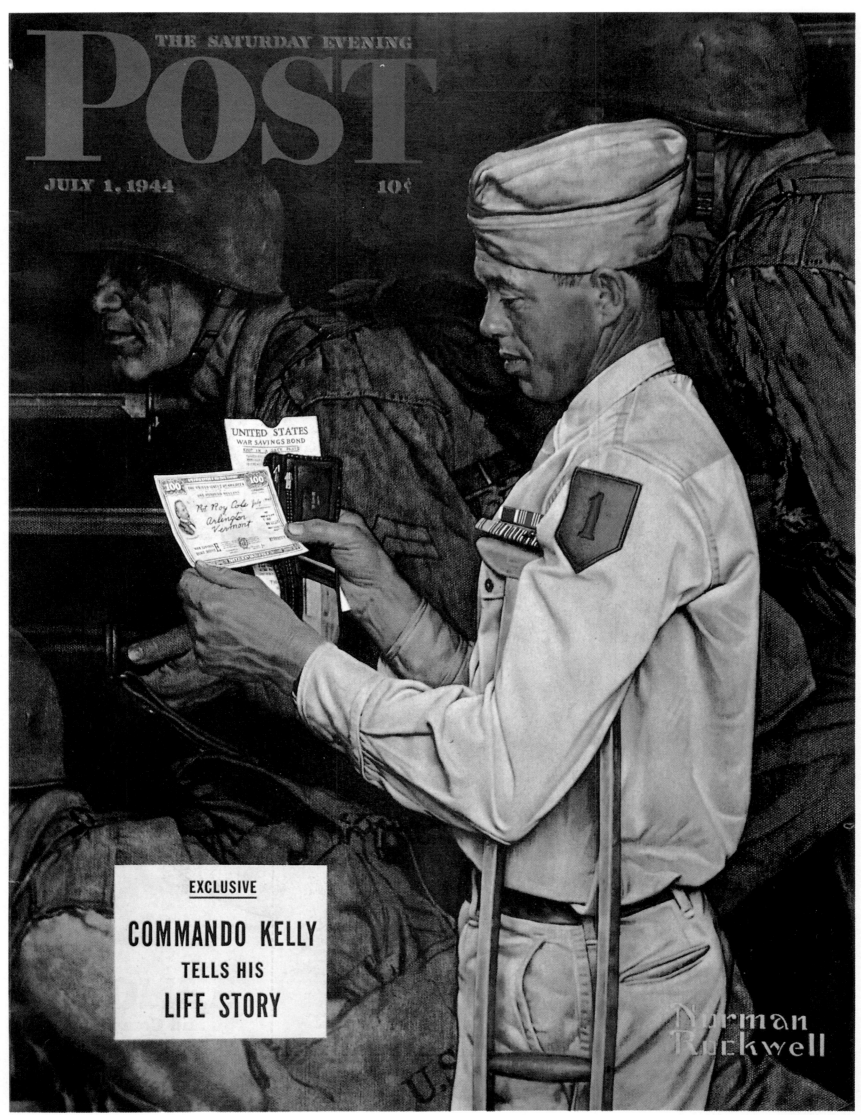

The War Savings Bond. Post *cover, 1944.*

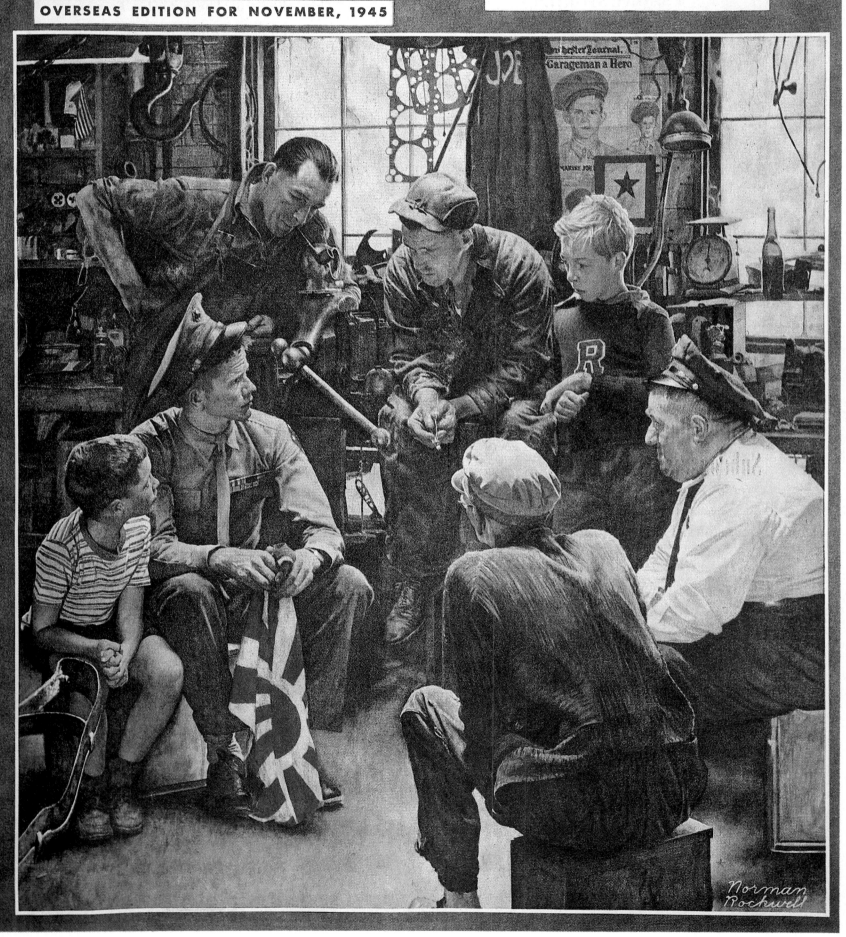

The War Hero. Post *cover, 1945.*

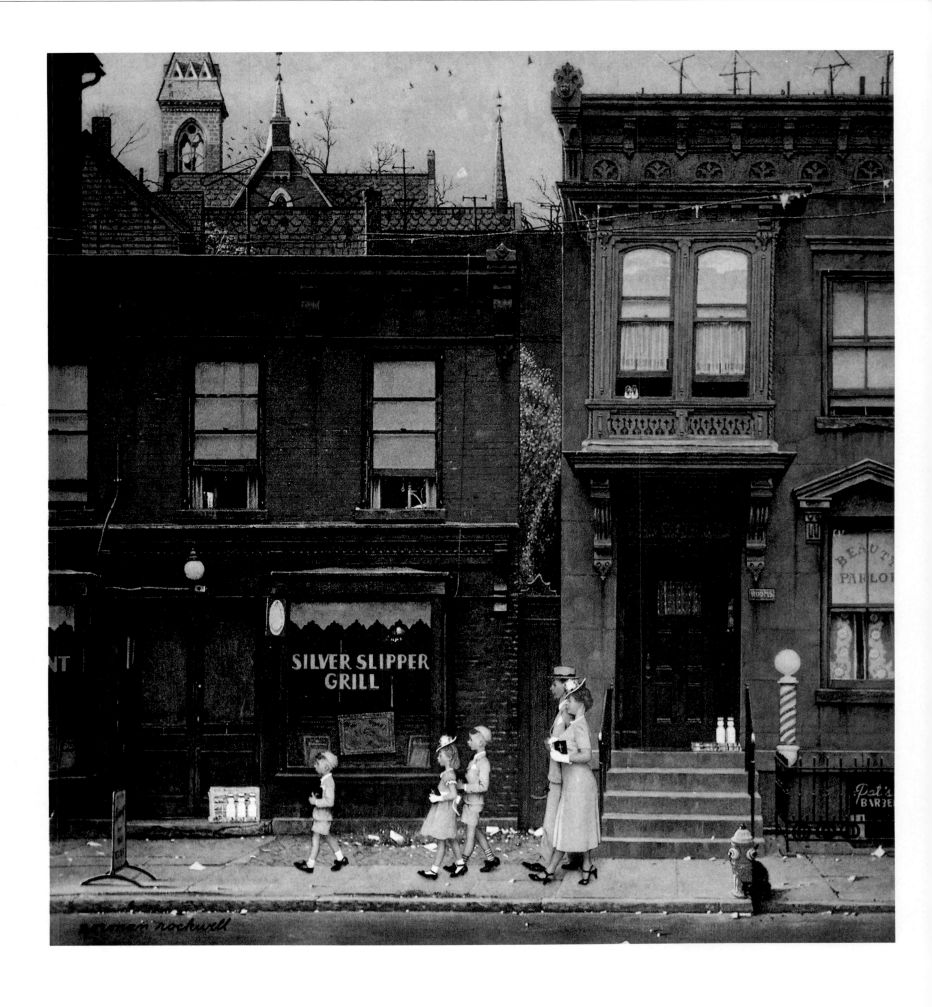

Walking to Church. Post *cover, 1953.*

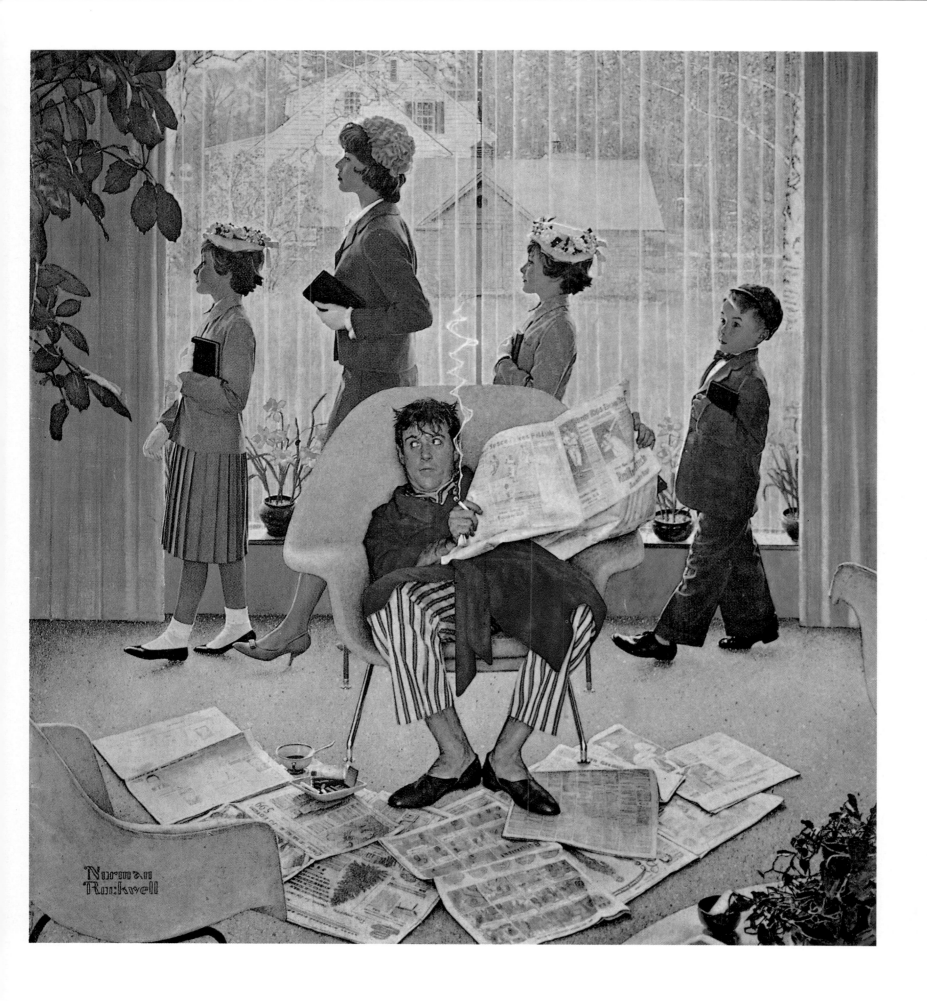

Easter Morning. Post *cover, 1959.*

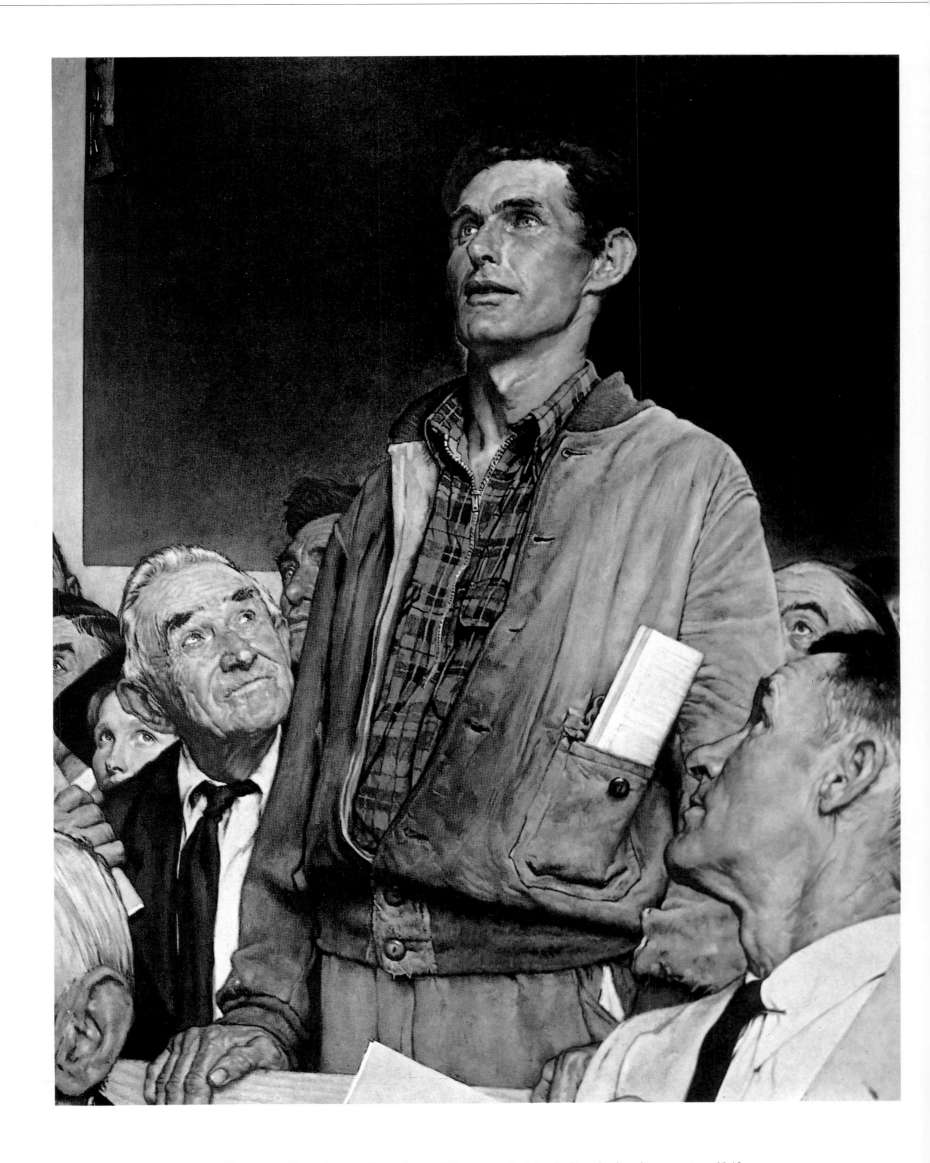

The Four Freedoms: Freedom of Speech. *Original oil painting for a poster, 1943.*

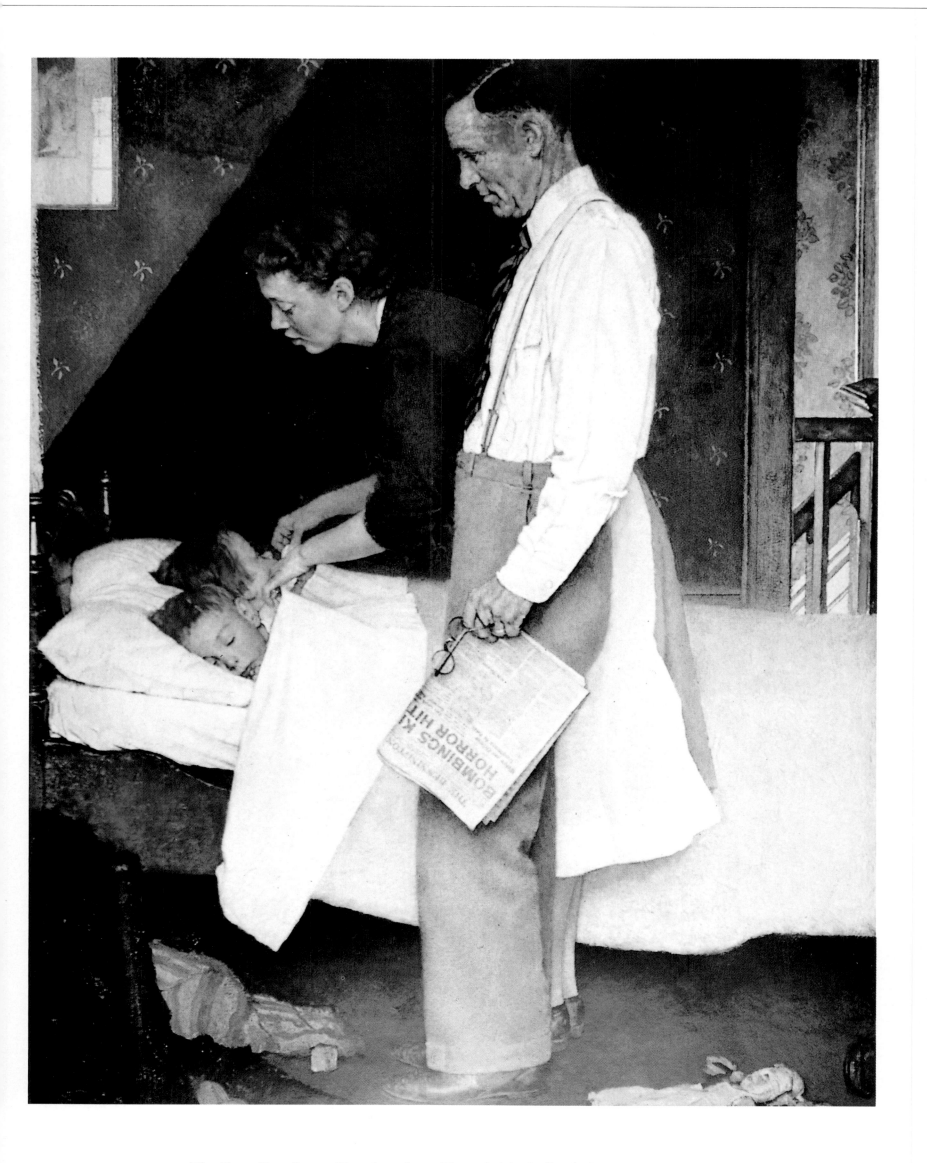

The Four Freedoms: Freedom from Fear. *Original oil painting for a poster, 1943.*

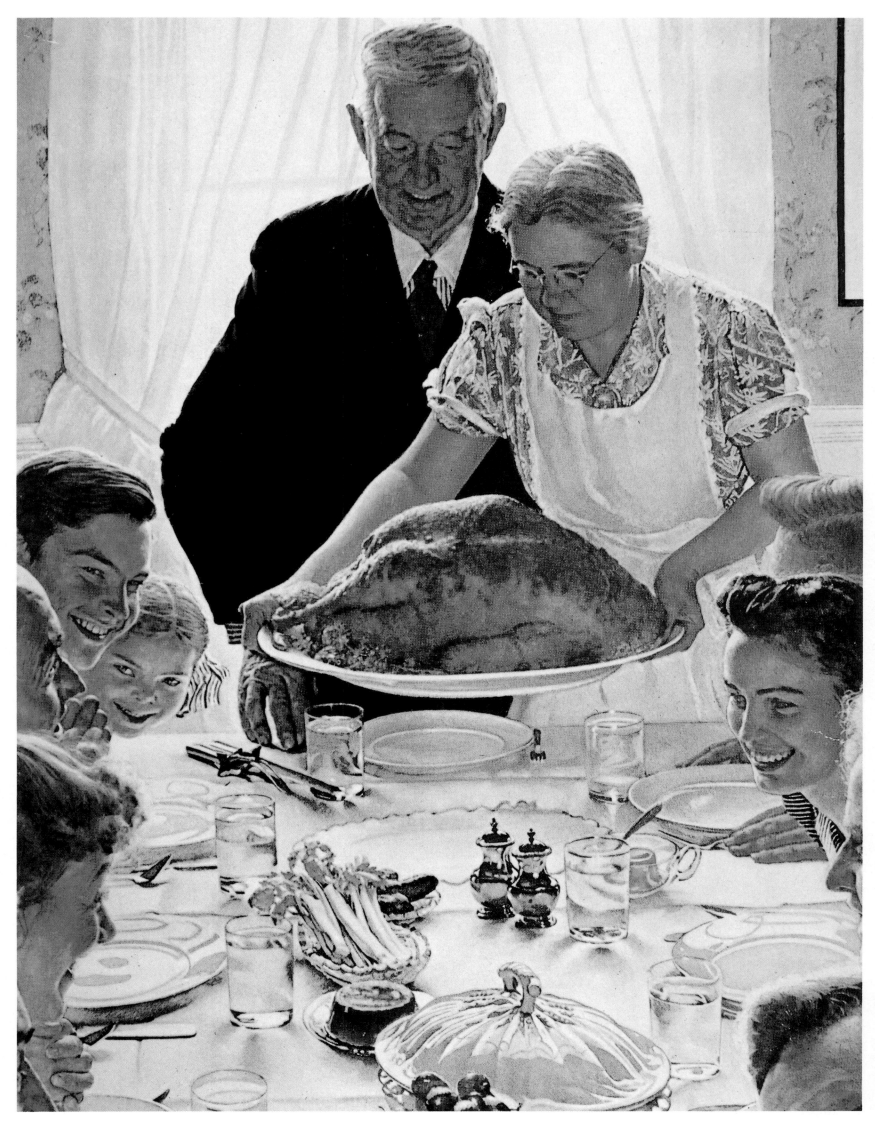

The Four Freedoms: Freedom from Want. *Original oil painting for a poster, 1943.*

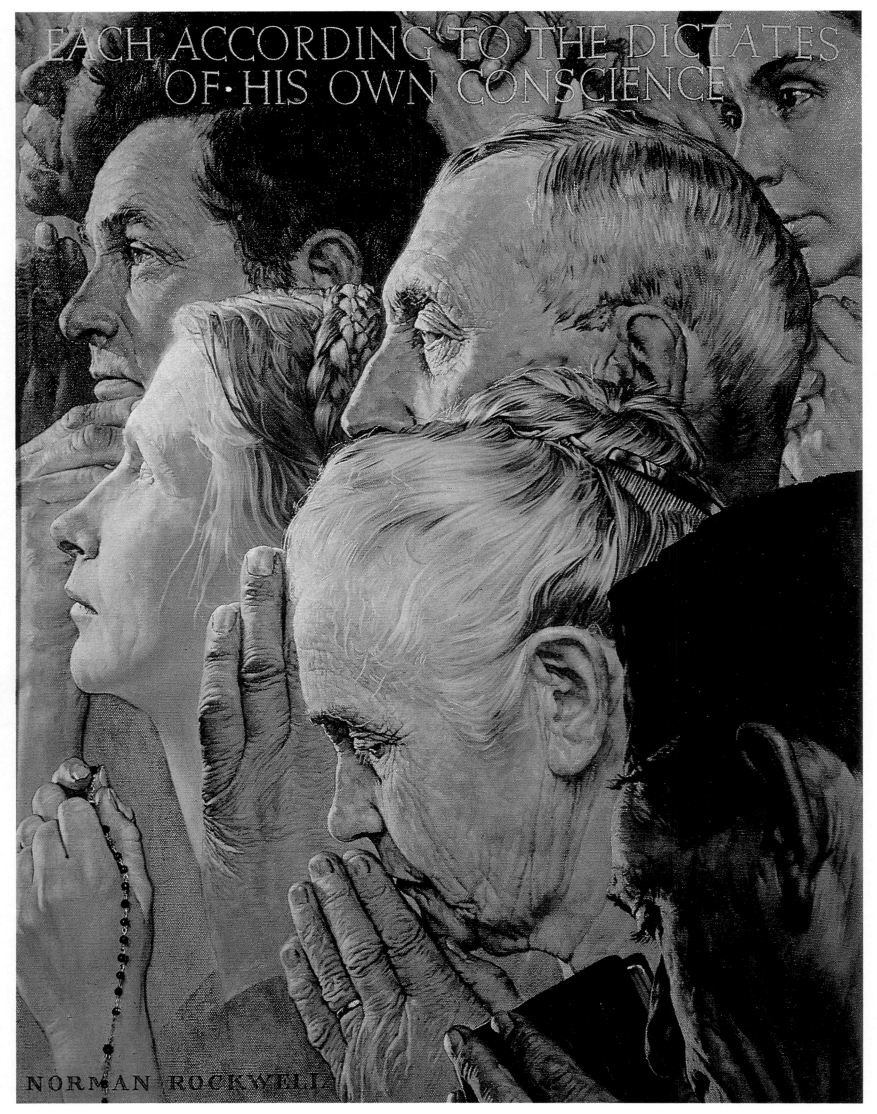

EACH ACCORDING TO THE DICTATES OF·HIS OWN CONSCIENCE

NORMAN ROCKWELL

The Four Freedoms: Freedom of Worship. *Original oil painting for a poster, 1943.*

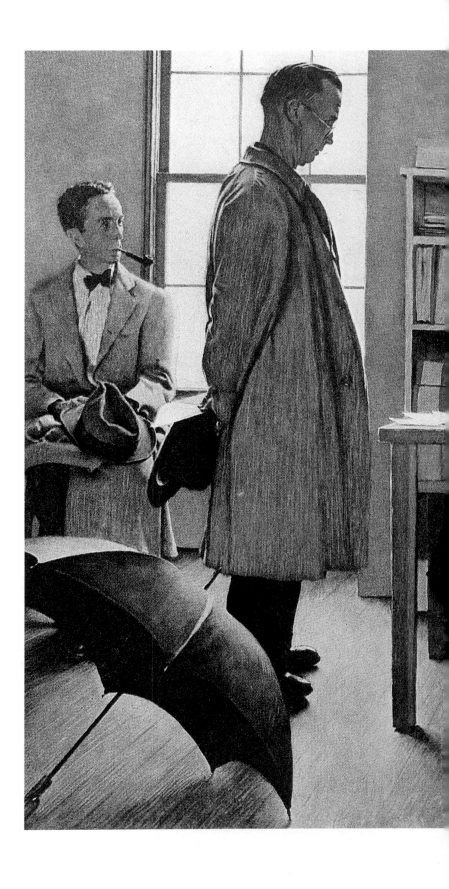

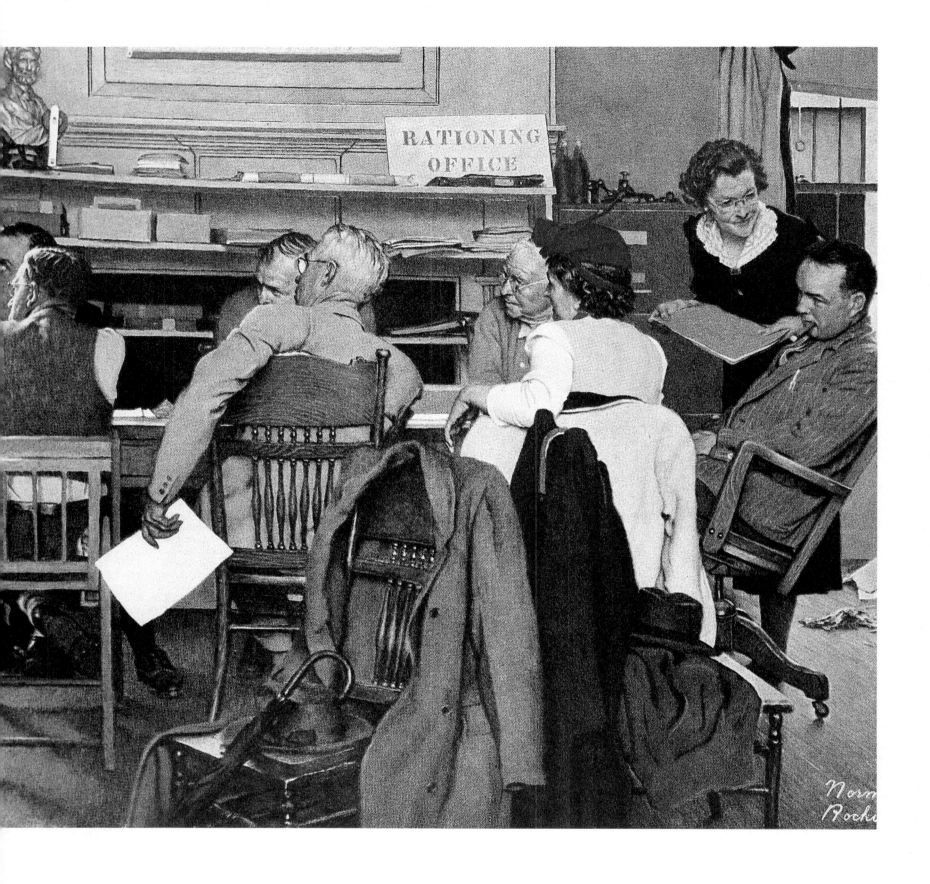

Norman Rockwell Visits a Ration Board. Post *illustration, 1944.*

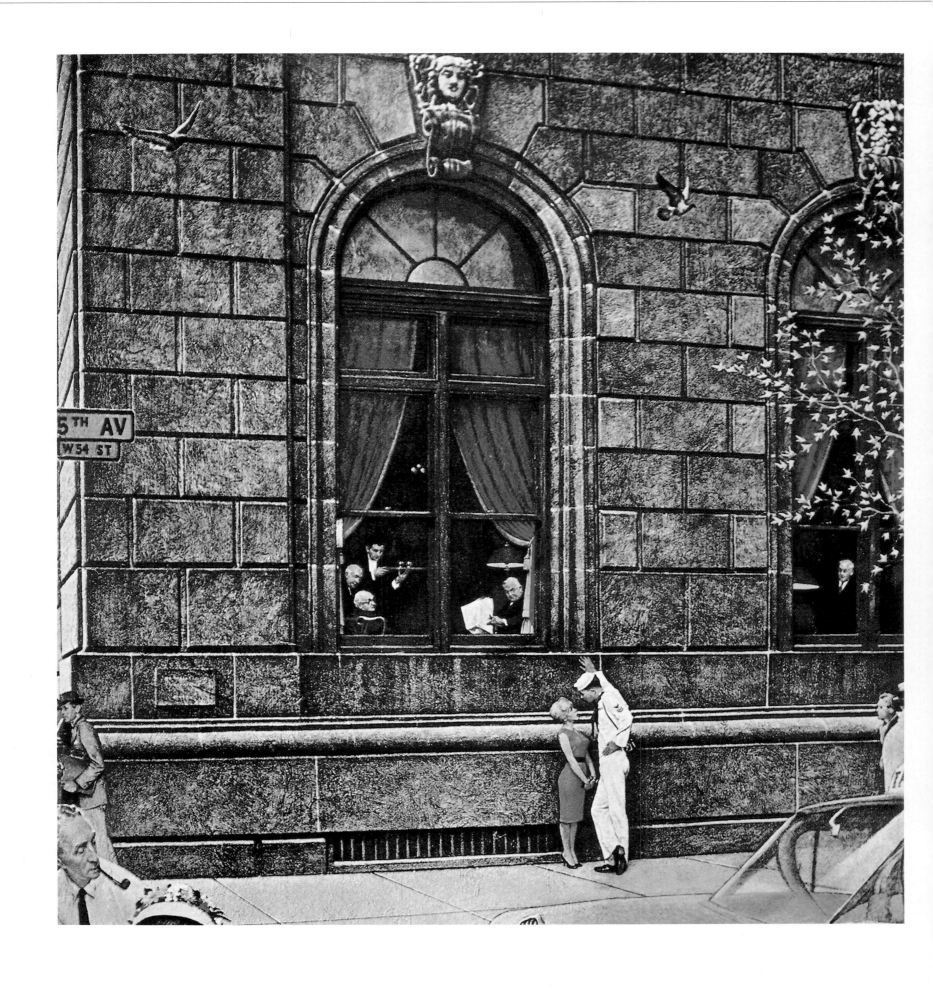

The University Club. *Original oil painting for a* Post *cover, 1960.*

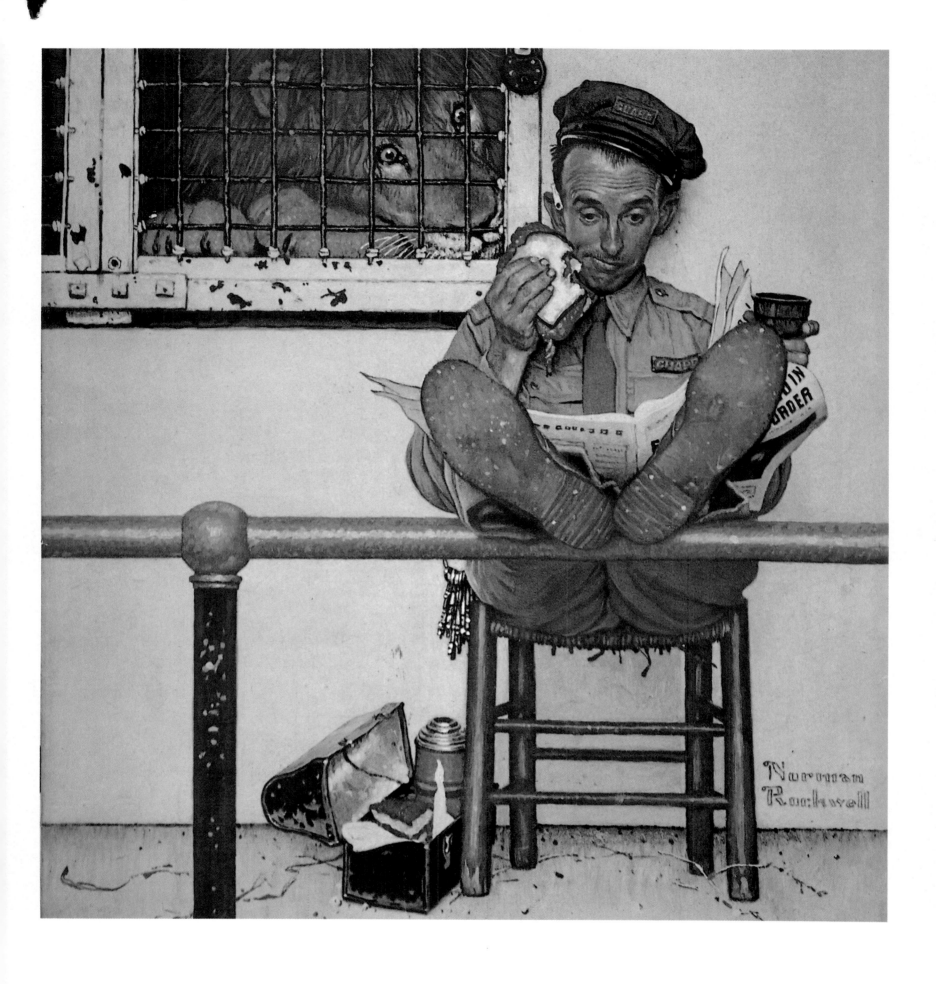

Lion and his Keeper. Post *cover, 1954.*

Adlai E Stevenson. Post *cover, 1956.*

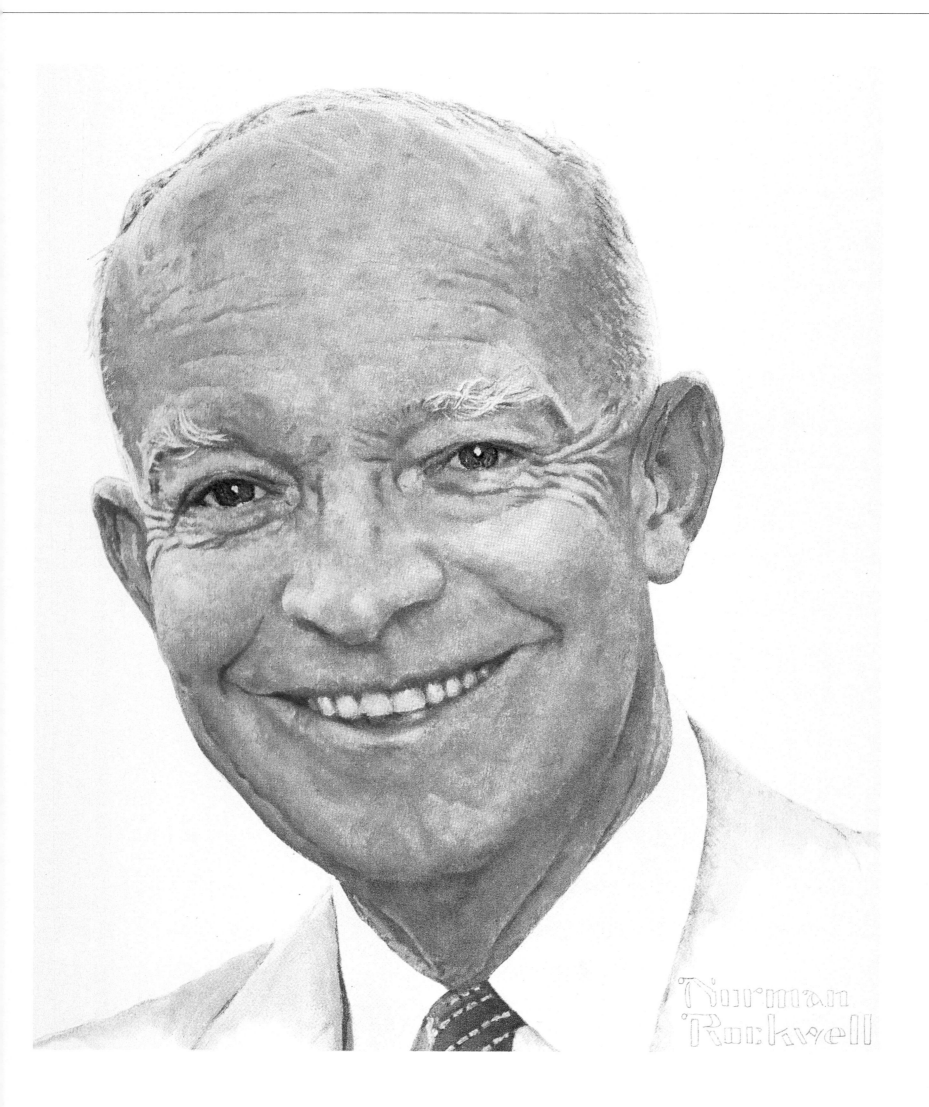

Dwight D Eisenhower. Post *cover, 1956.*

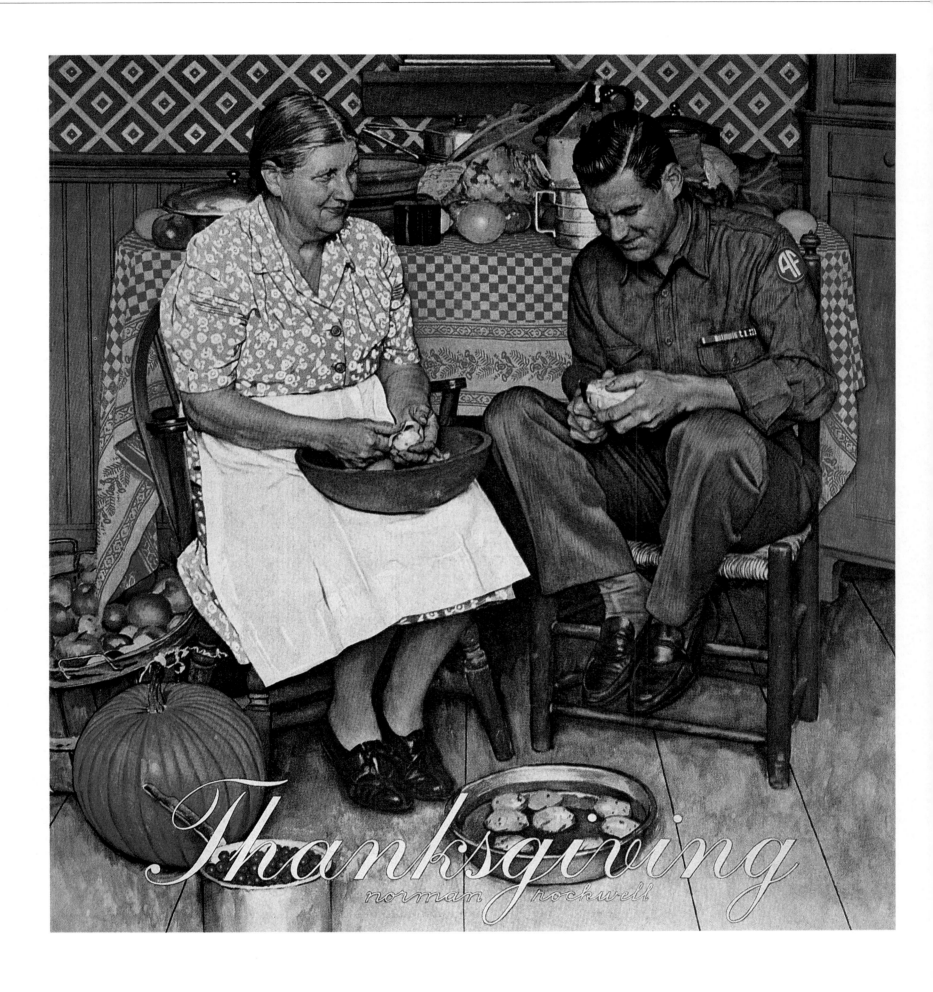

Home for Thanksgiving. Post *cover, 1945.*

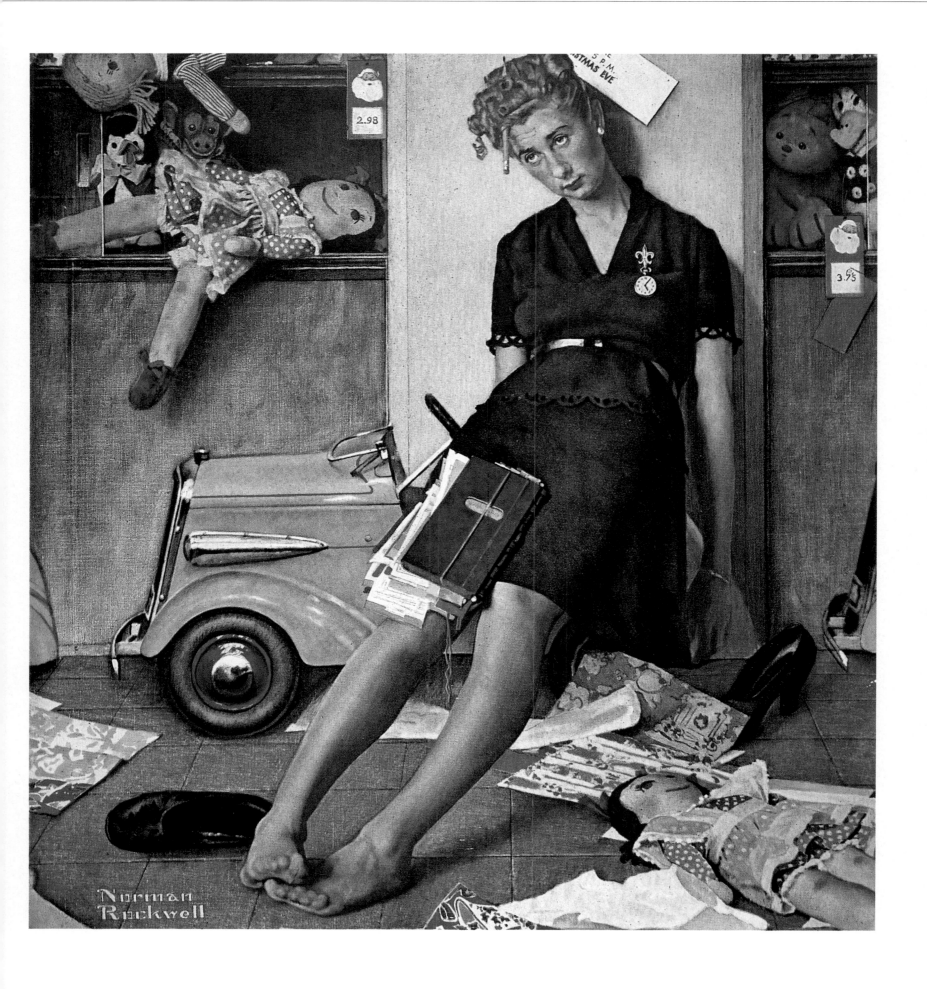

After the Christmas Rush. Post *cover, 1947.*

THE SATURDAY EVENING POST

SEPTEMBER 24, 1949 15¢

WHAT'S BECOME OF THE INFANTRY?
By Beverly Smith

THAT MAN, Jr.
By Wesley Price

Before the Date. Post *cover, 1949.*

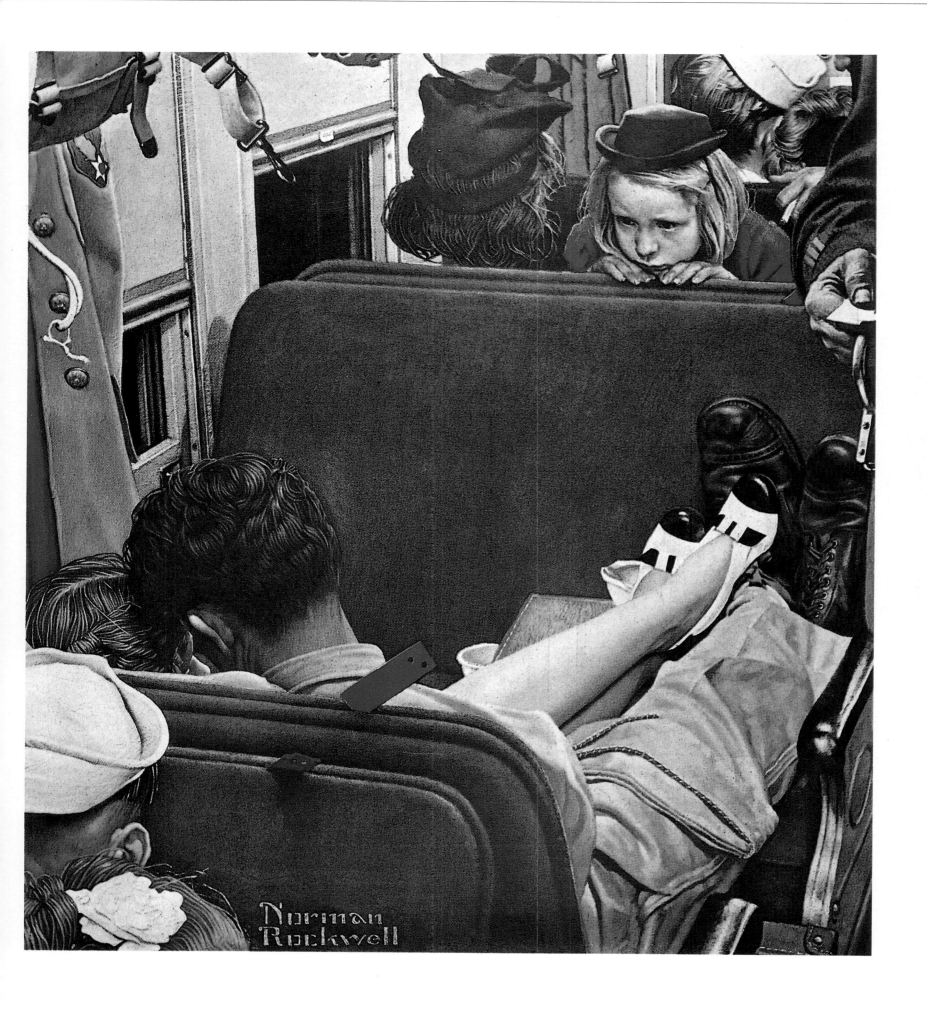

The Voyeur. Post *cover, 1944.*

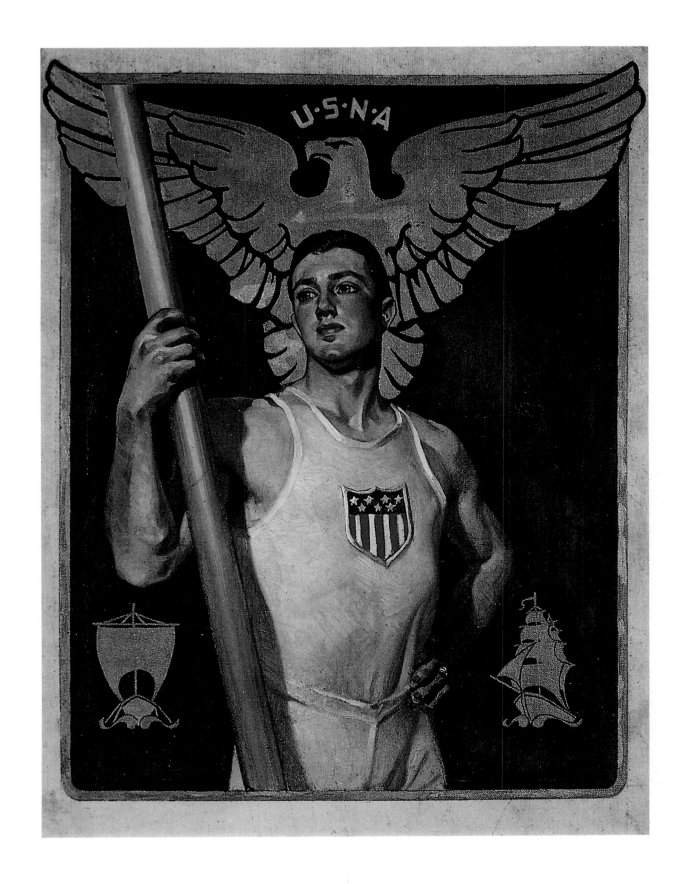

Naval Academy Oarsman. *Original oil painting for the US Naval Academy Yearbook, 1921.*

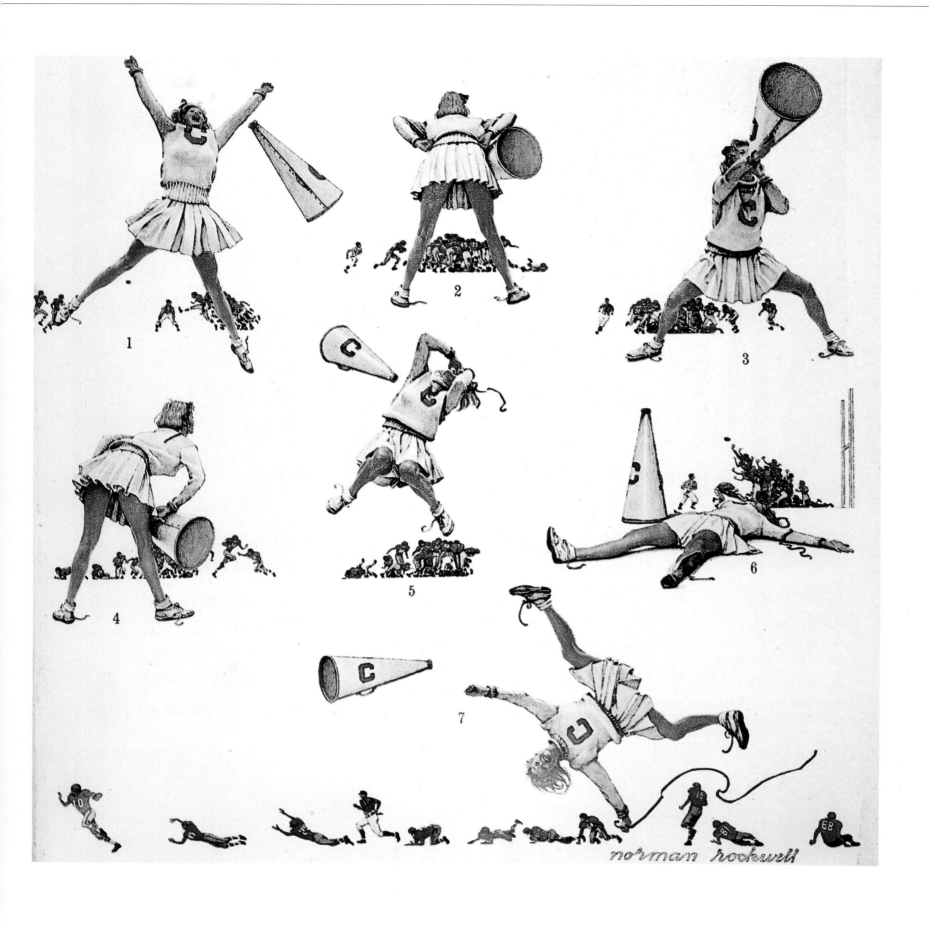

Cheerleader. Post *cover, 1961.*

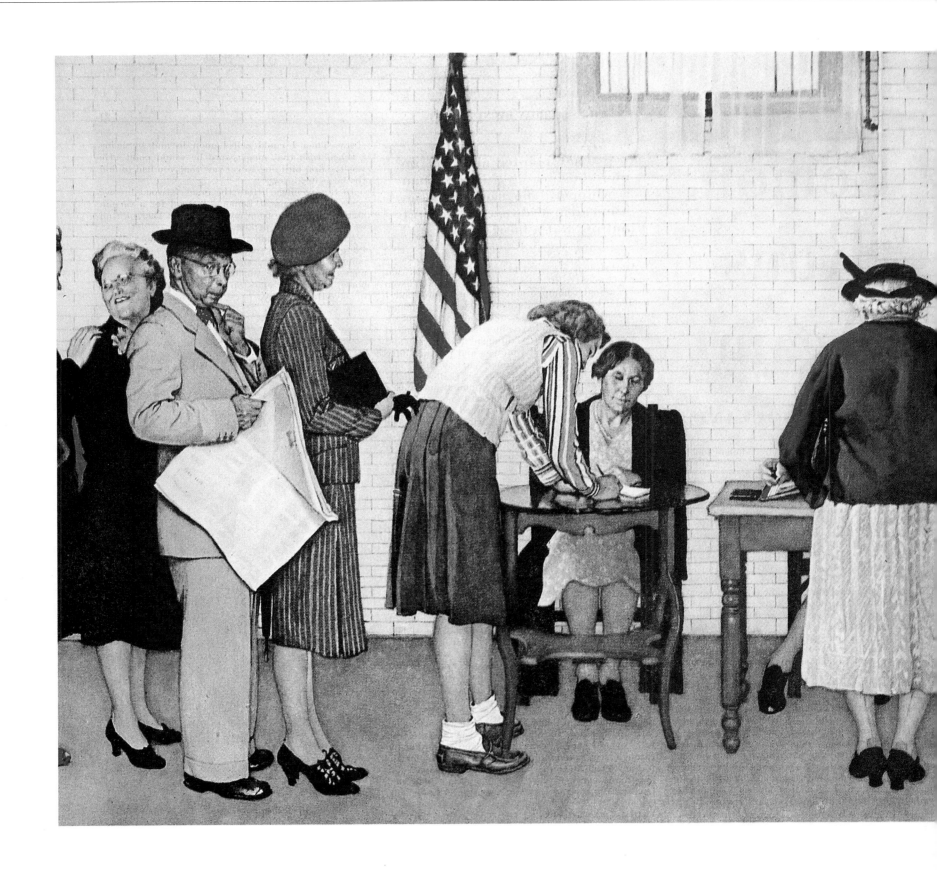

America at the Polls. Post *illustration, 1944.*

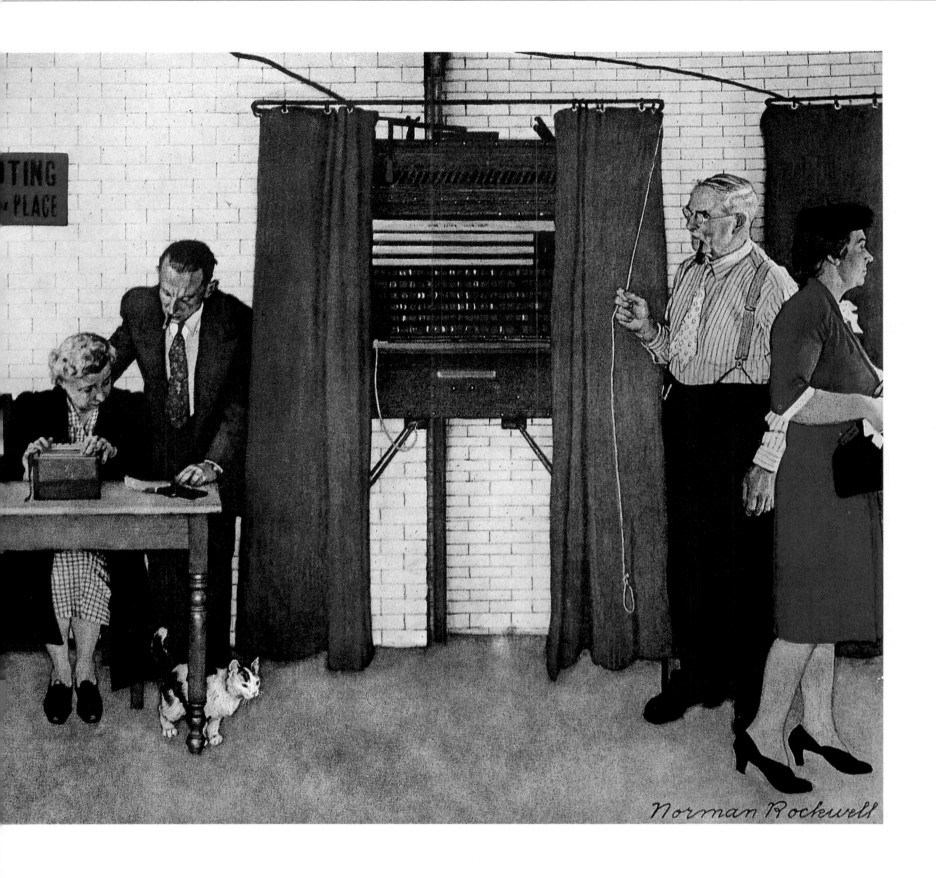

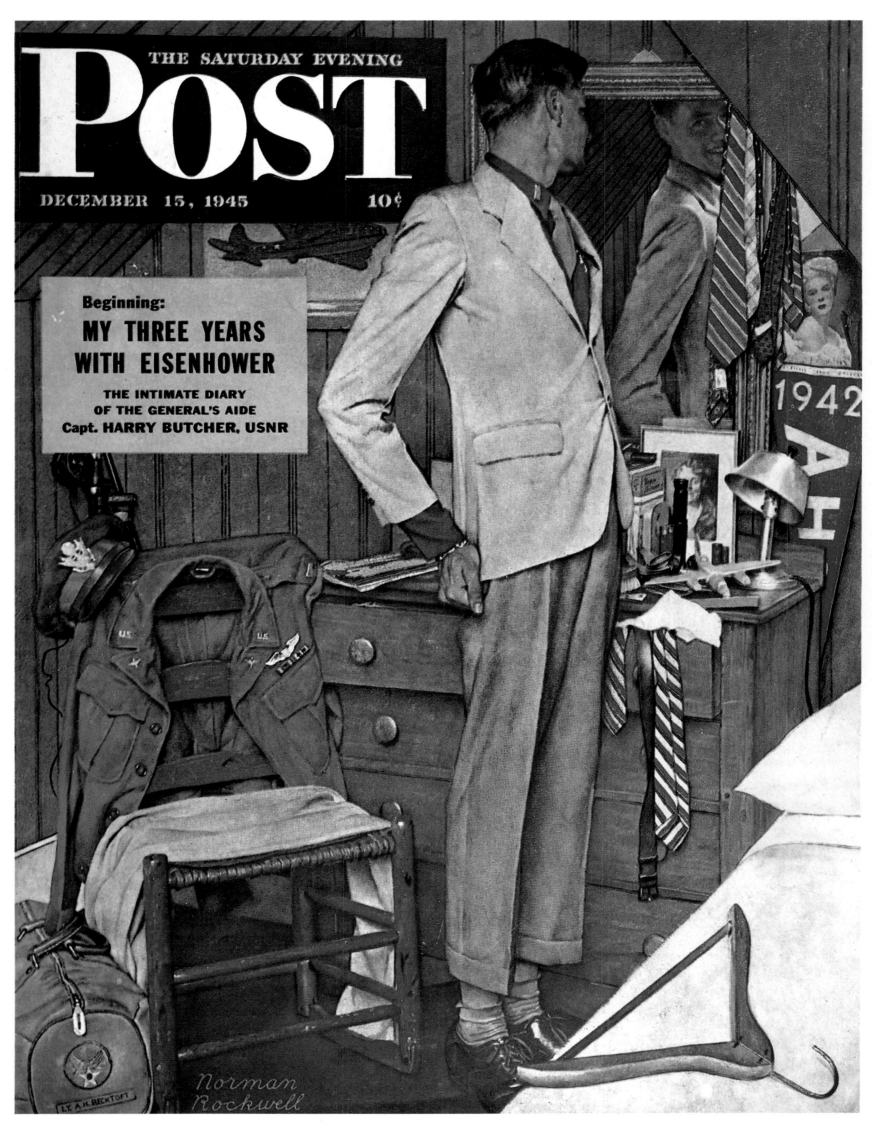

An Imperfect Fit. Post *cover, 1945.*

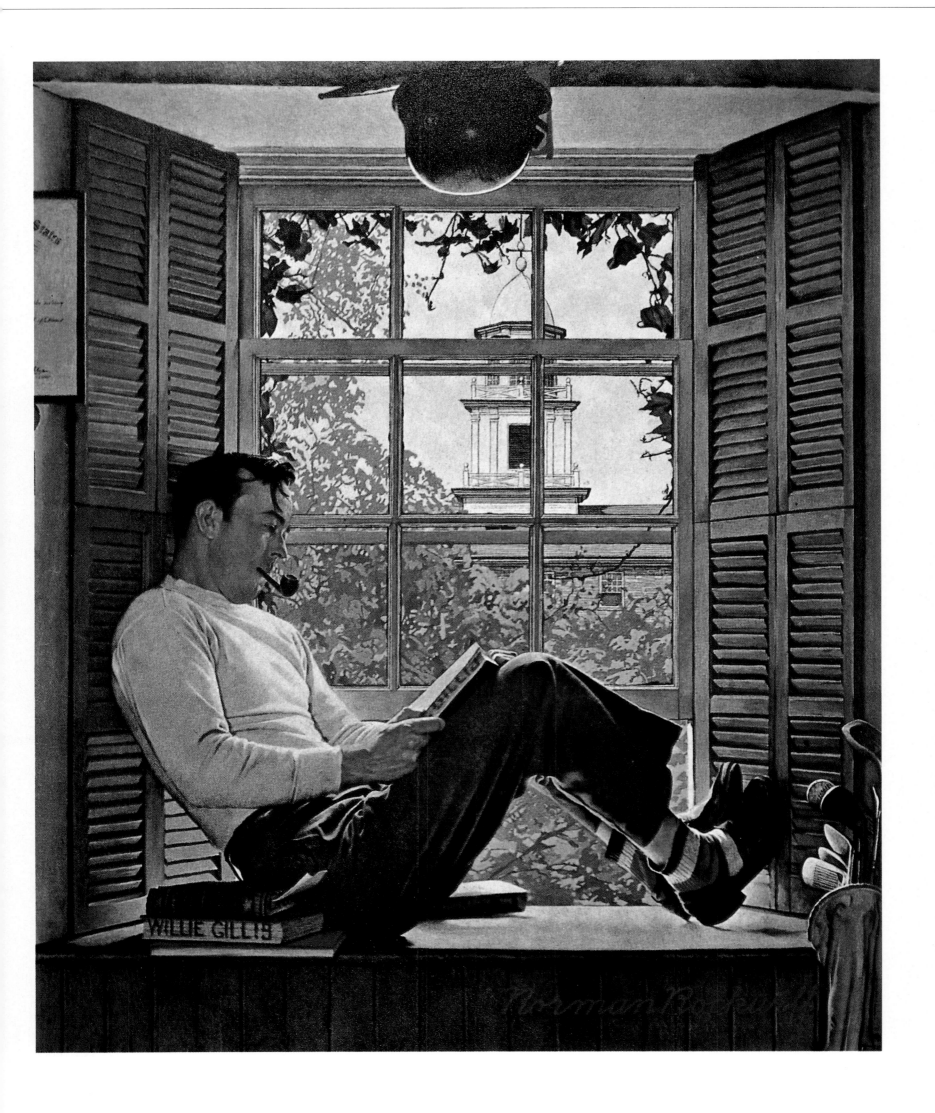

Willie Gillis in College. *Original oil painting for a* Post *cover, 1946.*

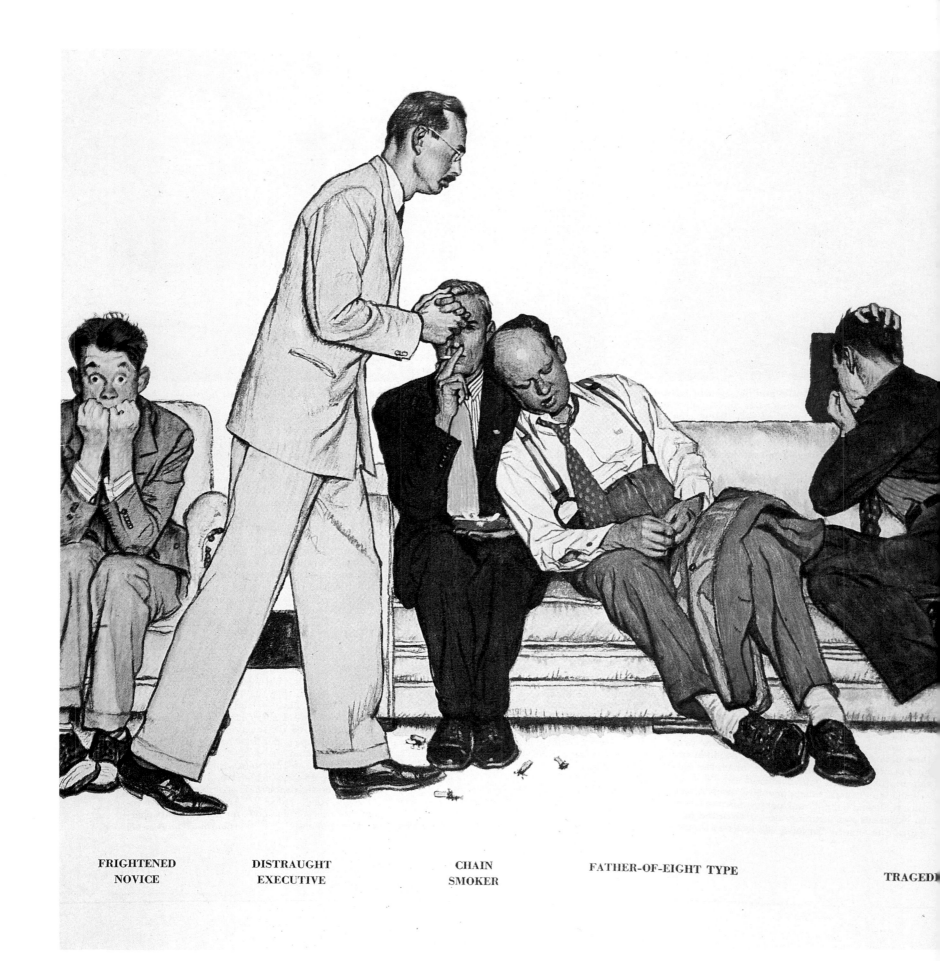

FRIGHTENED NOVICE DISTRAUGHT EXECUTIVE CHAIN SMOKER FATHER-OF-EIGHT TYPE TRAGED[

Maternity Waiting Room. Post *illustration, 1946.*

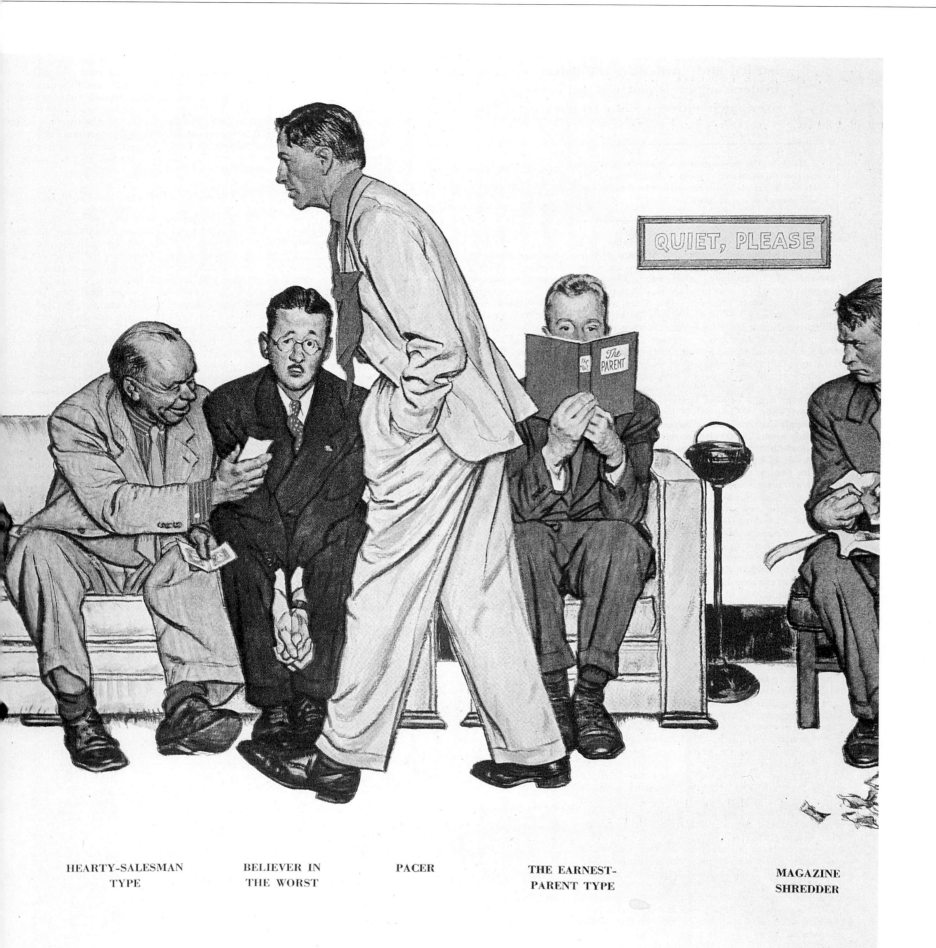

HEARTY-SALESMAN
TYPE

BELIEVER IN
THE WORST

PACER

THE EARNEST-
PARENT TYPE

MAGAZINE
SHREDDER

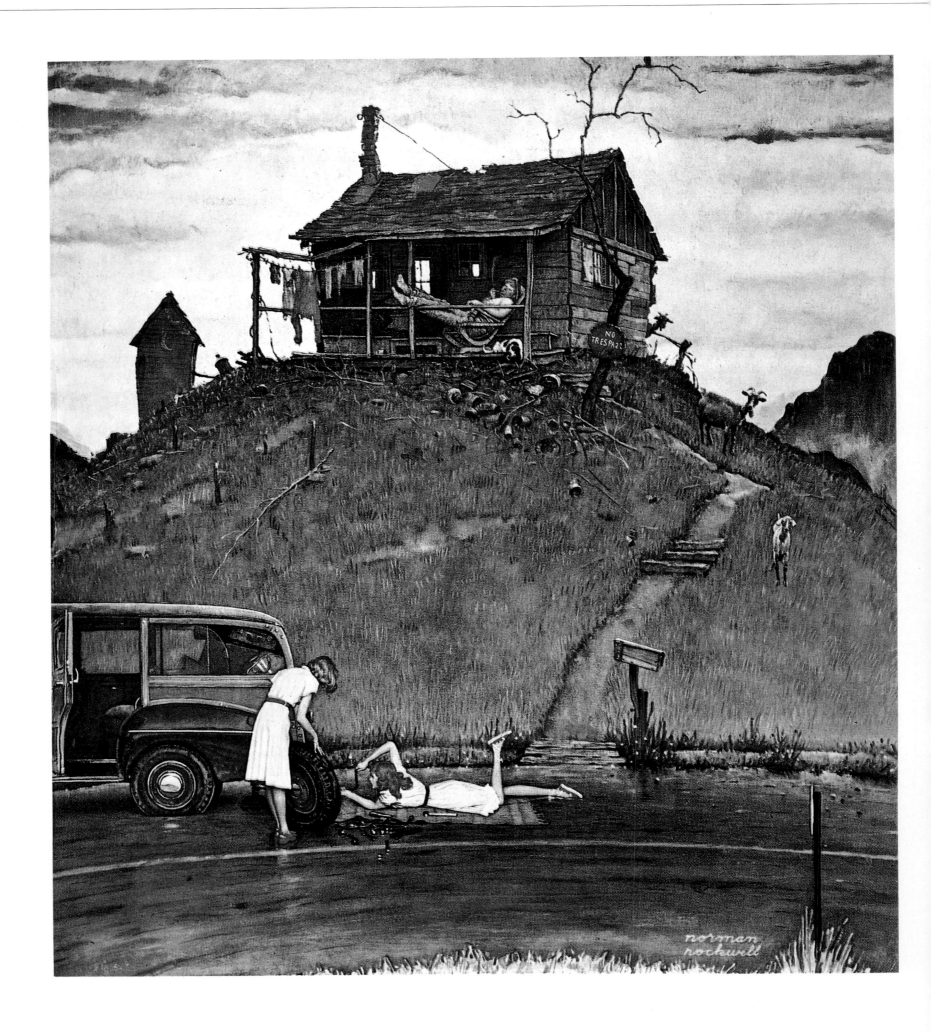

Fixing a Flat. Post *cover, 1946.*

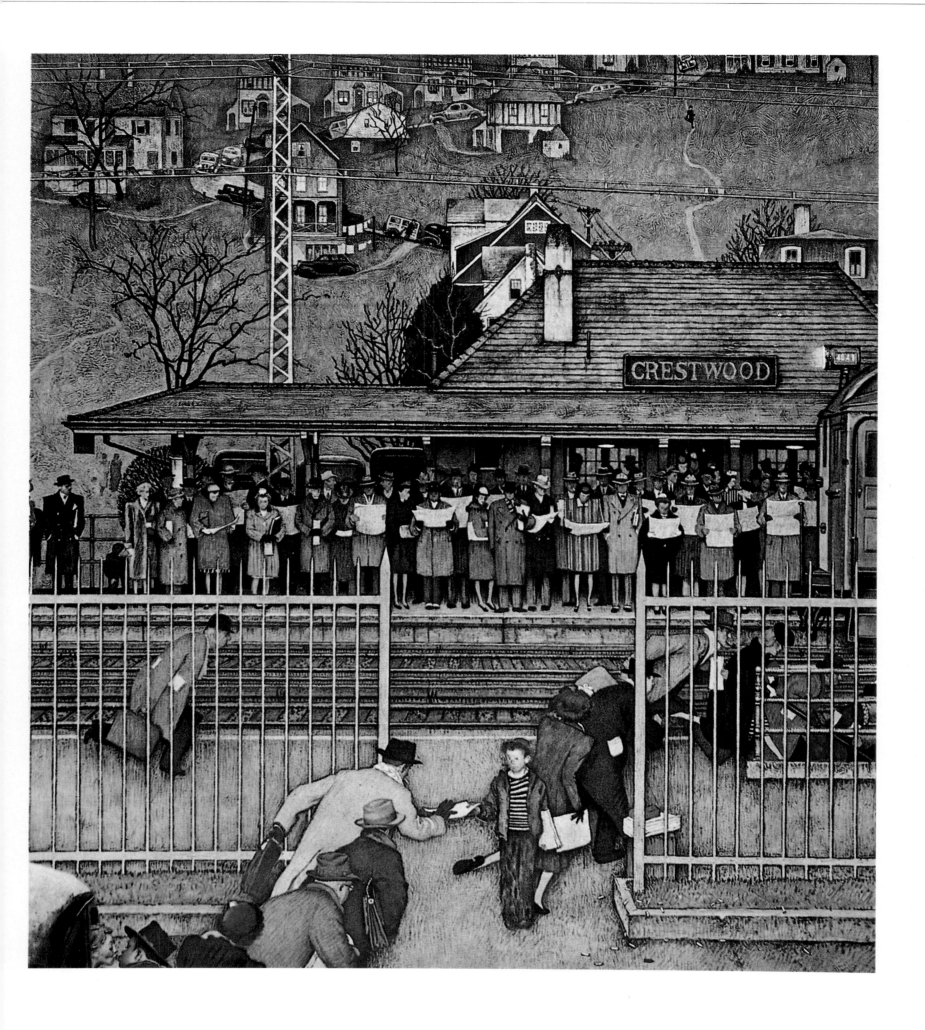

Commuters. Post *cover, 1946.*

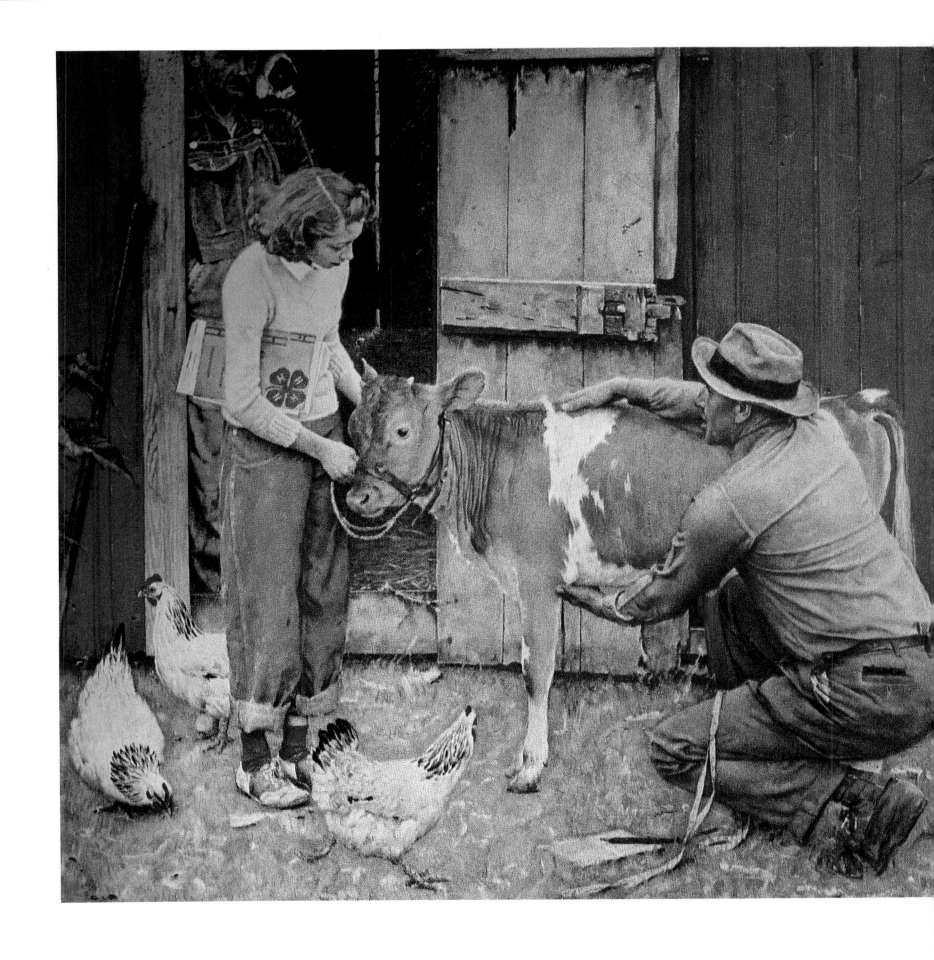

County Agricultural Agent. Post *illustration, 1948.*

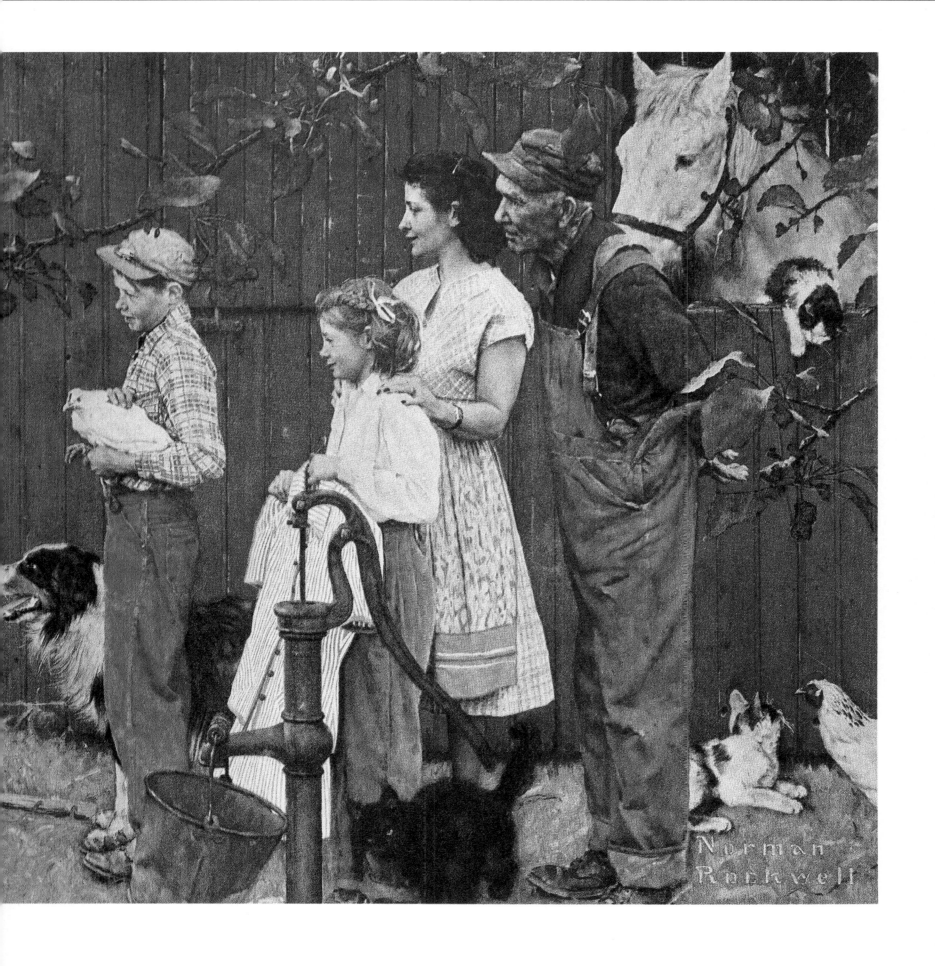

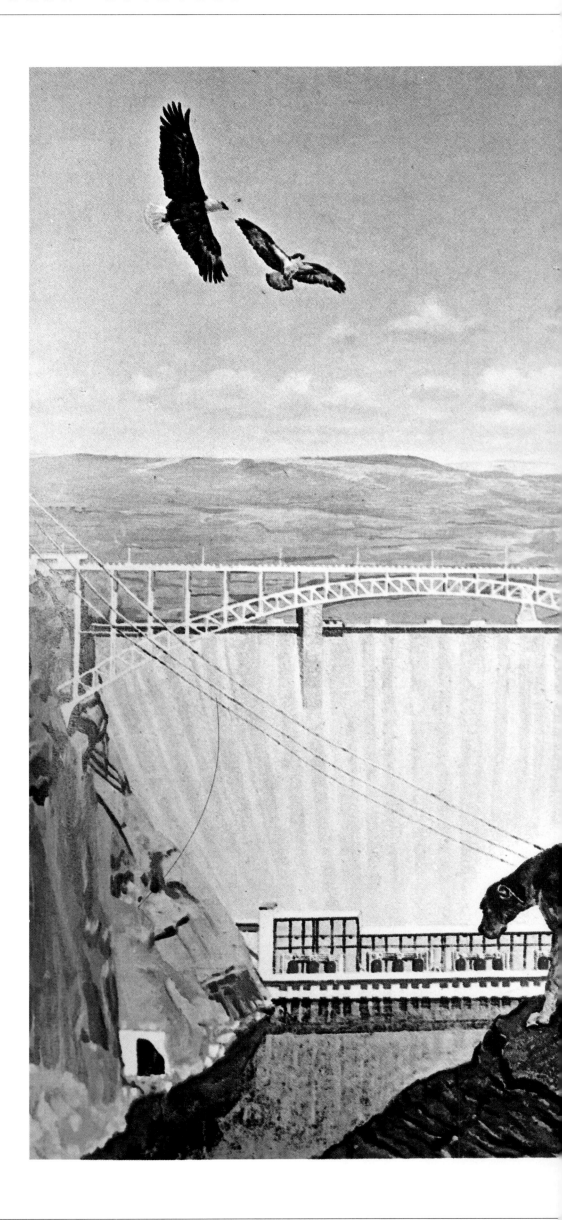

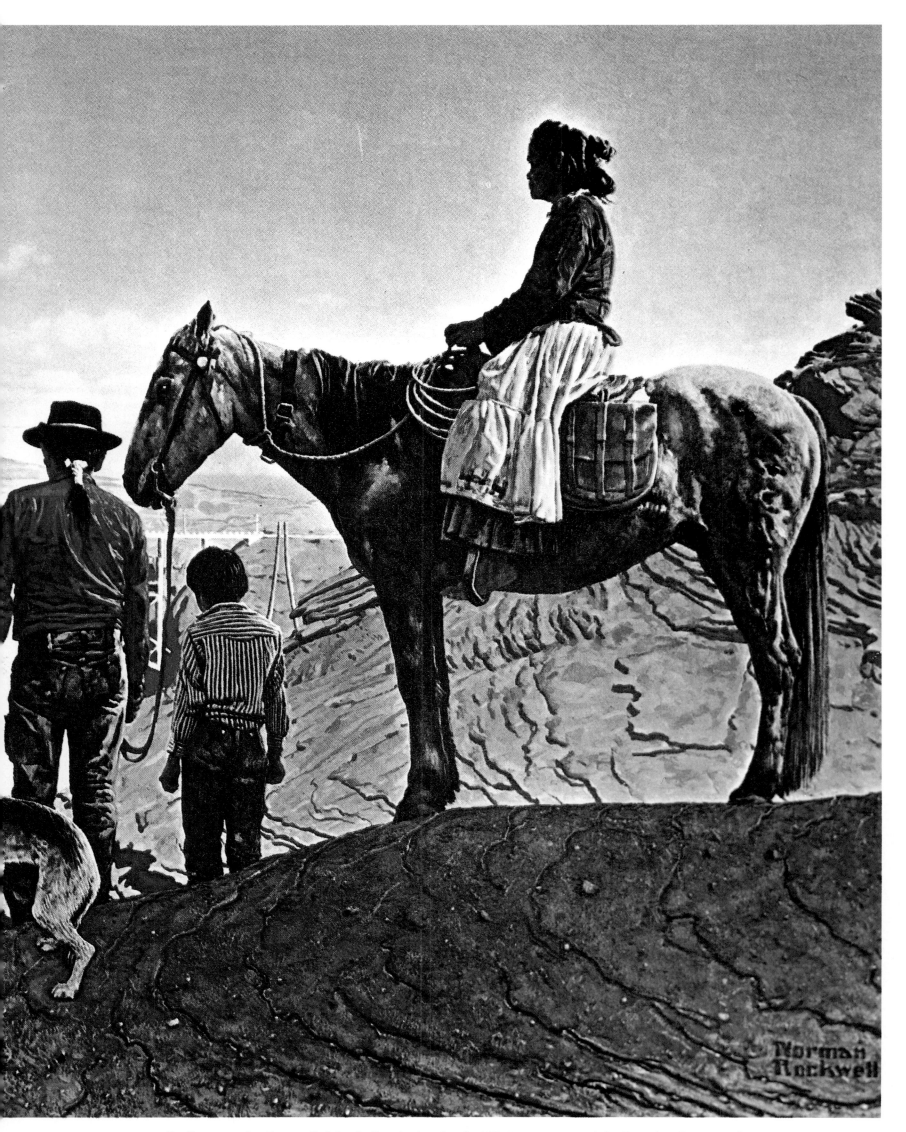

Indians at the Dam. *Original oil painting for the US Department of the Interior, Bureau of Reclamation, undated.*

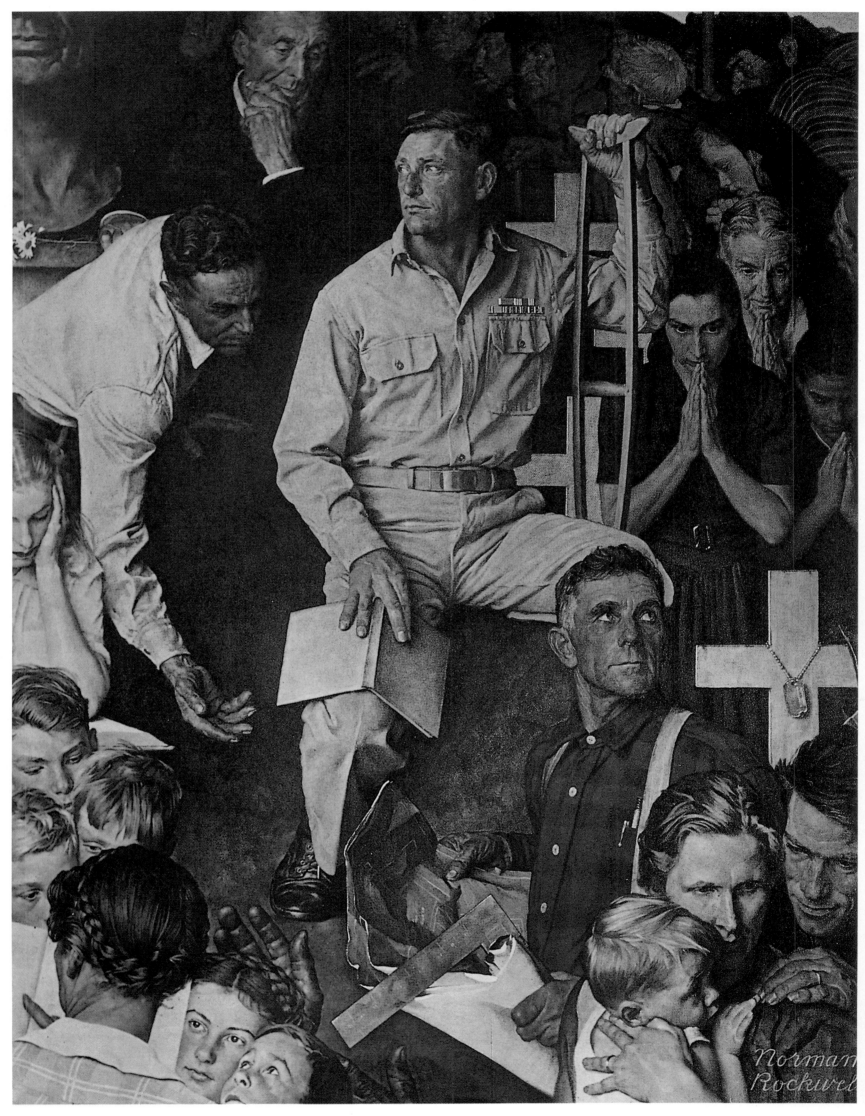

The Long Shadow of Lincoln. Post *illustration, 1945.*

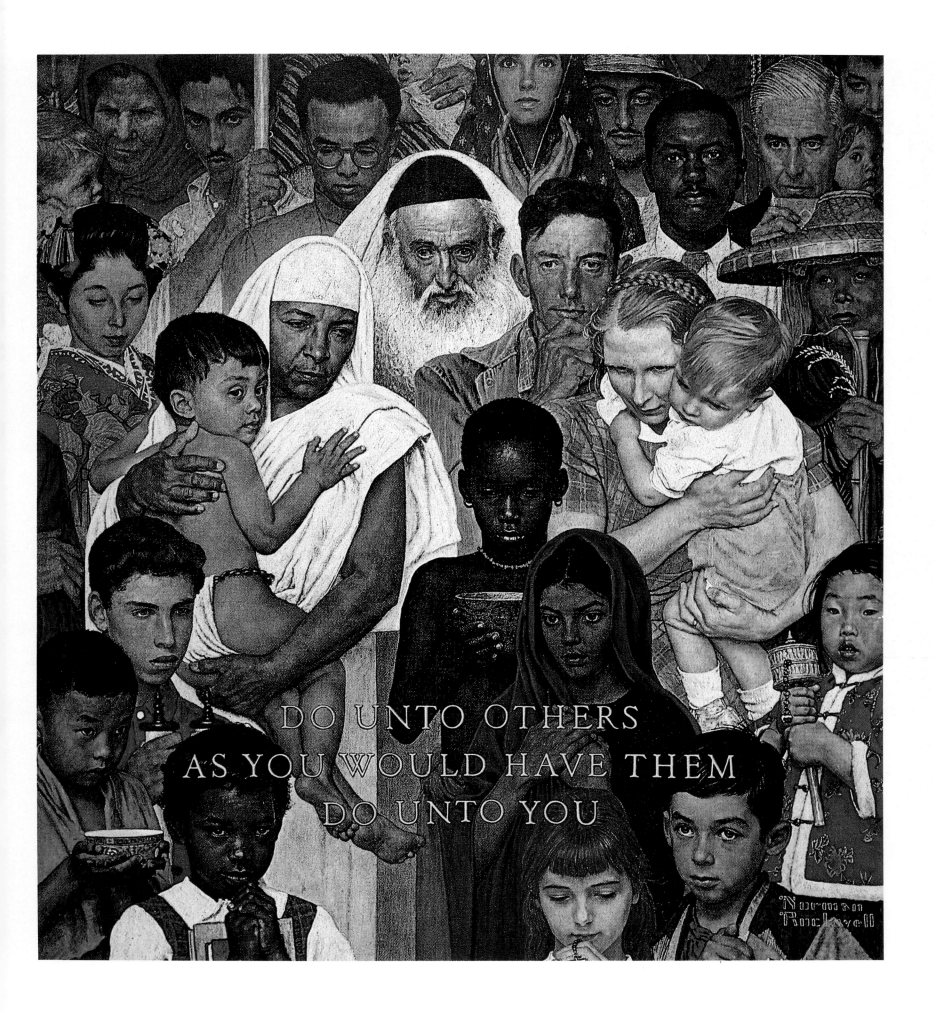

The Golden Rule. Post *cover, 1961.*

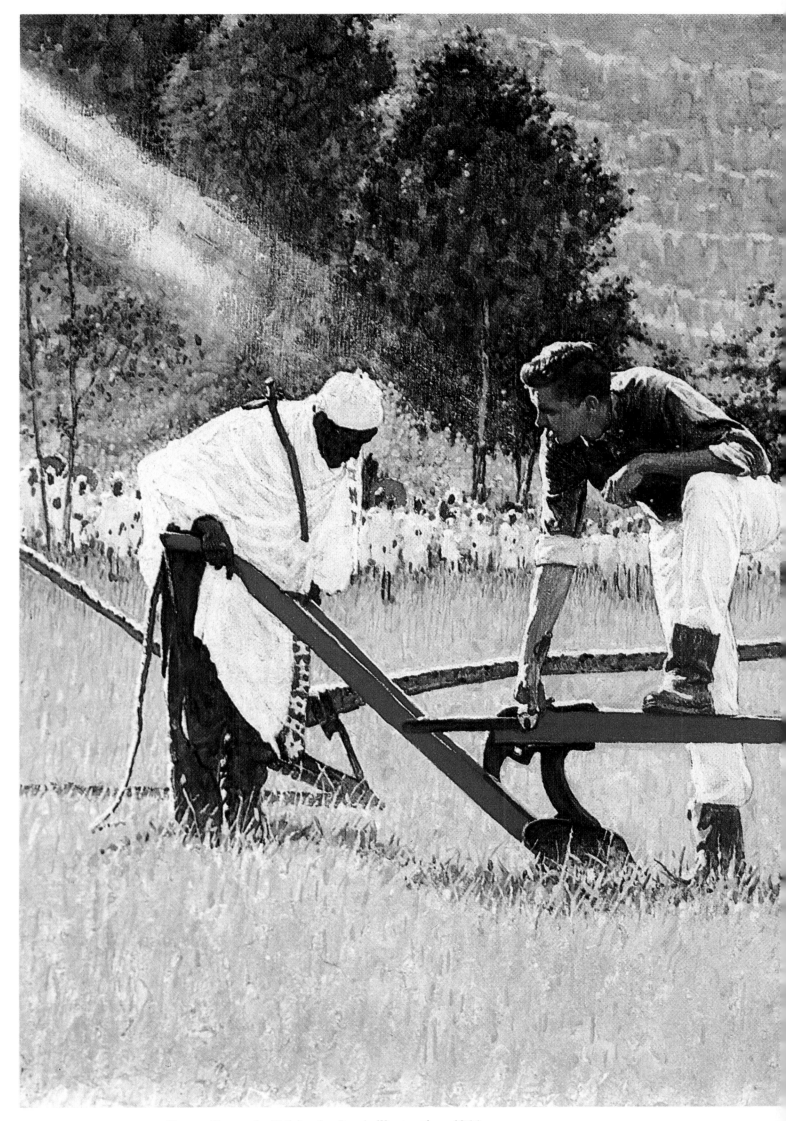

Peace Corps in Ethiopia. Look *illustration, 1966.*

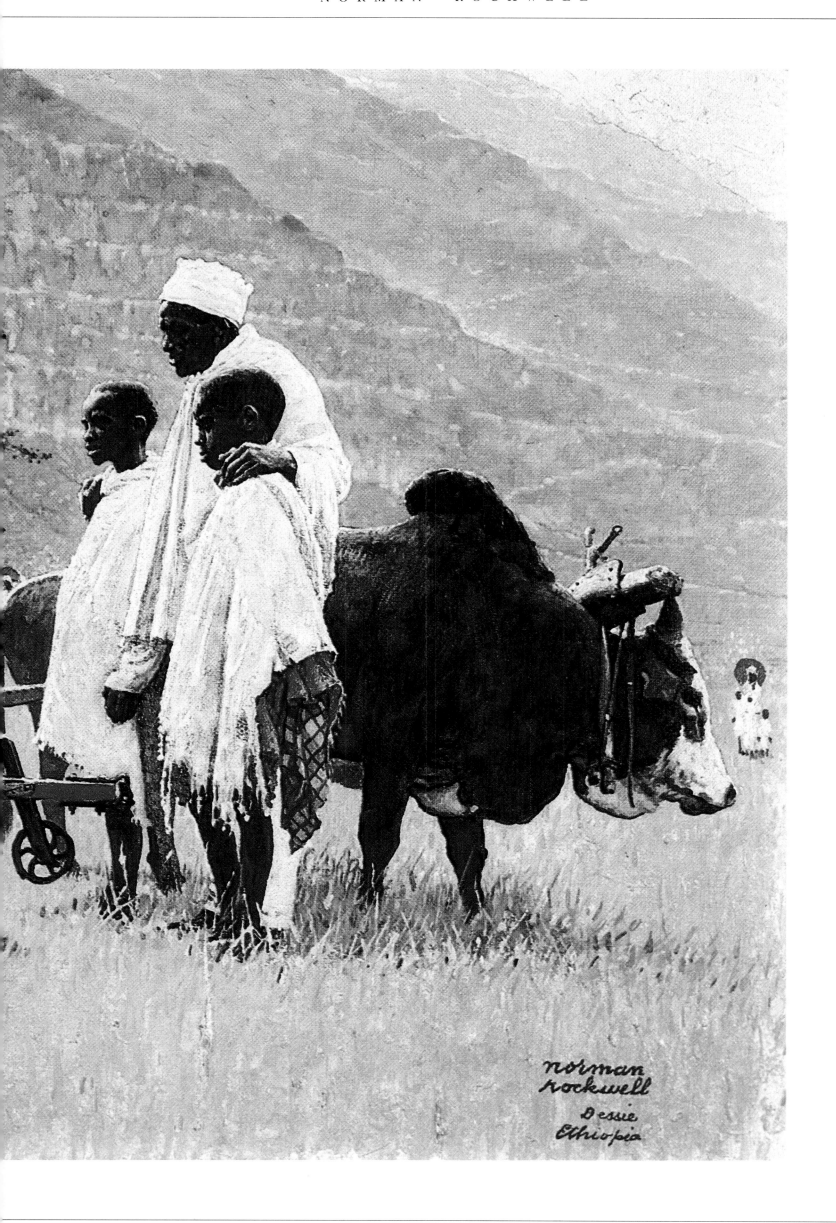

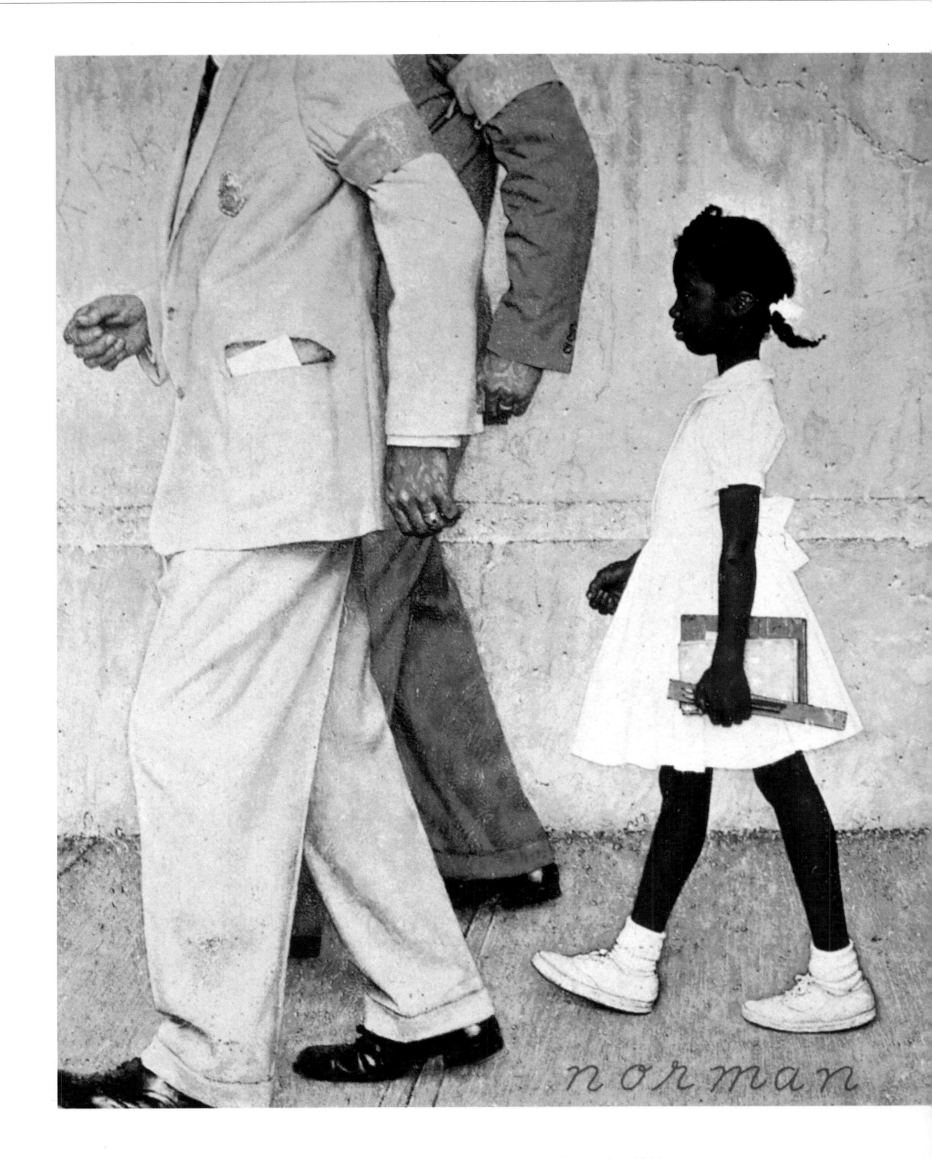

The Problem We All Live With. Look *illustration, 1964.*

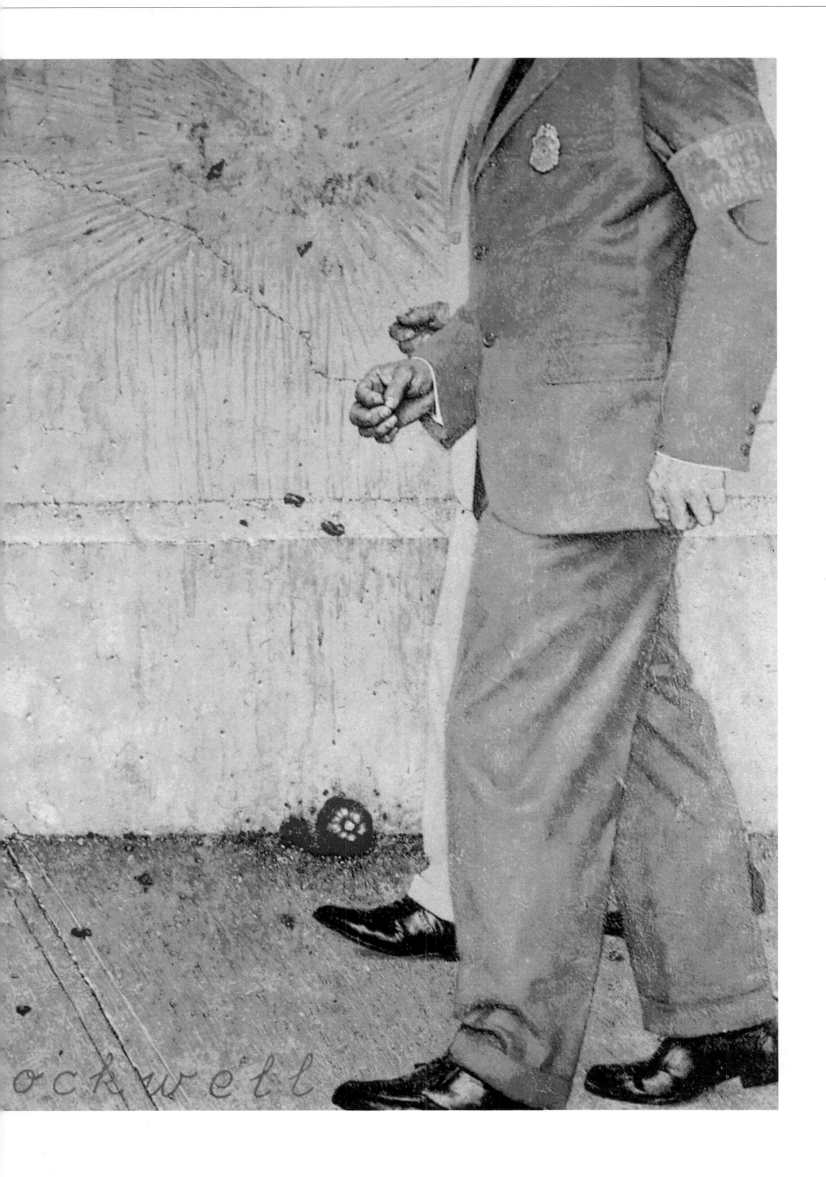

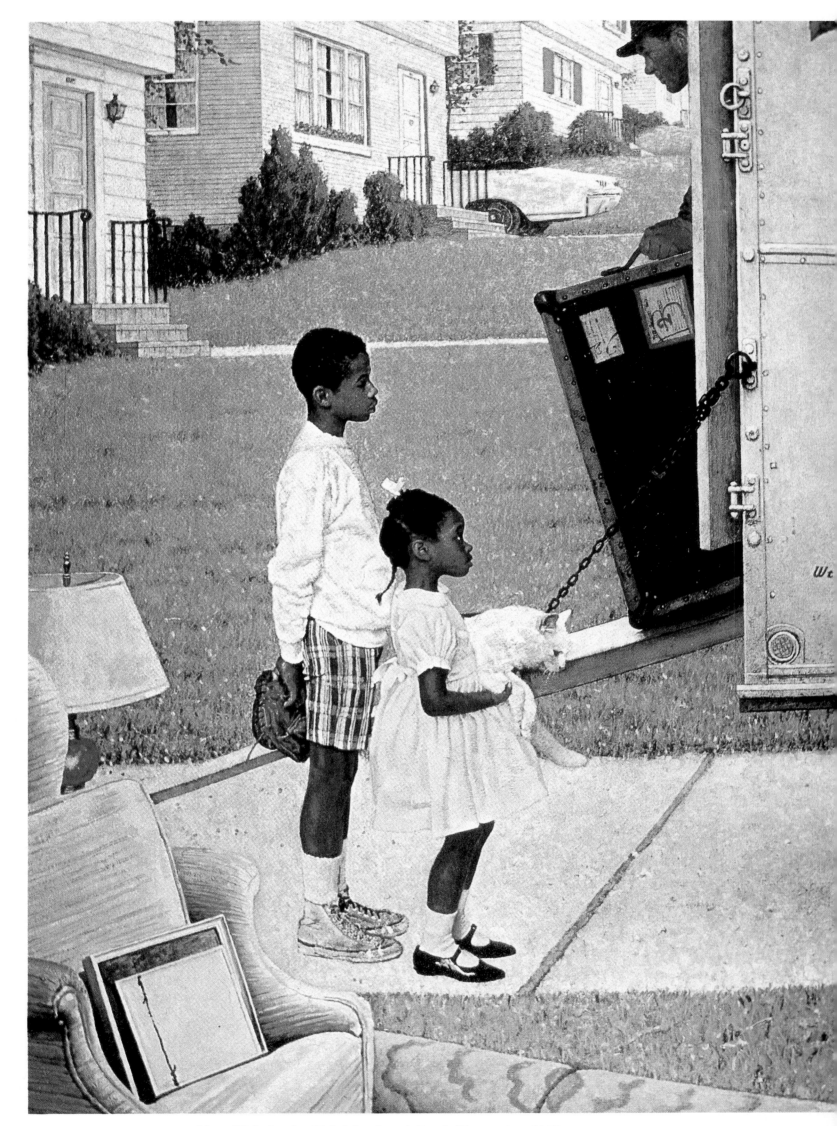

New Kids in the Neighborhood. Look *illustration, 1967.*

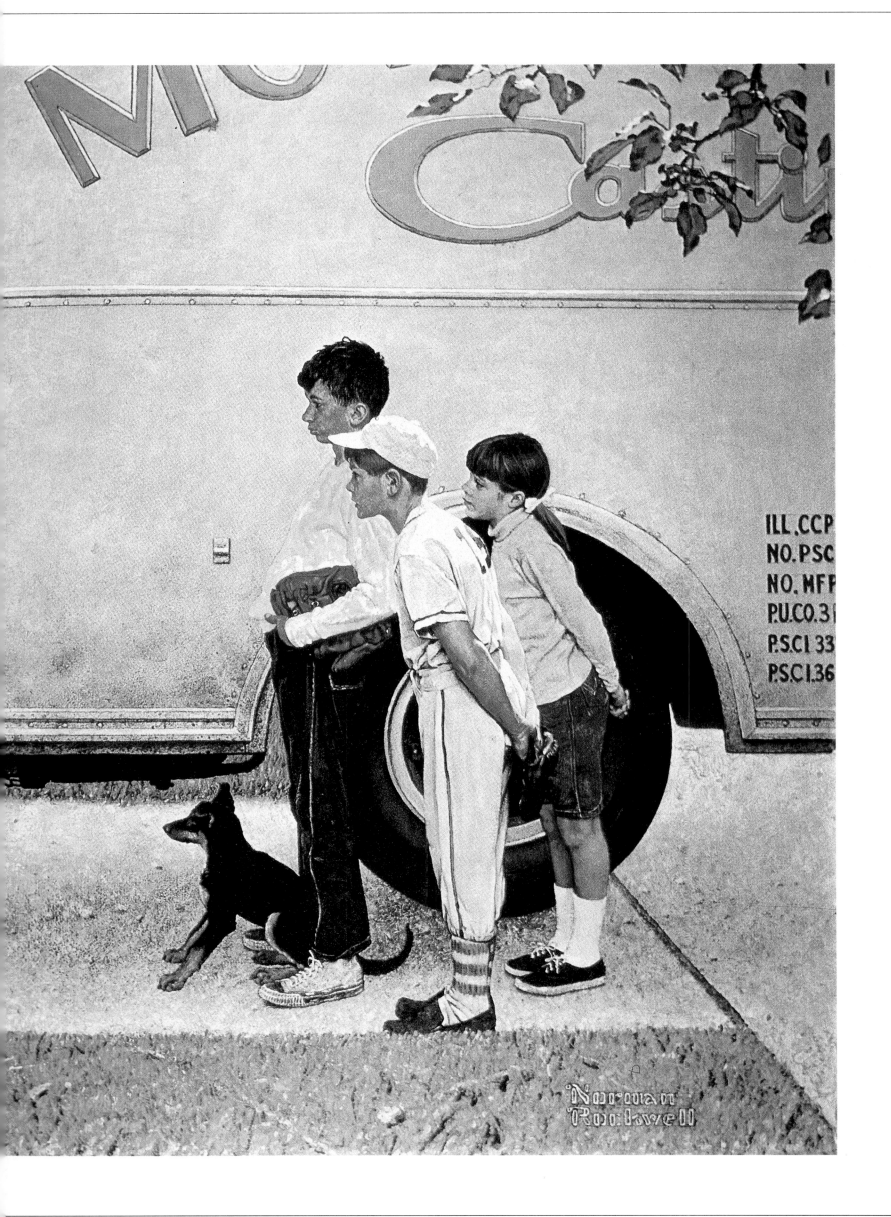

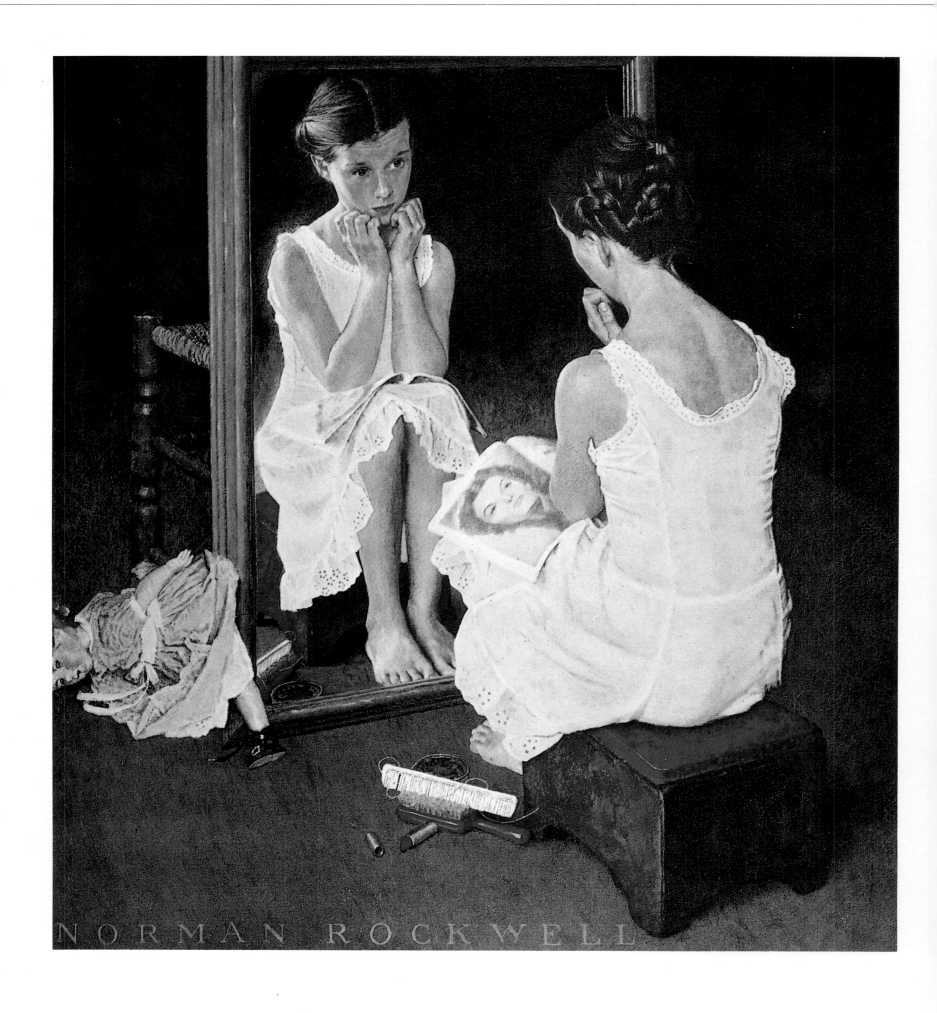

Girl at the Mirror. *Original oil painting for a* Post *cover, 1954.*

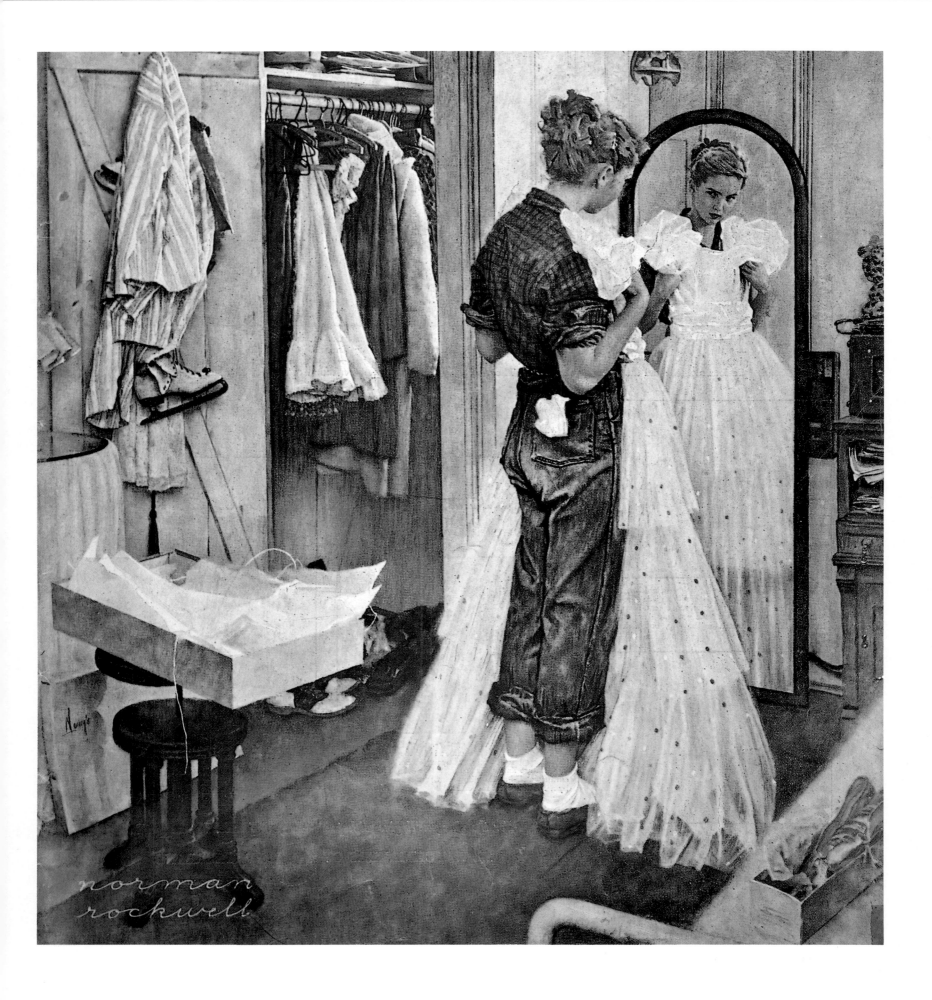

The Prom Dress. Post *cover, 1949.*

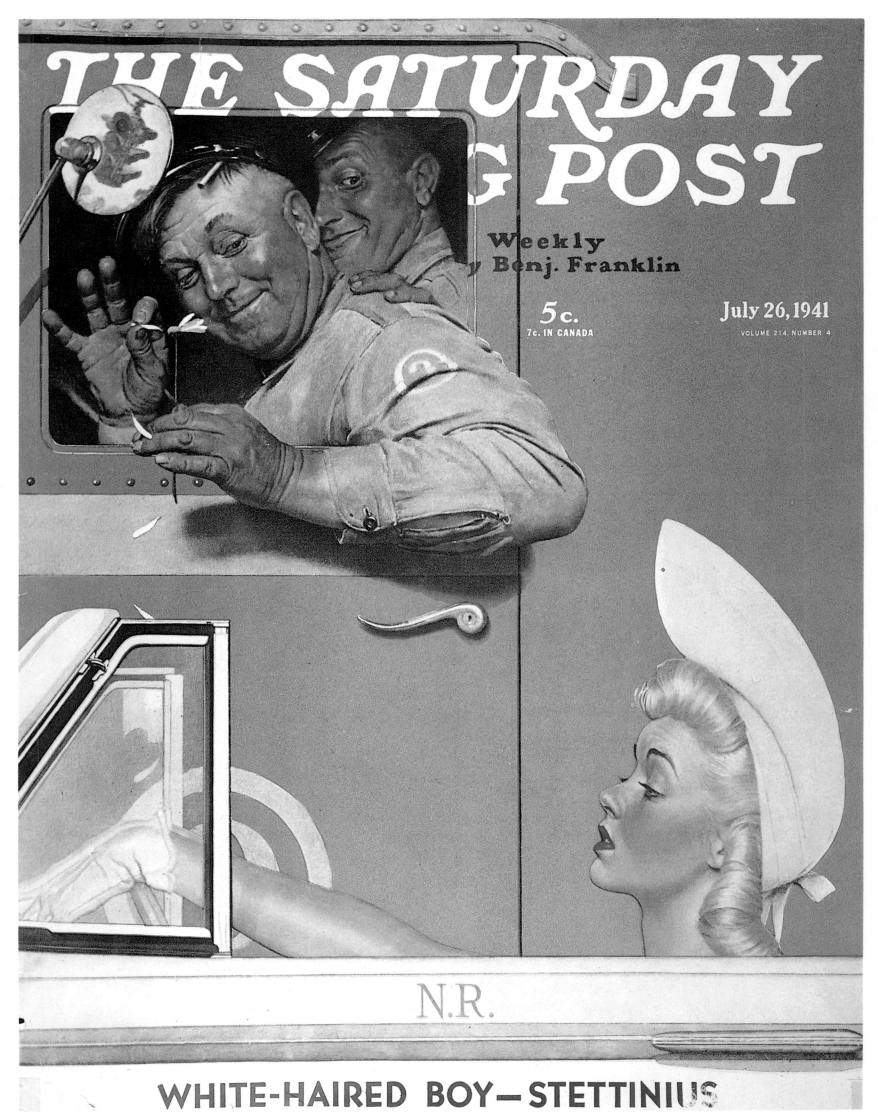

The Flirts. Post *cover, 1941.*

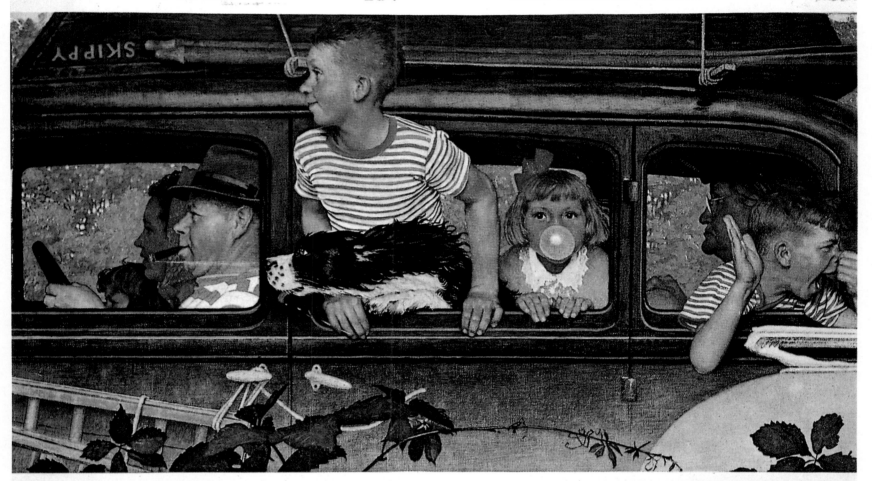

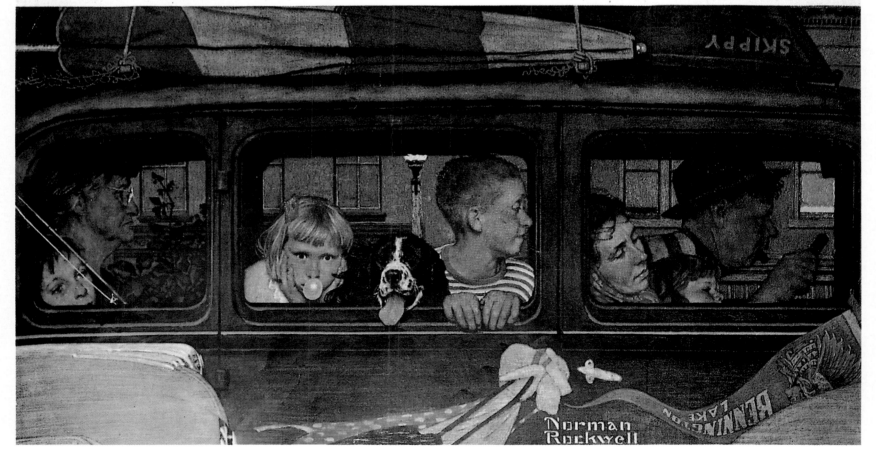

The Outing. Post *cover, 1947.*

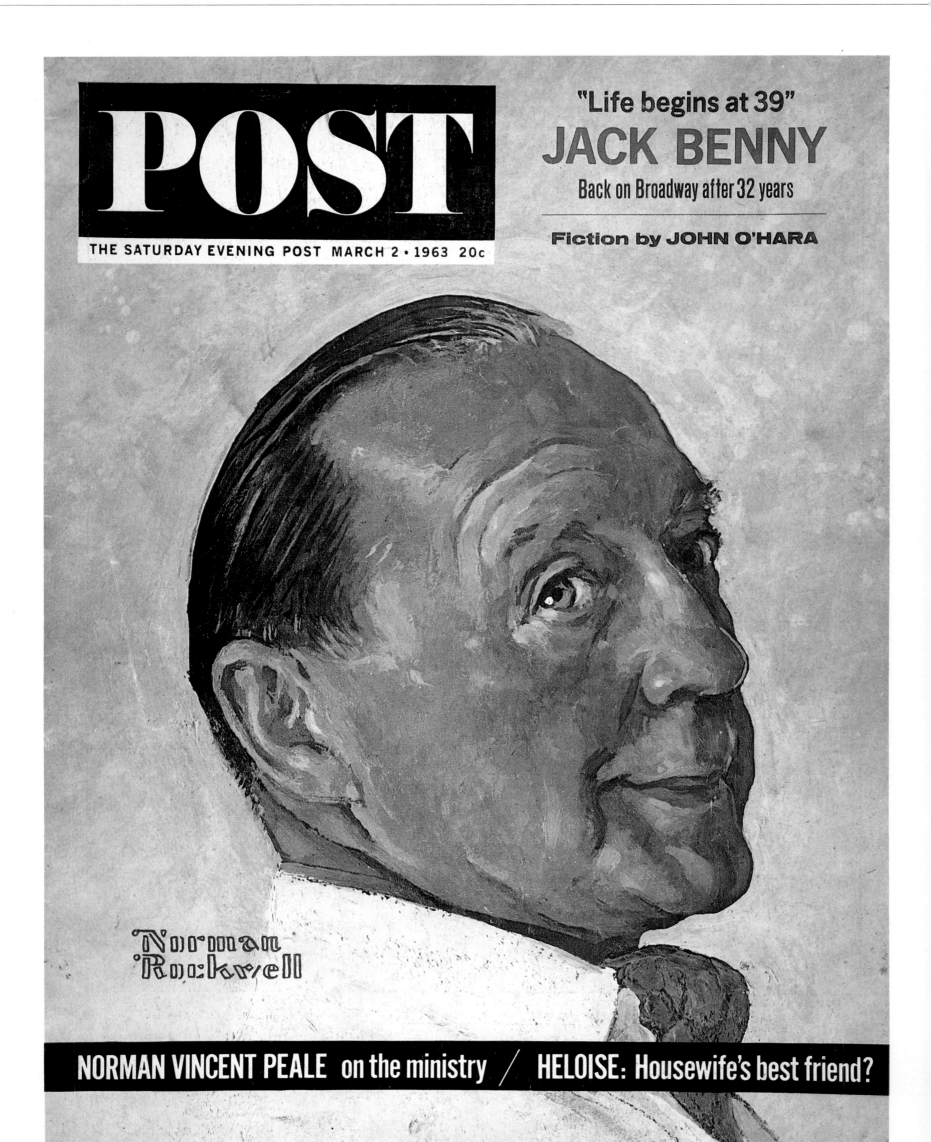

Jack Benny. Post *cover, 1963.*

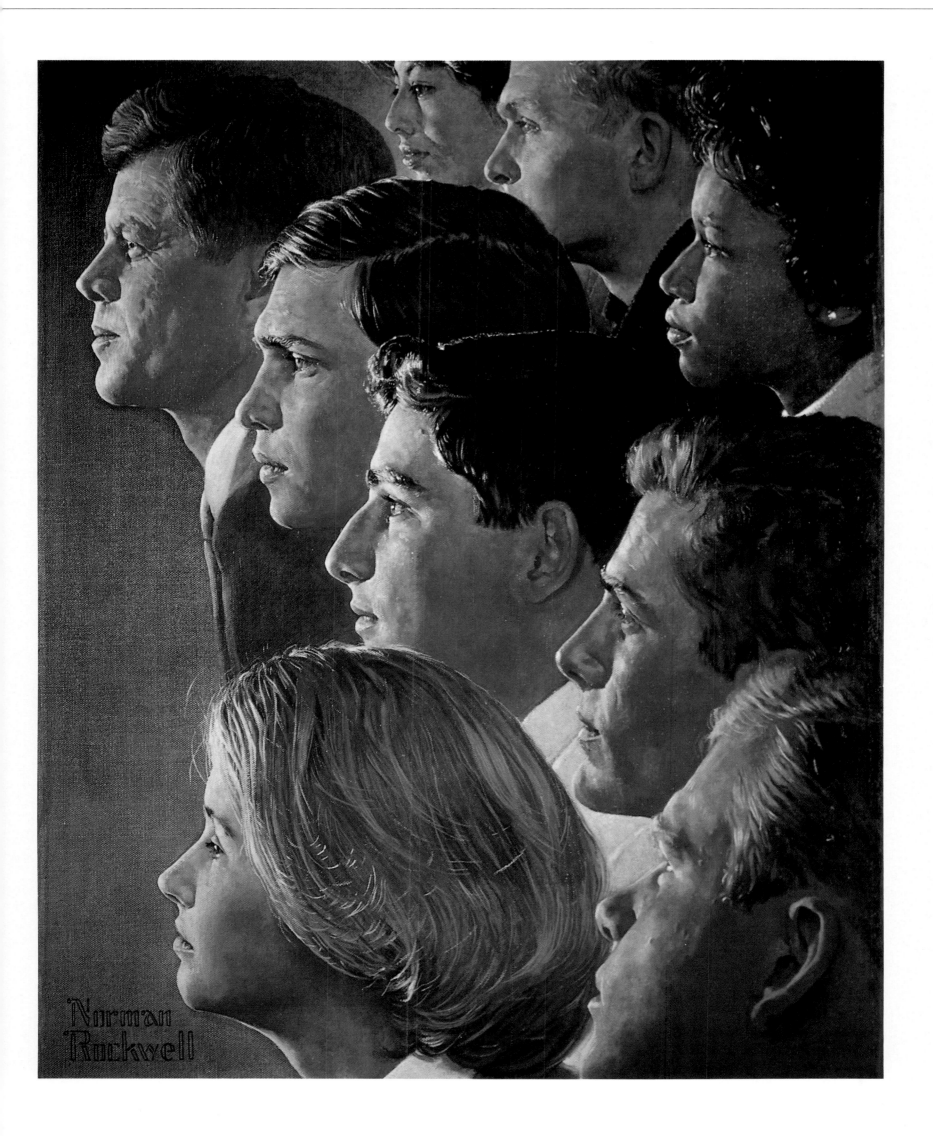

John Kennedy and the Peace Corps. *Original oil painting for a* Look *cover, 1966.*

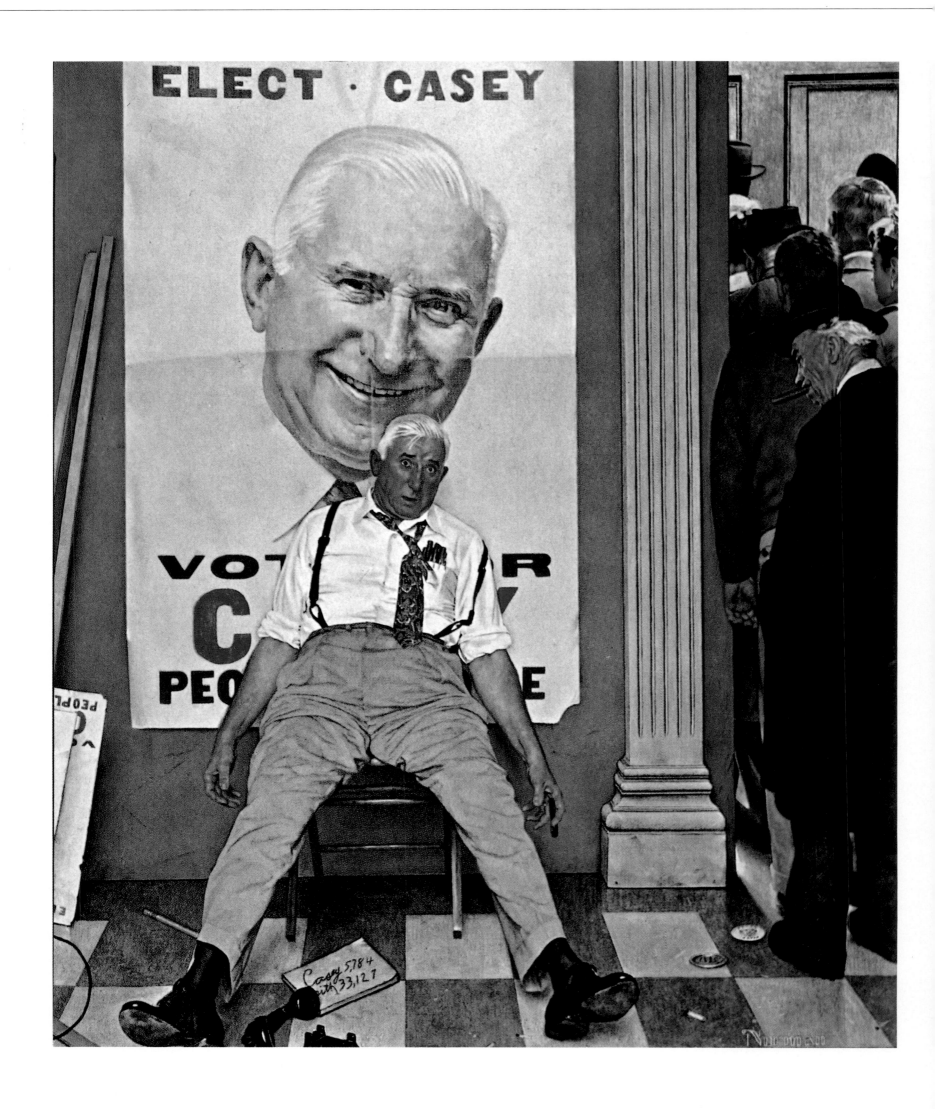

Elect Casey. Post *cover, 1958.*

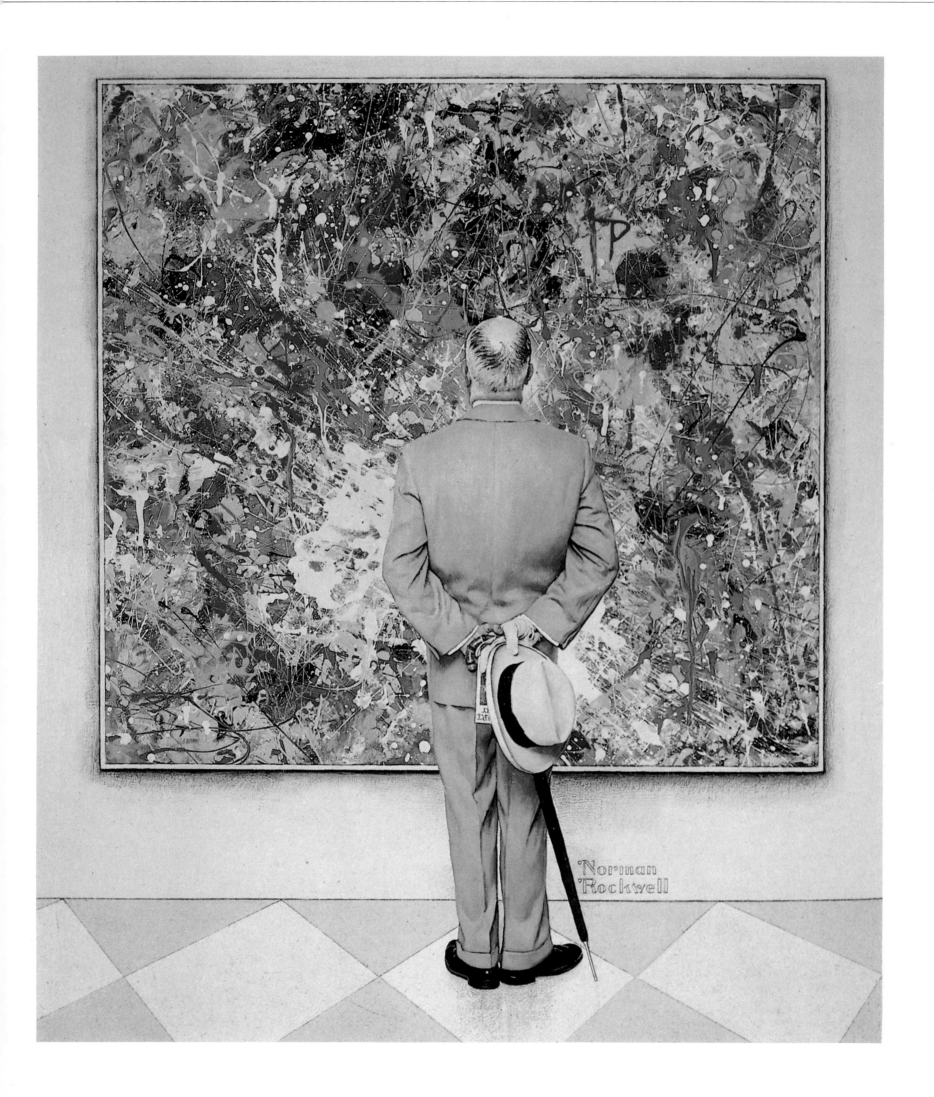

The Connoisseur. *Original oil painting for a* Post *cover, 1962.*

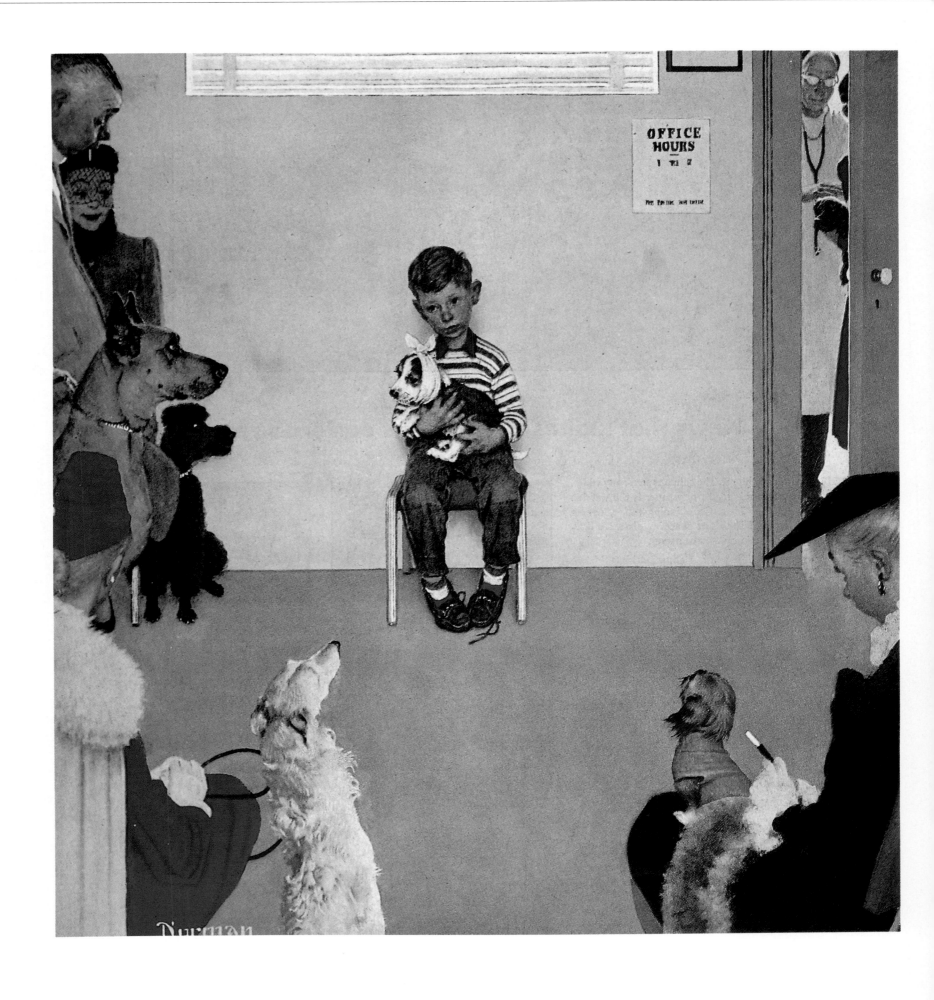

Waiting for the Vet. Post *cover, 1952.*